LABORATORY SCIENCE AND ART FOR BLIND, DEAF, AND EMOTIONALLY DISTURBED CHILDREN

LABORATORY SCIENCE AND ART

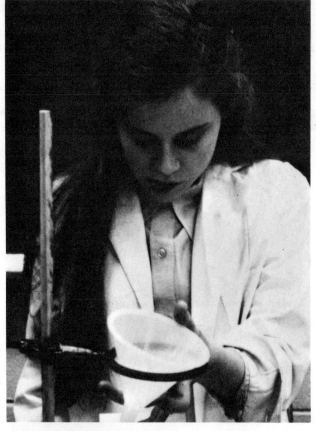

FOR BLIND, DEAF, AND EMOTIONALLY DISTURBED CHILDREN

A MAINSTREAMING APPROACH

by **DORIS E. HADARY, Ph.D.**
Professor of Chemistry
College of Arts and Sciences
The American University

and
SUSAN HADARY COHEN, M.A.

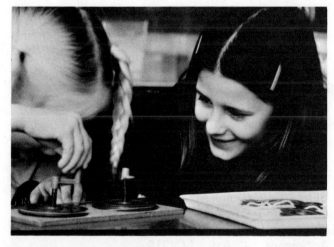

UNIVERSITY PARK PRESS
Baltimore

UNIVERSITY PARK PRESS
International Publishers in Science and Medicine
233 East Redwood Street
Baltimore, Maryland 21202

Typeset by Britton Composition.
Manufactured in the United States of America by Universal Lithographers, Inc.
and The Optic Bindery Incorporated.

Library of Congress Cataloging in Publication Data
Hadary, Doris E
 Laboratory science and art for blind, deaf, and emotionally disturbed
children.

 Bibliography: p.
 Includes index.
 1. Blind—Education—Science. 2. Blind—Education—Art. 3. Deaf—
Education—Science. 4. Deaf—Education—Art. 5. Mentally ill children—
Education. I. Cohen, Susan Hadary, joint author. II. Title. [DNLM: 1.
Handicapped. 2. Education, Special. 3. Science. 4. Art. LC4015
H125L] HV1664.S4H33 371.9 78-1982
ISBN 0-8391-1230-0

To Gideon

CONTENTS

Section III

BACKGROUND INFORMATION

Section VI

INTRODUCTION TO ART ACTIVITIES

ART ACTIVITIES

PREFACE

It was a crisp, sunny autumn day when as a young child I wandered through the woods with my grandfather. I held his firm and confident hand silently experiencing a beautiful day. He knelt to the ground, picked up a handful of rich, black soil, looked at me, put the soil in my cupped hand, and said with reverence and excitement, "In your hand you hold miracles of nature."

At that moment the content of this book was born.

As a student, teacher, and professor of chemistry, biology, and physics for many years, I have been researching, observing, and studying the world my grandfather opened for me; as a result, it is my belief that science and the way of thinking in science is a powerful tool in bringing happiness, contentment, excitement in understanding, and reason for being to the handicapped child, making the child a "whole" person. This is what this book is about.

The numerous requests pouring into our laboratory for the past several years expressing demands for ideas related to the role of education in intellectual development of handicapped children have stimulated the writing of this book. As a result, it is addressed to those whose interest and expressed needs caused its creation and design—teachers and supervisors of special education, science educators interested in science education for handicapped children, itinerant teachers, students in schools of education, regular classroom teachers, institutions for handicapped children, and parents of handicapped children.

Another impelling reason for its being is the passing of the legislation Public Law 94-142 that brings into the realm of experiences for all teachers

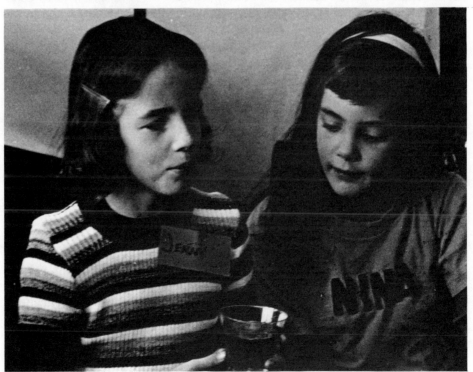

Figure 1. Blind child (left) and sighted child participating in science demonstration, learning together.

the challenge of knowing and teaching the handicapped child in a mainstream situation. We have found this challenge a very rewarding experience. However, it is important to note that careful curriculum preparation and strength in science content are the keys to success. I hasten to say that, without preparation, this exciting venture can become the antithesis of a beautiful experience. It is the goal of this book to nurture success by giving specific ideas and ways to not only address the issue of what "*should* be done" but also what "*can* be done."

Therefore, this book is written for college students in schools of education as pre-service preparation to becoming elementary school teachers, whose early exposure to the education of the handicapped child is vital in view of the present changes taking place in our society. It is also written for teachers—in service—who for the first time in their teaching career are being exposed to meeting the educational needs of the handicapped child, and also for the itinerant teacher seeking activities to advance the education of the child.

Because the least restrictive environment of the mainstream setting may not be educationally profitable for all handicapped children, this book also addresses itself to teachers teaching in schools for the deaf, blind, and disturbed children, where science and art play a significant role in the conceptual, cognitive, and emotional development of the child.

The contents of this book are based on the Laboratory Science and Art Curriculum for Blind, Deaf, and Emotionally Disturbed Children that is presently an ongoing program at The American University in Washington, D.C. It started in 1972, supported by the William T. Grant Foundation, New York, due to the sincere interest and unique sensitivity to the needs of the handicapped child of a very special person, Mr. Philip Sapir, President of the William T. Grant Foundation. The purpose of the program is to especially design, implement, test, evaluate, and finally put into a mainstream situation, a laboratory science and art program for blind, deaf, and emotionally disturbed children that has intellectual development and fulfillment of human potential as its goal. The program also includes pre-service as well as in-service training for teachers. Therefore, the activities presented have been designed, tested, implemented, revised, and evaluated for the past five years in our laboratories and schools.

Experiments from leading elementary school programs, experiments by the Lawrence Hall of Science and by The American University staff (Thier and Hadary, 1973) have been adapted for blind, deaf, and disturbed children. The success of the adapted experiential elementary science program for teaching content and process as well as achieving progress in intellectual and conceptual development for the handicapped children has been shown (Linn, 1972; Struve, Hadary, Thier, and Linn, 1974; Hadary and Long, 1975; Struve, Hadary, Thier, and Linn, 1975).

Hadary, Thier, and Linn (1974) noted significant differences between experimental and control groups of the program in logical reasoning, science content, and science process.

Studies in the mainstream situation have shown that the handicapped child can achieve the same education goals as in an ideal resource situation (Linn and Hadary, 1977). These studies also indicate that the handicapped children were well accepted by their mainstream peers, and that non-handicapped children exposed to instruction with handicapped children were very positive about the experience (Linn, Hadary, Rosenberg, and Haushalter, 1977).

Our studies indicate that, with careful curriculum design to fit the needs of each handicap, proper teacher training, careful determination of suitability of the mainstream situation for each child, and carefully designed classroom management, mainstreaming can not only be effective but can also be a very significant enriching experience in the cognitive and social aspects of the educational process of all the children—handicapped and non-handicapped.

The scope of this book permits the inclusion of only a fraction of the science and art lessons designed, tested, and implemented in the program as well as the relevant science background papers.

Because this book is addressed to readers who may have little scientific or art background, we deliberately did not attempt to overwhelm this audience by copious narrative dealing with background information or overviews. Instead, we have incorporated the science and art concepts in such a way as to cause them to become unfolded within the appropriate experiments and art lessons. Photos are included to bring reality to the lessons and concepts.

The background information sections are written to relate to the experiments and to suggest extended and adapted activities; e.g., "Science and Music" section indicates the possibility of working with the deaf child and the "Slinky" explores understanding the nature of sound.

It is hoped that the general principles involved in the adaptations suggested in the lessons will give clues to the teachers of how to adapt many lessons on their own and the inspiration to do so.

This book is only a beginning—there is much to be done.

Doris E. Hadary

ACKNOWLEDGMENTS

We should like to express our deep admiration for and appreciation to Mr. Philip Sapir, President of the William T. Grant Foundation, for the sustained inspiration and support he has given us throughout the years of development of this program. Because of his sincere interest and unusual sensitivity to the needs of the handicapped child, he has caused new worlds to be opened for blind, deaf, and disturbed children. He has worked to bridge human concern and science. He is a "real" person. We thank the William T. Grant Foundation for their generous support for the past five years.

We are deeply grateful to Dr. Herbert Thier and Dr. Robert Karplus of the Lawrence Hall of Science, University of California, Berkeley, California, for their friendship, encouragement, continued support, professional advice, and for their cooperation in adapting laboratory materials for the blind child. I thank Mr. George Moynihan for his assistance in obtaining permission from the Science Curriculum Improvement Study to use and adapt selected experiments copyrighted by the Regents of the University of California.

To Dr. Marcia Linn, psychologist of the Lawrence Hall of Science, I give thanks for her excellent work as the research psychologist in the evaluation of the program as it developed.

We are indebted to Dr. Nicholas J. Long, psychologist of the School of Education, for his seminars and continued guidance in dealing with emotionally disturbed children.

To Dr. Joseph J. Sisco, President, The American University and Dr. Frank J. Barros, Assistant Provost for Academic Development, thanks for their continued support.

Thanks to all my colleagues who have served as consultants throughout the development of the program, and writing of this book:

Mr. Norman Anderson, Faculty, Maryland School for the Blind

Dr. David Cohen, Professor at The Johns Hopkins University, Baltimore, Maryland, for his assistance in the preparation of the manuscript

Commander Joseph Coyle, for his engineering advice in building equipment

Dr. R. Orin Cornett, Director, Office of Cued Speech Programs, Gallaudet College, Washington, D.C.

Mr. Paul J. Cunningham, Faculty, Gallaudet College, Model Secondary School for the Deaf

Ms. Janice Guzzy, for design of prototypes of "Seefee" posters

Mr. Joel J. Hadary, for designing data processing approach for our research

Dr. Sharon G. Hadary, for her assistance in designing research instruments

Dr. Franz E. Huber, School of Education, Psychologist, The American University, Washington, D.C.

Dr. Alice Koller, for her assistance in preparing the manuscript

Dr. Carol Ravenol, Department of Art Education, The American University, Washington, D.C.

Dr. Romeo A. Segnan, Department of Physics, The American University, Washington, D.C.

Ms. Jo Ann Stockglousner, Supervisor, Auditory Services, Montgomery County, Maryland

Mr. Henry Vlug, Faculty, Gallaudet College, Model Secondary School for the Deaf, Washington, D.C.

Dr. Richard V. Waterhouse, Department of Physics, The American University, Washington, D.C.

Cooperating School Systems and Schools:

District of Columbia, Grant School, Mrs. Gwendolyn Haines
District of Columbia, Jackson School, Azalee Harrison and Grace Stephenson
Fairfax County Auditory Programs, Mr. Donald McGee
Fairfax County, Ms. Jane Milnes, Vision Coordinator
Fairfax County Vision Program, Braille Teacher Mrs. Caroline Sledzik
Loudoun County Public Schools, Nelda Robrahn
Maryland School for the Blind, Mr. Kirk Walters
Montgomery County School System, Dr. Rosemary O'Brien, Supervisor, Vision Program
National Child Research Center, Ms. Terry Vandebossche
Prince George's County Public Schools, Visual Program, Mrs. Ann Bertch
Virginia Commission on the Blind, Ms. Constance Taylor

Portions of these activities have been adapted from *Science...A Process Approach II*, © Copyright, 1975, 1974, American Association for the Advancement of Science. Used by permission of the publisher, Ginn and Company. (Xerox Corporation).

Materials have also been adapted from the Elementary Science Study Unit, *Clay Boats*, with permission of Education Development Center, Inc.

Thanks to:

The Redskin Foundation, for support in trying times
Xerox Corporation, Rand McNally, and Webster/McGraw-Hill, for granting permission to adapt selected experiments
Writers, designers, and teachers of the Art Program described in the book:
Tamara Hadary Moshman and Ruth Levine, Faculty, Department of Art, The American University, Washington, D.C.
Photographs by Marc Moshman

We are deeply indebted to the faculty and principal, Mrs. Lillian Dezon, of Mann Elementary School, our *Model School*, which has been the "backbone" of the program for six years.

Thanks to Inge Engel for her editorial contributions, efficiency, punctuality, and interest in typing the manuscript.

I am deeply indebted to my assistant Mr. Robert Haushalter—a master teacher—whose exceptional ability and sensitivity to teaching laboratory science to handicapped children gave the initial and sustaining spark to the life of this program. His six years of devoted participation in curriculum design, development, adaptations, and teacher training played a major role in the existence and development of the program, making this book possible.

Thanks to Richard Rosenberg for his superb administration of the model school program, as well as for his invaluable work in teacher training and classroom demonstration teaching—above all, for his devotion and loyalty to the program.

We give thanks to our four blind children with whom we started the experimental program in 1972, and who pre-tested our experiments for four years; we give them our thanks, our love, and everlasting admiration: Susan, John, Robin, and Pam.

To all the children in our school.

Section I

SCIENCE, ART, AND THE MAINSTREAMING PROCESS

WHY SCIENCE?

Science is a powerful tool for the fulfillment of human potential of all children—the blind child, the deaf child, and the disturbed child. As an individual coping on a day-to-day level, the child finds life literally bombarded with stimuli from his environment. Stimuli that, especially for the handicapped child, are jumbled together, coming from all directions. How does the child sort these stimuli in a meaningful way? How does he[1] make decisions? How does he gain mastery of his environment? How does he distinguish between fantasy and reality, cause and effect?

Science offers a myriad of phenomena and possibilities for experimentation to help the child meet these fundamental problems. As is evident from the science activities described in "Introduction to the Laboratory," science can address these needs by offering the child models for interpreting, observing, relating, sorting, classifying, and predicting—these are the necessary skills, attitudes, and understandings that the child must develop in order to cope with his environment. The child needs to learn at an early age to store concepts and relationships with which to build resources for interpretation. Science answers that need.

Interaction with scientific phenomena provides the way for the child to attain systematic reasoning powers, and makes it possible for him to gain mastery and understanding of his environment, since many of the phenomena and materials with which science deals are part of the real world in which the child lives. In addition to being part of his world, he finds the sciences intrinsically fascinating and highly motivating. The very nature and structure of science allows for the need for many modes of learning, thus providing the opportunity to develop cognitive ability through sensory learning.

[1]Masculine pronouns are used throughout the book for the sake of grammatical conformity and simplicity. They are not meant to be preferential or discriminatory.

Figure 1.1. Blind child listens to detect color change using light sensor and contrasting beaker.

A distinguishing and extremely important characteristic of science to recognize when working with mixed groups of children is the potential to permit specific sensory additions to all lessons to substitute for deficient or missing senses of the handicapped child. These additions

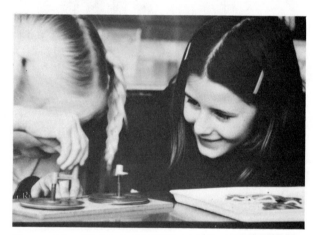

Figure 1.2. Sighted child shares the joy and excitement of discovery by blind child.

add another dimension, and enhance the learning of all children. Another, and very significant, reason why science is of compensatory and therapeutic value for children who seek order in a world of disorder is the nature and structure of science—order, design, cause, and effect. In the science laboratory, the child is removed from his world of introspection to the world of discovery and excitement. He utilizes all of his remaining senses in a world where the wonders of the world are made real to him through science. He shares science with his peers and is complete.

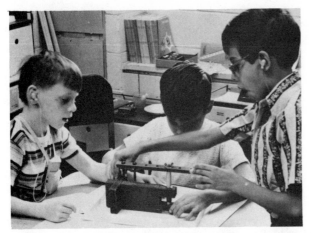

Figure 1.3. *A blind child shares science with deaf peers.*

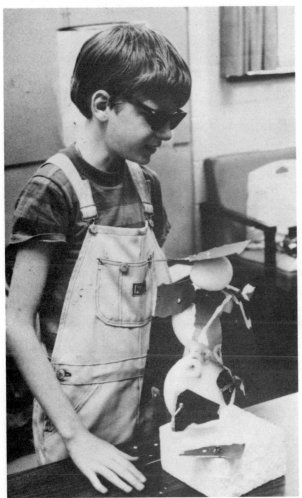

Figure 1.4. *"It started out being small, but I felt that it needed to grow bigger. When I move one part, another part moves."*

WHY ART?

Art draws on a universal quality in children—the need and desire to express experience and the emotions stimulated by experience. Blind, deaf, and emotionally disturbed children have the same, if not greater, need as "normal" children for expression. Handicaps of blindness, deafness, or emotional problems are only superficial characteristics; the need for expression is part of being. Side by side, deaf, blind, and emotionally disturbed become once again "all children" working to create their expressive interpretation of experience.

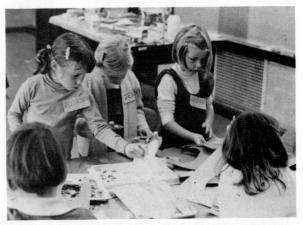

Figure 1.5. *Side by side blind and sighted children work together to create their expressive interpretation of shared experience.*

WHY SCIENCE AND ART?

Abstract thought and concrete action—interdependent qualities of mankind, inextricable—both intoxicating, both fulfilling.—Ben Gurion

This unique program of art and science for the handicapped was developed on the assumption that both disciplines share common learning experiences and procedure. In both science and art, the student experiences of discovering, describing, and demonstrating are integral to the process of learning. Unlike a purely intellectual exercise or verbal presentation, a learning system that relies both on verbalization and creation allows the child to internalize experience in a unique manner. The premise on which this interdisciplinary and interactive program was developed, then, is that both art and science are encountered by means of the same behaviors. Fur-

Science, Art, and the Mainstreaming Process 3

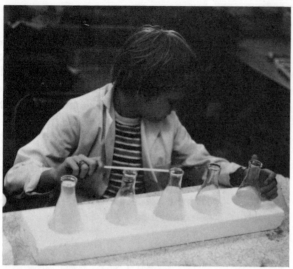

Figure 1.6. Blind child discovers different tone intervals in a science experiment.

Much of the learning takes place in the laboratory/studio setting. In the laboratory, touching, manipulating, and creating are the ways in which effective learning occurs. Because verification is necessarily strongly tactile for the handicapped child, three-dimensional materials dominate, and these are manipulated and arranged to illustrate scientific processes and visual patterns. Both parts of the program have as long range goals the reintegration of learning.

The particular challenge lies in making available to the handicapped student a carefully structured and sequenced interplay between scientific knowledge and imaginative sensory experiences. Often the science components offer concrete territories for further exploration. Notions of energy transfer chains, chemical mixing, and movement stimulate explorations in equivalent visual notions such as mobile string and shell sculptures, color mixing, and stitchery walks.

The same elements and principles considered in the normal curriculum are covered in this special art and science mainstreaming program. There is no distortion or truncation. Ideas of

thermore, these behaviors reinforce each other in the two areas. In both disciplines, a body of information exists that can be presented and understood partially by description and analysis, but most significantly through the student's own participation and production.

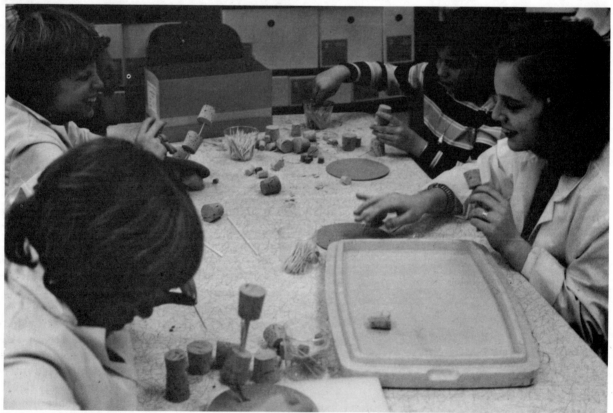

Figure 1.7. Different tone intervals are expressed in sculpture in art activity.

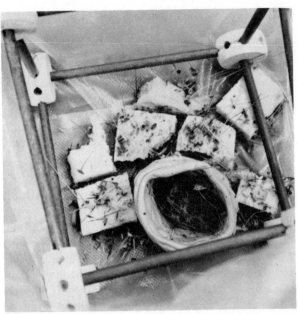

Figure 1.8. *"I made a greenhouse, a home for a seed. It wasn't just science, it was science and art. The seeds grew and I felt them make lines through space"* (blind child).

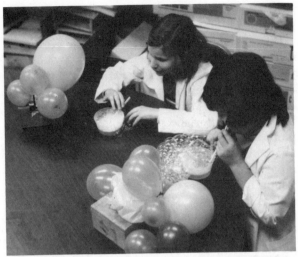

Figure 1.9. *"Baking soda and vinegar make bubbles. I observed the interaction in science. In art I made more bubbles—I wanted them to last so I made balloon bubbles and put them together the way I thought they'd be if they didn't pop so soon"* (blind child). Sighted and blind child work together.

properties, for instance, are fundamental. The properties of size, shape, and texture shared by both science and art are easily understood by all children, including the blind, when presented in three-dimensional materials. Modification occurs, therefore, in a greater emphasis on tactile and dimension materials. With the help of a series of questions by the teacher, these materials are classified and categorized. The student then arranges the materials according to a visual plan. Systems of repetition, alternation, and progression may be introduced at this time.

The organization of elements into coherent patterns is made meaningful by reference to models of the natural world. A crystal, plant, or human form may provide stimulus for understanding structure, plan, or relationship. Organizing principles such as centrality, symmetry, asymmetry, circularity, counterforce, and branching are deduced from the model and restated in the student's own terms.

Nature itself combines science and art: the life cycle of the butterfly, the structure of the butterfly wing, and the structure of the flower are a few. For the handicapped child, nature provides tactile inspiration: textures of bark, branch growth, and the structure of feathers are examples. The elusive quality of a bubble, the lightness of a dandelion seed, and the growth of a plant involve color, form, line pattern, movement, balance, and textures—the components of art.

The affective and expressive areas are also valued, and operate concurrently with the linguistic, conceptual, and experiential phases. The "wow" reaction, indicating valuing and responding, is integral to the entire program. There is a

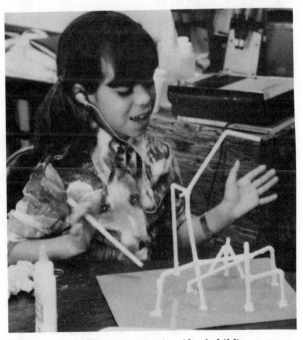

Figure 1.10. *The* wow *reaction (deaf child).*

high level of enthusiastic response as the child successively uncovers meaning and relationship.

One of the most critical facets of this program is its stimulation of the "will to form," which is a precondition of all aesthetic activity. This "will" is nurtured by information, encouragement, and increasing confidence based upon the series of integrated experiences. The opportunity to explore and to create through the same materials available to the sighted and hearing child increases immeasurably the self-esteem of the young blind or deaf artist. What is most significant is that these projects or activities are linked together to increase the value of each. Learning proceeds, then, with maximum understanding, participation, and joy.

There is only the way of intuition, which is helped by a feeling for the order lying behind the appearance.—Albert Einstein

THE LEARNING PROCESS

Children and Learning: Bringing Them Together

Sometimes that explosive response of a child's mind takes place in unexpected ways at unexpected times. In the American University pilot program science classes, blind, deaf, and "normal" children are able to work together in a mainstreamed setting using adapted and specially designed curricula. For example, in studying the properties of the pendulum, children count the number of times the pendulum swings back and forth in a minute. Each time the pendulum completes a cycle, its bob comes between a beam of light and a light sensor. The light sensor converts lights of varying intensity into buzzing sounds of varying pitch. In this way the blind children, as well as the sighted children, can keep track of the pendulum's movements.

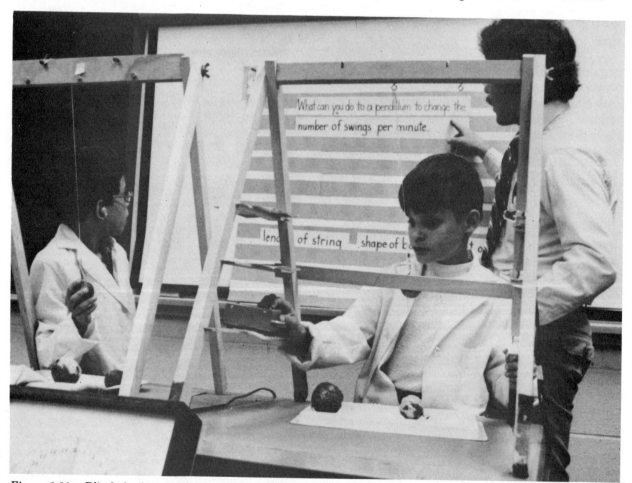

Figure 1.11. Blind, deaf, and ordinary children study together the properties of the pendulum. Blind child, right, holds a light sensor that keeps track of the pendulum's movement as the bob comes between the light source and the light sensor.

Troy is a profoundly deaf child. He cannot hear the buzzing, but he can see what the blind and sighted children are doing. He becomes more and more curious. He picks up the sensor and begins playing with it. Suddenly, Troy becomes aware of the buzzing through his fingertips. His classmates and the teachers are watching him in silence and growing excitement.

You can almost see the ideas taking shape in his head. He realizes how the light sensor works. He moves it closer to and farther from the light source. He carries it over to the windows.

Everyone shares Troy's total involvement in an experiment that had originally been adapted for blind children. The three groups of children are learning together that there are many ways of sharing the same experience. Each group reinforces and enhances what the other two groups learn. Each group gives to the other two an opportunity to see familiar things new ways.

Here we use "see" in its deeper sense of "understand." Understanding is seeing with the mind. Such pictures in the mind are not made by eyes alone. To know the shape, size, and position of something is seeing with the mind. It is what the blind girl means when she tells her friend: "I can see all right, but not with my eyes."

Figure 1.13. "I can see all right, but not with my eyes."

There are many ways of seeing for all of us. We see a great deal through sense of touch, which is why we often say of a new situation, "Well, I'm just getting the feel of it." It is not merely the artist who paints with his hands. Our fingers are like ten brushes painting on the canvas of our minds.

A cat's tongue is but a small red tongue to the eye of sight. But when a cat licks your fingers, the picture becomes unforgettable: rough as sandpaper, fluttery and damp as a breeze in a spring rain. And if the picture of the cat's tongue is at our fingertips, the portrait of the bedroom floor is in our toes: soft and warmer where the carpet is, hard and colder beyond the carpet's edge...

Seeing does not come with light, nor darkness with the lack of sight. True darkness comes only through ignorance and misunderstanding. We understand with our minds. And understanding is the light that lets us see through the dark in as many ways as there are thoughts and feelings (Weiss, 1976).

As the blind child learns to *see* with his mind, so the deaf child can learn to *hear* with his mind. It was Troy's fingers that *explored* the light sensor, picking up the vibrations. It was Troy's eyes that *explored* the pendulum, seeing it interrupt the light at the same time that the vibrations stopped. These were concrete experiences.

Figure 1.12. Deaf child observes the blind child's method of observation.

Science, Art, and the Mainstreaming Process 7

From these concrete experiences, Troy *invented* an idea new to him: the sensor responds to light by buzzing. He tested the idea by pointing the sensor at the window, and by changing the distance of the sensor from the light. In this way, he discovered another use for the sensor: he discovered that the sensor's buzzing changed when the intensity of the light changed. Troy became involved in intellectual pursuit in a nonverbal way.

Exploration, invention, and discovery: these are the basic ways in which the laboratory science and art classes try to give children opportunities for conceptual development. Troy's experience serves as a model for learning in the science and art classrooms.

Troy learned by a hands-on approach to his surroundings—by handling objects and moving them about, either physically or in his mind. This manipulation of objects and ideas amounts to a type of nonverbal thinking. It helps explain why, for example, the deaf child learns concepts of time and numbers at about the same age as the "normal" child, even though the deaf child is usually deficient in his grasp of verbal language (Furth, 1973). In Furth's words, "A deaf

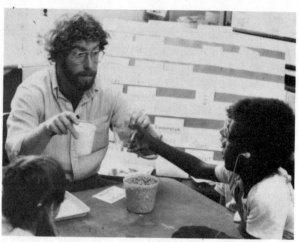

Figure 1.14. Science experiments permit nonverbal communication.

child can comprehend that there are more plants than flowers and that one's uncle can be younger than oneself and that 162+73 is the same as 160+75. He comprehends it even though he may not be able to verbalize it and he may not have been told these particular facts. He has within him his own criteria of comprehension—the framework of concrete operations which he can apply to these and others" (1973).

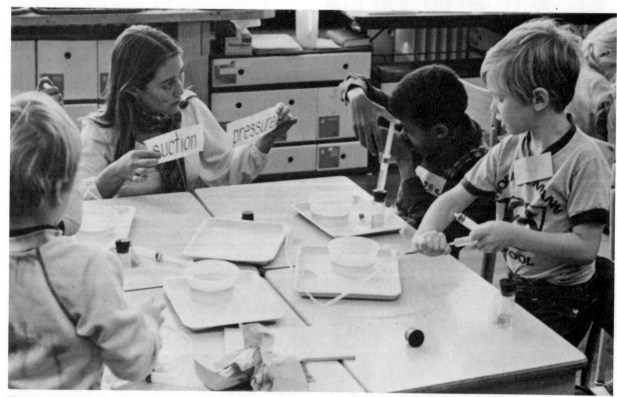

Figure 1.15. The hands-on approach to learning through exploration, invention, and discovery.

8 Laboratory Science and Art for Blind, Deaf, and Emotionally Disturbed Children

Figure 1.16. *"He has within him his own criteria of comprehension—the framework of concrete operations which he can apply to these and others" (Furth, 1973).*

Nonverbal thinking is not unique to deaf children. Many creative people have testified that they often think in nonverbal terms. According to Jean Piaget, the development of logical thinking is not based primarily on language (Inhelder and Piaget, 1958). Language, of course, can be a powerful tool in abstract thinking, but this use of language comes later, after the child has formed the idea of logical relationships through concrete experiences with objects and events around him.

Thus, a child who lines up blocks to reach a certain distance is learning, among other things, that distance can be measured in equal-sized block units. He can learn this at an age when the idea of using a ruler to compare the lengths of two things would be difficult to understand. What he learns with the blocks, however, is preparing him to grasp the concept of the ruler as a measuring tool.

This transition from concrete to abstract thinking is not abrupt. In our science and art classrooms at American University we take advantage of this gradual unfolding. The ordered ways of thinking in art and science can be communicated through ways other than verbal language. On the elementary school level, many basic scientific principles can be learned through action. Troy's discovery of the uses of the light sensor is a typical example, and is only one of many that you can see from going through the experiments and art activities provided in this book.

The excitement and joy generated by Troy's discovery is also typical. It is an excitement shared by everyone in the classroom, teacher and child alike, in an intellectually stimulated atmosphere. Troy's excitement is his success, his sheer joy of discovering a new line of thought and realizing that it *works*, and his discovery that he can understand, predict, and even, to some extent, control what is going on in the experiment, despite the realm of silence in which he lives. The excitement of the other children and the teacher is in sharing Troy's success and enlightenment in a social, emotional, and intellectual involvement.

It is not only the deaf child, the blind child, or the emotionally disturbed child who benefits from this concrete approach. *All* children make this gradual transition from concrete to abstract thinking, and they do it at a time when they hunger and thirst for an understanding of the world. The laboratory science and art experiences give them a chance to use and develop their thinking abilities throughout this transi-

Figure 1.17. *On the elementary school level, many basic scientific principles can be learned through action. Blind child experiments with variables in the whirly bird activity.*

tion without placing a premature emphasis on language and reading skills. Therefore, it offers the children *a chance to succeed on their own terms*. Success, in turn, stimulates further development.

The science and art program also avoids the trap that premature emphasis on language sets for the unwary teacher: the trap of supposing that a child who has learned to repeat in words the "right" answer to a problem understands the problem. To understand, as Piaget observed many times, is to invent, not merely to repeat by rote. Repetition for its own sake, or for the sake of a pat on the head or a good mark, is an unintelligent use of language. We want to prepare the child to use language intelligently.

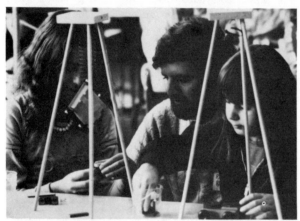

Figure 1.18. Through the way we work with the child, much more than through words, we say, "I like you the way you are."

Through the way we work with the child, *much more than through words*, we say to him in effect: "I like you the way you are. I like you as a human being. I want you to show off your thinking. I want you to show me how clever you are. I want you to feel the joy of creative thinking, whether you do it in terms of images, sounds or words. I want you to know the world through all your senses and to think with your body and your mind working together" (Furth, 1973).

All children, and particularly handicapped children, who often run into difficulty and frustration in reaching out to others, have a need for what might be called the comfort of order. In science, they can uncover the order that lies beneath the surface of nature. In the art classes, they create and model their own conceptions of order and beauty; these are derived from what they have learned in science.

Creating these models for themselves adds depth to what they have discovered in science and makes it even more memorable and real. A blind girl who has "watched" seeds grow through her sense of touch, and then has modeled the root structure, writes: "I made a greenhouse, a home for a seed, it wasn't just science, it was science and art. The seeds grew and made lines through space."

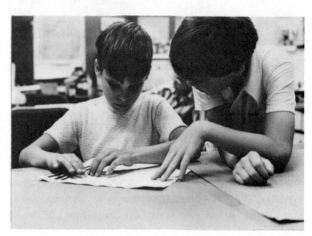

Figure 1.19. Blind child (left) and ordinary child lose their fear of one another.

Through sharing different ways of seeing—of understanding—the children gain self-respect, and respect for each other. Handicapped and "ordinary" lose their fear of one another.

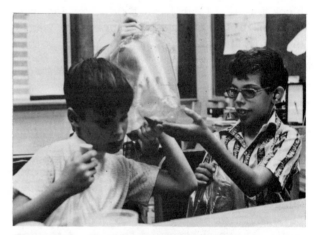

Figure 1.20. Deaf child helps blind child.

We have seen deaf children helping blind children to set up their equipment, and blind children helping deaf children to understand what they cannot hear. We have seen both blind and deaf children helping sighted children to over-

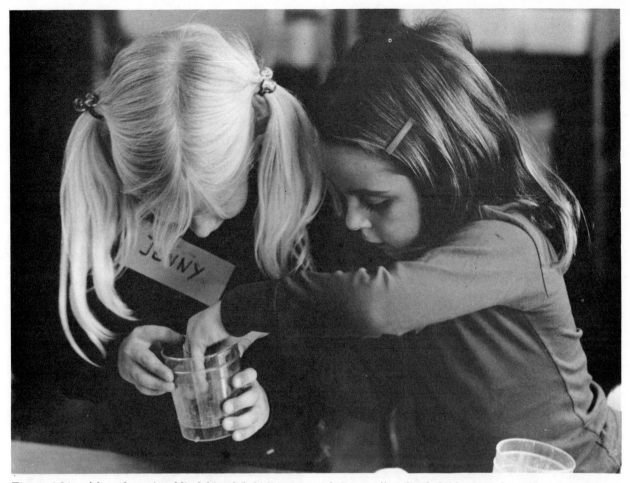

Figure 1.21. After observing blind friend (left) "seeing with fingers," sighted child tries it herself.

come their fears about working with the handicapped, just as the sighted child has helped them.

We have enclosed the word "ordinary" in quotation marks because there is no sharp line between ordinary people and handicapped people. Rather, we are all on a continuum. If the blind lack sight, the deaf lack hearing, and the emotionally disturbed are limited in other ways, then, by the same token, we have limitations.

The strategems of science and art are paths to intellectual development, paths to a better understanding of the world, and to an understanding of each other. By using them, the children learn to perceive in each other their similarities—enthusiasm, thirst for knowledge, eagerness to learn—and not their differences.

Let us follow their example. Let us separate the child from the handicap, but not the children from each other.

Figure 1.22. Blind (center), deaf, and ordinary children "listen" to a reaction. The eagerness to learn is a common denominator.

The Teacher and the Children: Bringing Them Together

Exploration, invention, and *discovery*—we have mentioned these concepts before. They describe the three stages of the learning cycle. In order, they make up the framework of our laboratory science and art program.

Exploration means just what it says. The child explores the challenge of a new idea largely on his own. We give him very little guidance, if any. His own thirst for knowledge is the driving force. We do not tell him that we expect this answer or that result. (This might happen quite spontaneously, as it did with Troy and the light sensor.)

Figure 1.23. Exploring the challenge of a science activity. Blind child (right) uses a light sensor in the exploration of mystery powders.

Invention often occurs when new unifying ideas are introduced by the teacher to bring together different aspects of what the child has explored on his own. Usually the teacher has to introduce these concepts. However, surprises are always possible. Troy made the intellectual leap and arrived at the idea of how the light sensor worked by himself. The teacher must be ready for such surprises, and they should be part of the joy of teaching. The ideas and discoveries of the children should be encouraged, and should be used as a guide in the teaching strategies.

An example of *discovery* is Troy's spontaneous extension of the uses of the light sensor. The

child discovers new applications for a concept or skill he has just learned.

However, from a more conventional and formal point of view, here is how the three stages are made part of the structure of one of our science lessons—"The Structure of a Flower."

1. *Exploration* Students explore a flower and its structure—pistil, stamen, anthers, petals, and stem.
2. *Invention* Teacher guides the students to an understanding of the relation of flower structure to flower function—for example, attracting insects, ensuring pollination, and reproduction. (Note that in step 1, the children get to know the flower structure by contact and through action. In step two, words (concepts) are related to concrete experience.)
3. *Discovery* The students compare a number of flowers from different plants and discover similarities and differences. In general, it is important that a wide variety of materials—

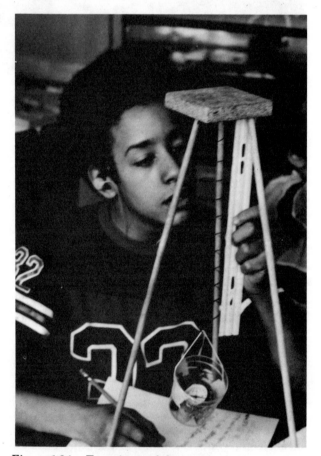

Figure 1.24. Experimental design.

in this case, flowers—be investigated in this stage, so that each child can test what he has learned under varying conditions. The student begins to partake in experimental design.

How have we developed our program at American University? Working within the context of these teaching strategies, we have adapted existing programs such as the Science Curriculum Improvement Study (SCIS), Science—A Process Approach (SAPA), and Elementary School Science (ESS), and we have designed our own experiments that are appropriate for handicapped children.

For the blind children in the laboratory classes, visual stimuli are changed to sound, e.g., by using the light sensor. Instruments and test materials are adapted so that students can use their sense of touch to read them. (Adaptations are given for all activities included in this collection.)

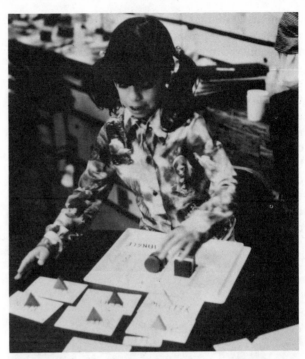

Figure 1.26. Deaf child matches object with language card.

Figure 1.25. Blind child uses adapted aquarium that enables her to observe the fish.

For the deaf children, visual stimuli largely replace sound. Another adaptation is that the children are given language cards while they work in the laboratory. The cards relate words and phrases to the materials that they use, and to the concepts and processes that they discover.

There are no specific adaptations for emotionally disturbed children, because their deficiencies are not specifically sensory. Their problems are likely to be lack of security, confidence, self-esteem, and, consequently, poor self-control. The structure of scientific thinking and artistic expression provides a responsive, therapeutic environment for these children. As we have seen, it allows the child to succeed to the extent that he is capable of succeeding so that he will be inspired to enlarge his capabilities. The sense of being in an orderly environment that can be understood and controlled, the opportunity to interact with other children on an equal footing—all of these things can help to restore security, confidence, self-esteem, and self-control (Hadary, Long, and Griffin, 1975).

A Portrait of the Teacher's New Role in Mainstreaming

The teacher of the new era of teaching handicapped children in a mainstream setting must have a new and full sensitivity for teaching. He addresses all senses of the child simultaneously. Through his teaching strategy, he relates to the child who cannot see through feel and sound. For example, to the child who cannot hear, he relates through visual and tactile stimuli. His approach must provide a pattern of objectives for the emotionally disturbed child.

Science, Art, and the Mainstreaming Process 13

The new image of the teacher demanded by mainstreaming provides an exciting challenge to the teacher. He never loses, for one moment, the awareness of the handicapped—or "normal"—children in the class. He reaches out to all of them, according to each child's limitations and abilities. His teaching strategies must compensate for the deficiencies of the handicapped child. It is essential for the teacher to address the abilities rather than the disabilities of handicapped children. Studies have shown that teacher attitudes and expectations are reflected in the child's academic performance and level of achievement (Hadary, Long, and Griffin, 1975).

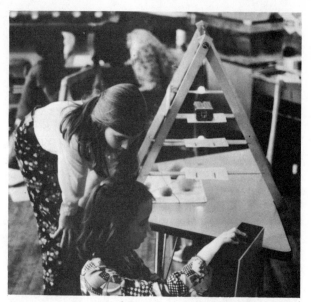

Figure 1.28. "They seem to have an uncanny sense of when to help and when to let the handicapped kids help themselves" (student teacher).

Figure 1.27. Student teachers explore adapted apparatus that will be used with blind children in the mainstream setting (teacher training).

The Nature of the mainstreaming science and art approach helps the teacher to fulfill this new mainstreaming role, and to function sensitively and effectively with all children. Remarks made by student teachers using these materials in the American University program clearly demonstrate their growth as well as their developing sensitivity toward, and awareness of, the needs of handicapped children:

"Before I started, I wondered how it was possible to teach handicapped children in a normal classroom. Quite honestly, I thought it was impossible."

"I was a bit nervous because I had never worked with handicapped children before. But teaching as well as observing made me more aware of their needs."

"I noticed that quite a few of the normal kids took great pride in helping out the deaf and blind. They weren't too dominant over them either. They seemed to have an uncanny sense of when to help and when to let the handicapped kids help themselves."

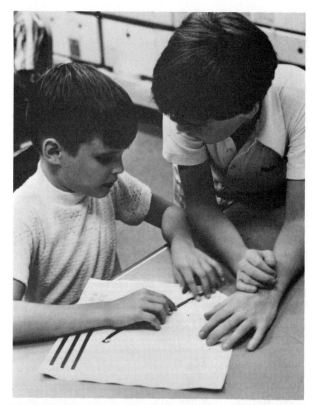

Figure 1.29. Blind child and sighted child discuss graphing data.

"It was amazing to see how hard the handicapped children worked. The best part was watching the excitement on their faces when they succeeded. The deaf children looked around for praise from the

other kids and the teacher, just as almost any kid would. They loved being proud of their work and sharing it."

"Today, Robbie, a 'normal' child, was the partner of Scott, who is blind. Robbie got fascinated with Scott's brailler. He wouldn't go on with the experiment. Scott had to show him how to use it."

Figure 1.30. A hearing child learns sign language from her deaf partner.

"Kurt [sighted] worked with Jimmy [blind]. They were doing pendulum games. I was really surprised at Kurt's consideration and sensitivity. He let Jimmy set up the pegs on the challenge sheet, giving him directions while Jimmy worked. He let Jimmy swing the bob, and collected the knocked-down pegs for him to count. Finally they had a little contest between them."

"At first Scott, who is blind, got very upset if he spilled anything, especially if it went all over the floor. He thought that everybody was laughing at him. Gradually he forgot about being so self-conscious because his partners helped him pick things up."

"The special children can learn from the teacher, themselves, or the other kids. I saw many times where the deaf child would watch carefully what was going on around him and then work with his own equipment. Deaf children are usually the most observant."

"Paul, a profoundly deaf child, had a history of being withdrawn and remote. Two weeks into the

program I asked the whole class a question and Paul had enough confidence to answer. His words were distorted, but he made clear what he was saying—'the spring moves up and down.' A wave of pleasure washed across the entire room. Paul had arrived. The children felt it. I felt it. His eyes gleamed with triumph."

These are just a few of the student teachers' comments. The comments indicate a sensitivity, an awareness, and a positive understanding of the interaction—interaction among the children, interaction between the children and the teacher. Interaction and mutual learning is at the heart of our program, as perhaps it should be at the heart of all teaching. We might illustrate this interaction by drawing a sort of "Mainstreaming Learning Triangle," an equilateral triangle with the "normal" child at one apex, the deaf child at a second, the blind at a third, and the teacher in the center. The triangle is the same viewed from any perspective, and there is no "top" apex.

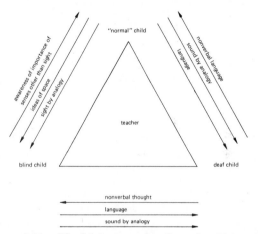

Figure 1.31. The Mainstreaming Learning Triangle.

Of course, we may have more than three different groups of children in a class. The learning diagram need not be a triangle. It might be a square or a pentagon. As with our classroom techniques, it can be as many-sided as the teacher chooses to make it. What is important is that the teacher interacts with all the children in the class according to their abilities. He shares their wonder when the liquid Freon in a closed bag boils from the warmth of a hand, and the bag swells.

The teacher turns a mistaken answer into a new question. A child, for example, may say

that the liquid Freon has just vanished. The teacher may then wonder aloud what will happen if the bag is put in cold water. When the Freon reappears as a liquid, someone may say it was water that leaked into the bag. What will happen if you take the bag out of the cold water and again hold the bag? (It starts to boil.) Does *water* boil in your hand?

Day by day, the teacher provides new challenges, and the child's thirst for knowledge drives him on.

Science lays bare the richness of the natural world.

Art helps the child to shape his understanding of that richness with his own hand and mind.

There is no stopping point.

Figure 1.32. Teacher must "show and tell" blind, deaf, and ordinary children. His goal is to create an intellectual and highly motivating atmosphere.

Figure 1.33. *"I know when you are smiling, and I smile too" (blind child).*

KNOWING THE CHILD

Frequently the young blind, deaf, or otherwise handicapped child has had little experience with the objects and organisms in his environment. Well-meaning but shortsighted desires on the parts of parents, teachers, or others to protect the child from danger cause the child to grow up in a sterile environment where "Don't touch" is the most prevalent suggestion made by adults to children. The child's lack of direct experience with the objects and organisms in the environment leads to the child feeling insecure, frightened, and overly wary of all encounters with the environment.

Knowing the Visually Handicapped Child

In working with the visually limited or blind child, many beginning teachers and other specialists such as social workers, psychologists, physical therapists, and speech pathologists are not sure as to how to approach the problems unique to this particular handicapped child. It is essential for these professionals to remember that each child is a human being and is like any "normal" child. The number of experiences each child has been exposed to will vary from individual to individual.

Observations made by student teachers clearly indicate the differences in personality and skills of blind children who are the same age.

> "S. has absolutely no problem keeping up with the other children. She is always eager to volunteer an answer and frequently explains things to her sighted partner. She manipulates materials well—cuts, ties, and pastes as well as the other children in the class."

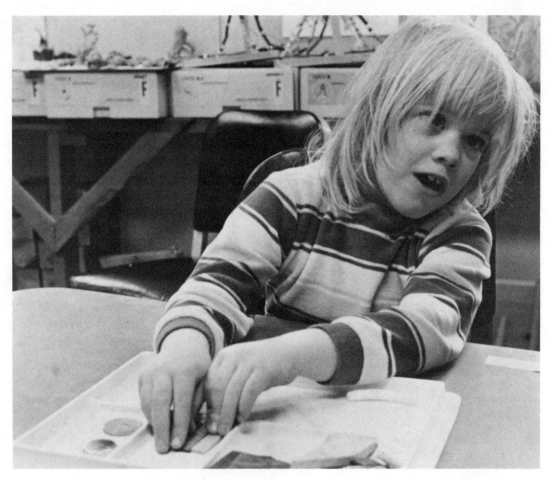

Figure 1.34. Blind child explores the properties of objects. It is essential for handicapped children to have direct experience with objects, materials, and organisms of their environment.

"R. is shy and quiet. She clearly understands what is going on and although she rarely volunteers an answer, she is delighted at the attention of a question directed at her. Her answers indicate a very careful consideration of the question and often stimulate discussion among her sighted peers. Her very soft and gentle personality makes her well liked by the other children who enjoy being with her and helping her."

"J. likes to talk and joke, discuss television programs, and sing popular tunes he has heard on the radio as he works. He is full of energy, works quickly, and likes to be the first one finished. He playfully teases girls and responds delightedly to their response. He has difficulty manipulating a scissors and other materials, but is learning quickly through direct experience. He has no problems with learning, making discoveries and more discoveries with the hands-on approach to learning."

Such comments clearly indicate the wide spectrum of individual qualities in the children observed. They remind us that blind children are

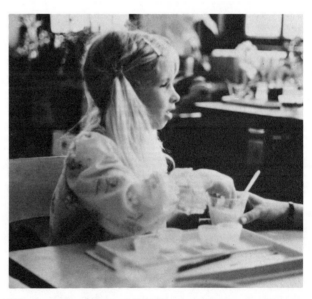

Figure 1.35. Blind child discusses evidence of interaction with teacher.

just like other children—some extrovert, some shy, some playful, and all eager to learn.

When using models, maps, and worksheets, especially in the elementary grades, no more than two or three items should be shown. Contrast, size, texture, and shape are important features to remember when making or selecting materials. In order to adapt a map of the state, for example, that shows waterways, railroads, counties, and cities, each of these items would have to be illustrated on a separate brailled sheet.

Words such as "this," "that," and "from here to there" mean nothing to someone who cannot see. It would be much better for the handicapped child, indeed for all the children, to say the name of what is being discussed. For example, when examining a map, it would be more meaningful to say, "The plane traveled from Baltimore to Chicago in one hour," than to say, "The plane traveled from here to there." In math, it would be better to say, "The dividend 35 divided by the divisor 5," to a child rather than, "This number divided by this number."

If you have little or no experience in working with blind children, the following list should be helpful:

1. Talk and act naturally. Use words such as "see," "blind," "look," and color words with a blind child. He lives in the same world as sighted people and speaks the same language you do.
2. Speak to a blind child by name. Because the blind child cannot see you, addressing him by name makes him certain to whom you are speaking.
3. Identify yourself by name. This should be done until the child learns your voice.
4. Speak distinctly and in a normal tone. This is the child's main channel of communication; keep it clear and distinct.
5. Let the tone of your voice relate your feelings. Remember that your voice expresses your emotions—a blind child cannot see your facial expressions.

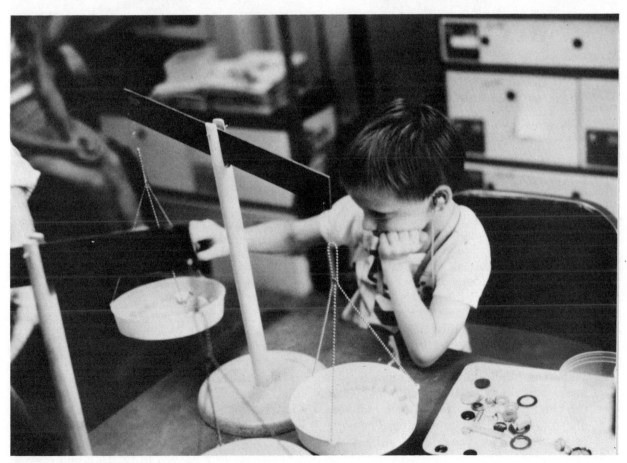

Figure 1.36. Encourage the children to work independently.

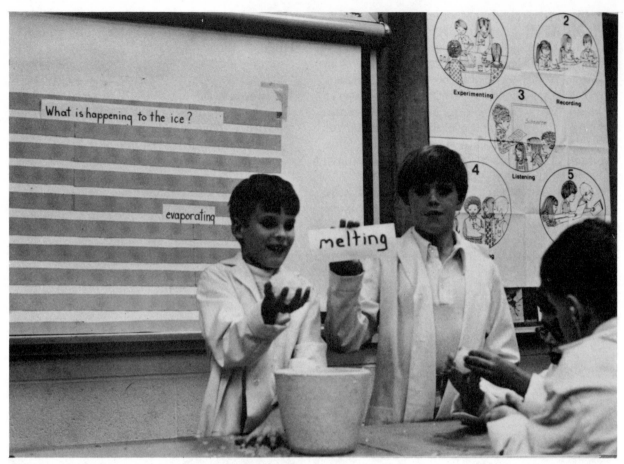

Figure 1.37. Blind, deaf, and ordinary children participate in a demonstration—a word, an activity, and a concept.

6. Encourage the blind child to do as much by himself as possible. A major goal in the education of a visually handicapped child is to make him as independent as possible.

7. Give a blind child praise and reward only if they are truly deserved. Visual impairment should not be a determining factor in receiving praise. Praise should only be awarded for the quality of performance.

8. Give explicit verbal directions. Use directional words such as left/right, up/down, top/bottom, and backward/forward.

9. Have the blind child take your arm just above the elbow, or if a small child, have the child hold your wrist. Keep a half step ahead of the child when walking. The natural movement of your body will let the child know when you are stepping up or down, turning or stopping.

10. Have the blind child work with a sighted partner. Children enjoy helping each other and seem to know when help is needed. Most assistance that the blind child needs can be provided by the sighted partner.

11. Always involve the blind child in demonstrations.

At the beginning of the science and art activities sections, techniques and teaching strategies are developed for working with the blind child in these areas. In addition, adaptations for the blind are specifically discussed with each activity. By using teaching strategies and activities adapted to meet the needs of the blind child, teachers will find the presence of a blind child in a mainstreamed setting an exciting and rewarding challenge.

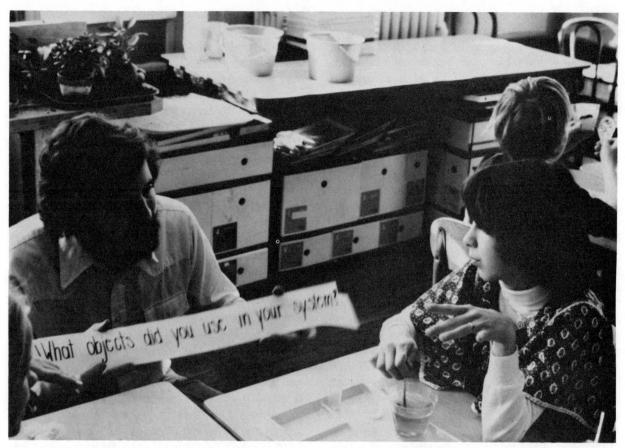

Figure 1.38. *"Language should be considered a product and never an explanation for thinking" (Furth, 1973).*

Knowing the Deaf Child

You have heard that you will have two hearing-impaired students in your class this fall. You wonder what you should do on the first day or, for that matter, during the entire year.

What will these children be like? It is too late for you to study the further "development of language in a deaf child" or the "psychology of deafness" in depth, but a few suggestions will help you interact with the deaf child. If you can succeed with these deaf children, you will have become a better teacher for all of your present and future students.

School starts today. The students are beginning to come into the classroom. Which one is David? Is that Kay? You may not be able to tell which child is hearing impaired. In most ways, the deaf child is the same as the hearing child. His physical, mental, and emotional characteristics are the same as for the hearing child. Some are brilliant; others are not. Many are pretty, or cute, or handsome. A few are stub-

born and self-seeking. Some have poor self-images. Many have a lively curiosity and intense interest in learning. Are they any different from their hearing peers? The only difference is that they cannot hear very well, if at all. You may see a hearing aid, a few signs, or finger-spelling, depending on the child's background.

Will you be able to communicate at all with David and Kay? Will they be able to read your lips? Can you understand their speech? David and Kay may well be very different individually. To understand the behavior of a deaf child, it is necessary to know something of the child's hearing problem. What is the degree of hearing loss? If it is slight, the use of an aid may make the child's hearing almost the same as that of a hearing student. He may be slightly hard-of-hearing or profoundly deaf. The kind of hearing loss should be known. Certain losses may be helped by some aids; other losses will not be helped.

The age at which the child becomes deaf usually affects the language and speech development. You may notice a difference in the pitch, intonations, loudness, and quality of grammar. The speech and the language of a child deaf since birth are far different from those of one who becomes deaf after speech has developed and language patterns have been learned. Some have been given a great deal of excellent teaching at home before entering school. Many parents communicate well with their deaf child, and attempt to include him in all "everyday" conversations.

Some deaf children are very good lipreaders. Many do not become proficient in this skill. All deaf children will lipread to some extent. You cannot depend only upon lipreading for communication in most cases. Better lipreaders may only receive 30-50% of your words by lipreading. Imagine what information you would receive should you only hear every other word of a conversation. Many words or sounds appear the same on the lips—for example, "fifteen" and "fifty." You can help by becoming more aware of being precise without causing your speech to become slow and unnatural. The deaf student will find slow, unnatural speech harder to understand. Avoid mannerisms whereby you cover up part of your face with your hand or other object.

You wonder if the deaf child will be able to write and read. Your other students learned to read and write by being exposed at home and school to the sight and sound of words at the same time. From birth, a hearing child learns the rules of our language by hearing them used often, and then by imitating them. Slowly, after much trial and error, the child conforms to the peculiarities of our language, including its patterns, tones, and inflections. The deaf child misses this process. It may be some time before parents find out that the child is deaf. Many parents are not prepared to give the child what he needs at this time. He may not really begin learning much about language until preschool or first grade. By that time, he is several years behind. A hearing child enters school knowing several thousand words; the deaf child knows only a fraction of this number. You will note the absence or misuse of prepositions, articles, tenses, and the possessive in his written work. The sentences may be mixed up or sound awkward. Deaf students who have been very concerned about this problem, or whose parents reinforced their learning, may have a good command of English.

You wonder what special aids, materials, and teaching strategies must be used to teach the deaf child. Anything that you think is appropriate for a hearing student can probably be used with deaf children. Of course, you cannot, for the most part, use materials with sound. There are many educational and entertainment films that are captioned for deaf people. These films can be used for the whole class. Several schools for deaf people have produced interesting materials that can be used by deaf persons in individualized situations or self-contained classrooms. You will probably find that these same materials can be readily used with your hearing students.

Can the deaf learn equally well as other students? Will I have to accept less from them? You may have to accept less if you are using the wrong approach or strategies. However, if you truly determine the student's educational needs and locate and adapt materials for his level, he will respond as readily as your other students. As indicated earlier, he probably will be unable to express his ideas in proper English, but he has a wealth of experiences on which to build. Provide him with further worthwhile experiences that have meaning to him, and your deaf student will be better able to improve his language while you, and others, give him input and direction. No pity is needed or desirable. The student may come to feel that he must be treated differently, and he will expect this treatment.

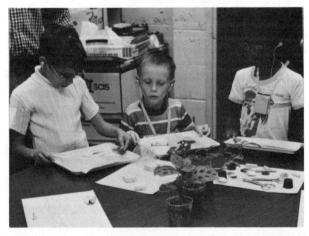

Figure 1.39. Provide the deaf child with worthwhile experiences on which to build.

You want a few ideas to help you provide the best atmosphere for learning in the classroom. Here are a few.

One of the greatest concerns of the deaf child is that of being in a situation where he cannot see all of the participants. A deaf child, even though he is seated at the front so he can be close to the teacher, misses much of the flavor and content of the class by being exposed to only "half a conversation." He may know the

Figure 1.40. Arrange seating in a circle so that deaf children can see the entire class.

teacher's question, but he does not hear the other students' ideas. He may miss the teacher's response to a student. If possible, the classroom should be physically arranged so that the deaf children can see all other individuals. This is especially true during group or class work. The tables or seats can be arranged in a circle or partial circle.

You may have to obtain the services of an interpreter who will work with you until you have learned to communicate with the deaf students. Deaf students will not be able to communicate fully with you in your language, so you will have to learn to communicate with them, possibly by using "total communication," a method of using fingerspelling, signs, miming, and lipreading, or by using other methods that are philosophically compatible with your school and the parents of your deaf students. Meeting the student on his communication level is important.

It is a good idea to try to squash some of your inhibitions about communication with your body. Your deaf students will attempt to receive information any way possible. Your facial expressions and body movements can convey a wide range of ideas. To be more effective

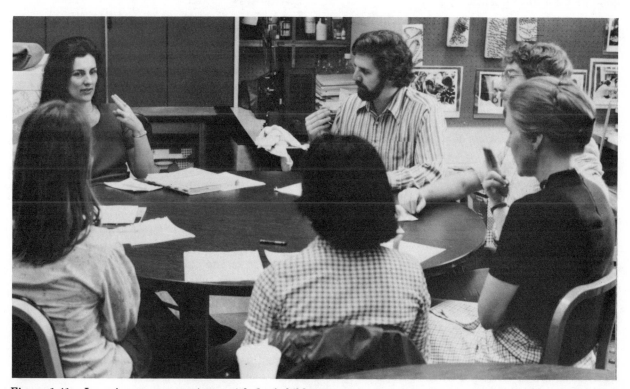

Figure 1.41. Learning to communicate with deaf children.

Figure 1.42. Use facial expression and pantomime to communicate with the deaf child.

teachers, we need a little of the actor in us. Imagine what you would do if you needed to communicate with a person who did not speak your language. You would use a great amount of pantomime along with any words you knew. The deaf child will often communicate with you using pantomime.

When you plan your activities for the class, try not to go into lengthy discussions or lectures. This is tiring for deaf students and you will find them "dropping out." Give the students time to ask questions. Of course, this is a good idea for all students.

Figure 1.43. To sustain attention, keep demonstrations and discussions short, and keep children in small groups.

When you are demonstrating, or giving instructions for an activity, explain a portion and then stop talking and show the student what you want him to do. Deaf children cannot do a good job of watching sign language and the demonstration at the same time. Always involve the deaf child in the demonstrations.

If you think that the deaf student did not understand you, remember that it usually will not help to raise your voice or shout. The student may not have received your communication, or, if he did, he may not have understood. Hearing is a matter of determining the words, but perception and internal synthesis is necessary for understanding. You must be willing to slowly repeat and/or rephrase until the student understands.

Use the blackboard often for drawings, instructions, or new words. For those words, phrases, or concepts that can be anticipated, prepare charts or language cards.

Figure 1.44. Use language cards to reinforce language for the deaf child. Relate language to an experience.

Make posters showing lab setups, graphs, etc. Make sure suitable dictionaries are available. Encourage reading of all kinds by providing interesting books and magazines.

Some hearing-impaired children may begin by interacting only with the teacher or a small group of hearing students. Even a small amount of communication is important. The teacher must find ways to cause interaction with the entire class.

The deaf child may have problems with certain concepts that are more or less understood by others in the class. Concepts related to time and space may need strengthening.

Make sure that one child speaks at a time during discussions. Taking turns becomes extremely important in discussions involving the deaf.

When using audiovisual materials, it is important to plan pre- and post-discussions. The deaf child will know what to expect from the pre-dis-

Figure 1.45. The science experience motivates the child to read.

cussion, and he may be able to clear up problems during the post-discussion.

Even where you stand and how you dress can be of importance in the classroom. Should you stand with a bright light at your back, the student may find it hard to see your lips or hands when communicating to him. The color of clothing can make it difficult to see your hands. Of course, you can never turn your face or body away from the deaf child while you are speaking or signing.

These are some of the things to remember when teaching deaf students. Many of these are important to hearing as well as deaf students. Adapting teaching style and strategies to relate to the deaf children in the class as well as the hearing will provide a rich opportunity for the deaf children, the hearing children, and the teacher.

Knowing the Emotionally Disturbed Child

Knowing the disturbed child is knowing many different children. There are profuse labels that are applied to these children—emotionally disturbed, socially maladjusted, and emotionally handicapped are some. These labels signify various constellations of behavioral patterns and emotional responses. For simplification, we can categorize disturbed children into two groups: those with externalized problems and those with internalized problems. Externalized problems are manifested by verbal or physical aggression against objects, others, or self. The child with externalized problems may exhibit belligerence, negativism, disobedience, uncooperativeness, antisociability, passive resistance, destructiveness, hostility, or low frustration tolerance. Internalized problems include anxiety, over-sensitivity, lack of self-confidence, fearfulness, depression, self-preoccupation, withdrawal, poor reality contact, and inhibition of aggression.

The teacher needs to structure learning and interaction that will enable these children to find success in the classroom. Many disturbed children have marked academic deficiencies. It is important to provide experiences that can be completed successfully. Sequential and incre-

mental learning experiences are needed. The disturbed child needs structure and clearly defined objectives. To rebuild the child's self-image, it is essential to avoid failure experiences. Success in learning breeds more success. Positive reinforcement is necessary. Always search for any special skills the disturbed child does possess and highlight these for his peers. Make use of these special skills as frequently as possible. Include the disturbed child in demonstrations and thank him for his help. Be sensitive to situations where the disturbed child can help others. Such situations range from helping you distribute materials to assisting a blind child by verbally describing something he cannot see. It feels good to help, and disturbed children need to feel good about themselves.

Many psychomotor skills needed in the classroom are not developed to the same level in disturbed children as they are in other children. Provide practice for the development of such skills—e.g., cutting, pasting, assembling, tying—in the learning experiences made available to the children.

The adapted science and art experiences in this book provide the structure and defined objectives needed by disturbed children. Because there are no wrong answers, the child feels little or no frustration as he explores, invents, and creates on his own. Creations and discoveries provide the child with self-confidence. Successful learning experiences provide the child with an improved self-image that enables him to interact more successfully with himself, his classmates, and his teachers. Working with concrete objects in this hands-on approach provides the support the disturbed child needs to make discoveries and to create expressive art forms. As a teacher using these adapted materials, remember to be supportive of the disturbed child, and emphasize his success. What may be a rather simple task for other children may be more difficult for the disturbed child. Meet the child at his level of accomplishment and provide the appropriate activities for his intellectual growth.

By providing stimulating, well-structured experiences with defined objectives for the disturbed child, he will experience success and will gain self-confidence. This gain in self-confidence will facilitate intellectual growth, as well as interaction with other children in the learning environment.

Figure 1.46. Providing the rich opportunity for deaf children to interact in a mainstream setting. We learn from each other, and communicate through science experiences.

PROJECT SEEFEE

Project Seefee is an exciting new project in which deaf child, blind child, and ordinary child work together in producing a "seefee": a three-dimensional poster expressing science concepts discovered in the science class. One can "see" and "feel" a "seefee." Objects such as seeds, pipe cleaners, cotton balls, ping pong balls, etc., can be used as media. The deaf children use the language cards for labels and the blind child brailles the labels. The posters are placed around the room at a level at which all the children can see and feel the raised models. Project Seefee includes posters such as "Life Cycle of the Fly," "Life Cycle of the Frog," "Life Cycle of the Mealworm," "Life Cycle of a Seed," "Development of the Chick," and others the children suggest (see Figure 1.47).

Deaf and blind children enjoy collaborating with each other and are proud of the seefees they make. The project has been highly successful in developing motivation, self-help, and cooperation skills, as well as helping the children understand and teach one another.

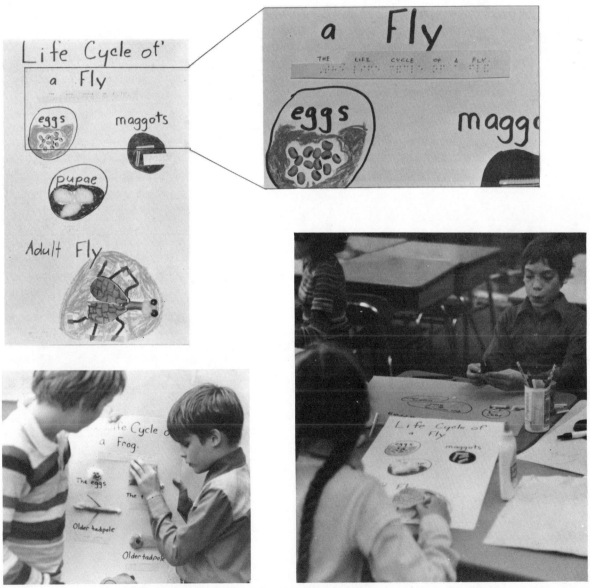

Figure 1.47. Seefees are three-dimensional posters that express science concepts. Learning becomes both a visual and a tactile experience. Blind child discusses poster with sighted student.

Section II
INTRODUCTION TO THE

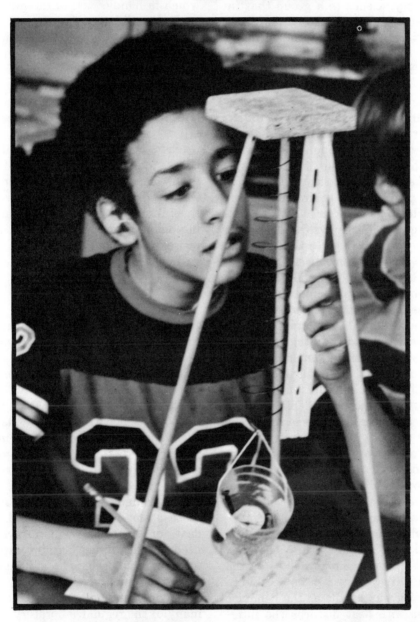

LABORATORY

THE LABORATORY
IN A MAINSTREAM SETTING

Teaching laboratory science to a group that includes blind, deaf, and emotionally disturbed children is an extremely exciting and fulfilling experience. The experience is not easy to describe because it involves a multitude of intangibles—emotional, social, intellectual—within the complexity of human behavior.

The science laboratory is a temple of understanding—understanding human interaction, understanding the phenomenon of science, understanding the forces of our environment—and thereby makes wonders of the world real for all children. It provides an environment that prepares the child to receive meaning and concepts via language by direct physical experience through experimentation. It gives the child the opportunity for corrective feedback by interacting with the teacher and the children in his group. A combination of principal factors is vital to a successful laboratory experience. It is essential for the children to interact with a teacher who sees the child, not the handicap. The teacher must be sensitive and must show the feeling of wonder and excitement that science naturally offers the child; the teacher must create an intellectual atmosphere. This involves two interdependent levels of excitement. On the first level we see the child's natural involvement and fulfillment in discovery of natural phenomena on the macrodomain. He see things happening, asks questions, and pursues avenues of inquiry and discovery. On the second level is the teacher who finds excitement in understanding—understanding where and how to lead the child in his quest, and understanding the phenomena of science, on the microdomain as well as on the macrodomain. How rewarding it is to be able to see the making of a wax candle as the behavior of wax molecules with heat disturbs the intermolecular forces of the molecules. As a result, the wax melts. Take the energy out of the system by cooling—dip it in cold water—and the liquid turns to a solid—a candle.

Another factor essential to a successful laboratory experience is the sensitive and multilevel teaching approach. With this approach the teacher is constantly aware of the sensual deficiencies, and he provides compensations needed in the presentation for each handicap in the class. The teacher does not for a moment lose the awareness of the needs of the blind, deaf, disturbed, or otherwise handicapped child in the class. Awareness is "built in" to the approach, which is handled as an integrated "whole." An understanding awareness of the limitations related to visual, auditory, and emotional impairments becomes an integral part of the teacher—an inseparable part of how the teacher relates to the child. No child is separated from the class. (The approach is described in detail later in this section.) The teacher addresses himself to all the children at the same time. The teacher, by understanding, identifies with each child's individual limitation, and he compensates in the teaching with interventions appropriate to the degree of limitations. Like a juggler juggling several objects at once or like an octopus reaching out in several directions at once, he encompasses, commands, and leads each individual within the group to the heights of learning.

PROGRAM DESIGN

How did we select and adapt the series of activities for our program? The project was designed and based upon the innovative science curricula designed for the ordinary child—Science Improvement Curriculum Study (SICS), Science—A Process Approach (SAPA), and Elementary School Science (ESS). The ideas upon which these projects were based emphasize direct physical experience, freedom of inquiry, discovery, exploration with materials, and formulating and testing hypotheses. They are organized around a progression of thinking processes. The handicapped child, whether blind, deaf, or emotionally disturbed, has a unique need for such direct learning experiences. Therefore, we have designed and adapted the existing activities, making it possible to include the blind, deaf, and emotionally disturbed child in as many of the regular laboratory science activities as possible.

Activities were not entirely rewritten for the benefit of handicapped children, because this would separate them from the ordinary children

in the class. Therefore, we have deliberately not developed many new activities, and have concentrated on adapting existing programs. However, as you will encounter in the activities, it has been necessary in some cases to design new, but related, activities. For handicapped children who are rapid learners, the American University staff, in cooperation with Dr. Herbert Thier of the Lawrence Hall of Science, University of California at Berkeley, has developed a series of enrichment activities conceptually compatible with the program.

It is interesting to note that we are bringing to life the dormant but obvious fact that designing activities for the handicapped child provides a program that "fits" all children, and adds new dimensions for the ordinary child that have long been neglected! The kinesthetic approach has been verbalized, but how much attention has been given to actual implementation? A new era of educational realization has come to light. This alone has many educational implications. Therefore, the experiments presented are a result of adapting teaching strategies, procedures, and materials, which make it possible for ordinary and handicapped children to successfully work side by side, with great excitement for all of the children involved. Because we have adapted the teaching strategies and materials to fit all of the children, few additional adaptations had to be indicated in most cases. The adaptations involve designs that address the importance of sensory learning. They make use of and help develop the available senses for all children—tactual, audi-

tory, visual—in the development of cognitive ability. For the blind, the visual is changed to auditory or tactile; for the deaf, the auditory is changed to visual or tactile. The lesson models are appropriate for the entire class.

The design of the enrichment activities that one may choose to add to the regular lesson takes into account the basic rules indicated to compensate for the individual needs of each handicapped and ordinary child. If at all possible, all demonstrations have been converted to pupil activity for all the children. Each lesson describes adapted materials and procedures for the blind and deaf children.

CLASSROOM MANAGEMENT AND TEACHING STRATEGIES FOR THE ENTIRE CLASS

Laboratory stations of groups of four are set up in the classroom. Place the handicapped children with the ordinary children in each group. This structure provides for individual learning rates as well as for individualized teaching, allowing each child to advance according to his ability. Therefore, any individual help needed for the handicapped children is built into the system without detrimental academic effects on other children. This setup also provides for peer teaching and social interaction among the children. We found that the handicapped child works most effectively in small groups. An interesting observation was that children with emotional problems have in some cases worked well with blind children. A case in point occurred when one of the children in the class, who refused to talk for a year following a tonsillectomy, began to talk because she wanted to tell her blind partner what she saw under the microscope.

Laboratory materials for examination and exploration are distributed to each station. All materials are labeled for the deaf child and the blind child (braille). All stations and distribution centers should remain in the same place all year. Each station should be well supplied with paper towels and a bucket (blind children generally do not like a mess).

Questioning and discussions should take place in small groups where all the children can see each other and the blind child can comfortably hear the remarks. Group arrangement in a circle or semi-circle is the preferred way.

Figure 2.2. Laboratory stations with four children working at each. Handicapped child works with ordinary children. Peer interaction and teaching is an important part of the learning process.

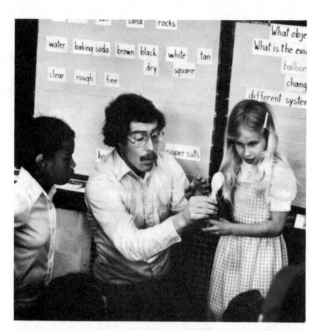

Figure 2.3. Demonstrations must include handicapped children as assistants (deaf child left, blind child right).

Demonstrations and introduction to lessons in which problems are posed for the class are necessary. The same problem should be presented to all the children. However, there are times when the different stations are engaged in different activities. An example of this is when one-half of the class (without blind children) is exploring the properties of light with the optics experiments, while the other half (including blind children) is investigating the properties of light with the light sensor (see experiment: Using the Light Sensor). In this case, each group is treated separately. All of the lessons describe the adaptations and teaching strategies for each handicap.

Demonstrations and discussions *must* include the visually impaired and auditory-impaired children as assistants so they can handle the equipment and thus relate to what is being shown and discussed. It is important that the ordinary child is also included as an assistant in the demonstration to avoid being accused of partiality to the handicapped children. If there are a number of blind and deaf children in the class, make sure that the blind children have the materials in their hands during the demonstration and that the deaf child is close enough to watch. *The teacher should be doing every part of the demonstration as it is being discussed.* The deaf child

observes very carefully and takes clues from observing. Language cards may be displayed and presented simultaneously as the specific materials and concepts are introduced if appropriate for the level of the students involved. The entire class participates in the language activity.

It should be a rule in the class that whoever reports their observations to the class should, if possible, accompany the reporting by demonstrating with the equipment, by writing on the board, or by referring to posters, graphs, charts, or models. The reporter should speak very clearly. Do not go into lengthy discussions with entire groups. If you do have discussions, have them within the small groups. A laboratory aide who can interpret for the deaf child should be present to avoid any confusion on the part of the deaf child. The teachers in our program learn the different means of communication. However, the deaf child cannot watch sign language and a demonstration at the same time. Show the child what the activity or problem is by demonstrating with material and by using language cards. When necessary, stop the demonstrating and discussion for clarification, but do not call upon the child to watch the demonstration and interpreter at the same time.

Figure 2.4. Deaf child uses the microscope. Encourage the deaf child to use the microscope.

To avoid situations where one type of handicap may cause the deletion of part, or all, of an activity that does not lend itself to adaptations or has not yet been adapted, alternate activities are added to the program. The teaching strategy

is modified, providing extensive work with the microscope for the deaf child when sound is the focal point of an activity. The ordinary children work with both activities. However, this does not separate the children in the sense that they discuss, show, and describe these activities within their group. These experiments are a way to cause interaction within a group as well as with the entire class.

When working with handicapped children remember to always address all the available senses of all the children. It is more dangerous to assume that the child does not have the ability to learn than to worry about going above his level of ability. Maybe he cannot read words or verbalize thoughts, but they are there!

For the handicapped child it is important that the experiments and activities are sequential and orderly, repetitive in concept, and provide variety in experiences.

Figure 2.5. We communicate through science laboratory experiences of which language is considered a product.

The Deaf Child in the Laboratory

Language should be considered a product and never an explanation of thinking (Furth, 1973).

The fundamental principles of our experiential laboratory approach to science give emphasis to the development of cognitive ability through experiences—through sensory learning. We communicate through science laboratory experiences of which language is considered a product. How-

ever, this does not mean that language development and communication are not an important part of the program. On the contrary, you will find in our program that the laboratory experience gives the advantage of nonverbal experiences, and that these experiences lead to language development—an ideal combination for the deaf child. The child is first given the opportunity to discover and internalize concepts through experiences whose implications he has discovered. Language cards are introduced only if and when the child is ready for them.

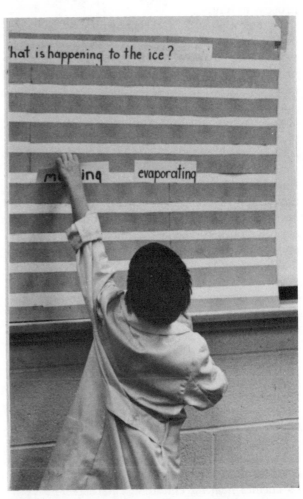

Figure 2.6. Deaf child reaches for language card to describe his observation.

Our program does not overwhelm the child with language before his experiential background and willingness to accept language indicate his readiness. The teacher must use judgment and decide which language cards to use, and when to use them.

In the experiments presented, suggestions are made about vocabulary words and sentences. However, these depend upon the level and nature of the class and the questions asked by the children. There are times when no language cards are indicated—when the child needs more freedom of exploration. However, if language cards are indicated for language development, care should be taken that the language is presented during, and again after, the activity. The language should permit the child to bring order and identification to the sensory impressions of experiences he has already had or is in the process of having.

To get a "feel" of the enormity of the deaf child's task in language development, let us consider the great changes in a hearing child's use of language. Consider how much language that child has listened to before he has in turn fashioned it for himself. Consider how long it lay external to him and how gradual was the process of absorbing it, internalizing it, and making it a tool he could use. The deaf child does not have that wealth of exposure to language. Words and sentences are not like light and shadow, they are not simply there. From the first they must be fashioned. Language is not something that simply comes to the deaf child. He must go out and achieve it.

What does this have to do with a science lesson? Most directly, it has to do with how the teacher communicates his instructions to the deaf student, and how the teacher knows whether the student has learned what was desired from following those instructions. As an example, let us take an actual case. One of the lessons on the kindergarten level, dealing with comparison, asks the student to select different-size shapes, e.g., "Find a circle smaller than this one." This task and its many variations should provide no special difficulties for the deaf student. It has been shown that deaf children are quite as able to perceive and distinguish shapes as normal hearing children. Yet there is a communication problem. The deaf child is by no means as familiar with the names of the shapes. Where a hearing child may have heard such words as "square" or "circle" a thousand times, these activities may well mark the deaf student's first encounter with them. Consequently, the deaf student is likely to require both an explicit introduction to these words and a great deal of repetition before fixing them.

The same is likely to be true of the comparative terms used, and here the problem strikes at deeper roots. How can we ask a student to find a smaller circle if he does not understand the word "smaller"? Again, there is no reason to believe the notion that being smaller is a problem. We would expect the same student who cannot use the word "smaller" to become upset when his share of the goodies is *smaller* than it ought to be. This is a serious problem. The deaf student may be comfortable with comparative operations four or five years before he learns the rules for "small," "smaller," and "smallest." It is not an option to stop the science lesson, to stop the child's cognitive development, and work on such language rules first. The child is able to select that smaller circle and to proceed to more complicated tasks, learning as he goes. The problem is, how do we ask him? In our experience, we find ourselves led naturally to communicate with the child in whatever way we could—or better, in as many ways as we could. Our goal is to reach the student as clearly as possible. The technique used in the science and art laboratory is to illustrate the activity by doing it ourselves to whatever degree is necessary to get the problem across. In this connection, mime, natural gestures, and the sign language each contribute to setting the child onto the right track of the problem. A great deal can be explained to the child, and learned from him, through expressions, gestures, the language of signs, and the experiences in the laboratory approach to science which gives the basis for language development.

Laboratory Suggestions for the Deaf Child

Have the deaf child assist with demonstrations.
Face the class or deaf student when talking.
Give the child freedom to explore.
Do not stand with your back to a window or other light source.
Use pantomime liberally.
Demonstrate instead of giving only verbal directions.
Use visual aids extensively.
Use the blackboard often.
Keep discussions to small groups.
Seat or place participants in a circle so everyone can see everyone else's face.
Put the question under discussion on the blackboard or on the language chart as a heading

and record the students' comments under this heading.

Rigidly enforce "only one speaker at a time."

Have the speaker wait a moment or two after being recognized by the leader and before starting to speak.

Label or make identification cards for all of the materials in each exploration. These cards should show the word and the pronunciation. Make vocabulary cards for important vocabulary. These cards should have the word, the sign, and the pronunciation. The identification and vocabulary cards should be prominently displayed in the room, and used if and when needed during discussion or demonstration.

Prepare question and direction cards that apply to many of the explorations. Examples are: Observe carefully. What do you think will happen? What did you see? Why did this happen? How are they different? How can we find out who is right? How are they the same? How can we test the prediction? What caused the differences?

The teacher introduces the language cards with the assistance of a deaf child. At the end of the lesson the deaf child is asked to show the proper cards during the discussion. The entire class is involved in the language development process.

Use language cards with discretion—use a few at a time, and make certain that they relate to the real object, to an ongoing activity, or to an experienced activity. Use the language cards only if the child is ready to accept them.

The Blind Child in the Laboratory

It is extremely important to avoid verbalism by the blind child—using words without understanding their meaning. He hears, but does not see. Therefore, he must experience concrete operations that give him a mental image to use as a referent to language and cause-effect relationships.

Studies of cognitive development in blind children (Tobin, 1972; Higgins, 1973) have indicated some lag in abstract thinking and in meaningful use of language without performance of concrete operations, or without having available concrete materials. Studies by Levin (1971) and Hadary (1973) have shown gain in abstract thinking with performance of concrete operations.

Figure 2.7. Blind child records on a brailler.

Provide the child with labels for all materials. Provide a brailler that the child can use so that the words in the activity enhance his language development. Brailled lesson sheets with questions and vocabulary related to the activity bring meaning to words, thereby avoiding verbalism.

Laboratory Suggestions for the Blind Child

Have the blind child assist with demonstrations and discussions (see Figure 2.3).

The blind child should always have the materials in hand during discussions and demonstrations.

Label all equipment in braille.

Prepare brailled laboratory sheets (as indicated in experiments).

The blind child's experiment report should be done in such a way as to allow him to re-examine the report independently. Many blind children enjoy having a shape or piece of material either stapled or pasted on their report. If a small plastic bag was used to collect gas, an identical bag could be stapled to the brailled report.

The children enjoy using workbooks in which they can attach and feel objects.

Introduction to the Laboratory 35

Allow and expect the child to control his own environment in terms of moving about freely. Body contact is a good way to discover, (all children take bumps) and a good way to remember where his educational materials are because *he* put them there.

Use models when class is using microscopes. Give preference to the real or actual over models.

All equipment for the blind child should be solidly anchored so that it cannot tip over or be knocked over, thereby preventing the child from finding the object. (Special adaptations are described with each experiment.)

All equipment should be placed in specified areas in adapted tray (see Figure 2.8).

Figure 2.8. All equipment should be placed in specified areas in adapted tray.

Tell the child what he has on his tray.

Describe the objects and position on the tray.

Identify yourself when speaking to him.

Have the child work with a sighted partner.

Have paper towels readily available in case of spillage.

Let him explore the laboratory surroundings with a sighted partner at first.

Be aware of safety precautions.

Be careful to ask questions that he can relate to (see Section I, "Knowing the Blind Child").

All lessons for the blind child using the light sensor should be preceded by the lesson, "Using the Light Sensor," page 212.

The Emotionally Disturbed Child in the Laboratory

What kind of teacher intervention is needed to help the emotionally disturbed child? What are the needs of the child that the teacher must address and how is this accomplished? The answer lies in the structure and nature of science. Observations and research studies made by Hadary and Long (1973) indicate that the laboratory approach to science has the potential of helping the emotionally disturbed child by fulfilling some of his basic needs. For the past six years, we have seen emotionally disturbed children enter our science laboratory classes where the "emotional disturbance" disappears. In a study made in an analysis of lesson preference and pupil interest (Long, Hadary, and Griffin 1971) the findings demonstrate that emotionally disturbed children can find learning exciting, motivating, and useful (Hadary and Long, 1975).

Emotionally troubled elementary school children are characterized as underachievers, possessing a low self-concept, lacking controls over their impulses, and having poor interpersonal relationships with parents and other adults. They experience school as frustrating and painful, and classroom teachers find them difficult to teach and manage. While many remedial approaches have been reported to help these pupils, the use of science as a motivator for learning has been neglected. This is a distressing fact. Science is a powerful tool in therapy of the disturbed child. Science not only has a natural appeal to children, but it fulfills the need of the disturbed child for a rational, logical explanation and control over a confusing world. The knowledge of, and experiential approach to, science helps these pupils replace their magical thinking and omnipotent fantasies with general truth and laws. Science deals with reality—not fantasy. It facilitates cause and effect observations of behavior, the separation of facts from feelings, and the teaching of a problem-solving approach to conflict. It provides the child with positive feedback such as "I can learn!"—"I'm not dumb or stupid!"—"Learning is interesting!"—or, as one pupil said, "I didn't even know I liked science, but now look at me, I'm a scientist!" It appears that science and psychotherapy have many similar goals. People in some cultures would attribute a tidal wave to their god's personal retribution for something they did to offend him. Emotionally troubled children similarly live in a world of magic, guilt, and confusion. To master this stressful world, these pupils need to understand that life events do not happen because they are bad or powerful, but that they are related to cause and effect reality principles and that these events can be controlled. Laboratory

science, by giving the pupil autonomy in conducting his own explorations and investigations, can perhaps be used to help these pupils gain self-confidence and self-esteem, and to learn to live more comfortably with themselves and their world.

Laboratory Suggestions for the Emotionally Disturbed Child

Provide an intellectually stimulating experience.
Project a friendly and professional attitude.
Activities should be sequential, orderly.

Activities should have variety in concept.
Provide variety in activity.
Reinforce laboratory performance verbally.
Encourage discussion of discoveries.
Group the disturbed child with a blind child (if possible).
In discussion, develop logical sequential thinking on the child's part.
Develop thinking processes before action responses.

Experiments included in this program have been field-tested especially for emotionally disturbed children (Hadary and Long, 1975).

LISTING OF SCIENCE ACTIVITIES
AND THEIR SUGGESTED ART MATCHES

SCIENCE ACTIVITY SUGGESTED ART MATCH

Properties and Characteristics

Objects in the Classroom (p. 46)
- Property Patterns (p. 269)
- Soft-Smooth-Bumpy-Rough (p. 263)
- Making Textured Totem Poles (p. 265)
- Textured and Smooth Clay Pendants (p. 267)
- Nature Collage (p. 295)

Shapes (p. 49)
- Around the Outside: Contours (p. 256)
- Snowflakes, Stars, and Flowers: Recognizing and Creating with Geometric Shapes (p. 258)
- A Building That Never Was (p. 260)

Serial Ordering and Comparison of Objects (p. 52)
- Straw Structures (p. 348)
- Cork Towers (p. 377)

Rock Candy and Sugar Cubes (p. 55)
- Look What Happened to the Paper! (p. 287)
- Look What Happened to the Crayon! (p. 289)

Floating and Sinking Objects (p. 58) — Boats with Anchors (p. 291)

Buoyancy of Liquids of Different Densities (p. 62)
- Weaving: Yarns Close Together and Far Apart (p. 366)
- Density Windows (p. 368)

Using a Balance (p. 65) — Can You Balance a Mobile? (p. 293)

What Are the Mystery Powders? (Physical Properties) (p. 68)
- Look What Happened to the Paper! (p. 287)
- Look What Happened to the Crayon! (p. 289)

What Are the Mystery Powders? (Chemical Properties) (p. 73) — Bubbles and Balloons (p. 325)

Balloons and Gases (p. 81) — Bubbles and Balloons (p. 325)

Interaction

Evidence of Interaction — Energy Transfer (p. 90)
- Interaction Games (p. 320)
- Candle Making (p. 343)

"Inventing" the Systems Concept (p. 91)
- Making Puzzles (p.340)
- The Printing Process (p.323)

Exploring Pulleys (p. 93) — Stitchery Pulleys (p. 327)

Comparing Pulley Systems (p. 96) — Stitchery Pulleys (p. 327)

SCIENCE ACTIVITY SUGGESTED ART MATCH

Interaction *(continued)*

Solutions and Mixtures (p. 98)——————— Mixing Your Own Dyes for Tie Dying (p. 345)

"Inventing" Interaction at a Distance (p. 100) —— Interaction Games (p. 320)
Articulated Puppets (p. 333)

Investigating Magnetic Fields (p. 104)——————— Expressing Magnetic Lines of Force (p.331)

Electric Circuits (p. 107) —— Making Lanterns (p. 337)
Electric Circuit Designs (p. 339)
Moving Machines: Energy Transfer (p. 358)

Objects That Can Close a Circuit (p. 111) —— Making Lanterns (p. 337)
Electric Circuit Designs (p. 339)
Moving Machines: Energy Transfer (p. 358)

The Magnetic Field of a Closed Circuit (p. 115) ——— Expressing Magnetic Lines of Force (p. 33l)

Growing Beans and Peas (p. 120) —— Taping the Lines of Roots (p. 305)
Creating Roots with Wire (p. 309)
Building a Greenhouse (p. 314)
Printing Seeds, Leaves, or Branches (p. 299)
Progression Fold-Outs (p. 301)
The Beauty of Seed Germination (p. 303)
Creating a Flower (p. 311)
Clay Life Cycles (p. 318)

The Life Cycle of the Frog (p. 124) —— Mosaic Life Cycles (p. 316)
Clay Life Cycles (p. 318)

Variables and Experimental Design

Separating a Powdered Mixture (p. 130) —— Big or Little? Creating Designs by Sorting and
Classifying by Property (p. 281)
Felt Pictures: Before and After (p. 342)

"Inventing" the Subsystems Concept (p. 132) —— The Printing Process (p. 323)
A Subsystem Mobile (p. 341)

Colored Liquids (p. 136) —— Solution Sculpture (p. 329)
Mixing Your Own Dyes for Tie Dying (p. 345)

Salt Solution (p. 139) ——————— Wavy Patterns (p. 363)

Properties of Freon (p. 142) ——————— Candle Making (p. 343)

Converting Liquid Freon to Gas (p. 145) ——— Felt Pictures: Before and After (p. 342)

SCIENCE ACTIVITY SUGGESTED ART MATCH

Variables and Experimental Design *(continued)*

Whirly Birds (p. 150) ———————————— Straw Structures (p. 348)

Controlling Variables (p. 155) ———————— Straw Structures (p. 348)

Coiling Clay Pots (p. 273)

Pendulums (p. 158) ————————————— A Pendulum House (p. 380)

Energy

Exploring Rotoplanes (p. 168) ————————— A Cycle-Mill-O-Plane (p. 355)

Temperature Change as Evidence of Energy
Transfer (p. 172) ——————————————— Candle Making (p. 343)

Motion as Evidence of Energy
Transfer (p. 176) ————
- A Cycle-Mill-O-Plane (p. 355)
- Energy Transfer Hangings (p. 360)
- Articulated Puppets (p. 333)
- Interaction Games (p. 320)
- Moving Machines: Energy Transfer (p. 358)

The Angle of the Stopper Popper (p. 180) ———— A Collage of Angles (p. 365)

Energy Transfer from Spheres to Sliders (p. 183) —— Making Balls Roll (p. 364)

Energy Transfer (p. 188) ————
- Making Balls Roll (p. 364)
- Interaction Games (p. 320)
- Jack-in-the-Box (p. 371)

Drive a Nail 1 (p. 192) ———————————— Metal into Wood (p. 283)

Drive a Nail 2 (p. 195) ———————————— Metal into Wood (p. 283)

Enrichment Activities

Archimedes' Principle (p. 198) ———————— Look What Happened to the Paper! (p. 287)

Sound Transmission Through Different
Media (p. 203) ———————————————— The Sounds and Vibrations of a Branch
Harp (p. 273)

Air as a Medium for the Propagation
of Sound (p. 205) —————————————— Vibrating Art Forms (p. 375)

Musical Strings (p. 207) ———————————— The Sounds and Vibrations of a
Branch Harp (p. 373)

Intensity of Light (p. 210) ———————————— A Building That Never Was (p. 260)

SCIENCE ACTIVITY SUGGESTED ART MATCH

Enrichment Activities *(continued)*

Using the Light Sensor (p. 212) ——————————— A Building That Never Was (p. 260)

Bounce That Light (p. 213) ——————————— Aluminum Foil Reliefs (p. 379)

Pumping Pulse (p. 215) ——————————— Lub-A-Dub Paper Chain Rhythms (p. 370)

Heartbeat (p. 217) ——————————— Lub-A-Dub Paper Chain Rhythms (p. 370)

Water Wheel (p. 221) ——————————— Cycle-Mill-O-Plane (p. 355)

Coils (p. 224) ——————————— Expressing Magnetic Lines of Force (p. 331)

SCIENCE
ACTIVITIES

PROPERTIES & CHARACTERISTICS

Properties and Characteristics in Nature

Physical Properties of Objects and Materials

Structure and Function

OBJECTS IN THE CLASSROOM

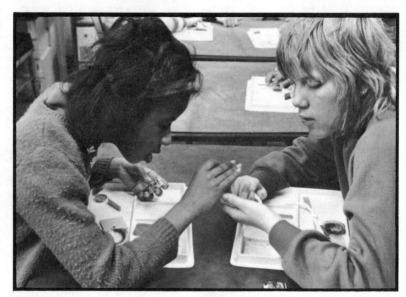

Figure 2.10. Blind children examine and discuss the properties of objects.

EXPLORATION

To identify and to describe objects by their properties rather than by use. To sort and to classify objects according to properties.

SCIENCE CONCEPTS

The word "object" is used when referring to a piece of matter. Objects can be identified by describing their characteristics which can be referred to as their properties.

MATERIALS

For each child

1 tray	soft objects—cotton balls
rough objects	hard objects—buttons, nails

PROCEDURE

Have the blind child and the deaf child assist in the discussion. Make sure that they handle all the objects referred to in the discussion.[1]

Present objects around classroom as well as various objects which clearly represent properties such as cotton, beads, sandpaper, and your shoes, and ask the children to tell you about them.

If the children seem puzzled by your question, ask individual children to describe a specific chair, for example, as though you had never seen one.

As different children describe different objects, use the term "object" as you call their attention to each one.

Display appropriate language cards.

Ask some individuals to select any object in the classroom and to describe it to you. After several objects have been described,

[1] Italicized words in the Procedure section of all Science and Art Activities pertain to directions for blind, deaf, or emotionally disturbed children.

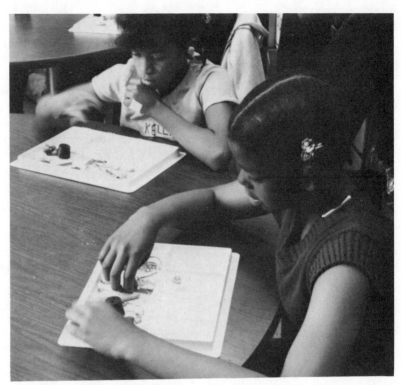

Figure 2.11. Deaf children describe the properties of an object.

invite the children to name objects in the room. Try to elicit their understanding that every item in the room can be referred to as an "object."

A child will describe an object by talking about its shape, color, texture, or other properties. Affirm the child's statement by using the term "property" (show card), or perhaps saying, "Yes, rough is a property of the paper." Continue to repeat their descriptions by using the term "property" until several children begin to use the term in their descriptions of objects.

Make a chart headed "Properties and Objects." Ask individual children to help you list some of the properties already named. *Have the deaf child put language cards on chart. Have the blind child tell the class what some of the property words are.* As new property terms are used by the children in other or later activities, add them to the list.

Have a blind child hold up an object. Any child who correctly names a different property of the object stands. After a time, count the number of standing children. Tell the class that the object has (at least) that many properties. Give each group a set of property word cards. Have the children place objects under the proper property word—e.g., a rough object under the word "rough," etc.

ADAPTATIONS

Adapted Materials for the Blind Child

Adapted tray with compartments.

Adapted Procedure for the Blind Child

Make sure that the objects chosen for the blind child differ in weight, size, or texture. Give each visually impaired child a tray. Suggest that he place all his objects in the large space and then use the four small compartments to help keep track of his sorted objects. During the discussion of properties the blind child can offer properties after feeling the objects. Asking sighted children to identify properties in ways other than visual is an interesting extension of this activity for all the children. The emphasis on observing, comparing, and reporting of this activity is important for the handicapped child.

The beginning activities give a good indication of how extensively future activities will have to be modified to meet the needs of the special children.

Suggested Adaptations for the Deaf Child

Prepare language cards appropriate to the concepts of the lesson to be placed on chart: Object, Rough, Smooth, Hard, Soft, Properties, This is an object. Additional cards can be made while the children discuss properties.

Because this is one of the early lessons, use language cards with great discretion. Do not overpower the children with language. Let them explore and discover. Make sure that you are facing the deaf child at all times when speaking or demonstrating to the class. All of the children should be made aware of this.

COMMENTS

When the children begin talking about an object, they will describe its uses as well as its properties. The objects described should be made available for the blind child to handle and for the deaf child to see. Accept statements related to use, but keep focusing attention on properties. If children can name only a few properties of an object, go on to another object. Do not try to define the term "object," but try to get across the idea that almost anything that can be pointed to can be called an object.

SHAPES

MATCH BOX

Suggested Art Match:
Around the Outside p. 256
Snowflakes, Stars, and
Flowers p. 258
A Building That Never Was
p. 260

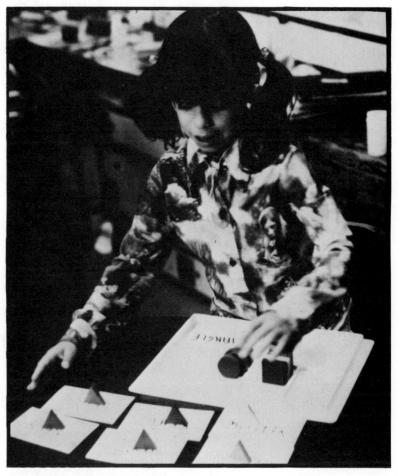

Figure 2.12. Deaf child places objects on word cards.

EXPLORATION

To identify two-dimensional shapes on three-dimensional objects.

SCIENCE CONCEPTS

Two-dimensional shapes can be identified on three-dimensional objects such as spheres, cubes, cylinders, pyramids, and cones. Three-dimensional shapes appear when two-dimensional shapes are rotated.

MATERIALS

For each group of 2

7 shapes: sphere, cube, cylinder, cone, pyramid, ellipsoid, rectangular prism
1 board with cut-outs of two-dimensional shapes
drawing paper

ADVANCE PREPARATION

Prepare trays for each pair of children.

PROCEDURE

Activity 1

Do the activity as you discuss it with the children so that the deaf child can follow the instructions.

Ask the children to pick up one of the three-dimensional shapes from their trays and to find a two-dimensional shape on it. Ask the children to locate the same two-dimensional shape on the cut-out board and then to test the guess by trying to fit the three-dimensional shape into the cut-out. If the shape fits into the cut-out, ask the children to place the shape on the side of the tray.

Present the language cards designating the three-dimensional shape and the two-dimensional shape.

If the three-dimensional shape does not fit the cut-out, ask the children to locate another cut-out that the shape will fit; then ask the children to place the three-dimensional shape back on their trays. *When working with a visually impaired child, hand the three-dimensional shape in question to the child, who should have his own cut-out board and shapes.*

Ask the children to select another three-dimensional shape and match with a two-dimensional shape on their cut-out board. Continue until all of the three-dimensional shapes have been matched with the two-dimensional cut-outs. For reinforcement, the reverse procedure may be followed. Point to one of the two-dimensional cut-outs on the board (show the visually impaired), and then ask a child or the class to suggest a three-dimensional shape that fits it.

Have a blind child turn the sphere 90 degrees and ask the children again what two-dimensional shape they see. Turn the sphere slightly again, and ask for the two-dimensional shape. Invite someone to comment that a circle has appeared each time.

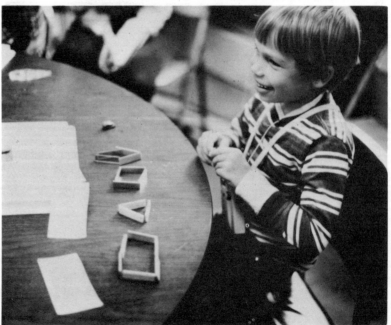

Figure 2.13. Deaf child making geometric shapes.

Continue until all of the two-dimer
paired with a three-dimensional shar

Referring to the shapes that the
ask a blind child to hold up or
name the shape. *Allow all the u.*
the object being shown. Invite in.
two-dimensional shapes they see or ic
shape. Repeat with each of the assort.
ferent children.

Give each child a three-dimensional shape an.
Ask each child to draw a two-dimensional shape t....
on the three-dimensional shape. *Give the visually impaired child*
a thin piece of paper and have him place it on a screen board.
Then, using a crayon, have him draw a two-dimensional shape.
Let the children check each other's drawings.

Have the children trade shapes with a neighbor and draw
another two-dimensional shape. Continue the trading as long as
the children seem interested.

Activity 2

Have a blind or deaf child hold up a sphere. Ask several chil-
dren whether they see a two-dimensional shape on the sphere. *If*
possible have two identical half spheres so that the visually im-
paired child is better able to recognize a circle. When some chil-
dren have seen a circle, hold up a cardboard circle.

ADAPTATIONS

Adapted Materials
for the Blind Child

Screen board, crayon or grease pencil, 4 sheets of extra thin
paper (newsprint), identical half spheres.

Suggested Adaptations
for the Deaf Child

Language cards: Sphere, Cone, Pyramid, Cube, Cylinder, Two-
dimensional, Three-dimensional.

SERIAL ORDERING AND COMPARISON OF OBJECTS

```
┌─────────────────────────────────┐
│          MATCH BOX              │
├─────────────────────────────────┤
│  Suggested Art Match:           │
│  Straw Structures p. 348        │
│  Cork Towers p. 377             │
└─────────────────────────────────┘
```

EXPLORATION

To identify certain properties of a group of similar objects and to serially order the objects according to one or more properties.

SCIENCE CONCEPTS

The process of arranging objects in order according to length, weight, flexibility, or another single property that permits comparisons of "more" or "less," is introduced.

MATERIALS

For each child

1 cardboard tray
5-6 objects chosen from:
 scallop shells, auger shells, wires, plastic spaghetti, rocks, crayons, and pencils.

For each group of 4

pieces of sandpaper
pieces of metal foil
6-8 white cards
rubber ball
piece of clay

ADVANCE PREPARATION

Prepare and distribute trays for each child. Prepare special tray for blind child.

PROCEDURE

Have the deaf child relate objects to language cards whenever appropriate. Equipment should always be in hands of blind child to relate to all discussions.

Ask the children to examine and compare the objects on their trays in terms of similarities and differences of properties. *Show deaf child similar and different objects and relate the language cards.* Ask the children to arrange the objects on their trays in order from shortest to longest.

If some children seem puzzled, bring your own collection of crayons or of plastic spaghetti to each station, serially order them by length, and introduce the words "serial order." Then mix up the objects and ask the children at the station to help you rearrange them by length, perhaps by asking one child at a time where each piece of crayon goes side by side across your cardboard tray. *Have blind or deaf child assist you.* Invite the children again to arrange the objects on their own trays.

Invite the children to choose a second property (shiny, rough, smooth), and to serially arrange the objects on their trays a second time. Ask several children what property they chose, and the reason for their choice.

Make sure that the blind child has all the prepared brailled cards illustrating properties (of your choice) that assist with lessons. Show language cards for the deaf child. When the reasons provided by the children begin to use words such as "greater than," "more than," and "smaller than," pick up a ball and a piece of clay from one station (*have blind child do it at the same time with adapted materials*) and drop both objects to the floor. Ask the children to tell you which object bounces more. Write the word "bouncy" on a card, and set it aside with the ball and the piece of clay.

Pick up a piece of sandpaper and a piece of metal foil and ask the children to compare the properties of these objects, and to choose one, for instance, "roughness." Write the word "rough" on a card and set it aside with the two pieces of paper.

Write the comparison sign > on a card (*give brailled card to blind child*) and explain that it is a shorthand way of writing the words "greater than" or "more than." Clip the "greater than" sign to the word "bouncy" and lay both cards on the table with the ball and the piece of clay on either side, thus:

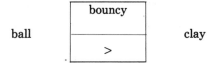

Invite a child to "read" the "sentence." If several children are puzzled by your request, go back over the demonstration of bounciness and the meaning of >. When they can "read" the "sentence," replace the card with the word "bouncy" by the card with the word "rough" (or whatever the second property word was). Ask a child to "read" the resulting "sentence." Write the comparison sign < on another card and explain that it is a shorthand way of writing the words "less than" or "smaller than." Clip the "less than" sign to the word "rough" (or the second property) and lay both cards on the table between the pieces of sandpaper and foil, thus:

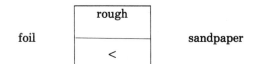

Invite a child to "read" the resulting "sentence." Try to elicit the comment that the two comparison signs are alike except for pointing in different directions. Ask a child how the objects in the first sentence can be compared by using "less than." One child may "read" the "sentence" from right to left. Ask for another way, until a child switches the > to point in the opposite direction. Continue the discussion until the children realize that there is really only one sign that can read "more than" or "less than," depending only upon the direction in which it is pointing. *Encourage deaf and blind children to participate in discussion.*

PROCEDURE—*continued*

Let the children make their own signs on the cards at their stations. *Give the blind child ready-made cards or have him make them by using sticky neoprene tape or wire.* Ask them to compare objects on their trays using the signs and some property they choose. Ask several children what property they are comparing. Invite them to rearrange the objects on their trays in terms of other properties that can be compared using "greater than" and "less than." Ask one child at each station to arrange his objects and signs while the other three children guess what property is being compared. Ask the other children to play the game in turn using a different property.

ADAPTATIONS

Adapted Materials for the Blind Child

Rubber ball with string firmly attached, piece of clay (size of the ball) with string around it, 7 pipe cleaners or neoprene tape for children to make 7 cards ("<" or ">").

Prepare raised and brailled sign cards illustrating properties as described in Procedure. Brailled word card: Bouncy and Rough. Adapted tray.

Suggested Adaptations for the Deaf Child

Language cards: Shiny, Dull, Shortest, Longest, Serial Ordering, Similar, Different, Same.

COMMENTS

When the children are serially ordering their objects and come upon two crayons, for example, of equal length, either discard one of the crayons or explain that they may be placed next to each other. For children who seem unable to serially arrange objects of different sorts, repeat your demonstration at individual stations. Give them a new collection of objects to try. Challenge very able students to find more than one way (thickness, weight, length, color) to arrange objects such as shells, crayons, or wires. Encourage children to bring in their own objects to form comparison sentences.

Sign cards for the blind child can be made with string or wire glued to the card for the raised part (>). The words are brailled with a brailler.

ROCK CANDY AND SUGAR CUBES

MATCH BOX

Suggested Art Match:
Look What Happened to
the Paper! p. 287
Look What Happened to
the Crayon! p. 289

Figure 2.14. Crushing the sugar cube: physical change.

EXPLORATION

To bring about change in form of objects by crushing and dissolving.

SCIENCE CONCEPTS

Two objects that differ in form may be made of the same material. Physical changes in objects may be brought about by crushing, dissolving, and heating. Size and surface area of a particle is one of the determining factors in degree of solubility.

MATERIALS

For each child

cubes of sugar	magnifiers
pieces of rock candy	1 mortar and pestle
plastic spoons	1 paper towel
cardboard trays	2 half tumblers of water

ADVANCE PREPARATION

Assemble the materials on a tray and distribute to each child.

PROCEDURE

Have the children examine the sugar and candy. Ask them to report the similarities and differences they observe.

Ask the children to set aside the rock crystal for the moment and to work only with the sugar and other items on the tray. Have them place one sugar cube in the mortar and break it into several large pieces with the pestle. Ask the children to examine these smaller pieces, with and without the magnifier, also by feeling, and to describe to each other the similarities and differences between the smaller pieces and the unbroken cube remaining on the tray. *A sighted child should be a partner of a blind child with whom he can discuss the observations.*

Ask the children to place some of the small pieces of sugar on the tray with the sugar cube, leaving some pieces in the mortar.

Have each child grind the pieces in the mortar. Have them scrape the powder onto the tray, using the plastic spoon. Discuss and compare the properties of the cube, the pieces, and the powder with and without the magnifier. Have all the children feel the different forms and report observations. Suggest that they taste the sugar.

Have the children wipe the mortar and pestle with a *dry* paper towel. Repeat the procedure with the rock candy. Ask the children to examine the small pieces and the powdery material on both trays, with their fingers, with magnifiers, and by testing. Ask them to describe the properties of both powders. Try to elicit the statement that the powder is another form of the original cube or piece of candy. Have the children add a sugar cube to one cup of water and a powdered cube to another. *Ask them to observe (blind child feels) what happens.* Is this still sugar? Then have the children put the solution in small dishes to evaporate.

Figure 2.15. Tasting the crushed sugar. "Is it still sugar?"

ADAPTATIONS

Adapted Materials for the Blind Child

1 adapted tray.

Adapted Procedure for the Blind Child

Demonstrate to the class or individual child how to "grind" the sugar cube and rock candy. Most children tend to "pound" at the two objects. When this is done, more often than not the sugar or rock candy flies out of the mortar. This could pose problems for the blind child. Make sure that the blind child has a good supply of paper towels.

Suggested Adaptations for the Deaf Child

Language cards (to be used with discretion): Sugar, Crystals, Powder, Mortar and Pestle. Is this sugar? How are they the same? How are they different? Use of language cards depends upon the age and educational background of the child. The child should be left free to explore, experience, and discover before introducing language cards.

COMMENTS

When the children break the sugar and the candy into small pieces, point out that the pieces are material objects too, and therefore that the parts of objects are also objects themselves. When the sugar dissolves, a change has been brought about. What property tells you that it is still sugar? If no one notices, point out that it took the cube longer to melt in that form than in powder form. Compare for yourself the words the children use to describe these objects and their properties with the words they used at the beginning of the unit. This can be your own informal gauge of the growth of the children's language abilities.

FLOATING AND SINKING OBJECTS

MATCH BOX
Suggested Art Match: Boats with Anchors p. 291

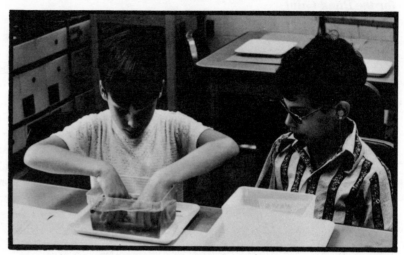

Figure 2.16. *Deaf child watches blind child observing with hands. "My hands are my eyes."*

EXPLORATION

To design a clay object that will float. To find out why a particular design holds a bigger load than others. To discover what makes an object sink or float.

SCIENCE CONCEPTS

In the case of water, immersed objects are buoyed upward because the pressure acting up against the bottom of the object exceeds the pressure acting down against the top. An immersed body is buoyed up by a force equal to the weight of the volume of the fluid it displaces. A floating object displaces a weight of fluid equal to its own weight. More dense fluids will exert a greater buoyant force upon a body than less dense fluids.

MATERIALS

For each child

1 plastic box, $7'' \times 5'' \times 3''$
1 ounce oil base modeling clay
1 tray, $12'' \times 18''$
12–18 small, uniform weights (small tiles, pennies, washers, paper clips can be used)
1 plastic medicine cup, 30 cc capacity
1 multi-purpose balance (see Figure 3.4)
paper towels at each station
waste basket at each station (for discarded paper towels)

For the class

1 package wax paper
1 package plastic bags
dowels or round pencils
mop
paper towels
sponges

The plastic box, modeling clay, and tray are included in Class Kit for Clay Boats available from Webster Division of McGraw-Hill Book Company.

ADVANCE PREPARATION

Divide each pound of modeling clay into one-ounce pieces. Plasticine and Clay-cene work best. Set aside the uniform weights and plastic cups for a later activity. Prepare trays and distribute to each child. Fill plastic boxes with warm water. Remember to put paper towels and wastebasket at each station. Keep balances to be distributed for later activities.

PROCEDURE

Activity 1—Floating the Clay

Begin with brief demonstration. *Have the pupil assistants (blind child and deaf child with one normal assistant) hold up a one-ounce section of modeling clay for the class to see.* Instruct them to roll it into a ball. Ask the children what will happen when you put the ball of clay in water. Discuss their answers.

Have the children place the clay ball in water. Let the children see it as it sinks.

Ask the children what happened to the clay. (Nothing, it just sank.)

Ask what you could do to make the clay float.

Ask them to go to their stations and experiment to see if they can make the clay float.

If some children find it difficult to get the clay flat, suggest rolling it on wax paper with a dowel or a pencil.

If some children cannot get the clay soft or make it stay together, the water may be too cold. Give the children warmer water and ask them to try again.

If some children seem puzzled about how to begin, suggest they try to get just a small piece of the clay to float at first. Encourage children to get their entire piece of clay to float. As more children succeed, they will start to call the objects "boats." Do not use the word until the children do, so that you do not confine them to trying just one shape.

Invite children to design their boats to carry cargo.

Let some children make a bigger boat that will hold a bigger load if they wish.

Distribute the balances and show the children how to use them. *Have the blind child do the demonstration.* Suggest that they weigh the amounts of clay their boats carry without sinking. Encourage the children to use the balances whenever they wish.

Activity 2—Loading the Boat

Distribute 12–18 uniform weights to each child. Invite the children to discover how many weights their boats will hold. Call the weights "sinkers" (or wait until the children do so), because the weights can sink the floating boat. Invite the children to discover whether the same boat will always hold the same number of sinkers.

Ask the children what happens if water gets into the boat. Ask whether the sinkers must always be placed in the same position every time, and whether the sinkers must be placed into the boat in a certain way (dropped, thrown, or put in gently).

PROCEDURE
Activity 2—Loading the Boat—
continued

Invite the children to discuss whether a boat that sinks weighs more or less than a boat that floats. Ask for their ideas on how they could find out, and let them test their ideas and report the results.

Ask the children what they can do to make their boats hold more sinkers. Let them experiment.

Invite a child to make a list on the blackboard of all the ways the children report. *Have the blind child make a list using the brailler. Have the deaf child show what he has done.* As each child reports he should show what he did as well as explain. If the children neglect to mention any of the following, try to elicit: no holes in the boat, making the sides taller, making the boat wide inside, making the clay thin, making a shallow (not a deep) boat, putting the sinkers in gently (not hard), drying the sinkers (or the water will add weight), keeping the inside of the boat dry. Invite the children to show and discuss the design of their boats. Suggest setting aside some good boats for the whole class to look at and discuss.

Ask the designers to say how many sinkers their boats hold. Let the children compare the number of sinkers their boats hold and let them discuss why each boat holds a different number.

Ask the children which shape holds the most sinkers. Ask other children whether each boat would hold the same number of sinkers if everyone made boats the same shape. Let children discuss their disagreements and propose and carry out tests to decide the question.

Invite some children to say which shapes make better boats than others. The children will be able to say what makes a good boat, and what a "good" boat is, without knowing *why* the boat floats.

Activity 3

Distribute the 30-cc plastic medicine cups.

Float a cup in a container of water next to a clay boat, and invite the children to examine and compare the two objects. Ask several children to describe how each "boat" sits in the water.

Add some sinkers to the clay boat to determine how many it will hold. Repeat this two or three times to establish a number the children agree on.

Now ask the children to predict how many sinkers the plastic will hold. Invite each child to test his prediction.

When the children have loaded and reloaded their plastic cups a few times, ask some children how many sinkers their cups held. Try to elicit the statement that all the plastic cups hold about the same number of sinkers (seven). If some children report three or four sinkers, invite them to show the class how they loaded their cups. (The cups tipped over, so the children learned to load carefully.) Other children may report five or six sinkers. Invite them to demonstrate. (They probably drop the sinkers into the cup instead of placing the sinkers in gently.) Ask these children to try again by being careful and by placing the sinkers gently in the cups. Ask them to report the number of sinkers the cups hold while still staying afloat. (Remind the

children that placing more sinkers in the cup while it is sinking but before it reaches the bottom does not count as "floating.")

ADAPTATIONS

Adapted Materials for the Blind Child

The blind child can do this experiment with no adaptations.

Suggested Adaptations for the Deaf Child

Language cards: Sink, Heavier, Float, Lighter, Clay ball, Flat, The boat holds _____ sinkers. How many sinkers does the boat hold? Which boat holds more sinkers?

BOUYANCY OF LIQUIDS OF DIFFERENT DENSITIES

MATCH BOX

Suggested Art Match:
Weaving p. 366
Density Windows p. 368

EXPLORATION

To test the buoyancy of liquids with different densities by weighing certain quantities of liquids.

SCIENCE CONCEPTS

Density is equal to the weight per unit of volume. The buoyancy of a liquid depends upon its density. The greater the density, the greater the buoyant force.

MATERIALS

For each child

1 medicine cup
2 large plastic drinking cups or plastic containers for floating objects
8 ounces coarse (kosher) salt
3 ounces glycerin
1 plastic spoon
1 balance for station (ESS balance)
weight

For the class

1 pint cooking oil
liquid detergent and bottle brush
rubber cement
assorted objects: erasers, sponge, bar soap, paraffin, crayons, candles, corks
assorted liquids: vinegar, corn syrup, pancake syrup, motor oil, linseed oil
assorted powders: sugar, baking soda

ADVANCE PREPARATION

Weigh out a small cupful of oil for each child. Prepare a bucket of sudsy water and keep it accessible for the children to place oily items into. Prepare salt water solution by adding about three pounds of coarse salt to one gallon of water, a handful at a time, and stir to dissolve. Prepare one container of oil large enough to hold big objects, and set it out of the way of traffic but in a convenient place for all children to share. Have the children bring out their shoe boxes containing materials from the previous lesson. Make a chart on the blackboard with headings to indicate: Liquid Used, Weight of the Liquid, Object, Sink or Float.

PROCEDURE

Introduce the balance. *Show, with the assistance of blind and deaf children, how to use the balance.*

At each station pour salt water into half the children's plastic containers and pour tap water into the remaining containers without telling the children that one liquid is saltwater.

Let the children test their objects as before and wait until some children notice that some of the objects that sink in their containers float in their neighbor's.

Let the children discover for themselves that one liquid is salt water. Some child will notice that it feels different from tap water.

If children do not ask for salt to make their own salt solutions, ask them how much salt they think is needed to get the acrylic objects to float. (They will underestimate.)

Let the children dissolve salt in water and tell you how much they needed in how much water before the acrylic objects floated.

Ask the children whether the objects interact differently with the water as salt is added. (They sink at a slower rate.)

After noticing how much salt is needed in order to get the acrylic objects to float, some children may wonder whether the salt water weighs more than tap water. Let them weigh quantities of each liquid on the balance, but let them discover the proper procedure for themselves. (First weigh the empty cups, then add equal amounts of each liquid.)

Invite the children to compare the weights of the other liquids being used: glycerin, oil, sugar solution, baking soda solution. *See Adapted Procedure for the Blind Child below.*

Suggest that the children try to float their objects in these liquids, and ask the children to record and describe their observations by demonstrating what happened.

If children have difficulty with glycerin, suggest they add the glycerin slowly to water. (The objects will float.) Then suggest they add water to glycerin gradually. (The objects will sink.)

Encourage the children to test their objects in some liquids lighter than water, such as alcohol, cooking oil, linseed oil, motor oil. Then ask them to try to float their objects in liquids heavier than water, such as corn syrup or pancake syrup.

Invite several children to report their observations. Ask other children to criticize their findings and to suggest tests where results conflict.

ADAPTATIONS

Adapted Materials for the Blind Child

Adapted balance—has one inch masking tape positioned in the center of, and projecting one-half inch above, the balance arm between the slit in the balance post; 1 set adapted large assorted objects (the ones used in regular lesson) with 8 inches of string tied around each one; light sensor; one-half pound Plasticine; adapted tray; adapted 6-inch tube (as described in regular lesson) with a strip of raised dots (1/2" apart) taped vertically to the outside of the tube.

Adapted Procedure for the Blind Child

While other children are working with liquids of different densities have the visually impaired child participate by using an adapted 6-inch tube instead of the plastic container. Do not have the tube filled to the top. Have the child press the tube into some Plasticine in small compartment 1 of the adapted tray. Have the light sensor placed in front of the tube. Instruct the

ADAPTATIONS
Adapted Materials for the Blind Child—continued

child to test each object in the liquid by lowering it by the string into the tube. Make sure that the child holds onto the string. If the object sinks to the bottom, the sound from the light sensor will lower. If the sound does not lower, that means that the object is floating somewhere in the liquid. If this is the case, the light sensor must be guided up the tube until the sound lowers. This will indicate the height that the object is floating in the liquid.

The visually impaired child should list the liquid being used, weight of the liquid per cup, each object tested, and the height at which the object is found floating during this activity. When the balance for weighing the liquids is introduced to the class, have the blind child assist in the demonstration with the adapted balance. The child will be able to check to see if the balance is level. Show the child that if he slides his fingers along the top of the post of the balance where the slit is, a piece of tape will be felt if the balance is not level. The tape will not be felt if it is level.

Suggested Adaptations for the Deaf Child

Language cards: Glycerin, Salt water, Sink, Float, Buoyancy. Make cards as suggested by the child's activities.

COMMENTS

The children should record all their observations making a chart with headings: Liquid Being Used, Objects Tested, Floats, Sinks.

USING A BALANCE

MATCH BOX

Suggested Art Match:
Can You Balance a Mobile?
p. 293

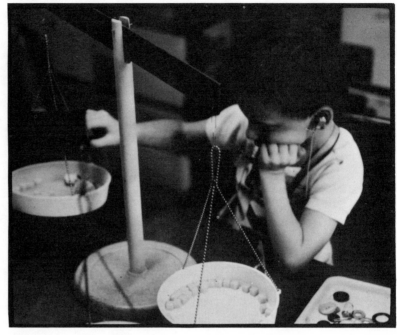

Figure 2.17. Comparing weights of different objects.

EXPLORATION

To use a balance to weigh objects.

SCIENCE CONCEPTS

To compare weights of different objects. To sort and to order objects into sets according to weight. The earth-pull on the heavier of two objects is greater than it is on the lighter object. Objects of different weights can be compared on an equal-arm balance.

MATERIALS

For each pair of children

1 box of paper clips or brass fasteners
2 books
2 drinking straws
2 boxes of crayons
2 metric rulers
2 blackboard erasers
30 one-cm cubes

1 equal-arm balance (from ESS Program), consisting of a base, balance arm, two balance pans, two pan halters, and two sliding compensators
small objects—4 each: washer, bolt, screw, or slug; cubes; bar magnets; hand lenses; metal nuts; droppers

ADVANCE PREPARATION

Distribute the materials to the children. Let the children watch you assemble the balance, with the assistance of a blind child, then have them assemble their own.

PROCEDURE

Activity 1

Ask each child to arrange his book, drinking straw, box of crayons, ruler, and eraser in order from lightest to heaviest. Let the children at each station compare their results and give reasons

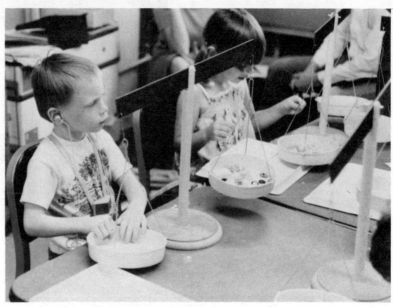

Figure 2.18. Intellectual development.

for and against any differences. Ask the children to compare and order the assorted small objects by using the balance. When they have finished, let each child report to the others a few comparisons so that each child has a turn ("The bolt weighs more than the slug;" "The washer weighs less than the screw"). If there are disagreements, let the children demonstrate how they weighed their objects until the disagreement is resolved. If a disagreement cannot be resolved, ask the children's opinion concerning the reasons for the differences.

The balance may not be correctly adjusted. The balance arm must be level when the pans are empty. Let the children slide the compensators until the balance arm is level. The children may have compared objects indirectly and thus may have made incorrect inferences.

Objects of the same kind may vary slightly in weight. Let each station decide on the proper technique for using the balance. Ask one child from each station to demonstrate the selected technique, and let the other stations decide whether it leads to correct or incorrect conclusions.

Let the stations test the procedures that differ from their own, until the class reaches a consensus about the proper procedure. Ask one or two children to state the procedure decided upon.

Activity 2

Ask the children to place one of the assorted objects into one pan of the balance, then ask what they might do to make the pans balance.

Let the children suggest putting something on the other pan, or making the force bigger on the lighter side. Have them try out their suggestions.

Some suggestions may work but may not be measurable. For instance, a child may suggest pushing down on the pan with his finger. The pans can be made to balance, but "finger-push" is too variable and not measurable by these means.

Someone may suggest putting identical objects, such as cubes or clips, in the second pan until balance is achieved. Ask the children to test this idea by using the cubes, and then recording the number of cubes needed to balance each of the assorted objects. Ask each station to account for discrepancies among each other, and let the stations resolve their differences.

When the children agree on the number of paper clips or cubes needed to balance each object, have them arrange the objects in order from lightest to heaviest. Have them compare this ordering with the ordering they arrived at in Activity 1. Put on board the ordering arrived at in Activity 1 for comparison. Let them try to account for any discrepancies.

ADAPTATIONS

Adapted Materials for the Blind Child

Adapted balance, brailler and paper (see Figure 3.4).

Adapted Procedure for the Blind Child

To make the adapted balance, place masking tape on perpendicular balance arm in its center. The tape should be sticking up about one-half inch above the balance arm. The tape on the balance arm should not be felt if the balance is level. As soon as the weight becomes disproportionate between the two pans, the edge of the tape will protrude from the slit in the balance post. This can be felt when a finger is rubbed along the top of the post. This indicates that the balance is not level.

Suggested Adaptations for the Deaf Child

Language cards: Level, Lightest, Heaviest, Weight, Force, Earth-pull, Equal-arm balance, Straws, Weigh, Balance, Arrange in order, Compare, Bolt, Slug, Washer, Screw.

COMMENTS

Let the children experiment as much as they like with the balance, even letting them use measuring techniques that you know to be wrong. When the groups compare results at the end of the experiments, the children will become aware of their errors.

WHAT ARE THE MYSTERY POWDERS?
(Physical Properties)

MATCH BOX

Suggested Art Match:
Look What Happened to
the Paper! p. 287
Look What Happened to
the Crayon! p. 289

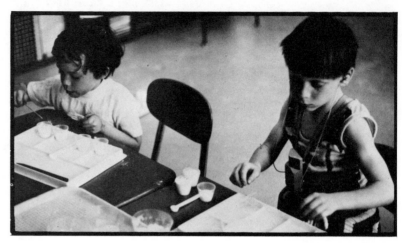

*Figure 2.19. Examining mystery powders. A deaf child becomes inde-
pendent.*

EXPLORATION

To set up experiments to identify physical properties of sugar,
salt, baking soda, starch, and plaster of Paris by smelling, feel-
ing, magnifying, and comparing with known substances. To de-
sign experiments to explore the reaction of these powders with
water.

SCIENCE CONCEPTS

Physical properties of matter commonly determined include
solubility, luster, crystal structure, hardness, odor, color, taste.
Matter can be partially identified by its physical properties.
These properties can be observed without changing the molec-
ular structure of the substance investigated.

MATERIALS

For each child

5 paper medicine cups, 30 cc
5 plastic spoons
1 shoe box or similar container
2–3 sheets black construction
 paper
1 hand lens
1 dropper bottle of water
10 plastic or wax paper sand-
 wich bags
1 children's stereomicroscope
 (Bausch & Lomb) (optional)

For a class of 30

10 pounds granulated sugar
6 boxes table salt
10 pounds baking soda
10 pounds powdered laundry
 starch or corn starch
10 pounds plaster of Paris
1 box flat toothpicks
10 four-quart pails or any
 other large containers (paper
 paint pails)

ADVANCE PREPARATION

Ask each child to bring from home a shoe box or similar con-
tainer to store their materials in. Number the five pails and fill
each with starch (1), baking soda (2), plaster of Paris (3), salt (4),
or granulated sugar (5). Prepare one set of powders for each

child by scooping one medicine cup of each of the five powders and numbering the cups similarly. Make "Seefee" posters for magnified powders. Assemble the materials for rapid distribution.

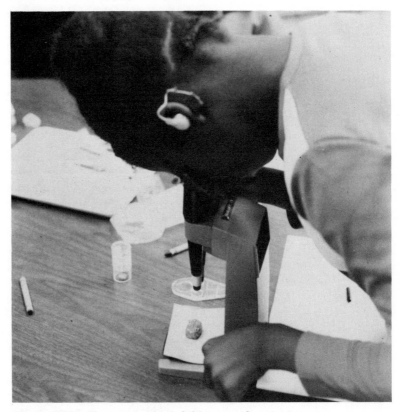

Figure 2.20. Encourage deaf child to use the microscope.

PROCEDURE
Activity 1

Show the children the five pails of unknown powders. *Have blind child feel them.* Let them speculate about what the powders might be. When you distribute the cups, refer to the cups with the same numbers that appear on the supply pails.

Explain and show that the plastic spoons can be used to scoop powder from the cups onto the black construction paper. Let the children number the spoons with the same number that appears on each cup, so that the spoon from one cup does not contaminate the powder in another cup. Tell the children they are to identify each of the mystery powders any way they can. Explain that while it is dangerous to taste unknown substances, you know that the Mystery Powders are not dangerous and that therefore they may taste these powders in small amounts, but they should not swallow the powders. Show while telling that they just touch their tongues with a tiny bit of the powder.

Suggest that the children place a small amount of each powder on the sheets of black construction paper. Show them how you want them to do this.

Encourage the children to set up their own experimental design to identify the physical properties of the powders. If direc-

PROCEDURE
Activity 1—*continued*

tion is indicated, ask the children to examine the ways in which the powders are alike and the ways in which they are different. Invite the children to feel the powders and to report any differences or similarities. Ask the children whether the powders have an odor.

Invite the children to list the properties of each powder that they have discovered.

Invite the children to examine the powders using their hand lenses and microscope. *The blind child examines by feeling.* Ask them whether they discover anything new about the powders. Have all the children refer to "Seefee" posters of magnified powders, if available.

Ask whether they believe they can identify the powder by the shape of its particle. (Salt and sugar are made of cube-shaped particles, but salt is much more uniform and less broken. Corn starch, baking soda, and plaster of Paris are similar in appearance, and it is difficult to distinguish one from another.)

After the children have examined the powders, with and without the lenses, ask them to describe which properties of the powders seem to be the same and which seem to be different.

Invite the children to discuss which properties are helpful in describing a particular powder.

Let the children put a teaspoon of each powder in separate sandwich bags. They may use the labeled plastic spoons.

Let the children number their bags to correspond with the numbers on the pails, then tell the children to tape or staple the bags closed and take them home.

Encourage the children to try to identify each bag of mystery powder by comparing it with known white substances in their kitchens at home. If the children are unable to identify with certainty one or more of the powders, the powder should continue to be referred to by its number until identification becomes final.

Encourage the children to keep records of each of their observations. You may want to wait until the children discover for themselves the importance of keeping records. If they do not, suggest that the children list the number of each powder on a page, describe what observations he carried out to identify the powder (feel, taste, grind, reaction with water), and name any powders identified. *Blind child will record on brailler.*

Invite each child to describe the various tests they performed at home. Let them say what they think each powder is. If children disagree, as is likely, let them propose tests to compare their results, or suggest that they repeat their tests while the other children watch and discuss where the tests seem to differ. Differences of opinion stimulate discussion and should be elicited wherever possible.

Activity 2

Invite the children to investigate the effect of water on the powders. *Blind child will investigate by feeling and by listening to light sensor.* Can they identify any evidence of interaction? Let the children use five empty medicine cups for a small sample of

each of the mystery powders from their filled medicine cups. Suggest that the children add several drops of water to each sample.

Ask the children to observe what happens to each powder when they put a few drops of water on it. Let the children describe whether each powder mixes with the water, and whether any of the powders disappear.

Lead the children to investigate the effect on dissolving of adding different amounts of powder to the same amount of water. Have them report their findings. *Show the deaf child the process if he needs help.*

Let the children explore. Discuss their observations, then invite the children to predict what will happen if they add 20 drops of water, then if they add 50 drops, then if they add 80 drops of water to the same amount of powder. Let them discuss whether additional water affects the powders, and if so, how.

Have them record observations.

The children will discover that sugar, baking soda, and salt are soluble in water.

Let the children leave the medicine cups holding the powder and water mixtures on a windowsill or table overnight, then ask them to examine the cups in the morning and to report whether anything has changed. (Plaster of Paris will harden if permitted to stand for a short time.)

Ask the children whether they can find the powders they let stand overnight in water. Invite the children to describe the ways in which some of the powders have changed. Ask other children to compare each powder after mixing with water with a sample from their shoe boxes. Try to have the children discuss what happened to the powders in terms of what they know about evaporation and solubility. Suggest that the children compare the textures of the powders. (Some are harsh to feel, others are smooth and silky.) If some child mentions that some powders make more dust than others, suggest that the children rub some of each powder on the black construction paper and see how much remains when the child blows the loose powder away. Let the children record the "powderiness" of each sample.

ADAPTATIONS

Adapted Materials for the Blind Child

4 clear plastic cups labeled in braille 1, 2, 3, 4 (omit sugar as an unknown at the beginning); 4 braille labeled plastic spoons for each cup: 1, 2, 3, 4; 1 adapted tray; 1 regular rimmed tray 9" × 12"; 1 brailler and paper; 1 mortar and pestle (optional).

Adapted Procedure for the Blind Child

Follow regular procedure with the following adaptations: Tray set-up: large compartment—4 cups with powders, small compartments—4 spoons.

Place one spoon of each powder into appropriate compartment: powder 1 into compartment 1, powder 2 into compartment 2, powder 3 into compartment 3, powder 4 into compartment 4. Have visually impaired child record at least three properties of

ADAPTATIONS
Adapted Procedure for the
Blind Child—continued

each powder using a brailler. Encourage the child to feel, rub, and grind the powders (use a mortar and pestle). Once the children have identified the powders, label the cups by name (keep the number on each cup in addition to the name, for organizational purposes).

Activity 2

Adapted tray set-up: large compartment—light sensor, small compartments labeled and numbered empty cups and spoons; regular 9" × 12" tray; 4 labeled and numbered cups with powders; 1 adapted syringe; 1 container with water (pint size). Have the visually impaired child transfer two spoonfuls of each powder from the rimmed tray into the appropriate labeled cup on the adapted tray. Instruct the child to fill cup 1 on the adapted tray with 100 cc (10 syringesful) of water. This should fill the cup half way or above. The child should stir the mixture with the spoon provided. Encourage the child to observe mixture 1, tactilely and with the light sensor (see Figures 3.15 and 3.16). Have the child record all observations using a brailler. The child should repeat the same procedure using powders 2, 3, 4. If new powders are introduced at a later time, have the cups labeled 1, 2, 3, 4 as before. This will avoid any unwanted mixing of powders caused by inadvertent misplacing of cup in the adapted tray compartments.

Suggested Adaptations
for the Deaf Child

Language cards: Properties, Baking soda, Starch, Salt, Plaster of Paris, Sugar, Physical properties, Taste, Alike, Different, Same, Smooth, Slippery. (Children will suggest others.)

COMMENTS

When the children make a paste with plaster of Paris, they will find that after about 15 minutes it hardens and "gets like a rock." Some children may discover that some heat is generated in the setting process. Students may also notice that other powders harden too, although not as quickly or in the same way. If hardened starch or salt is broken up into powder and mixed with water, it will harden again; plaster of Paris can become hard only once. Children will like mixing the powders with water. They will describe interactions like bubbling, dissolving, and becoming soupy, sticky, or hard. They may describe the solubility of plaster of Paris or starch as "it just stays there," or "it makes the water cloudy," or "you mix it and you mix it and it goes to the bottom." Give the children time to explore with the powders. They need time to make mistakes, to try something over and over, and time just to think. They cannot help learning something about texture, odor, and appearance during such undirected work. Have the children keep notebooks to help them remember what they find out. Help them design charts on which to record the results of their experiments.

WHAT ARE THE MYSTERY POWDERS?
(Chemical Properties)

MATCH BOX

Suggested Art Match:
Bubbles and Balloons
p. 325

Figure 2.21. Blind child tests a mystery powder.

EXPLORATION	To test with heat, iodine, and vinegar, and to test mixtures. To observe reactions of salt, starch, plaster of Paris, baking soda, and sugar with heat, iodine, and vinegar.
SCIENCE CONCEPTS	Chemical properties are those that can be observed only when the substance undergoes a change in composition.

MATERIALS

For each child

1 dropper bottle of iodine
1 dropper bottle of vinegar
5 pieces of aluminum foil, 6″ square
10 paper medicine cups, 30 cc
toothpicks for mixing

For the class

4 containers (for mystery liquids)
red food coloring
1 ounce tincture of iodine (Caution)
2 small cans of Sterno
6 wooden clothespins
newspapers, sponges, broom
aluminum foil
extra medicine cups, 30 cc

ADVANCE PREPARATION Remove combustible litter from the area where the candle or Sterno is to be used. Set the heat sources (hot plate, candles, or cans of Sterno) on a piece of asbestos board or foil-wrapped cardboard. Let only a small number of children heat the powders at the same time (see Comments). There should always be

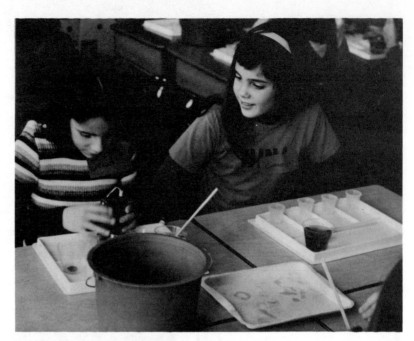

Figure 2.22. Sighted child observes blind child using the light sensor to identify reactions of mystery powders.

ADVANCE PREPARATION—
continued

a teacher or assistant present. Dilute the iodine by mixing it with two quarts of water. Do not let the children handle the supply bottle, because iodine is poisonous. Fill sufficient dropper bottles with iodine solution and with vinegar. Distribute the new materials, including additional newspapers to cover the children's desks. Have the children bring out their supplies from the earlier lesson. Replenish powders where necessary.

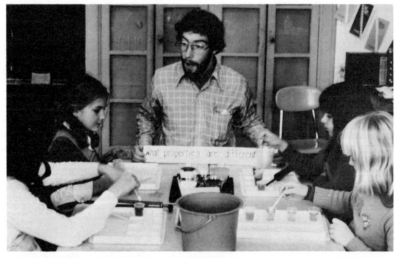

Figure 2.23. Deaf children in a mainstream environment testing mystery powders.

PROCEDURE
Activity 1—Heat Test

Solicit ideas from the children of what other kinds of experiments they could do to identify the mystery powders. Lead

them to suggest that they will conduct tests using heat, iodine, and vinegar to make more decisive identifications of the powders.

Show the children how to make a little cup from aluminum foil, then show them how to hold the cup over the heat source by using a wooden spring clothespin as a handle for the cup. Caution the children to tie back their long hair and to roll up loose sleeves while working with the heat source.

Explain to the children that they should heat only a small amount of powder and that the powder should always be dry to prevent spattering. Demonstrate by heating one sample for several minutes, or until no more changes occur.

Encourage the children to record their findings on a sheet of paper that lists the name of the powder and describes what happens when a small sample of each powder is heated.

Ask the children whether any of the powders changed when heated. (Baking soda and plaster of Paris seem to remain unchanged, but salt snaps and crackles. Starch turns brown. Sugar melts, bubbles, smokes, turns brown, burns black, and finally hardens.)

Ask the children whether any of the powders give off an odor when heated. (Starch smells like burnt toast. Sugar smells like caramel.) *Encourage the blind child to report observations that he discussed with sighted partner.* Ask the children whether all the powders look the same when they cool as before they were heated. Let the children compare the heated and cooled samples with the batches in their shoe boxes.

Invite the children to decide whether the heat test seemed to affect one of the powders more than any of the others. Some of the children should mention sugar.

Leave the children to express the discovery that the heat test is a way to detect sugar.

Ask the children to set up an experiment to identify sugar in a mixture of the mystery powders; because it is the only Mystery Powder to melt and turn shiny black when heated, it can be detected as part of the mixture.

Invite several children to describe any new substances that were formed by heating. When someone mentions caramel, demonstrate that it can be made by melting a batch of sugar in a pan. When the sugar becomes brown, pour it into a number of paper cups to harden. Then distribute the candy for a treat.

Activity 2—Iodine Test

Have the children spoon a portion of each powder into the empty clean medicine cups.

Tell the children to add a few drops of iodine to each sample, to use the toothpicks to stir the mixtures, then to observe the interactions. Demonstrate while you explain.

Encourage the children to record their findings on a chart, listing the name of the powder and describing what happens to each powder when interacting with the iodine.

Ask the children if all the powders react with iodine in the same way. (The starch will turn a striking blue or blue-black color when iodine is added. Baking soda is stained orange, and

PROCEDURE
Activity 2—Iodine Test—
continued

plaster of Paris is stained yellow.) Invite the children to consider how iodine can be used to distinguish one powder from another. (The blue-black color of the starch on contact with iodine is the standard test for the presence of starch.)

Ask the children to bring bread, crackers, rice, wheat, and flour samples from home and test them with the iodine. Discuss their observations. The children will discover that the starchier the food, the more obvious and deep the blue color will be. *If the objects are ground up and are put into water, the color change can be detected with the light sensor for the blind child to observe (see Figures 3.15 and 3.16).*

Without the children watching, tint some water to the color of a weak iodine solution, or mask the iodine's true color with ink or some other dye. Place the container among containers of iodine solution and of vinegar. Then ask the children whether they can pick out the iodine solution from other solutions that look the same.

Wait until several children test their powders with each of the solutions and discover that one of the solutions turns their starch sample black. Elicit the statement that starch can be used to detect which of several liquids is iodine solution, just as iodine is a decisive test for detecting even small amounts of starch.

Invite the children to test other substances at home with their iodine solutions. Remind them not to taste any of the substances afterwards. Suggest they test powdered milk, lettuce, potato chips, and powdered sugar. *Put these into the solution for testing by the blind child.* (Iodine turns powdered sugar black, since about three percent starch is commercially added to the sugar to prevent caking.)

Let the children discuss what they find out when the iodine does *not* produce the blue-black color on the substance being tested. (Starch is probably *not* present.)

Activity 3—Vinegar Test

Have the children spoon a portion of each powder into five clean medicine cups and add a few drops of vinegar to each sample.

Have them prepare a chart reporting their observations. They can list the name of the powder, and describe what happens to each powder with vinegar.

Ask the children what happened with each powder, and whether any powder reacted more than the others. (Vinegar makes baking soda fizz actively, while other powders fizz only slightly or not at all.)

Invite the children to predict whether powders that dissolved in water will also dissolve in vinegar. Let them test their predictions and report the results.

Invite the children to predict which powder will need the least and which powder will need the most vinegar to dissolve. Let them test their predictions and describe their tests and results.

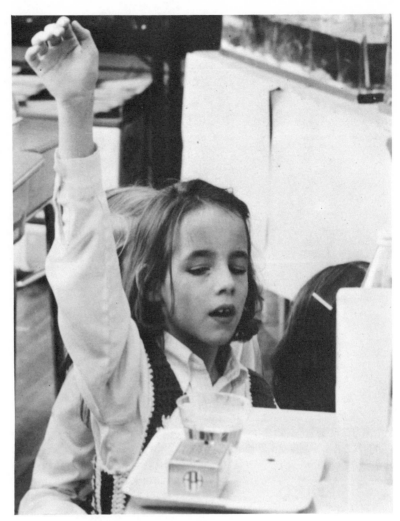

Figure 2.24. Blind child reports discovery.

Have the children set up an experiment to show how vinegar can be used to distinguish baking soda from the other mystery powders.

Ask the children whether they could be sure that an unknown substance that bubbled when vinegar was placed on it was baking soda. (Fizzing does not necessarily indicate that the powder is baking soda, but if any powder does *not* fizz with vinegar it probably is not, or does not contain, baking soda.)

Ask the children to comment on how this test for baking soda compares with the test for starch.

Let the children test other powders with vinegar. (Baking powder fizzes when either vinegar or water is added, and a solution of powdered milk is curdled by vinegar.)

Activity 4—Mystery Powders

Supply each team with an unlabeled powder from one of the five numbered supply pails.

Invite the children to identify the powder.

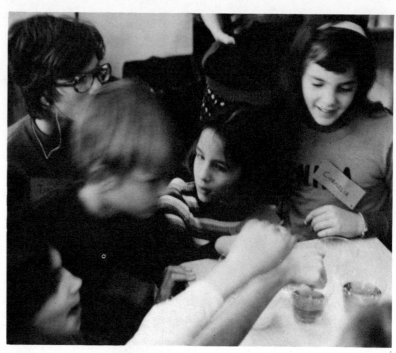

Figure 2.25. *Blind child listens to and deaf child observes chemical reaction during group discussion.*

PROCEDURE
Activity 4—Mystery Powders—
continued

When the children report their identifications, ask them what characteristics of the powder and the testing solution helped them identify the sample.

Repeat this experiment with each of the other powders, and let the children report their results.

Fill four separate containers, one with iodine, one with vinegar, and two with water. Disguise the liquids by adding a few drops of red food coloring. Do not let the children smell the liquids. Ask the children to use the five powders to identify the liquids.

Provide some mixtures in clean medicine cups when the children are not watching. Mix equal parts of baking soda and sugar in one cup, baking soda and starch in another, baking soda and plaster of Paris in a third, and sugar and starch in a fourth. Stir the mixtures well, and distribute them.

Invite the children to use the heat, iodine, and vinegar tests to determine the compositions of the mixtures. Encourage the children to prepare one chart for each powder mixture. Suggest that they write the number of the powder, then describe what they did with the powder and what happened. Let them add two other columns, one headed "Powders the mixture probably does *not* contain," and the other headed "Powders the mixture probably *does* contain."

Indicate how the children are to fill out the charts by saying things such as: "If heat makes the mixture melt and blacken, the presence of sugar is indicated," and "If nothing happens with vinegar, there probably is no baking soda."

Invite them to consider an unknown powder that bubbles when tested with vinegar. Ask them whether they can be sure of the powder's identity.

Invite them to consider an unknown powder that dissolves in water. Ask them whether they can identify the powder or whether they will need additional tests. Ask them whether they can be sure what the powder is *not* if it dissolves in water.

Let the children understand that all substances have properties that distinguish them from other substances, and that the more properties of a substance that are known, the better are the chances for identifying the substance.

ADAPTATIONS

Adapted Materials for the Blind Child

For those children with minimal sight only: 6″ aluminum pie plate or tart tin, 1 pair of tongs. For other visually impaired children: Regular 9″ × 12″ tray; adapted tray; two sets of 4 clear empty plastic cups, labeled with a mystery powder name and a number from 1–4; iodine (dilute) in an eyedropper bottle; 1 container with water (pint size); 1 adapted syringe; 4 spoons, braille labeled by number 1–4; 4 cups each containing a mystery powder labeled by powder name and a matching number corresponding to the clear plastic cups; 1 light sensor; 1 medicine bottle of vinegar.

Adapted Procedure for the Blind Child

Activity 1—Heat Test

For the heating of the powders, the child with minimal sight is capable of carrying out the procedures as described. A 6″ aluminum pie plate or tart tin is recommended in place of the aluminum foil for stability. Tongs should be used instead of the clothespins for an extra margin of safety. The totally blind child should be encouraged to work with the vinegar or iodine while the rest of the students are doing heat tests. Have a sighted partner show the heat tested powders to the totally blind child after each has cooled a bit. One method to avoid alienation of the totally blind child during this lesson is to have half of the class doing the heat test while the rest are working with the vinegar or iodine.

Activity 2—Iodine Test

Adapted tray set-up—small compartments: 4 empty labeled (by name and number) clear plastic cups with numbered plastic spoons, large compartment: light sensor. Regular tray set-up—4 cups each containing a different powder labeled with name and number, 1 container with water (pint size), 1 adapted syringe, 1 eyedropper, braille labeled bottle of iodine or starch indicator. Have visually impaired child add 100 cc (measured with syringe) of water to each of the empty cups on the adapted tray. Water level should be one-half to three-quarters of a cup.

Have the child position the light sensor in front of cup 1 and turn on the switch. Have the child add an eyedropperful of io-

dine to the cup. The tone of the light sensor will go down, indicating a color change if there is one. Any observations should be recorded on the brailler. One eyedropperful of iodine may be added to cups 2, 3, and 4, which contain water. (These should give the same sound as cup 1.) After recording observations, instruct the child to position the light sensor in front of cup 1 on the adapted tray. Have the child add one spoonful of powder 1 to the cup on the adapted tray. Encourage the child to stir the mixture after a few moments and record any observations with the light sensor. (The tone will go down if color becomes more intense.) Cups 2, 3, and 4 may be tested with the iodine in the same manner as with cup 1. Make sure that the child positions the light sensor in front of each cup before the iodine is added. Have the child record his observations using the brailler. When the children bring bread, flour, or crackers from home, grind them up and put into water. Stir the mixture thoroughly. This will enable the blind child to test for starch with the light sensor.

Activity 3—Vinegar Test

Have the visually impaired child rinse the four clear cups on the adapted tray, then refill them with 100 cc of water (10 syringesful). The adapted syringe has notches on the plunger piece. The visually impaired child, using his finger or listening to the clicks, counts each notch as it disappears into the tube of the syringe when the plunger is depressed. One spoonful of each powder should be added to the proper cup on the adapted tray. Taking the vinegar bottle, the child should squirt two eyedroppersful of the vinegar into each cup, and observe what happens. Encourage the child to listen for any evidence of bubbles or fizzing.

Suggested Adaptations for the Deaf Child

Language cards: Iodine, Vinegar, Mystery powders, Chemical reaction, Chemical properties.

COMMENTS

Be sure that the children never test a powder over heat if the powder has been mixed with a liquid. Let some children go on to other activities when the small groups of children are conducting the heat tests. Children find it difficult to understand that a negative test result lets them eliminate a substance from consideration. Therefore, use such tests wherever possible. The mixing sticks may contaminate the powders so that a baking soda sample, for instance, turns black in the presence of iodine. Let the children repeat the test and try to discover the reason for their inconsistent result. Try not to call your student's identifications of the powder mixtures right or wrong. Let their identifications rest solely upon the results of their tests, not upon your declaration. It is important for the children to experiment and observe, and to draw conclusions based upon their data.

BALLOONS AND GASES

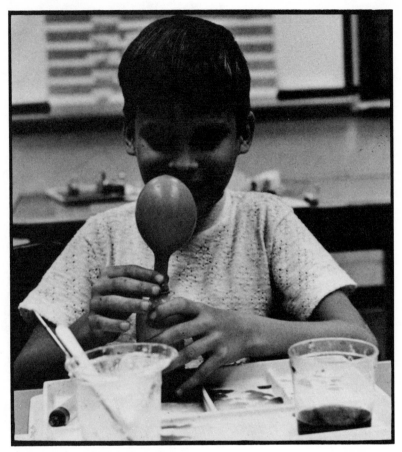

Figure 2.26. Blind child collecting carbon dioxide.

EXPLORATION

To observe properties of acids and bases, to collect and test carbon dioxide. To test methods that distinguish between fluids that look alike. To identify gases by reaction with limewater or bromthymol blue (btb).

SCIENCE CONCEPTS

Acids react with bicarbonates to form a salt, water, and carbon dioxide. Properties of acids and bases (acids turn btb yellow—bases turn btb blue). Air is made up of several different kinds of gases. Gases can be identified by their chemical properties. When chemicals combine, evidence of interaction can be observed.

MATERIALS

For each child

3 one-ounce plastic graduated medicine cups
3 two-ounce plastic graduated medicine cups
2 eyedroppers
1 flexible plastic vial 6″ × 1″

For each group of 4

1 two-ounce plastic squeeze bottle btb
1 four-ounce plastic squeeze bottle vinegar
1 four-ounce plastic squeeze bottle dilute ammonia

MATERIALS—*continued*

wooden coffee stirrers
3 round balloons, 8″ diameter expanded
1 Erlenmeyer flask
2 one-hole rubber stoppers
2 stiff plastic tubes, 4″
1 balance

1 two-ounce plastic squeeze bottle limewater
2 measuring spoons, 1/4 tsp
1 eight-ounce jar citric acid crystals, labeled
1 eight-ounce jar baking soda, labeled (sodium bicarbonate $NaHCO_3$)
newspapers, sponges
buckets for water and waste
extra medicine cups
hand pump
1 multi-purpose balance (balance used in SAPA Program)
paper clips

ADVANCE PREPARATION

Prepare the btb solution by putting about 0.2 gm of the powder (size of a pea) into a one-pint narrow-mouth plastic bottle. Fill with clean water, cap it, and shake to dissolve. Pour enough solution into 2-ounce squeeze bottles for your pupils, and label. Prepare the ammonia solution by mixing four parts water and one part household ammonia. Shake well. Pour enough solution into 4-ounce squeeze bottles for your pupils, and label. Prepare limewater solution by placing 1/2 tsp of hydrated lime (calcium hydroxide powder) into an empty clean quart bottle, fill with distilled water, cap the bottle, and shake it for a minute or so. Let the bottle stand undisturbed overnight to precipitate the undissolved lime and insoluble carbonates. Pour off only the clear solution into a clean pint bottle. Pour enough solution into 2-ounce squeeze bottles for your pupils. Label the bottles. Set the bottles aside for later.

Pour citric acid crystals into 8-ounce jars for each group of four children. Pour baking soda into 8-ounce jars for each group of four children. Set the jars aside for the second activity. Assemble and distribute the materials. Have the children place newspapers on their desks. Let them see where the sponges are in case of spills.

PROCEDURE

Activity 1—Btb Solution

Invite the children to see what happens when they place a little ammonia and a little vinegar into the same cup of btb solution. Let them use the eyedroppers, and add the liquids to one another drop by drop.

When some child notes that the btb has turned from blue to orange or yellow after adding the vinegar, ask the child whether he can turn it back to blue again. (The child adds ammonia.) *Have the blind child use the light sensor to observe the color changes.*

Ask the children whether there is a color "between" blue and yellow. (Some children report five shades of green.) Tell the children to empty their cups into the handy waste buckets if they want to start again.

Suggest that the children feel the ammonia solution by taking some on their fingers and rubbing thumb and finger together. Suggest they feel the vinegar the same way. Ask some children to describe the textures. Have the children describe the liquids. Remind children that unless instructed to do so, no one may taste or drink any substance used in the science experiments.

Let some children report their observations about how to turn btb yellow, then how to turn it back to blue again. If the children disagree, invite them to present their evidence, or to go back to their materials and test again. Now ask the children to put about 1/4 tsp of citric acid powder into one of the clean medicine cups. Let them add water and stir. Be sure to demonstrate by showing the activity in order that the deaf child can understand. *Have the blind child help with the demonstration.* Ask the children to describe what happens. They should do so by showing what happened.

Ask for their predictions on what the citric acid solution will do to a btb solution. Let them test and report their observations.

Invite the children to see whether the baking soda will dissolve as the citric acid did. Ask some children to describe what happens when a little soda is dissolved.

Let the children test the baking soda solution on btb, then on citric acid. Ask several children to report their observations. *The blind child will feel and hear the fizz.* When the children discover how to make the baking soda fizz, ask them what would happen if the baking soda and acid mixture were placed in a closed space.

If some children understand that a gas is being generated, ask them to suggest a way to collect the gas. Let them experiment, but do not expect results.

Invite other children to make a layered solution by placing about 1/4 inch of baking soda in the bottom of the 6-inch cylindrical plastic vial. Then suggest that they pour about an inch of btb solution on top of the soda without stirring the mixture. Now let the children add vinegar by trickling it slowly down the side, as gently as possible, until they have added about three inches of vinegar.

Ask the children to describe what happens. (The mixture will layer and give a beautiful slow reaction that is fascinating to watch.) *Blind child can listen to the slow reaction with a stethoscope, which is part of the adapted material at the Lawrence Hall of Science.*

Activity 2—Collecting and Testing Carbon Dioxide

If the children who tried to collect carbon dioxide in the preceding activity succeeded, let them describe what they did and report their observations. (Few children will succeed in the undirected attempt.)

Suggest that the children put a dry mixture of 1/2 tsp each of baking soda and citric acid crystals into an Erlenmeyer flask, add about 2 ounces of water, then quickly put a balloon over the top of the flask. *See modified procedure for blind child.* Use

either method, depending upon the manipulative skills of the child.

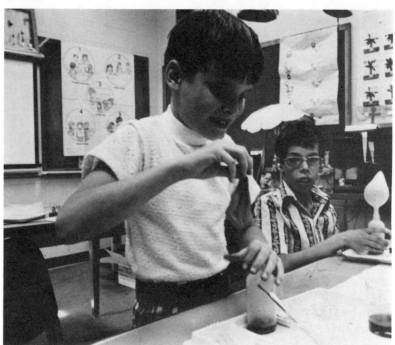

Figure 2.27. Deaf child observing blind child.

Let the children describe what happens to the balloon. (Carbon dioxide collects in the balloon and inflates it.) Challenge the children to discover whether the carbon dioxide balloon is heav-

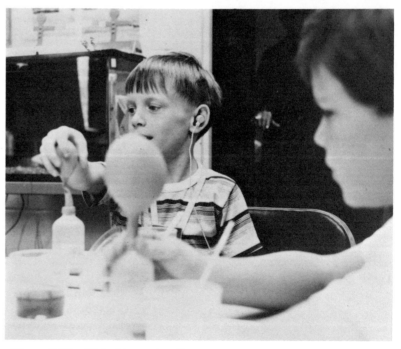

Figure 2.28. "I feel it coming."

ier than an air balloon. Let the children use the hand pump to fill a balloon with room air. *Have a sighted partner help the blind child.*

Let the children become familiar with the balance if they have not already worked with it. Then ask some children to tell you how much heavier which balloon is, using paper clips as units of weight.

Ask the children whether the carbon dioxide balloon is heavier because one balloon is fuller than the other.

Explain to the children that you are now going to perform some chemical tests with the carbon dioxide and that you want to have a collecting device that is more permanent than what they have done with the flask.

Show the children how to connect the stiff plastic tube into the one-hole rubber stoppers, one at each end. Then place an empty balloon on the top of one of the stoppers. The bottom stopper will then fit into the neck of the flask.

Let the children repeat the mixing interaction, collecting a full balloon of gas. When the balloon is full, or when the reaction stops, tell the children to twist the neck of the balloon, and press their fingertip on the top end of the tube (inside the balloon's neck) to prevent the gas from escaping. Then let the children remove the entire collecting device from the flask.

Explain that the children will now test the reaction of the carbon dioxide with btb solution.

Tell the children to pour about 5 cc of btb solution into the bottom of a clean medicine cup. Have them place the bottom end of the collector tube, from which they have removed only the bottom stopper, into the btb. Let the children allow the gas to bubble gently through the btb. Explain that they can control the bubbling by pinching the neck of the balloon. Ask several children what happens to the btb. (If they have collected carbon dioxide in the balloon, the btb will gradually turn from blue to yellow.)

If some children want to repeat the test, suggest that they turn the btb solution back to blue again by adding only a few drops of ammonia.

Invite the children to describe what happens when they bubble air through the btb solution. Urge them to rinse the tube free of acid before trying this test.

Explain that the children will now test the reaction of the carbon dioxide with limewater solution. Distribute the labeled squeeze bottles of limewater to each station.

Tell the children to place about 5 cc of limewater into a clear, clean container and bubble the carbon dioxide through it as they did with the btb solution.

Ask several children to describe what happens. (Carbon dioxide turns limewater milky.) *Blind child uses light sensor.*

Invite the children to discover whether the limewater reaction is reversible, and to compare their results with the btb test (see Figure 3.15).

PROCEDURE
Activity 2—Collecting and Testing Carbon Dioxide— *continued*

Suggest that the children use room air (use pump) or their breath (blow through straw) with the limewater.

Ask them to describe the results. Invite them to try room air and their breaths with the btb test.

Encourage the children to discuss the results of these tests, and to try to say what they have learned about the interaction of carbon dioxide with the various solutions.

ADAPTATIONS

Adapted Materials for the Blind Child

Adapted tray; braille labels 1, 2, 3 for three bottles and eyedroppers (to be refilled); 1 clear plastic cup half filled with water; adapted syringe; 2 small cups with spoons—one with vinegar (or citric acid), and one with baking soda; 1 stirring stick; 1 stethoscope (can be obtained from Lawrence Hall of Science, University of California at Berkeley) (optional).

Adapted Procedure for the Blind Child

Activity 1

Supply the visually impaired child with his own bottles of btb, ammonia, and vinegar. Label the bottles 1, 2, 3, and set them in small compartments 1, 2, 3 of the adapted tray. The three eyedroppers used should be marked 1, 2, 3 and placed in the proper compartment. One clear plastic cup half filled with water should be placed in the fourth compartment for mixing various liquids. The light sensor is placed in the large compartment in front of the fourth compartment. Have the visually impaired child mix 5 eyedroppersful of btb with the water and record, using a brailler, the observations. Remind the child not to place fingers or hand in or on the back of the cup with water because doing so will change the pitch of the sound produced by the light sensor. Allow the child to explore what happens to the pitch of the light sensor when a few drops of vinegar and a few drops of ammonia are added to the btb and water. The child may want to stir the mixture once he discovers that a color change is occurring. A popsicle stick or plastic spoon may be used. Make sure that the lower tone produced when the stick or spoon is added is not confused with the color change. Encourage the child to record all activities. Should the child want to test other substances, first mix them with water in a bottle and replace them for the vinegar and ammonia bottles. It is advisable to also replace the eyedroppers and to use clear plastic cups and water with new materials so that the new mixtures are not contaminated. Team up a visually impaired child with a sighted peer and have him participate in the making of a layered mixture. Once it is made, the visually impaired child should be able to locate the layer of baking soda and the bubbles given off as the baking soda and vinegar interact.

Activity 2

Provide the visually impaired child with an adapted tray. On it, have a small funnel (4″ diameter), a stirring stick, a balloon, an 8-ounce bottle (or Erlenmeyer flask), a small cup with baking soda, a small cup with citric acid (or vinegar), a cup of water, and an adapted syringe. Have the visually impaired child place the funnel in the mouth of the bottle or flask. Tell the child

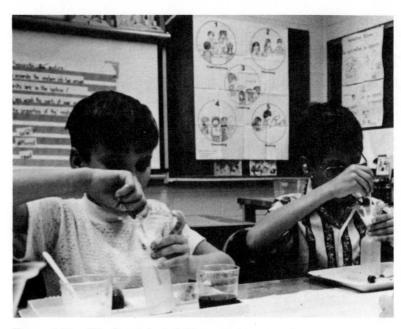

Figure 2.29. Blind and deaf children working together.

to take a spoonful of baking soda and pour it into the funnel. The child should then push the baking soda into the bottle with the stirring stick. Repeat the process adding a spoonful of citric acid to the bottle containing baking soda. Instruct the child to fill the balloon with three syringesful of water. The balloon should be lipped over the bottle, and care should be taken not to spill any water into the bottle. Slowly lift the balloon bottom up. Make sure that the mouth of the balloon is held securely over the top of the bottle. The balloon will inflate as the carbon dioxide gas is liberated in the reaction of baking soda and citric acid. Provide another clear plastic cup half filled with water, a btb bottle, syringe, and a light sensor. The visually impaired child should add three eyedroppersful of btb to the cup of water. He should have the light sensor directed toward the cup to detect any color change. After another balloonful of carbon dioxide has been collected, the visually impaired child can immerse the mouth of the balloon in the water and slowly release the gas. Encourage the visually impaired child to release the gas a little bit at a time and check to see if any color change has occurred. The child's hands and the balloon must be removed from the btb and water to observe any concrete change in color. Repeat the same procedure using limewater instead of btb and water.

Suggested Adaptations for the Deaf Child

Language cards: One-hole rubber stopper, Erlenmeyer flask, Gas, Btb, Baking soda, Turns yellow, Turns blue, Gets milky, Carbon dioxide, Limewater, Citric acid crystals, Ammonia, Bubbles, Fizz, Heavier, Lighter, What will happen if . . .

COMMENTS

This experiment opens up many opportunities for experimental design. It has been successful with fourth and fifth grade levels

COMMENTS—*continued*

with mixed populations that include blind, deaf, and disturbed children. However, it has also proved to be an exciting experience for first and second grade mixed groups in our program.

REFERENCE

See film: *Laboratory Science and Art for the Blind,* The American University.

INTERACTION

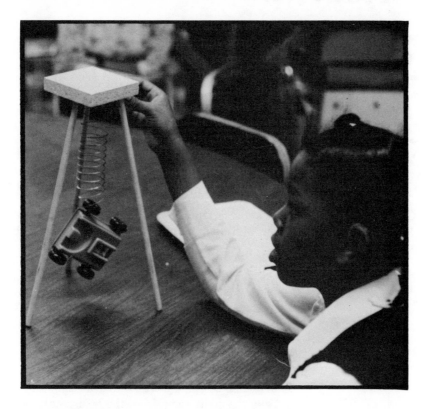

Objects Interact—
Evidence of Interaction

Organisms Interact
with Their Environment

Life Cycles

EVIDENCE OF INTERACTION— ENERGY TRANSFER

MATCH BOX
Suggested Art Match: Interaction Games p. 320 Candle Making p. 343

EXPLORATION

To explore the transfer of energy from a heat source to a bimetallic strip. To construct an experiment to show evidence of interaction between a bimetallic strip and a heat source.

SCIENCE CONCEPTS

Bimetallic strips bend when thermal energy is transferred to them. Metals expand at different rates when heated.

MATERIALS

For each child

1 bimetallic strip in holder (can be obtained from science supply houses)
1 cup hot water
1 cup cold water

PROCEDURE

The bimetallic strip is brought into contact with the heat source (radiator, hot water, etc.) and soon begins to bend. The bending is evidence of energy transfer from the heat source to the strip.

Take the strip away from the heat source, and it will straighten out again.

The strip is made of two different metals sandwiched together. When heated, one expands faster than the other. It is this expansion that causes the bending. You could bring to the attention of the children that the adapted thermometer they have used is made of a coiled bimetallic strip instead of a liquid to indicate temperature. Experience with the strip is valuable for the entire class (see Figure 3.14).

ADAPTATIONS

Adapted Materials for the Blind Child

Put all materials on an adapted tray.

Sugested Adaptations for the Deaf Child

Language cards: Bimetallic strip, Heat source, Bending, Energy transfer, Evidence of interaction, Metal expands. Posters showing heat sources and the evidence of interaction between a heat source and a metal.

COMMENTS

In some lessons concerned with heat energy transfer, the children work with color cards. However, seriously visually impaired pupils would get nothing out of the work unless the colors permit the use of the light sensor. Therefore, for them, we have substituted a bimetallic strip that bends when thermal energy is transferred to it (this can be purchased from Activity Corner, Lawrence Hall of Science, University of California at Berkeley).

"INVENTING" THE SYSTEMS CONCEPT
(A Brief 10–15 Minute Lesson)

```
┌─────────────────────────────────┐
│        MATCH BOX                │
├─────────────────────────────────┤
│ Suggested Art Match:            │
│ Making Puzzles p. 340           │
│ The Printing Process p. 323     │
└─────────────────────────────────┘
```

EXPLORATION

To identify a system. To group objects into a system of interacting objects.

SCIENCE CONCEPTS

A system is a group of related objects that form a whole. A system maintains its identity as long as no new matter is added and none of the original matter is excluded.

MATERIALS

For each child

1 each battery, motor, light bulb, and aluminum wire
1 large magnet
1 colored candy ball
1 spring (Slinky)
1 clear tumbler to be filled with water
1 pair of blunt small scissors
pencil
paper clips

PROCEDURE

Have the children explore the following activities (*the deaf child can watch for clues from his hearing partners of the group*) however the materials suggest activities to the child: (1) pick up the paper clips with the large magnet, (2) hang the scissors at the end of the spring, with the pencil through the loop at the top of the spring, (3) light the bulb with wire and battery, (4) make the motor run with wire and battery, and (5) dissolve the colored candy ball in water. Assist any of the children who have trouble with any of the equipment.

With each activity ask the children to name the particular interacting objects involved.

Write the names of these objects on the blackboard. Have the children record the names of these objects in a group on an experiment recording sheet. *The blind child records with brailler.*

Make sure that the actual number of similar objects is mentioned (such as "five paper clips"), not just a general term (such as "paper clips").

Have the deaf child put language cards in groups that describe the interacting objects.

You may choose to have all the children make groups of language cards since they all enjoy the process.

ADAPTATIONS

Adapted Materials for the Blind Child

In addition to regular activity: adapted tray with compartments, paper towel.

Adapted Procedure for the Blind Child

Provide nonvisual ways for identifying and describing a system and the changes that take place, such as having the child feel the objects. By doing so, the visually impaired child can identify the system. Let the visually impaired pupil feel the spring, the scissors, and the pencil through the ring in the top of the spring (the spring is suspended from the pencil). Feeling the pull on the ring and the stretching of the spring will provide a helpful experience. In addition to the light bulb use the motor with the battery. The candy ball and water activity can be used by giving the visually impaired child the opportunity to feel the water.

Suggested Adaptations for the Deaf Child

Make language cards that describe the interacting objects used in the experiment.

COMMENTS

The sighted children work with the visually impaired, the deaf work with the hearing discussing the systems concept. They all benefit from the experience.

EXPLORING PULLEYS

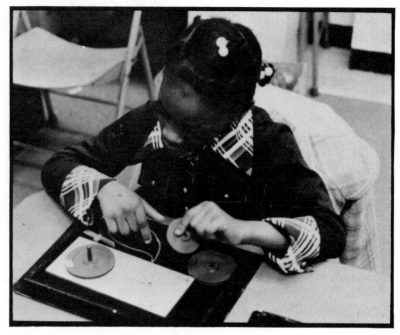

Figure 2.31. Assembling a pulley.

EXPLORATION

To apply the systems concept. To assemble and to operate systems of interacting pulleys, and to construct many different systems.

SCIENCE CONCEPTS

Pulley systems can transmit motion and energy. A system refers to a group of related objects, and does something that the separate parts cannot do. When a rope or belt links pulleys of different diameters, the smaller pulley turns faster than the larger one.

MATERIALS

For each group of four

4 pulley sets consisting of: 2 each large, medium, small pulleys
1 rubber band
2 shafts
1 propeller
1 handle

For the class

1 pulley set and tray
1 opaque cover

ADVANCE PREPARATION

Place pulleys of different sizes on the base. Insert the shafts. Stretch the rubber band around the pulleys. Close the opaque cover. Place the propeller on the shaft with the smaller pulley and the handle on the shaft with the larger pulley (the propeller will then turn faster than the handle). Distribute the trays and pulley sets to each station.

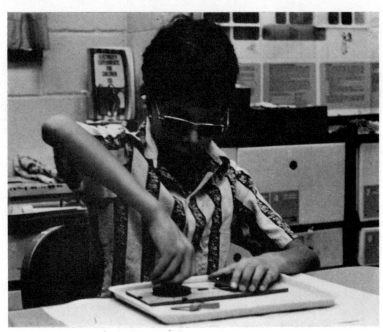

Figure 2.32. Operating the pulley.

PROCEDURE

Have the blind and deaf children assist with the introduction. Let them hold up a covered pulley system and turn the handle so that the class can observe the movement of the propeller. Ask the children if they think that the handle and the propeller are interacting.

Discuss with them what kind of objects they think might be under the cover.

Ask how they could find out what is under the cover other than by taking the cover off the covered pulley system. Give them the challenge of solving the mystery by doing experiments with their materials.

After a period of experimenting, ask if they found the solution.

Encourage the children to assemble several different pulley systems and to compare their operations.

Lead them to discover that the pulley, which is a flat rimmed wheel, is used with a rope or belt to transport motion and energy to another pulley.

Suggest, if they have not done so, to set up a series of experiments where the belt links different size pulleys. Ask the children if they can set up their pulley system to show how a pulley joined by a belt can be used to produce speed changes in machinery.

Invite the child to tell you which objects on the tray are in the system you displayed initially.

Suggest to the children to find some way to make the pulleys, shafts, propeller, and handle interact so that only the handle needs to be moved.

ADAPTATIONS

Adapted Materials
for the Blind Child

1 adapted pulley set consisting of: a normal pulley set with an adapted base, 1 brailler and paper.

Adapted Procedure
for the Blind Child

The adapted pulley set used by the visually impaired child includes simply a base pulley of three different sizes and one rubber band. The teacher should adapt an existing pulley base for each visually impaired child. A raised dot or dried drop of Elmer's glue should be placed at quarter turn intervals at the edges of the printed scales on the pulley base. This allows the child reference points for the turning rates of the propeller and/or handle. The work with pulley systems is about the same for the visually impaired and the sighted child. Using the adapted pulley system, the visually impaired child can keep track of the turning rates. The members of the group help with the manipulated problems, if any, in setting up the pulley system. The visually impaired child can participate in the covered pulley system activity. Let him hold and operate the system himself.

Suggested Adaptations
for the Deaf Child

Language cards: Pulley, System, Energy, Handle, Propeller, and Belt. What objects are interacting? What objects are in our system? How can a pulley be used to produce speed change in a bicycle?

COMMENTS

This activity gives the child, and especially the handicapped child, a very concrete situation in which to apply the systems concept. Since the objects are easily interchangeable, many different systems can be explored and observed.

COMPARING PULLEY SYSTEMS

MATCH BOX

Suggested Art Match:
Stitchery Pulleys p. 327

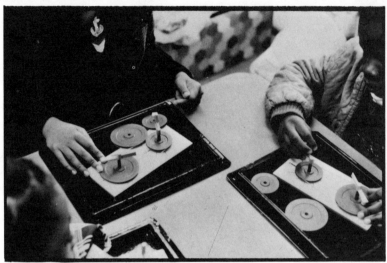

Figure 2.33. A pulley system.

EXPLORATION

To analyze the action of the handle and propeller on a pulley system. To construct different pulley systems for comparison of turning rates. To predict the relative turning rates of interacting pulleys.

SCIENCE CONCEPTS

The rate at which handles and propellers attached to shafts in a pulley system turn depends upon the relative sizes of the pulleys.

MATERIALS

For each group of four	For the class
4 pulley sets	2 pulley systems with opaque covers
4 cardboard trays	string, elastic ribbons, cloth ribbons

ADVANCE PREPARATION

Assemble two pulley systems. Use two equal pulleys for one system, and a large and a medium pulley for the other. Use a rubber band in standard fashion for one system; twist a piece of string into a figure eight and tie it off so that the pulleys turn in opposite directions from each other. Distribute the trays and pulley sets to each station.

PROCEDURE

Have blind and deaf children assist in demonstration.

Invite the children to observe the two covered pulley systems while you turn the handles to make the propellers rotate. Ask some child to name the interacting objects he can see or can guess are parts of the system.

Let other children give the names of other objects. Ask them how they know about the objects they cannot see. Invite them

to explain how the handle interacts with the propeller. Draw attention to whether the two are turning at the same rate and in the same direction, as well as turning at the same time.

Focus their attention on the connection (unseen) between the two pulleys.

If a child says it is a rubber band, ask for his reason. Ask for ideas about other ways of connecting the pulleys.

Bring out the string, elastic ribbons, and cloth ribbons, and invite the children to use these in their experiments. Leave your covered pulley systems in an accessible place.

Invite the children to experiment with their pulley sets. Ask the children to do experiments that might show what arrangement lies under the covered systems.

Ask them to perform experiments that tell them about the sizes of the pulleys in each system, and whether the propeller in each system is turning faster or slower than the handle.

Try to elicit the idea that the turning rates depend in some way upon the relative sizes of the pulleys.

When several children have constructed pulley systems, ask them to explain by showing the interactions that occur.

Ask the children to compare the changes they observe in the covered systems with the systems they have constructed and to decide whether their systems are identical with yours.

Ask the children to set up an experiment to make the propeller turn much faster than the handle.

Get additional pulley bases for the children to work with in further exploration. Have them explore their ideas on how the bases can be placed together and connected.

ADAPTATIONS

Adapted Materials for the Blind Child

1 adapted pulley, 1 brailler and paper.

Suggested Adaptations for the Deaf Child

Language cards: Pulley, System, Energy, Handle, Propeller, Belt. What are the interacting objects? How can you connect the pulleys?

COMMENTS

The children will offer many ideas that they should be permitted to explore.

SOLUTIONS AND MIXTURES

```
┌─────────────────────────────────┐
│  MATCH BOX                      │
├─────────────────────────────────┤
│  Suggested Art Match:           │
│  Mixing Your Own Dyes for       │
│  Tie Dying p. 345               │
└─────────────────────────────────┘
```

EXPLORATION

To make a salt solution and a sand/water mixture.

SCIENCE CONCEPT

A solution is a system consisting of a homogeneous mixture of two or more substances. Salt dissolved in water is a system that is actually a mixture of substances. These substances can be separated by evaporation. Reappearance of solid salt is evidence of the conservation of substances during the solution process. The sand/water is a system that, unlike solutions, is a heterogeneous mixture of two physically distinct portions that can be separated by filtration.

MATERIALS

For each child

small container of salt (NaCl)
small container of sand
2 plastic tumblers
2 shallow dishes or lids

2 plastic teaspoons
tray, 9″ × 12″
paper towel
pitcher of water
brailler and paper (for blind child)

PROCEDURE

Children mix sand with water and salt with water, observe, and describe evidence of interaction in each case. You or the children design an evaporation experiment to obtain salt crystals from the one solution.

Distribute the small containers of sand and salt to each visually impaired child. Ask them to feel each substance and to describe any similarities and differences they find.

Many similarities and few differences will be identified at this time. Some children may feel that the two substances are the same. Ask what they think might happen if one mixed each of the substances with water. After briefly discussing the question, encourage the children to carry out this experiment.

Distribute two cups, each a little more than half full of water. Ask each child to mix most of the material in one container with the water in one cup and most of the material in the other container with the water in the other cup.

They can place the container of material near the cup in which they mixed it so that they know which is mixed in each cup of water. The spoons should be used to stir the liquids, and the children should be asked to find any evidence of interaction in each case and any evidence of differences between the results of the two mixing experiments.

With the spoon or with their fingers the children will observe that while one material (the salt) seems to "dissolve away" or "disappear," forming a single liquid, the other material (the sand) goes to the bottom and can be felt there with the spoon or their fingers.

Identify the one that seems to disappear (dissolve) as salt and the other as sand.

Discuss evidence of interaction with the children, including ideas such as "the sand is wet," "the salt is gone," "the spoon is wet," "the water moved around," "the liquid spilled," etc. In each case, ask them to identify the system throughout their description.

The Evaporation Experiments: At this point, raise the question of where the salt went and how one could get it back. Alternatively, you can simply ask what would happen if you allowed some of the liquid from each cup to evaporate. Would anything be left when each of the liquids dried up? Either way, the children should set up such experiments by spooning or pouring (with your help, if necessary) some of each liquid into a separate empty shallow dish or lid.

Each dish should be labeled in print or braille to indicate the liquid in it.

The dishes should be put aside and the liquids allowed to evaporate.

The salt solution will leave an obvious residue of salt while the water from the sand/water mixture will leave little or no residue.

Discuss these results, mentioning evidence of interaction and describing the systems involved. The reappearance of the solid salt is evidence of the conservation of substances during the solution process and this idea should be emphasized. Have each child "write up" his own experiments and observations, *the blind children using a brailler.*

ADAPTATIONS

Suggested Adaptations for the Deaf Child

Language cards: Salt solution, Sand/water mixture, Filtration.

"INVENTING" INTERACTION AT A DISTANCE

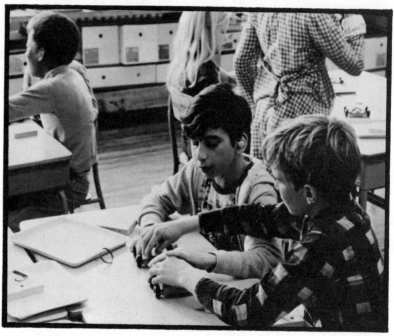

Figure 2.34. Deaf and hearing children working together to get the carts ready.

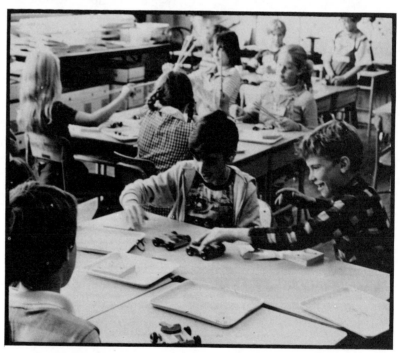

Figure 2.35. "Ready? Here they go!"

EXPLORATION

To identify systems of objects that interact at a distance. To distinguish between objects that do and objects that do not interact at a distance with magnets.

SCIENCE CONCEPTS	Some objects interact without what is commonly called "touching," including familiar interactions such as magnetism, sound transmission, and static electricity.
MATERIALS	For the class

2 large magnets
2 carts
1 large piece of plastic wrap
1 plastic coat hanger
1 wooden rod

thread
cymbals, large drum
pieces of wool, cotton, and synthetic cloth
balloons

ADVANCE PREPARATION

Suspend the hanger from ceiling or any other object as long as it hangs freely. Prepare language cards.

PROCEDURE

Have one blind student, deaf student, and different sighted students assist in the demonstration.

Ask a child to hold one magnet near, but not touching, one cart, and then to keep withdrawing the magnet so that the cart continues to roll toward it.

Ask other children to name the interacting objects and to describe evidence of interaction. Ask one of the children to find a way to hold the magnets face to face so that they repel each other.

Let the child place one magnet on each cart so that the magnets continue to repel each other. Ask the children what will happen if the child moves one cart gently toward the other. If some child guesses that the second cart will roll away from the first without being touched, let the child perform the test. Otherwise ask the first child to do it. Invite other children to try as well.

Let the blind child gently hold the cart to feel the attraction and repulsion.

Do the same with the deaf child and introduce appropriate language cards.

Ask some children to name the interacting objects and to describe their evidence for the interactions.

Evidence of interaction between the magnet and the cart is the magnet remaining firmly on the cart.

Evidence of interaction between the hand and the cart is the motion of the first cart.

Place the carts containing the magnets, still in the repelling position, on a level surface.

Have the blind and the deaf child hold the carts with both hands about an inch apart. Before doing so, ask the children what they think will happen when both carts are released at the same time.

Explain to the children that they have been observing interaction at a distance.

Put interaction language card on board—give brailled cards to blind student.

Point out again the amount of distance between the two repelling carts as an instance of interaction at a distance. Call at-

tention to the children's hands on the carts as two objects that interact only when they are touching with no distance between them.

Suggest "interaction without a distance" as a name for this relationship, or invite the children to name it some other way.

Ask the children to give examples of interacting objects and describe the evidence of interaction for each example. Whenever possible ask them to show or draw these examples. *Continue with blind and deaf assistants to the next demonstration and discussion.*

Display the coat hanger suspended from the stand. Ask one child to blow the hanger while standing a moderate distance away. Ask other children to name the objects interacting without distance (breath and hanger), and also the objects interacting at a distance (mouth and hanger).

Give a child the piece of plastic wrap and ask him to rub it over the entire hanger while holding the hanger steady near the hook.

Give another child a small book and ask him to guess what will happen if the child holds the object half an inch away from the charged coat hanger. If the child does not guess, have him perform the experiment and describe what happens (the hanger will gradually turn toward the book when it is brought quite close).

Ask another child to hold his hand half an inch from the hanger and to report how the hanger is drawn toward the hand. Ask other children to suggest, and test, other objects. In a few minutes the hanger will have discharged gradually because of dust or moisture in the air. When a child notices that the hanger has stopped being attracted, invite him to recharge the hanger.

Let other children continue the tests with other objects they choose, keeping the objects moving ahead of the hanger so that they do not touch.

Suggest that someone show how to make the hanger move in opposite directions.

Ask the children which objects are interacting at a distance (hand or other object, and coat hanger).

Ask them for their evidence (the motion of the hanger when the hand, or other object, is brought near).

Invite some children to rub a second plastic coat hanger, while others rub pieces of wool, cotton, and synthetic cloth. Ask still other children to rub some balloons while others rub paper. Ask each child to experiment with his rubbed object and the first rubbed suspended coat hanger (which functions somewhat like a compass needle). If no child volunteers the comparison, suggest it.

Ask the children to describe the interactions they observed and the evidence of interaction. Ask the children where the experiment involves interaction without distance (the rubbing and the objects) and where it involves interaction at a distance.

Suggest that some children experiment to discover the farthest distance between rubbed objects at which interaction at a distance was still observable.

ADAPTATIONS

Adapted Materials for the Blind Child

This activity does not need adapted materials.

Adapted Procedure for the Blind Child

The demonstration should be done with small groups of six to eight children. While doing the demonstration, let the blind child hold on to the cart lightly while you use the magnet to start it moving. Feeling the cart leave his hand will help him experience the interaction at a distance with the magnet. Conversely, he could handle the magnet and hear the cart start to roll. By assisting during the demonstration with interaction between magnets in the placement of the carts, and again by touching one as it is repelled by the other, the blind child can have experience with the fascinating interaction. Have each child in the class work with two small magnets (ferrite or alnico) for a period of time.

Classification of interaction: This will be meaningful as a discussion for the visually impaired child. Instead of the chart on the board, he can make his own record by collecting systems of objects. Also prepare a braille sheet with two columns headed:

Interaction at a Distance	Not Interaction at a Distance

Each child can list the different examples suggested by the class using a brailler.

The demonstration with the plastic coat hanger will prove valuable for the visually impaired child. The child will need additional preparatory experience feeling the hanger, how it is mounted, and exploring the saran wrap in order to understand the activity. Let the visually impaired child use his hand to attract the hanger. He may want to let it hit his hand. This is easy as long as you describe the idea that before hitting it was interaction at a distance, and at the point of contact it was touching interaction.

Suggested Adaptations for the Deaf Child

See Comments. Language cards: What will happen when two magnets come together? Interaction at a distance, Interaction without a distance. Put labels on all pieces of equipment. Make sure that the deaf child relates to all discussion by seeing and handling the objects discussed. If the objects are not available, suitable visual aids should be provided.

COMMENTS

Leave demonstration objects in an activity station so that the children may experiment with them at unscheduled times. Place language cards with equipment. All the children interact with each other at these activity stations. Everyone benefits by the experience—blind, deaf, and disturbed children, and all others.

INVESTIGATING MAGNETIC FIELDS

MATCH BOX

Suggested Art Match
Expressing Magnetic Lines
of Force p. 331

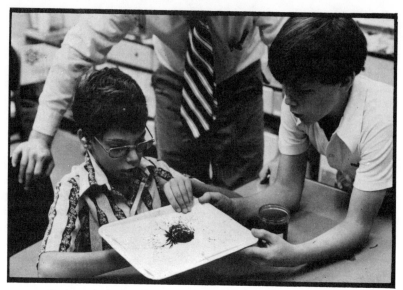

Figure 2.36. Investigating magnetic fields.

EXPLORATION

To use compasses and iron filings to investigate the magnetic fields of various magnets and magnetic systems. To observe and to record the directions of the magnetic field indicated by a compass pointer at various locations around a magnet.

SCIENCE CONCEPTS

A magnetic field is evidence of the property of magnets that they interact without touching. The region surrounding a magnet that is permeated by lines of forces is called the magnetic field.

MATERIALS

For each group of 2 children

1 ferrite magnet
1 alnico magnet
2 compasses
1 plastic dish
1 piece masking tape, 3″

For the class

1 jar iron filings
1 can of spray glue
50 sheets 8 1/2″×11″ paper
newspapers

ADVANCE PREPARATION

Pour enough iron filings into each clean, dry plastic dish to form a ring around the bottom but not to cover it completely. Cut the 8 1/2″×11″ sheets of paper in half to fit the trays. Set the filings and paper aside. Select an area near an open window for the spraying activity. Cover the area with newspapers to protect the table and floor. Observe the precautions on the can's label and do all the spraying yourself. Assemble the materials for distribution.

PROCEDURE

Distribute the half-sheets of paper and the iron filings. Ask the children to place the sheets on their trays and to explore how the magnets interact with the iron filings.

Let them discover that the magnets pick up the filings, that the magnets attract the filings through the material of the trays and dishes, and that it is difficult to completely remove the filings from the magnets. *The blind child feels the attracted filing by placing his hand under the objects holding the filings—use paper as one of the objects, making it easier for the blind child to feel the movement.*

Ask several children what evidence about the magnetic field is provided by the movement of the filings. Encourage them to interpret other findings in terms of the magnetic fields surrounding the magnets.

Show and suggest to the children that they cover a magnet with a tray, then gently sprinkle two or three pinches of iron filings into the general region of the magnetic field. Suggest that they tap the tray lightly and see what happens (the filings may further rearrange themselves into an attractive pattern). *Suggest to the blind child to use stethoscope, listen to the movement of filings, and gently feel the filings.* Invite the children to look closely at the filings oriented around the field. Let them discover that the filings very near the magnet tend to rise vertically. Ask them what evidence that offers about the magnetic field. (It extends above the tray as well as covering the horizontal area in the vicinity of the magnet.)

Suggest that some children may want to compare the patterns of filings produced by the magnetic field of the ferrite magnet when it is lying down and when it stands on edge. Show how it is done.

Invite the children to make different iron filing patterns.

Tell them to bring their trays to the spray area when they make a pattern they especially like. Spray the sheet lightly with glue, and let the children carry the papers to a place where they will dry without being disturbed.

Ask the children to describe the magnetic field revealed by iron filings. *The blind child should be assisted by a sighted partner to keep the filings from falling.*

Accompany every suggestion and invitation to the students by doing the activity to show the procedure clearly. Show and suggest that the students move a compass through a magnetic field in which an iron filing pattern has just been prepared. Invite them to compare the direction of the compass pointer with the direction of the iron filings. Suggest that they tilt the compass a little farther away from the magnet so that the pointer, which interacts very strongly with the magnetic field, does not jam by pressing so hard against the compass bottom.

Give each child a box in which he can "hide" a magnet so that its magnetic field is not noticeable outside. Suggest that they wrap the magnet and stuff the box with any materials they wish. Then let other children test the closed box for evidence of a magnet inside. (This activity highlights the region of space pervaded by the magnetic field.)

ADAPTATIONS

*Adapted Materials
for the Blind Child*

Stethoscope, adapted compass, adapted tray.

*Adapted Procedure
for the Blind Child*

The blind child can feel and hear the alignment of the iron filings with the stethoscope.

*Suggested Adaptations
for the Deaf Child*

Language cards: Magnet, Iron filings, Magnetic field, Lines of force.

ELECTRIC CIRCUITS

MATCH BOX
Suggested Art Match: Making Lanterns p. 337 Electric Circuit Designs p. 339 Moving Machines p. 358

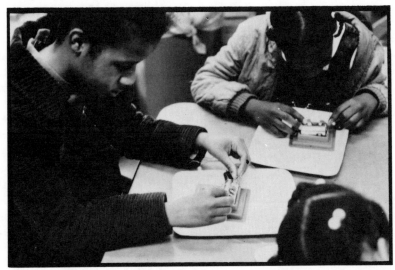

Figure 2.37. Blind children making electric circuits.

EXPLORATION

To investigate the operating circuit elements in various circuits.

SCIENCE CONCEPTS

Electricity is the flow or transfer of energy from one place to to another, e.g., from a battery to a bulb. The effects of electricity can be observed in the lighting of bulbs, the turning of electric motors, and the operation of electromagnets. Electricity goes along both a closed and an open circuit.

MATERIALS

For each child

size D batteries	bulb sockets
battery holders	D.C. motors
flashlight bulbs	4 wires
pieces of Nichrome wire, 4″– 8″	6 clips (Fahnstock) cardboard trays

ADVANCE PREPARATION

Experiment with the circuit equipment in advance to familiarize yourself with equipment. Test the batteries; get new ones if some cannot light a bulb. Distribute the trays of materials for each child.

PROCEDURE

Encourage the children to work with the equipment. If most of the class has difficulty with the Fahnstock clips, show the children how to attach one or more wires to the clip by squeezing the clip, slipping an uninsulated end of the wire under the tongue, and then releasing the clip.

Invite several children who wish to light the bulb or to make the motor work to explain how they intend to connect the wires and battery, then to test their ideas until the bulb lights or the motor runs.

If some children begin by making complicated circuits by using two or three circuit elements at the same time, ask them to try a simpler circuit consisting of only one circuit element in addition to the battery.

Encourage those children who begin with the simple circuits to connect two or three elements into a complicated circuit. Suggest the following circuit to a child who seems uncertain: Connect the battery to the light bulb, the light bulb to the motor, and the motor to the other battery terminal, thus closing the circuit. Turn the motor shaft manually to start it if it does not start when the circuit is closed.

Ask the children to compare the speed of the motor in this circuit with its speed when it is the only element in the circuit (it runs more slowly in the complicated circuit).

A child may point out that the bulb becomes dimmer and cooler as the motor runs.

Invite the idea that diminishing brightness and warmth and slower running motor are evidence of the simultaneous interaction of battery, bulb, and motor.

Explain and demonstrate to the children that their systems of interacting objects with wires and batteries are called "circuits." Write the word on the board, and on cards to be placed on language board.

Have the children make experiment report sheets with headings: Date, System of Interacting Objects, Evidence of Interaction.

Have the children attach paper disks or fans to the motor shaft.

Ask the children to determine whether the motor turns clockwise or counterclockwise. *Have deaf children and blind children demonstrate what is meant by clockwise and counterclockwise.*

Some children may wonder why their motors sometimes turn counterclockwise, sometimes clockwise. *Blind and deaf children will not have trouble with this concept when properly presented.* Have the children turn themselves (*help the blind child*) clockwise and counterclockwise. Call their attention to the fact that the battery has a knob on one end and is flat on the other. Invite them to test the direction in which the motor turns when the red wire (rough) is connected to the knob end and the blue wire (smooth) connected to the flat end, and the direction in which it turns when the wires are connected in the opposite way.

Discuss discoveries with the children.

ADAPTATIONS

Adapted Materials for the Blind Child

3 toy electrical motors with 3″ wires with rough and smooth ends labeled 1, 2, 3 in braille; 1 adapted tray; 1 brailler and paper; 3 pre-brailled sheets: Experiment report, Building electric circuits—A and B, Building electric circuits—C and D.

Adapted Procedure for the Blind Child

Substitute rough and smooth for red and blue wires. Supply the visually impaired child with the materials on the adapted tray.

Place the battery, 1 motor, clips, and battery holder in each of the four small compartments. Have the additional wires in the large compartment. If a demonstration precedes the class activity, have the child assist in the building of the circuit. Holding his hand, you may trace the circuit and the connections. In doing so, identify each object and how it is used. This time will also allow you an additional moment to guide the child over potentially frustrating rough spots (mainly the wires and Fahnstock clips).

Help the children connect the wires to the Fahnstock clips. Do not allow the visually impaired child to become frustrated. If you foresee a manipulative problem before the class begins, by all means have the two wires and two clips connected ahead of time. As the child explores the circuit, have him record what happens on a pre-brailled experiment report sheet with a brailler.

Example of an experiment report:

Braille Sheet

Experiment Report

Date_____

System of interacting objects

Evidence of interaction

Example of brailled "building circuits" sheet A and B:

Build the electric circuit described below.
A. Connect one wire to each side of the battery and clip system. Attach one electric motor between the two wires.

How does the motor run?

 fast_____slow_____not at all_____

Put a "G" after the right answer.

B. Connect one wire to each side of the battery and clip system. Take two motors and attach one electric motor wire to each wire of the battery and clip system. Connect another wire between the two motors. The wires and motors should form a circle.

How does motor 1 run?

 fast_____slow_____not at all_____

Put a "G" after the right answer.

Example of brailled "building circuits" sheets C and D.

Build the electric circuit described below.

C. Connect two wires to each side of the battery and clip system. Attach motor 1 between two opposite wires. Do the same thing with motor 2 and the remaining wires. Two circles should be formed. Each circle is made up of two wires and a motor.

How does motor 1 run?
fast_____slow_____not at all_____

How does motor 2 run?
fast_____slow_____not at all_____

Put a "G" after the right answer.

Build the electric circuit described below.

D. Attach motor 1 to one end of a wire. Attach motor 2 to the other end of the same wire. Now take four wires and connect two wires to each side of the battery and clip system. Attach the motor 1 wire-motor 2 subsystem between two opposite wires from the battery, clip, and wire system. Next attach motor 3 between the remaining wires.

How does motor 1 run?
fast_____slow_____not at all_____

How does motor 2 run?
fast_____slow_____not at all_____

How does motor 3 run?
fast_____slow_____not at all_____

Put a "G" after the right answer.

You might want to have the subsystem (motor 1, wire, and motor 2) already made for the visually impaired child.

Additional Materials
for the Deaf Child

Language cards: Circuits, Battery, Knob, Battery holder, Clockwise, Wire, Bulbs, D.C. motors, Paper disk, Counterclockwise.

OBJECTS THAT CAN CLOSE A CIRCUIT

MATCH BOX
Suggested Art Match: Making Lanterns p. 337 Electric Circuit Designs p. 339 Moving Machines p. 358

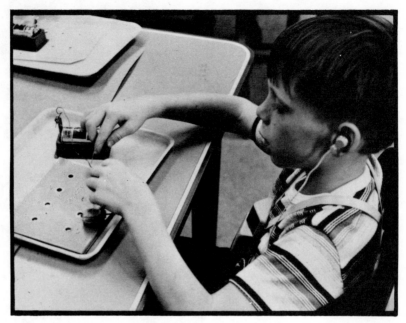

Figure 2.38. Constructing a circuit tester.

EXPLORATION

To identify open and closed circuits. To test common objects to determine if they can close a circuit.

SCIENCE CONCEPTS

Objects that can close a circuit are conductors of electricity. Any material through which charge easily flows when subject to impressed electrical force is a conductor of electricity.

MATERIALS

For each child

battery holders
flashlight bulbs
bulb sockets
2 wires
2 clips
size D batteries
5 assorted objects, such as string, short pencil stubs with both ends sharpened, aluminum foil, pieces of metal, rocks, bottle caps, metallized gum wrappers, steel nail, aluminum nail, paper clips

For the class

1 battery holder
1 size D battery
2 clips
2 wires
1 flashlight bulb
1 motor
1 bulb socket

ADVANCE PREPARATION

Prepare trays for each child. Make braille lists of test objects. Make a pre-brailled sheet of Open and Closed Circuits (see Adapted Procedure for the Blind Child).

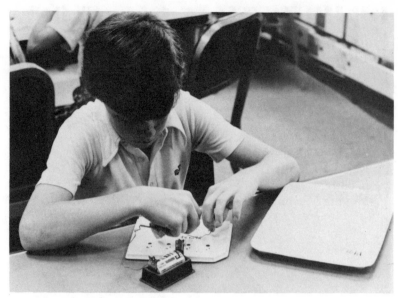

Figure 2.39. What happens when the two elements touch?

PROCEDURE

Ask the children to assemble their own circuit testers along with you.

Place the battery into its holder, insert wires into the two clips and slip these between the battery ends and the walls of the holder.

Connect one of the free ends of one piece of wire to the "ear" of the socket into which you have screwed the bulb. When the testers are assembled, a child will point out that the end of the remaining piece of wire and the other "ear" of the socket are not connected.

Ask the children what will happen if these two elements touch. Have them try it (the bulb will light—motor will work for the blind child).

Explain that the children have constructed a "circuit tester" (*put language card on board*), a circuit that can test whether any object placed between the two free ends can complete, or close, the circuit.

The circuit is *closed* when the motor works and the bulb lights.

If the bulb does not light and the motor does not work it is an *open* circuit.

Ask the children what tests they could make if the bulb did not light and motor did not work when the two free ends were placed together (the bulb could be loose, there could be a poor connection or a defective part).

Ask the children to predict which of their objects will close the circuit. Suggest that they set up experiments to see if their predictions were correct. Encourage the children to compare their results and to further test those objects on which they disagree.

Suggest that the children make a chain of identical circuit elements, such as pieces of Nichrome wire in series, and see whether the chain will close the test circuit. (The light bulb will no longer illuminate and the motor will not work if many objects are in the circuit at once.)

Try to elicit the idea that because there are so many objects, not enough electricity reaches the bulb to make it light.

Invite ideas on how this explanation can be tested. If no child suggests providing more electricity in the form of several batteries in series, show or suggest how it may be done.

Give the children a pulley system and ask them to see if the motor can operate a pulley system, and how an arrangement might be constructed (the rubber band can be wrapped around the motor shaft).

Let the children discuss their conclusions about which objects and which materials in general can close a circuit.

ADAPTATIONS

Adapted Materials for the Blind Child

1 brailled list of test objects used; 1 adapted circuit tester (consisting of a battery holder, battery, 2 Fahnstock clips—each with a wire attached, and a motor); 1 adapted tray; 1 pre-brailled sheet: Open and Closed circuits; 1 brailler.

Adapted Procedure for the Blind Child

Have the circuit tester parts placed in the four small compartments and the assorted objects in the large compartment of the adapted tray. Have the visually impaired child set up his own circuit tester. You might want to have the wires attached to the Fahnstock clips before giving the materials to the visually impaired child. This will alleviate possible frustration for the child with low manipulative skills. You may want to select some special objects that the visually impaired child can easily identify in addition to those already mentioned to work with in this activity.

Have the visually impaired child record his observations on the pre-brailled sheet: Open and Closed Circuits. It is suggested that with the pre-brailled sheet, a small brailled list giving the names of the objects tested by each child be included. This is to be used as a spelling reference. Example of the pre-brailled sheet Open and Closed Circuits:

<u>Open and Closed Circuits</u>

1. Which objects can close the circuit?

2. Which objects cannot close the circuit?

The optional activity using a pulley system can be participated in by the visually impaired child.

Language cards: Bulb, Battery, Open circuit, Closed circuit, Conductor, Non-conductor, Pulley and motor.

THE MAGNETIC FIELD OF A CLOSED CIRCUIT

MATCH BOX

Suggested Art Match:
Expressing Magnetic Lines
of Force p. 331

Figure 2.40. Examining materials to construct electromagnets for exploring magnetic forces (blind and sighted child).

EXPLORATION

To identify by experiment permanent and temporary magnets. To investigate the field of a magnet system by using a compass. To identify variables that affect the operation of a coil-rivet system in a closed circuit.

SCIENCE CONCEPTS

A copper wire coil placed in a closed circuit has a magnetic field that is detectable with compasses and magnets. A coil-rivet system placed in a closed circuit functions as a temporary magnet. The coil-rivet system placed in the closed electric circuit interacts more strongly than the coil alone.

MATERIALS

For each group of 2

1 wire coil
1 compass
1 ferrite magnet
1 rivet
1 circuit base
1 brass clip
1 cardboard tray
1 battery
2 pieces of graph paper

For the class

1 container of small steel disks
1 grid chart
1 grid chart in braille and neoprene circles
masking tape
felt pen

ADVANCE PREPARATION

Wrap two or three one-inch pieces of masking tape around each coil of thin copper wire. Scrape off about an inch of the dark insulating enamel from each end of the coil with a knife, scissors, or the edge of a brass clip. (The bright copper wires will become visible.) Label the grid chart "Steel Disks Picked Up by the Coil-Rivet System." Label the horizontal axis "Number of Turns of the Coil," and mark off the vertical lines from 0 to 7, letting each vertical line represent one turn. Label the vertical axis "Number of Disks," and let each horizontal line represent one disk (from 0 to 21). Make one in braille for the blind child. Assemble and distribute the materials to each team. Have the blind child work with a sighted partner and the deaf child with a hearing partner.

PROCEDURE
Activity 1

Show and tell the children how to set up a closed circuit with the circuit base, brass clip, battery, and the wire coil. Suggest that only one end of the wire coil be connected to one end of the battery by means of the brass clip. Let the children hold the other end of the wire in their fingers and touch the copper end to the other end of the battery intermittently, so that they may compare open and closed circuit conditions in immediate succession.

Show and tell the children how to investigate the magnetic field of the coil with a compass.

If some children are puzzled about how to begin, suggest that the coil be placed vertically in the card holder on the circuit base with the compass resting on the raised area (facing the inner circumference of the coil). Ask the children to open and close the circuit and to observe evidence of interaction on the compass pointer.

Suggest that the children let the coil hang over the edge of their desks, one end of the coil fastened to the brass clip, the other end free to be manipulated. Tell the children to hold the ferrite magnet in the middle of the coil in various directions.

Figure 2.41. Getting ready (blind and sighted child).

Ask several children to report their observations. (The coil, by hanging free, can swing or turn to show evidence of interaction.)

Suggest that the children lay the coil flat on their desks, one end fastened to the brass clip, the other end free to be manipulated. Suggest that they place the compass in the middle of the circle formed by the wire as they touch the battery intermittently with the free end of the wire. Ask several children to report their observations when they close and open the circuit. (The compass pointer will swing on its pivot.)

Suggest that the children replace the compass in the center of the wire with the ferrite magnet standing on its edge, then touch the battery intermittently with the free end of the wire. Ask several children to report their observations. (The magnet will tip.)

Suggest that the children explore the coil's magnetic field in other ways. Remind them that evidence of interaction can best be observed when the object being investigated is free to move (swing, turn, tip) as the circuit is closed. Now propose that the children investigate a system made up of a coil and a rivet.

Show several children how to twist the coil around the rivet. Lay the rivet inside the coil and at a right angle to it. Looking down at the rivet, you will see one twist of coil lying across it; that twist will count as one turn. Now twist the coil around the rivet again; you will see two twists of the coil lying across the rivet, and those two twists count as two turns.

Let several children demonstrate twisting the wire and reporting the number of turns before they begin the following experiments.

Ask the children to connect one end of the wire to the brass clip, and to leave the other end free to be manipulated. Ask them to give the coil-rivet system one turn, and to place the compass near the head of the rivet. Let them close and open the circuit.

Ask several children to report their observations. (The system deflects the pointer.)

Let them repeat the experiment by giving the coil-rivet system two turns and reporting their observations. Then ask them to give the system three turns and report their observations.

Distribute about 25 small steel disks to each team. Ask the children to replace the compass in the previous experiment with the steel disks. Let them repeat the experiment of opening and closing the circuit first with one turn of the coil-rivet system, then two turns, then three turns.

Ask several children to report their observations after each number of turns of the coil-rivet system.

Invite some children to consider whether the rivet becomes a temporary magnet. Ask the children to compare the coil-rivet system to the coil alone. (The system interacts more strongly than the coil alone.)

Ask the children to compare the coil-rivet system with the permanent and temporary magnets they investigated in the previous lesson.

PROCEDURE
Activity 1—*continued*

Ask the children to name the variables of the coil-rivet system. List the variables on the blackboard. (They will include: the number of batteries, the kinds of wire, the material of the "rivet," and the placement of the coil on the rivet.)

Ask the children to explore some of these variables and to record their observations.

Activity 2

Tell the children they will explore how the number of turns of the coil-rivet system affects the system's interaction with the steel disks.

Ask the children to connect one end of the coil to the brass clip on the circuit base but to leave one end free to open and close the circuit intermittently.

Tell the children to begin by pushing the coil against the head of the rivet as the first turn. By beginning as close as possible to the head of the rivet, the children will be able to make at least seven twists on the rivet by the end of the experiment. Suggest to the children that they can put many turns on the rivet by pushing them tightly together. Let them put as many turns on the rivet as they can.

Ask the children to pick up as many steel disks as they can with one turn, with two turns, and so on, up to at least seven turns. Ask them to record the number of disks the coil-rivet system picks up each time.

Let the members of each team take turns, one operating the system, the other counting and recording the disks picked up.

Figure 2.42. Blind child explores magnetic properties.

Suggest that the children count only the disks that hang freely. Encourage them to handle the system carefully so they do not knock any disks off prematurely.

Invite the children to identify the variables that affect the number of disks picked up. List them on the blackboard. (Size of disk, battery condition, care of handling will be among the variables.)

Ask the children to help you graph their data. *Have a deaf child do the graphing with your help. Have the blind child record on brailled grid on the board.* Have the child use cut out neoprene circles to mark with on chart. Post the prepared grid charts (*one in braille*).

Ask one child to state his results for one, two, three, and more turns. Mark the data on the chart, then draw a curved line near them to represent the trend of the child's data. Write the child's name near the line.

Ask the child to predict how many disks the rivet would pick up if there were zero turns of the coil around it (if the coil were not used at all). Give him time to realize that the rivet alone would not be a temporary magnet and therefore would not pick up any disks at all. If he replies correctly, ask him for his reason.

Ask two or three other children to report their data. Graph these data also. Invite the other children to add their data at unscheduled times.

Let the children examine the chart briefly. Ask them what effect increasing the number of turns has on the number of disks picked up. (They will conclude that increasing the turns boosts the "strength" of the magnet.)

Invite your mathematically inclined students to work out a formula relating the number of disks to the number of coil turns.

ADAPTATIONS

Adapted Materials for the Blind Child

Adapted tray; brailled grid chart as described in Advance Preparation; brailler and paper; adapted battery holder with wires attached.

Adapted Procedure for the Blind Child

Child should work with a sighted partner. The blind child should be told that the wires may get warm to his touch. The blind child needs help in the initial attempt at wrapping the coil around the rivet.

Suggested Adaptations for the Deaf Child

Language cards: Coil, Open circuit, Closed circuit, Permanent magnet, Temporary magnet, Wire coil, Brass clip, Compass, Ferrite magnet, Rivet, Circuit base, Twists, Steel disks, Coil-rivet system, Variables.

COMMENTS

Be alert for any students who report picking up many fewer disks than their classmates. Use the obvious difference between their data and those of the other children to call the children's attention to unsuspected variables, such as a discharged battery, poor wire contact at the brass clip, or other interfering condition.

GROWING BEANS AND PEAS

Figure 2.43. Visually impaired child explores the development of a plant.

EXPLORATION

To plant pea and bean seeds. To observe change involved in plant growth and development. To arrange in sequential order stages in the life cycle of a common plant. To identify the major structures of a plant. To design experiments to answer questions about plants.

SCIENCE CONCEPTS

Growth refers to an organism becoming bigger. Development: Each kind of plant and animal has its own life cycle. The bean plant starts from a seed planted in the soil. The seed germinates and grows into a mature plant that produces flowers, fruit, and seeds. The seeds grow into a new generation to repeat the cycle from seed to seed.

MATERIALS

For each child

4 planter cups (plastic cups with 4 holes in bottom)
4 planter bases (dish to set cups in—could use petri dishes
4 sticks, 1/8″ diameter, 8″ long
4 wire ties
16 each pea and bean seeds
4 labels
1 water sprinkler per group

For the class

soil
2 light sources—lamps with 100 watt bulbs
4 large cardboard trays

ADVANCE PREPARATION

Fill the planter cups with soil to about one-half inch below the top of the cup and place the cups on the planter bases. Distribute the materials to each station and let the children take their own. Set up light sources (tall lamp, 100 watt bulb) when the seedlings appear. Prepare posters that you can see and feel: "seefee" poster with raised figures of the life cycle of the bean and/or pea (see Figure 1.47).

PROCEDURE

Ask the children to plant their seeds by making one-half inch holes in the soil, dropping one seed into each hole, and covering the seeds with soil (use one cup for peas and two cups for beans). Let the children fill the planted cups to the top with water (to adequately soak the soil). Two of the cups of seeds will be used to pull seeds at different intervals to see what is happening to the seeds. Explain that the heavy watering is needed for the initial planting, but that afterward the planters need only enough water to keep the soil moist. Schedule a watering time for Mondays, Wednesdays, and Fridays for the next several weeks. Suggest to the children to pull the seeds out of one set of the cups, leaving the others to grow. Have them discuss what is happening to the seeds.

As soon as seedlings appear above the soil, have the children move the planters to the large trays placed under the light sources.

When the plants grow tall enough to need support, show the children how to attach them to planter sticks. Insert one end of a stick into the soil next to the plant. Loosely fasten the plant stem to the stick with a wire tie. Let the children prepare the same support for their planters. *Use adapted materials for the blind child, which may also be used for the entire class (see Figure 3.2).*

Invite the children to examine their plants whenever they wish and to discuss and compare their observations.

When most of the children have at least one pea or bean seedling visible above the soil, invite them to describe what they think is happening beneath the surface of the soil. Introduce the term "grow." Explain that we say organisms grow when they become bigger in size. Ask the children to name some things that grow.

PROCEDURE—*continued*

When some pea plants are about three inches tall, direct the children's attention to the plant foliage, which should include leaves and tendrils. (The tendrils are long, thin projections, extending beyond the leaves, that may attach themselves to a planter stick or other object.) Have the children compare pea plants having tendrils and open leaves with smaller plants that do not yet have these structures. Encourage the children to describe and name the plant parts; tell them the names again if they do not remember. *Use language cards in discussions.*

Introduce the term "develop." Discuss with the children that when a new structure (part) appears, we say that the plant develops these structures; for instance, tendrils and leaves develop as pea plants grow. Invite the children to name and describe other organisms that develop new parts as they grow.

When flowers appear on either the bean or pea plants, ask the children to tell you what these newly developed structures are and what they think will happen to these new parts. Flowers will probably grow sooner on the bean than on the pea plants.

When the fruit forms inside the flower, it will be visible as a pea or bean pod growing out of the flower. Encourage the children to examine the plants each day. The fruit develops from the flower so rapidly that the children might miss the process. When the bean or pea pods have grown large enough to contain seeds, have the children open some pods to observe what is inside.

Invite the children to help you draw on the blackboard the sequence of plant development by naming the stages. Begin and end with a sketch of a seed (bean or pea). In between, elicit suggestions that you draw seedlings above the soil, stems, leaves, and tendrils; flowers; pea pod developing out of the flower; fully developed pea pod; opened pod containing seeds; pea seed. Give each child a sheet of light pea plant pictures. The children are to cut out the pictures and arrange them sequentially. Tell them not to put two seeds together. Invite the suggestion that the sequence represents the life cycle of the pea plant.

The concept of "biotic potential" is defined as the number of young that an organism can produce. This concept applies to the study of both plant and animal development. Your students should be ready to consider this concept when they complete their study of the sequence of plant development.

ADAPTATIONS

Adapted Materials for the Blind Child

Brailler with paper, planting dowel 6″ × 1/2″ with six horizontal indentions in 1/4″ increments, 1 pound clay or Plasticine, 4 planter sticks, 4 ties, 1 roll masking tape, 1 screen board, crayons.

Adapted Procedure for the Blind Child

In this activity, have the visually impaired child prepare his own braille name labels. The child may need some assistance in cutting out the labels from the sheet of paper. Also have each child keep a continuous log of the growth and development of each seed. Questions, hypotheses, the introduction of new ma-

terials, and all observations should be recorded and dated using the brailler.

When the children prepare the cups for planting, be sure that the visually impaired child prepares his own. The visually impaired child uses the planting dowel as an indicator for the depth of the soil from the top of the cup, as well as for planting the seeds. Give the visually impaired child two extra sticks and ties for the plants. The extra support prolongs the life of the plants by reducing the chance of the child breaking them while observing. *The visually impaired child can draw the bean and pea plants on a screen board and form clay or Plasticine into shapes resembling the plants (see Figure 3.11).*

While the rest of the children are arranging the pea plant pictures, give the visually impaired child a pea seed, a pea plant, and a pea pod. Ask the child to arrange them from youngest to oldest. When he understands the task, give him another pea seed and ask that he arrange all of them and not put the two seeds together. When he succeeds in arranging the sequence of the cycle, then invent the concept of life cycles. Tell him that the arrangement represents a life cycle. If they are not arranged in a circle, shift them so that they are. Encourage the visually impaired child to observe them again. As the child observes their arrangement, explain that the reason it is called a life cycle is that seeds grow into plants, and plants produce more seeds.

Suggested Adaptations for the Deaf Child

Language cards: Pod, Grow, Foliage, Projections, Flower, Fruit, Develop, Tendril, Seed, Life cycle, Seedling. Identification cards for all materials.

COMMENTS

While the seedlings are growing under the light sources, leave the lights on during the day but turn them off at night unless the room temperature drops below 45°F during the weekend. If a planter cup becomes overcrowded, remove all but two of each kind of plant.

While you are waiting for plants to grow, have the children do other activities (e.g., physical science). The children may be more interested in the beans than the peas, because the beans grow faster and flower sooner. As an extended activity, have the children measure the growth of the plant and graph the results (see Figure 3.2). Blind children will need a braille ruler. They will also need adhesive dots to mark height of plant on sticks as the plant grows. Observations can be recorded on a raised graph.

THE LIFE CYCLE OF THE FROG

MATCH BOX

Suggested Art Match:
Mosaic Life Cycles p. 316
Clay Life Cycles p. 318

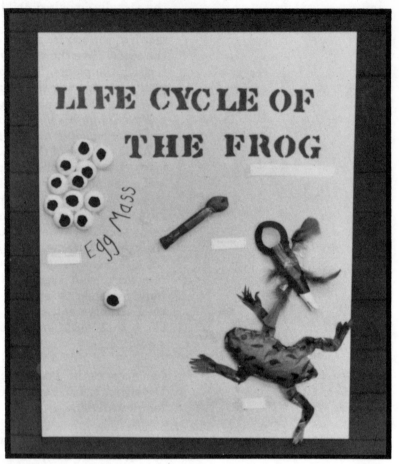

Figure 2.44. Seefee poster. Students can see and feel the life cycle of a frog. (Made by blind, deaf, and ordinary children in art class.)

EXPLORATION

To observe the stages of a frog's growth and development, from fertilized egg to larva (tadpole) to adult.

SCIENCE CONCEPTS

The frog is an amphibian. The eggs and sperm of the frog are laid in water. The fertilized eggs are nourished at first by the yolk. They then undergo cell division and develop into larvas, or tadpoles, in four or five days. The tadpoles breathe by means of gills on the sides of their bodies and feed on aquatic plants. The tadpole (larva) undergoes metamorphosis and becomes an adult frog after two or three months. Amphibian metamorphosis is regulated by thyroxin, the hormone secreted by the thyroid gland, and can be prevented by removing the thyroid or the pituitary, which secretes a thyroid-stimulating hormone.

MATERIALS

For the class

6 one-gallon plastic containers	film loops
15 anacharis sprigs	film loop projector

1 frog egg mass
1 dip net
16 or more magnifiers
tadpole food
white sand

loops:
"Frogs: Pairing and Egg Laying"
"Frog: Tadpole to Adult"
6 live or preserved frogs

The frogs can be purchased from Carolina Biological Supply House.

ADVANCE PREPARATION

Because frog eggs are available for use in the classroom from November 1–April 30, the ordering and teaching schedule should be adjusted accordingly.

Age (let stand for 48 hours) three gallons of tap water in a large container. On lesson day, place about 1/2″ of sand in five of the 1-gallon containers, add aged tap water, and float several sprigs of anacharis on the surface of each aquarium. The sixth empty container will be used during class. Make bulletin boards with raised objects related to activity. Set up a "film loop" corner where the deaf children can have the opportunity to review the film loops by themselves or in small groups. Make poster of the stages of the life cycle of the frog in raised forms (see Figure 2.44) for the blind child.

PROCEDURE

Have deaf child show the frog egg mass to the children. Have another child identify with a language card. Give a part of the egg mass to the blind child in the adapted equipment, making it possible for him to participate in the discussion. Let them describe what they see. Let a child ask about the black spots before explaining that the spots are the eggs, each of which is surrounded by a jelly-like coat. Have one of the children pour the eggs and the water from the shipping jar into the empty sixth container. Use the dip net to separate the eggs into five approximately equal portions, and distribute one portion to each aquarium. Discard the water in which the eggs arrived. *If possible, make a special aquarium with the eggs for the blind child and a sighted partner, giving the blind child more time for exploration.*

Invite the children to gather around each aquarium in small groups, and give them each a magnifier. Encourage their discussion among themselves. Ask several children to report and compare what they see. *The blind child will use adapted equipment and report observations.*

Ask the children to describe places where frogs live. Remind the children that a habitat is a place where an organism usually lives, so that an aquarium is not a true habitat, but rather an adequate substitute. Ask the children where they would go to find frog eggs.

To answer the question of how the eggs come to be in a pond, describe the process of mating and egg-laying by using posters with raised objects for the blind child to feel and the others to see. Suggest to the children to go to the film loop corner and look at film loops. Encourage questions from the children about how frogs lay eggs, and where the eggs come from.

PROCEDURE—*continued*

Invite the children to observe the eggs in the aquariums daily. In four or five days, some eggs will have hatched into tadpoles. Suggest to the children that the tadpole is the larval stage of the frog life cycle. *Have deaf child identify this stage on poster. Use the prepared language card. Refer to posters and raised figures on sheets for the blind child.* The development from egg to tadpole takes only a few days, but the series of changes from tadpole to adult frog takes several months. However, most tadpoles die. Few reach each of the successive stages of development, and very few become adult frogs. Invite the children to observe the tadpoles for the stages of developing rear legs, of developing front legs, of losing gills and tail, of becoming an adult frog. Isolate five or six of the newly hatched tadpoles in the sixth aquarium in order to ensure their development into adults. (Set up the aquarium first with sand, aged tap water, and aquatic plants.) Let the children watch how you feed the tadpoles a very small amount of food, and ask for volunteers to continue the feeding daily. In this uncrowded aquarium, the improved oxygen-carbon dioxide balance and the better food supply should increase the tadpoles' chances to mature. Let the children build other aquariums for isolating and caring for more tadpoles, if they wish.

At the age of three to five weeks, the tadpoles should have grown to several times their original size. Ask the children to predict what will happen to the tadpoles. Suggest that the children view the film loop, "Frog: Tadpole to Adult," which is in the film loop corner. Describe the successive changes by using visual aids such as related transparencies, *or by putting raised pictures in sequence and having the blind child do the placing.* Invite the children to observe whether front or hind legs develop first, what happens to the tail, and the way in which the body shapes of tadpole and adult frog differ. Encourage the children to use the term "growth" to refer to the increase in the tadpoles' size, and "development" to refer to the appearance of legs or other new structures.

Let the children informally observe the aquariums for several weeks. Let them report on and discuss their observations. Ask the children to help you draw on the blackboard the sequence of the frog's development by naming the stages. *Have blind child draw on screen board.* Elicit suggestions that you draw sketches of fertilized egg; tadpole with tail and gills; tadpole with rear legs; tadpole with front legs (and lungs); adult frog (without tail or gills); fertilized egg. Invite statements that the sequence represents the life-cycle of the frog, that the sequence from egg to adult represents one generation, and that the second egg represents the beginning of the second generation.

ADAPTATIONS

Adapted Materials for the Blind Child

1 plastic cup 3″ diameter at top with 1/8″ holes in bottom, or 1 plastic container 8″ × 4″ × 4″ with 1/8″ holes in bottom, 1 plastic cup 3″ diameter at top, or 1 plastic container 8″ × 4″ × 4″, 1

paper clip, 1 screen board and crayons, 1 pound of clay or Plasticine, raised pictures of the stages in the life cycle of the frog.

Adapted Procedure for the Blind Child

The visually impaired child observes eggs and tadpoles with special plastic cups as follows: Make a plastic cup with holes in the bottom and a plastic cup with no holes or two 8″ × 6″ tapered plastic containers, one with holes in the bottom. Let the visually impaired child examine the two cups (containers), then show him how to insert the cup (container) with the holes into the other cup (container). Have the child fill the two-cup system nearly full with aged water, or water from a classroom frog container, and place a paper clip or some other small items in the cup (container) with the holes. Then show how to lift the holed cup (container) from the water, and show that the holed cup (container) contains the clip. This is an easy technique for maintaining and retrieving live animals that can easily elude visually impaired children's attempts to catch them. Tell the visually impaired child to remove the paper clip and to place the frog eggs in the water in the holed cup (container). Encourage the child to practice using the system with the frog eggs. One clue you can give is to show how to lift the inner cup (container) near the surface of the water, but not entirely out of it. This makes it easier to get hold of an egg or tadpole, especially when they are floating in at least a little bit of water.

The visually impaired child can benefit from the film loop on "Pairing and Egg Laying" if the teacher or a sighted student explains what is being shown on the screen. The child's input will certainly be limited, but some idea of what the other children are observing is better than none. The teacher should procure a frog or a toad before showing the film, and the visually impaired child and the entire class will benefit from observing it. If you have the children draw pictures, let the visually impaired child use clay to mold several tadpoles or draw with screen board. Try the same technique with the film loop "Growth and Development" that was suggested for the "Pairing and Egg Laying" film. As with other children, the visually impaired child's first-hand experiences with frog development will be the most valuable to him.

While the other children are ordering their pictures, discuss with the visually impaired child the different stages of development. Have the child tell you the sequence in which development takes place.

Suggested Adaptations for the Deaf Child

Language cards: Habitat, Eggs, Larva, Egg laying, Tadpole, Kind, Gills, Stage of development, Larval stage, Front, Fertilized egg. Set up film loop corner for "Pairing and Egg Laying;" "Life Cycle of the Frog." Have poster of the different stages of the life cycle of the frog posted in the room.

COMMENTS

During metamorphosis the forelegs grow out of the fold of the skin that had developed them, the gills and gill slits are lost,

the tail is reabsorbed, the digestive tract shortens, the mouth widens, a tongue develops, the tympanic membrane and eyelids appear, and the shape of the lenses appear. Biochemical changes occur to provide for the change from a completely aquatic life to an amphibious one.

VARIABLES
AND
EXPERIMENTAL
DESIGN

SEPARATING A POWDERED MIXTURE

MATCH BOX
Suggested Art Match: Big or Little? p. 281 Felt Pictures: Before and After p. 342

EXPLORATION

To identify subsystems in a mixture of solids (sand, baking soda, and salt). To separate the subsystems from a system.

SCIENCE CONCEPTS

Mixtures of certain materials can be separated from one another and their properties can be distinguished.

MATERIALS

For each child

7-dram vials
vial cap rims
fine mesh cloth screens
coarse mesh cloth screens
cardboard trays
3 pieces dark construction
 paper, 4" × 4"
magnifiers

For the class

1 jar salt, sand, baking soda
 mixture
small packet baking soda
small packet salt
1 plastic spoon

ADVANCE PREPARATION

Fill each vial about half full of the soda/salt/sand mixture. Distribute these and the other materials to each station. Let the children take their own. Set aside the packets of salt and baking soda. Prepare trays for blind children. Place the four dark sheets of paper in the small compartments of the adapted tray. Have the two screens and filled vials in the large compartment of the same tray.

PROCEDURE

Invite the children to separate the mixture in their vials any way they wish. Tell them to work over their trays so that spilled material can be poured back into the vials. Do not identify the contents of the mixture by name.

Encourage the children in any technique they may try, from pushing the grains apart with a corner of the construction paper to sifting the mixture through the cloth screens. Invite the children to examine the mixture. If no child discovers the "salt-shaker" technique, show a few children how to mount the screens under the vial cap rims. Let the children discover for themselves how to use one screen first, then the other. If no child uses a separate piece of construction paper for each component of the mixture, suggest that one piece be used only for salt, and let the children work out the rest.

Ask a few children who have completed the separation how many different materials they found. Ask the children to make a separate list of the properties of each of their materials. *Have the blind child record the properties and the name of each separated material of the mixture using a brailler. Ask blind child to read the list of properties from the brailled notes. Write the list on the blackboard or put language cards on board.* Ask the children for additions to the list. *Have the deaf child "pull" property words from the language board.*

Now tell the children that the mixture was made from baking soda, salt, and sand. Ask several children to examine the lists on the blackboard and brailled recordings and to say which list identifies which material.

If no child in the class can identify the materials on the basis of the lists of properties, place some salt and some baking soda on separate pieces of construction paper and invite some children to decide which is soda and which is salt. If they decide correctly, ask them then to show you which list of properties identifies salt and which identifies baking soda. Write the correct name over the list on the blackboard. The third list will thus be identified as sand.

Ask the children to pour the separated materials back into the vial.

ADAPTATIONS

Adapted Materials for the Blind Child

4 dark sheets of paper, 2 1/2″ × 3 1/2″, one each in small compartments of adapted tray; 1 adapted tray; brailler and paper.

Suggested Adaptations for the Deaf Child

Language cards: Property, Crystals, Rough, Fine, Clear, Tan, Shiny, Rectangular.

COMMENTS

Most children will work on the task repeatedly, pouring the powders into the vials occasionally in order to begin again when they get a new idea about how to separate the mixture. Encourage those children who are usually slow to start on independent activities. Invite the children to discuss and compare their own lists of properties for each of the separate materials.

In addition to the above experiment of separating mixtures, the following is a recommended extended activity with a special adapted mixture that can be used by the whole class. For this experiment prepare a tray for each child consisting of: 1 small horseshoe or other magnet; 1 small, flat plastic cup containing adapted sifting mixture (steel ball bearings, corks, pieces of rock salt); 1 cup half filled with water; 1 small plastic spoon. Ask children to set up an experiment in which this mixture can be separated. Discuss their plans and discoveries.

"INVENTING" THE SUBSYSTEMS CONCEPT

```
MATCH BOX

Suggested Art Match:
The Printing Process p. 323
A Subsystem Mobile p. 341
```

EXPLORATION

To separate subsystems from a system. To set up experiments to identify interactions of subsystems.

SCIENCE CONCEPTS

A subsystem is a system that is entirely included in another system. Subsystems can be distinguished from the system to which they belong. It is possible to determine which subsystems contribute to a change involving an entire system.

MATERIALS

For each child

sets of sifting equipment (vial, cap, mesh screens, 2″×2″ paper squares, sifting mixture)
plastic cups
3 tumblers (2 for btb, 1 for waste)
magnifiers
cardboard trays

For the class

1 jar sifting mixture (mixture of sand, salt, baking soda)
1 vial
1 tumbler
2 cardboard trays
1 squeeze bottle bromthymol blue (btb) solution
1 bottle vinegar
1 pitcher of water
1 plastic spoon
1 plastic bag with wire tie

ADVANCE PREPARATION

Assemble the materials. Distribute them to each station, and let the children take their own. Pour some sifting mixture into the tumbler for your demonstration. Prepare adapted tray for the blind child with three dark pieces of paper in the first three small compartments, one plastic cup in the fourth small compartment, one tumbler of yellow btb, the two screens, and the sifting mixture in the large compartment. Have the visually and auditory-impaired children assist during the demonstration part of this lesson. Each one should have a set of the materials used to identify with the demonstration.

PROCEDURE

Have the children hold up the tumbler with the sifting mixture in it and ask them to identify the materials of the mixture. Drop a vial into the tumbler you hold. Designate the tumbler, the mix, and the vial as "System Mix." Identify this with the language card. Ask a child to tell and show what constitutes System Mix.

Place the vial on a tray, pour some mixture into it from the tumbler, and set the tumbler still containing some mixture onto

the same tray. Ask a child whether you still have System Mix. (No objects were added or removed.) Suggest that the vial containing mixture and the tumbler containing mixture might be thought of as parts of System mix. Show and tell the children that parts of a system are called "subsystems." Put language card Subsystems on language board. Invite the children to find other subsystems of System Mix. (Salt alone, sand alone, the two containers alone, one container alone.)

Ask some children to name some systems of interacting objects that are not subsystems of System Mix. (The hand and the tray; the tumbler and the tray.)

If the children find it difficult to pick out subsystems, designate your bulletin board as a system, *and have blind, deaf, and normal children take turns helping you point out one of the displays (should consist of raised objects so that blind child can feel) on the board as a subsystem*, and ask some children to point out other subsystems of that system. Designate an aquarium in your classroom (if you have one) as a system, point out the water as a subsystem, and ask the children to name other subsystems.

Ask three children to help you prepare yellow btb solution (*should be the special children and an ordinary child*), Let one child fill and hold a pitcher of water. Pour two or three squirts of concentrated btb into the water, and stir the solution with the plastic spoon. Ask one child to slowly pour a very small amount of vinegar into the pitcher and stir the solution, which will become yellow. Pour a little of the yellow liquid into the vial containing the sifting mixture. (The liquid will turn blue.) *Blind child should assist with light sensor that indicates change in color.*

Ask some children to describe the sequence of events. Urge them to talk in terms of evidence of interaction. Ask their ideas about which objects interacted to turn the yellow liquid blue.

Lead the children with questions to suggest that an experiment be conducted to decide whether the whole mixture of System Mix interacted to produce the color change, or whether only some of the subsystems of System Mix interacted with the solution to turn it blue. Let some children suggest possible experiments. Then propose the following method.

Tell the children that they will use the sifting equipment and the cup on their trays to determine which subsystems of the System Mix leave the mixture yellow. Have the children sift mixture into three separate piles. Then have them discover what happens when each pile is separately mixed with the yellow btb solution that you pour for them. *The visually impaired child should have his light sensor and his own yellow btb solution in a braille labeled tumbler in a compartment of the adapted tray. The deaf child should have a label on his tumbler "btb solution."*

Place a labeled waste bucket and a rinsing bucket at each station for disposing of the used mixture and cleaning of the plastic cup for another experiment. The tumbler needs to be thoroughly rinsed for true reading using the light sensor. The large

buckets are easily located by the visually impaired child. Each child will pour yellow btb from the tumbler into his cup for each separate test. Be sure that the cup is clean for each trial. Remind the children to rinse their cups between tests so that no test solution will be contaminated by material from a previous test.

When the children have completed their tests, make three columns labeled Sand, Salt, and Soda on the blackboard. *A suggestion is to have deaf child place language cards on board at the same time.* Ask the children how many found out whether sand leaves the solution yellow (yes). Show the sand and have the children choose between a yellow and blue solution to tell what they found out. Ask how many found out whether soda leaves it yellow (no; turns it blue). Ask how many found out whether salt leaves it yellow (yes). *Ask visually impaired child to assist in the following demonstration.*

Put two teaspoons of the powdered mixture and an uncapped vial full of vinegar into a small plastic bag on a cardboard tray. Be careful not to tip the vial or it will spill prematurely. Squeeze the air out of the bag and close it with a wire tie about an inch from the vial. Now tip the vial to pour the vinegar into the bag. It will interact with the mixture to produce a froth of bubbles that will slowly inflate the bag. *Visually impaired child feels the bubbling and the inflation of the bag.*

Ask the children whether the entire mixture or only one subsystem interacted with the vinegar to produce the bubbles. Let them suggest ways of testing to find the answer. Try by questioning to lead them to suggest the following. Sort the mixture onto pieces of construction paper, then use a medicine dropper to put a few drops of vinegar (from a tumbler of vinegar that you supply) onto each of the subsystems. Ask them to report and discuss their results. *If the blind child cannot feel this reaction, give him tumblers in which to put the subsystems to be tested with vinegar.*

ADAPTATIONS

Adapted Materials for the Blind Child

1 adapted tray; light sensor; 4 dark pieces of paper 2 1/2" × 3 1/2"; braille labels: System mix, Salt, Sand, Baking soda, Waste bucket, Yellow btb, Wash bucket; brailler and paper.

Suggested Adaptations for the Deaf Child

Language cards and labels: System Mix, Salt, Sand, Baking soda, Yellow btb, Wash bucket, Btb solution, Subsystem.

COMMENTS

The light sensor (for this lesson only) should be placed in front of the fourth compartment of the adapted tray and the nose aimed toward the plastic cup. Make sure that the nose is directly against the cup. The plastic cup need only be half filled with yellow btb to show results using the light sensor. Any observations or discoveries should be recorded using a brailler. When preparing the yellow btb use a large clear container so that the light sensor may easily detect the color change from blue to yellow. If possible, allow the visually impaired child to stir the container as the btb and vinegar are added to the water.

ECOSYSTEMS: MEADOWS, LAKES, DESERTS (AN EXTENDED ACTIVITY IN THE SPRING)

Each group of four was given an aluminum pan (their meadow) and a shallow container (their lake) which was placed in the center of the meadow. Rye grass, clover, and bean seeds were planted. Beans were planted under the soil and grass, and clover seeds were sprinkled on top of the soil. These were then watered with individual sprinklers.

For the lake sand and small rocks were placed on the bottom of the shallow container. A valisneria plant was then planted in the sand, and water was added. Some of the children put goldfish in their lakes and a few put tadpoles, frog eggs, and frogs (attached to leashes) in theirs. The life cycle of the frog was discussed at this point. Anacharis, elodea plants, and snails were finally added to the lakes. The oxygen-carbon dioxide cycle could now be discussed.

For the desert dry sand was put in another aluminum pan. Next a nonprickly cactus plant (succulent) was added. Large rocks were used to help keep the plants in place. Chameleons and lizards were then added to the desert. They were put on leashes and at the end of the leashes were paper fasteners that were attached to the aluminum pan. By following along the string the children could find where the chameleons and lizards were in the desert.

The meadow, lake, and desert were placed next to each other on a larger table to form examples of ecosystems. Because chameleons live in both damp and dry land, the children could follow them from the meadow to the desert.

This activity was extremely successful with the blind children. They recognized all the plants. They could follow the animals without losing them by tying the animals to a string and fastening the string to the equipment.

COLORED LIQUIDS

MATCH BOX

Suggested Art Match:
Solution Sculpture p. 329
Mixing Your Own Dyes for
Tie Dying p. 345

EXPLORATION

To identify and to classify liquid mixtures as solutions or non-solutions.

SCIENCE CONCEPTS

In a solution the solute is mixed thoroughly and evenly throughout the solvent. True solutions are transparent (sometimes colored), nonfilterable, homogeneous, and stable.

MATERIALS

For each child

5 tumblers, one to be filled with water
cardboard trays
medicine droppers
magnifiers
4 labels
4 five-dram vials, one each containing salt with red dye, blue dye, yellow dye, and starch
4 vial caps
4 paper towels
crayons of assorted colors

For the class

4 colored plastic sheets
4 tumblers with liquid mixtures: clear, colorless; clear, green; cloudy, white; cloudy, green
4 tumbler lids
1 plastic spoon
1 pitcher of water
desk lamp

ADVANCE PREPARATION

Posters showing true solutions and nonsolutions. Using the plastic spoon, fill each vial about 1/4″ deep with one of the four powdered mixtures. Write "solid material" on the blackboard, and under it children can refer to the list as they work. Distribute the materials to each station. Prepare four tumblers with these mixtures: water and salt (clear, colorless); water, salt, and starch (cloudy white); water, salt, blue dye, and yellow dye (clear green); water, salt, starch, blue dye, yellow dye (cloudy green). Use small amounts to avoid deep colors, and stir well.

PROCEDURE

Have blind child assist with light sensor—put object to be tested between a light (an ordinary desk lamp will suffice) and sensor.

Hold up an empty tumbler. *Describe it as "clear" and check with light sensor.* Hold up a colored plastic sheet. Call it "clear." Ask the children to tell you what "clear" means. Write "clear" on the blackboard. *Have deaf child put the words on language board.*

Ask the children to tell you about other clear objects in the classroom. *Provide objects for blind child to explore with sensor.* Hold up a tumbler lid. Call it "cloudy." Hold up a piece of waxed paper. Call it "cloudy." *Have blind child check with light sensor (see Figure 3.15).* Ask the children to tell you what "cloudy" means. Write "cloudy" on the blackboard. Ask another child to name other objects that are cloudy.

Hold up the tumbler again. Describe it as "colorless." Hold up the waxed paper. Call it "colorless." Ask the children to name other colorless objects in the room or elsewhere. Write "colorless" on the blackboard *and have deaf child put language card on language board.*

Hold up a colored plastic sheet. Describe it as "colored." Hold up a crayon. Call it "colored." Ask each child to name a colored object in the classroom. Write "colored" on the blackboard. *Deaf child puts language card on board. The following should be verified by the blind child using the light sensor (Figure 3.15)* (see Suggestions.) Hold up the tumbler, the waxed paper, and a colored plastic sheet, one object at a time, and ask the children to describe each as clear/colorless, cloudy/colorless, or clear/colored. Then hold a colored plastic sheet against a tumbler lid and ask the children to describe it (cloudy/colored). Repeat some of these examples until most of the children understand the terms.

Bring out the tray with your four tumblers of liquids. Ask the children to describe the liquid in each tumbler as clear or cloudy, and also as colored or colorless. Let the children who seem confused describe the liquids in these terms, until all the children use the words easily.

Let each child pour some water into the tumbler, then pour the vial of colored powder into the tumbler. Ask each child whether the liquid is clear or cloudy, and what color it is. (Each child will have a different colored liquid.)

Have the children save their liquids in vials that you provide. Let them label their vials with their names. Ask them whether their favorite liquids are cloudy or clear, light or dark, and what the color is.

Collect the vials of favorite liquids on a cardboard tray and place the tray on a windowsill or area with a well-lighted background so the children may look at the liquids without disturbing them (so that settled starch will not be stirred). Over the next few days, ask the children whether their liquids have changed and to describe the change (from cloudy to clear, for example).

ADAPTATIONS

*Adapted Materials
for the Blind Child*

Spoon or stick; light sensor and light source (lamp); adapted tray; 4 clear plastic cups half filled with water; braille labels—4 each: Clear, Cloudy, Colored, Colorless, 1, 2, 3, 4.

*Adapted Procedure
for the Blind Child*

Detailed procedure for the blind child: Each visually impaired child should have an adapted tray with four clear plastic cups half filled with water in each of the four small compartments.

ADAPTATIONS
Adapted Procedure for the Blind Child—continued

The 4 five-dram vials with solid materials should be labeled 1, 2, 3, 4 and placed in the appropriate compartments on the tray. The light sensor should be placed directly behind the tray. Have the child test each cup filled with water. He should conclude that all four cups contain "clear" water.

Have the child slowly sprinkle some of the solid material 1 into the cup in compartment 1 and stir the mixture with a stick or spoon. Observations should be recorded by using a brailler. The rest of solid material 1 should be added to the same cup. Before the child moves onto the next solid mixture, suggest sampling the mixtures tactually. After exploring and recording the four separate mixtures, allow the child to freely combine the mixtures and record any changes. Prepare a brailled sheet with four rows of labels—Clear, Cloudy, Colorless, Colored—so that the visually impaired child can identify the properties of each plastic sheet in regular class activity.

It is advisable to use objects that are easily distinguishable with the light sensor such as clear, very cloudy, deeply colored, colorless. Use four different 4″ × 6″ sheets of plastic red, yellow, clear, cloudy (wax paper). The visually impaired child might have difficulty differentiating between cloudy and colored using the light sensor, but its use with other verbal analogies (clear sky, cloudy sky) could make the total experience worthwhile. To test the four different plastic sheets, have the light sensor at one end of a table with the light source (lamp with 60 watt bulb) about 12″ away, and place each sheet between the light sensor and the light source.

Suggested Adaptations for the Deaf Child

Language cards for: Clear, Cloudy, Colored, Colorless, Starch, Salt, Dye, Mixture.

COMMENTS

This lesson is very exciting for the entire class in its use of the light sensor. The sound of the light sensor may be higher when exploring the cloudy (starch) mixture than the true solution because the particles of the cloudy substance will reflect light.

SALT SOLUTION

MATCH BOX

Suggested Art Match:
Wavy Patterns p. 363

EXPLORATION

To identify the subsystem of a system consisting of salt and water. To observe the evidence of interaction between salt and water. To observe evaporation of a solution and formation of crystals.

SCIENCE CONCEPTS

When a salt solution evaporates, crystals are formed. The outcome of permitting a salt solution to evaporate can be predicted. Schlieren indicates that a solution may be forming.

MATERIALS

For each child

2 salt packets
2 tea bags
2 tumblers
1 magnifier
cardboard trays
2 medicine droppers
2 labels

For the class

1 pitcher of water

ADVANCE PREPARATION

Distribute the materials to each station. Tell the children that one tumbler is for water.

PROCEDURE

Ask each child to examine the tumbler that will hold both bags of salt for a more concentrated solution, and to pour about an inch of water into the tumbler.

Tell them to empty one packet of salt into each tea bag, wet the bag, and quickly stick the bag to the side of the tumbler so that only the bottom edge of the bag touches the water.

Have each child fold the top edge of the bag over the rim of the tumbler, one bag opposite the other for easier viewing. Tell the children to watch the liquid below the bag and to observe the colorless liquid for evidence of interaction. When some children notice the movement of schlieren, put the word "schlieren" on the language board and tell them that schlieren are streaks that form a wavy pattern. Schlieren become visible when two transparent materials mix. *Blind child uses light sensor to follow schlieren (see Figure 3.15).*

Ask the children whether they have ever seen schlieren before. Remind them of the wavy patterns they have seen or felt on a hot highway when warm air mixes with cool air.

Let someone describe the schlieren that form when cold and warm water mix near an ice cube in a glass of warm water.

PROCEDURE—*continued*

Explain that schlieren are evidence that differing materials are mixing together.

Explain that schlieren indicate that a solution may be forming.

Let the children watch until all the salt dissolves. *Identify the evidence of interaction with language card.*

Ask whether what is in the tumbler is a solution.

Let someone suggest that the salt makes a colorless solution. Ask other children to describe the evidence of interaction. *The blind child makes observations with light sensor. Have the blind child report the observations with the sensor (see Figure 3.15).* Ask the children to invert the second tumbler. Tell them to use their medicine droppers to put one or two squirts of the salt solution on the bottom of the inverted tumbler and to label the tumbler with their names. Show how to do this activity.

Ask the children to predict what they will find on the inverted tumblers when the liquid they squirted on the bottom of the tumblers evaporates.

Tell the children to set their labeled tumblers on one or two cardboard trays that you provide.

Set the trays aside in some accessible place where the children can continue to observe the evaporation for the next two or three days.

Ask the children to empty and rinse the tumblers containing the salt solution.

Let them fill the same tumblers more than half full of water.

Give each child five or six shelled peanuts to drop in the water.

Then fill the tea bags with salt and place them on the rim of the tumbler as before, but this time let the bottom edges of the bag rest about an inch above the bottom of the tumbler.

Ask the children to report what happens to the peanuts that had sunk to the bottom of the tumbler (the peanuts will gradually rise as the salt dissolves).

Ask them to observe whether a schlieren pattern forms near the tea bags.

Invite the children to describe their observations and how the peanuts interact with the salt solution subsystem near the bottom of the tumbler.

ADAPTATIONS

Adapted Materials for the Blind Child

Light sensor, brailler and paper, light source or lamp with 60 watt bulb, adapted tray.

Adapted Procedure for the Blind Child

For each visually impaired child, have an adapted tray with a light sensor in the large compartment, one clear plastic cup half filled with water in small compartment 1, one salt packet in 2, one tea bag in 3. There should be a light source behind the tray.

After the child places the tea bag on the side of the tumbler, have him place the light sensor nose directly below the tea bag filled with salt. The schlieren can easily be observed with

change in pitch from the light sensor. Have the child set up a plastic cup for evaporating the salt solution.

Have a braille sheet prepared with three questions and space for answering. Questions: Describe the evidence of interaction between salt and water. Predict what will be on the plastic cup after the liquid dries. Describe what is on the tumbler after the liquid has dried.

The optional activity with the peanut described in Procedure can be done as is, with the visually impaired child using the light sensor. The layering of liquid can also be done if the liquids are of contrasting different colors so that the light sensor is able to detect the different layers of liquid.

Suggested Adaptations

Language cards: Predict, Prediction, Close, Far, Right, Wrong, Schlieren, Evaporation, Layer, Tumbler. What do you think will happen? What happened to the peanut?

COMMENTS

Let interested children do similar experiments with beans, raisins, or wood shavings in combinations of liquids such as corn syrup, salad oil, or liquid detergent, which will layer when added to water. Ask the children to describe the differences between the layered liquids that are destroyed when they are stirred (syrup and water form a solution) and the layered liquids that can be stirred but that return to layers in a short time (oil and water).

PROPERTIES OF FREON

```
┌─────────────────────────────┐
│        MATCH BOX            │
├─────────────────────────────┤
│ Suggested Art Match:        │
│ Candle Making p. 343        │
└─────────────────────────────┘
```

EXPLORATION

To explore the properties of Freon by comparing the liquid with water. To identify evidence to distinguish Freon from water (see Comments).

Caution: Do not inhale Freon. Use in well ventilated room.

SCIENCE CONCEPTS

Liquid Freon and water can be distinguished by their properties. Boiling point is a property of a substance. Different liquids evaporate at different rates. Liquids take energy from the surrounding objects to evaporate.

MATERIALS

For each child

plastic cups
small plastic bags
medicine droppers
cardboard trays
4 paper towels
1 pail of colored water (per group)

For the class

1 can of Freon-11 (**Caution:** see Comments)
1 bottle food coloring
2 tumblers
jar alcohol
projector

ADVANCE PREPARATION

Cover the label on the Freon can with masking tape. Prepare some deep blue colored water in the pails and distribute one to each station. Prepare and distribute trays for each child. Prepare special tray for blind child. Use colored water throughout the entire lesson.

PROCEDURE

Have the children partly fill one of their tumblers with water.

Do the activity with the children. *The deaf child will observe very carefully*.

Using the medicine dropper, have the children drop some of the water on a paper towel.

Ask the children to give evidence that the towel is wet. Invite their ideas on what will eventually happen to the water on the towel.

Squirt a little Freon into each child's plastic cup. Use just enough to cover the raised bottom of the cup. Let the children touch the liquid (Freon) with their fingers. Let them pour some liquid (Freon) onto a paper towel, place the towel/liquid system near a towel/water system, and compare properties of the two systems.

Ask the children to pour the colored water into one plastic bag, pour the liquid into another bag, and compare the fluidity of the two liquids.

Let the children add a few drops of food coloring to the liquids in their separate bags, and describe what happens. Pour the two liquids into one bag and mix them well. Ask the children whether the mixture is a solution.

Direct the blind child to use the light sensor to detect the layering (see Figure 3.15). Call attention to the separate subsystems if children say "yes." Ask the children to examine closely the tumblers containing the liquid. Point out that the liquid has almost entirely evaporated.

Ask the children to use a paper towel to wipe the inside of the tumbler that contained the Freon. Let them describe any evidence of interaction between the Freon and the plastic material of the tumbler.

Tell the children that the liquid is not water, but Freon. *Show the language card labeled "Freon."* Tell the children that Freon is used in refrigerators and air conditioners. Posters showing refrigerator coils and air conditioners would be helpful. Find out if they could relate this idea to the properties of Freon (makes your finger cold).

ADAPTATIONS

Adapted Materials for the Blind Child

1 adapted tray, 1 adapted syringe, 1 light sensor, water dyed deep blue.

Adapted Procedure for the Blind Child

Teams of visually impaired pupils will need more Freon for their explorations. Let them use up the first sample and then give them more. Assist the visually impaired in using medicine dropper, if necessary. Place the light sensor in large compartment of adapted tray so that it can easily be moved between small compartments 1-4 to compare sound differences of liquids. Later, have child pour the deep blue water into Freon tumbler. Then move light sensor up and down tumbler to discover that the two liquids are immiscible.

Provide additional experience with Freon and its properties by giving each visually impaired child a tumbler half filled with rather warm (90°F–100°F) colored water. Each child should put his finger into it so that he knows it is warm. Add some additional Freon to the plastic cup and help them set the plastic cup containing Freon into the tumbler of warm water. The Freon will soon begin to boil, and by placing his hand over or into the cup, the visually impaired child can directly experience the boiling of Freon. Use the results of this activity to further emphasize the difference between Freon and water.

This experiment is recommended for the entire class. This lesson provokes interesting discussions related to the different boiling points of different substances.

Adapted syringe has 10 ridges along the plunger section. The child should fill the syringe by pulling the plunger up slowly. (Caution the children not to pull too hard or the plunger will pop out.) The ridges are now exposed. The child squirts the number of "units" (each ridge one unit) desired by slowly pushing the plunger in and counting the ridges as they disappear.

Language cards: Freon, Alcohol, Evaporation, Evaporate, Boil, What are the subsystems of this solution?

COMMENTS

Caution: Ventilate the classroom while Freon is being used. Avoid inhaling Freon gas. Liquid Freon dissolves some plastic materials, but does not injure the skin. Warn the children not to taste the liquid. Warn them never to taste an unknown liquid and never to breathe deeply of any gas they may smell near a liquid. Do not sniff the Freon. Always handle Freon carefully.

Operate the Freon dispenser like a whipped cream, not a hair spray, dispenser. Push against the side of the nozzle while holding the container upside down. Freon will squirt from the end of the nozzle. Freon interacts destructively with the material of the vials and tumblers, but not with plastic cups, bags and pails.

Caution: The children must *not* taste the liquid. Warn them never to taste any unknown liquid and never to breathe deeply of the gas. Do not put Freon in vials and tumblers, because it interacts destructively with the material of which they are made. Use plastic cups, bags, and pails, which are Freon resistant. The cups to use for the Freon experiment are 4-ounce Sweetheart Plastics, made in Wilmington, Massachusetts.

Keep can of Freon out of reach of all the children. Put in closed cupboard at a high level when not actually being used for distribution.

The authors are well aware of the environmental objections to the use of Freon and the possible hazards if Freon is not handled with caution. However, taking into consideration the small amount of Freon used for the experiments and the safety record we have had in the six years of experiments, we feel that the value of the experience for the handicapped children outweighs by far the objections expressed. Therefore, we have not excluded the use of Freon in our program.

CONVERTING LIQUID FREON TO GAS

Figure 2.46. Blind child and deaf child share the excitement of discovery.

EXPLORATION

To condense Freon gas to form a liquid.
Caution: Do not permit children to inhale Freon. Use in well ventilated room.

SCIENCE CONCEPTS

A liquid can be evaporated to a gas by the addition of heat energy to the system. A gas may be liquefied by cooling or by taking energy away from the system. Different liquids evaporate at different temperatures.

MATERIALS

For each child

1 large plastic bag 9″ × 14″ (Freon resistant)
1 cork stopper
1 cardboard ring—1″ high, 1″ diameter
1 plastic cup (Freon resistant)
1 cardboard tray
1 bucket warm water, 90°F–100°F (for each pair of children)
1 bucket ice (for each pair of children)
paper towels

For the class

1 can Freon-11
1 bottle food coloring

ADVANCE PREPARATION

Prepare one plastic bag of crushed ice or ice cubes per child. Practice closing a plastic bag using the cardboard ring and cork stopper. Double over the top of the bag about two inches. Fold the top of the bag in half laterally three times. Push the folded end through the cardboard ring. Lean the cork stopper against a table or other hard surface and push it into the ring tightly. Distribute the materials to each station.

PROCEDURE

Ask the children to explain what happened to the Freon that disappeared rapidly during the previous session. Let someone mention that the Freon evaporated.

Suggest that although the Freon gas escaped into the air, now they are going to trap the Freon gas.

Have each child practice the process of closing the large plastic bag with the cardboard ring and cork stopper.

Give step by step directions while you are doing it. Have the children do it at the same time.

The deaf child will watch closely and follow the directions. The blind child will listen and follow the directions.

Dispense an amount of Freon to almost cover the raised bottom of the children's plastic cups and show the children how to pour it into the large plastic bags. Have them smooth out the bag to expel most of the air.

Tell them to close the bag as practiced earlier, explaining and demonstrating to the children each step.

Have the children hold the bag by its top so they can see and feel the Freon inside. Help the children fill and close their bags.

Designate the bag, the Freon, and any remaining air in the bag as the system for this experiment. *Show language card.* Let the children name it if they wish.

Elicit the idea that the Freon inside the system is the subsystem they are going to keep track of during the experiment.

Figure 2.47. Listening and observing Freon boiling (blind child left, deaf child right).

Let the children hold a corner in their cupped hands. Ask a child to describe what happens (the Freon boils).

Have each child dip the bag into the bucket of warm water (80°F). Ask the children to describe the evidence of interaction between the warm water and the Freon.

While the children notice that the Freon is disappearing, listen to and use their remarks for a discussion.

The blind child will shake the bag to determine the presence of liquid Freon.

Let the children describe the changes that took place in the Freon subsystem of the Freon-bag system.

Ask where the Freon subsystem is. Ask what the material is in the bag. Some children may ask whether the liquid Freon can be made to appear again. Let them suggest ways to find out, and carry out their tests.

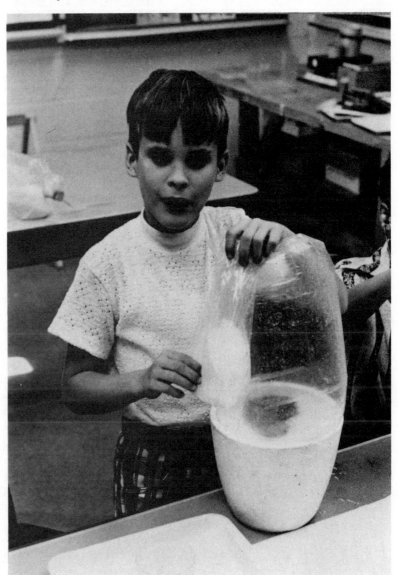

Figure 2.48. By placing bag of gaseous Freon on ice, blind child experiences condensation of gases.

PROCEDURE—*continued*

Some child may suggest placing the bag in cold water to reverse the effect produced by the warm water. If no one suggests this, give a bag of ice to each child. Show and tell them how to place the ice bag on top of the Freon bag (which is now away from warm water) and place the Freon bag into the bucket of ice.

Ask them to look for evidence of interaction between the Freon bag system and the ice bag system. (The Freon gas condenses and the bag collapses.) Discuss where the liquid in the Freon bag system is coming from. Elicit the statement that the Freon gas converted to liquid Freon.

Suggest that they design and carry out experiments to test the identity of the liquid in the bag. To test the identity of the liquid they can drop food coloring into the two bags (the one with ice water and the one with Freon) to compare the interactions.

Mix the contents of the Freon bag system with water, and inflate additional plastic bag with air to see if water from an ice bag will leak into an air bag, or if the air in the bag can be liquefied by surrounding it with ice.

Wait for some children to deny that the liquid now forming in the Freon bag system is water leaking through from the ice bag. Ask for their reasons. Try to elicit the statement that nothing was put into or taken out of the bag after the Freon was placed in it, and therefore the system is still the original Freon bag system, even though the Freon is not always in liquid form.

ADAPTATIONS

Adapted Materials for the Blind Child

1 adapted tray, 1 light sensor.

Adapted Procedure for the Blind Child

Have each blind child work with a sighted peer for this lesson. It is most important that the child feel the large plastic bag and realize that it has been flattened out both before and right after the Freon is poured into it. Have the child use the light sensor when the dyed water and Freon are placed in the bag together. This allows the child to detect the layering of the liquids. Visually impaired children will not be able to see the Freon condensing in the bag. They should be encouraged to listen to other children's descriptions of the phenomenon.

By having them hold the large Freon-filled bag at its lowest corner while the ice is placed on it, they will be able to feel the collected condensed Freon. The heat from the child's hand will cause the condensed Freon to start boiling again and this will be additional evidence of the liquid Freon's reappearance. To clearly describe and explain the changes taking place while some of the Freon is boiling close to the hand and some is condensing due to the ice is a challenging problem for all children. It is discussed with great excitement with their peers.

Suggested Adaptations for the Deaf Child

Language cards for: Liquid, Inflate, Condense, Evaporate, Liquefy, Boil, System, Pressure. Freon gas escaped into the air.

COMMENTS

Caution the children not to squeeze the Freon bag systems because squeezing might burst the bags. However, if it does happen, a lesson may be made around Boyle's Law (even though you do not state it as such), which states that the volume of a gas is inversely proportional to the pressure of the gas at constant temperature.

If the temperature is kept constant, and the volume is decreased (squeezing), then the pressure of the gas increases (bag bursts). This recurrence can be related to squeezing a balloon.

The possibilities of this experiment for additional activities are tremendous, especially when you can relate the evidences of interaction presented in Boyle's Law to the Kinetic Molecular Theory, which explains the behavior of gases. According to this theory, the pressure exerted by a gas results from the combined bombardments of the multitude of its molecules against the walls of the container, just as hailstones pounding down upon a roof exert pressure upon that roof. This is what happens inside the Freon gas bag and in the balloon. Therefore, with this experiment one can lead the child to discover basic concepts concerned with the properties and behavior of gases. Certainly, one does not lecture to the child about theories and laws at this time; the teacher is concerned solely with leading the child to discovery of the concepts expressed by the theories and laws, through laboratory experiences.

WHIRLY BIRDS (Subsystems and Variables)

Figure 2.49. Blind child explores the whirly bird.

EXPLORATION

Activity 1
To experiment with the whirly bird. To identify variables.

Activity 2
To experiment with whirly bird variables. To compare the operation of whirly bird with differing rivet placements, number of rivets, and rubber band twists.

Activity 3
To predict effect of a change in a variable. To experiment to observe the effect of a change in the variable. To analyze and compare data on a histogram.

SCIENCE CONCEPTS
The variables that account for a wide range of experimental results can be identified. Subsystems that fulfill distinct functions can be separated. A variable is a condition that can differ from one experiment to another. The effect of changes in one variable of a simple mechanical system can be determined.

MATERIALS

For each child

1 whirly bird set consisting of:
 base—2 pieces
 1 arm
 1 post with bolt and wing nut
 6 rivets
 1 rubber band
 1 screw eye

For the class

1 number line strip

ADVANCE PREPARATION

Tape the number line strip to the center of the blackboard. Distribute the whirly bird sets to each station. Label the compartments of adapted tray as follows: Small Compartment 1— Post and wing unit, 2—Rubber band, 3—Rivets, 4—Leave blank; Large Compartment—two part base. The arm should have the label "arm" directly attached. Place objects in labeled compartments. Prepare and distribute special trays to the visually impaired children.

PROCEDURE

Activity 1

Have the children assemble and explore the whirly bird system (see Figure 3.13). Allow them to invent different ways of assembling the parts so that the "arm" can turn around like a whirly bird (helicopter).

Have the children in each group show one another how they assembled their whirly bird systems. *A sighted partner works with a blind child.* Some of the children will attach the free end of the rubber band to the wing nut instead of the staple near the bottom of the post. This restricts the turning of the whirly bird arm.

Suggest to the children to find another way in which the rubber band may be attached to the post. As soon as anyone successfully attaches the rubber band to the staple, have that child demonstrate the procedure to the rest of the class. *Use language cards to identify parts of the whirly bird system.*

Have the children explore extensively with the whirly bird. While the children are exploring, ask children in individual groups what variables they discovered that affect the number of turns the whirly bird spins. Have them make a list of variables on paper. *The blind child should make the list using the brailler.*

Begin making a chart on the board listing the variables suggested by the children.

Activity 2

The second activity explores variables affecting the whirly bird system. From the variables chart on the board and the lists kept by the children, have the children devise individual experiments to test the effects of each variable on the whirly bird system. At this point the graph and the histogram are introduced. Explain to the children that they will now use their records to make a histogram for the number of turns completed by the whirly bird arms. *Give each visually impaired child a histogram board or a brailled chart with appropriate braille number lines attached for the x and y axis (see Figure 3.3).*

Demonstrate how each child reports the number of turns completed by the whirly-bird arm. He will depress the appropriate bump on the histogram board if the board is used. *Have a blind child help with this demonstration.* Have the children in the class set up a graph with an x and y axis. The y axis is the number of turns of the whirly bird arm. The x axis may be any one of the variables identified by the children, such as number of turns of the rubber band, number of rubber bands, or position of the arm on the post. Demonstrate very clearly by making a

chart on the board. Make sure that all the children understand the recording procedure involving a histogram.

Have each child select one variable at a time and set up an experiment to find out the effect of the variable on the number of turns of the whirly bird arm.

After each trial, the children should record the number of turns the arm went around on the graph. *Blind child records on histogram board or on graph with the brailler.* Two or three trials should be attempted with each change of the variable the child has selected.

After the effect of one variable has been tested, have the children select another variable.

Have the children start a new histogram.

Discuss with the children in each group the effects of the different variables.

Figure 2.50. Experimenting with positioning and number of rivets in construction of whirly bird (blind child working with deaf children).

Activity 3

Have the children predict how they think the number of turns of the whirly bird arm will be affected if weights (rivets) were added to the arm.

Give each child 6–8 rivets.

Have the children experiment with the positioning and the number of rivets in the arms of the Whirly Bird and observe effect on the number of turns of the system.

Have them record on charts and histograms as in previous activity. Have the children discuss their results.

ADAPTATIONS

Adapted Materials for the Blind Child

Braille labels: Arm, Post and wing nut, Rivets, Two-part base, Rubber band, Number of turns; 1 adapted whirly bird set; 1 histogram board; 1 braille number line in intervals of 5 vertically

from 0–50 for histogram board; brailler and paper; 1 adapted tray.

Adapted Procedure for the Blind Child

Have the children explore the whirly bird system. The adapted whirly bird allows the child to count the number of rotations of the arm by an auditory signal. With each rotation of the arm and post, a straw (on the post) makes contact with a nail (on the base), producing a click. The post has a nail extending from it so that the visually impaired child can easily attach the rubber band to it. A slit must be cut in the base so that the nail and the post can be positioned in the base. Because of a blind child's tendency to lean forward to hear the clicking sound, shorten the arm by four holes.

Provide the visually impaired children with additional opportunities to work with the equipment to identify variables mentioned.

To make sure that the blind child understands, have the class, as a whole, count the rotations of the arm in one experiment together.

Have a braille number line ready for the blind child in intervals of 5 from 0–50. Tape the number line onto a histogram board. Title the number line with the braille label "Number of Turns."

Additional Materials for the Deaf Child

Language cards: Interval on histogram, Rotation, Holes, Variable, Post, Number of rivets, Rubber band, Number of rubber band twists, Chart, Histogram, Position of rivets. Label tray as described for the blind child, or put labels on each part of whirly bird.

COMMENTS

The Whirly Bird experiments are excellent for providing the physical and emotional compensations needed by the exceptional children. The children are led to discovery by clearly defined experiences that provide clarity, organization of thought, and activity in an atmosphere lacking in frustration. The whirly bird was chosen for these activities because it can be easily separated into three subsystems that fulfill distinct functions. This separation helps in identifying the variables that affect the operation of the system. Also, several of its variables are easily measured. The identifiable variables include spinning subsystems in which the children can create different spinning subsystems by including various numbers of rivets. They can vary the positions in which the accepted number of rivets are placed on the rotating arms and maintain the original subsystem. Another source of variable factors is the starter system, which sets the spinning subsystem in motion. This may be the children's hand, a rubber band, or another system the children devise. The scientific significance of the starter system is that it furnishes the energy that sets the spinning subsystem in motion.

Besides providing an opportunity to apply the subsystem concept, these experiments provide data that can be compared

on a histogram, which leads to an examination of the variables in a whirly bird system.

Assembling the Whirly Bird System: Let the children assemble their whirly bird systems by assembling the "two-part" base in the shape of a cross. Place the base so that the cross rests flat on the table. Slip the post through the hole in the top of the base, then lay the arm on top of the post so that the protruding tip of the post pops through one of the holes in the arm. Screw the screw eye in the only small hole in the short axis of the base, then fasten the rubber band into the screw eye with a knot. Hook the loop of the rubber band around the staple in the post.

CONTROLLING VARIABLES

Figure 2.51. Setting up a whirly bird experiment.

EXPLORATION

To describe observations quantitatively and explain in terms of the interaction of objects and subsystems. To isolate the effect of a single variable by systematic experimentation.

SCIENCE CONCEPTS

A system is a whole made up of related parts. When one system is part of another, it is called a subsystem.

MATERIALS

For each group of 2

1 whirly bird set

For the class

chart of variables (number of rivets, position of rivets, number of rubber band twists) or use braille clock time measuring device such as a clock with second hand

chart paper

ADVANCE PREPARATION

Post the chart of variables where the children can refer to it easily. Distribute the whirly bird sets. Prepare brailled list of variables for blind child in the class.

PROCEDURE

Have blind and deaf children work with ordinary children as partners, and the disturbed child with a blind partner. Briefly review the possible variables (number of twists of rubber band, position of rivets, number of rivets) by asking the children what the variables may be. Introduce the idea of timing in an experiment.

Ask them what kind of experiments they would set up to find out what the effect of changing these variables would be on the number of turns in the whirly bird system. Solicit the suggestion that they set up four experiments, each of which will have one of the variables that changes while the other variables do not change.

Encourage the teams who can to proceed on their own.

For those who need help, discuss a few ideas with them. Suggest possible experiments to them, such as placing the same number of rivets on the arm in the same location on two birds, but changing the number of twists of the rubber band.

Suggest that they count the number of turns of the arm per minute and record the results: Number of twists, number of turns per minute. Ask the children how they would conduct the next experiment, which variables they would keep the same, and which variable they would permit to change. If the children understand the idea, let them conduct the experiment. If some children still seem puzzled, continue to discuss controlling variables with them until you are sure they understand.

Suggest that several teams carry out the same set of experiments so they may compare their results. Let these teams construct histograms to show the number of times the arm turned under each condition they explored. *Have the blind child record on histogram board (see Figure 3.3).*

Provide half-inch ruled grid paper for children who wish to graph their results. Help them to decide which factors to measure against each other on the graph, and what units (rivet position versus coasting time) the vertical and horizontal lines will represent.

Let them title the graph with the number of rivets they place on each side and the number of twists of the rubber band.

When some children have graphed three of four experiments, suggest that they predict the coasting time for some inter-

mediate placement of the rivets, basing their predictions on the graph.

Let them test their predictions and record the results.

ADAPTATIONS

Adapted Materials for the Blind Child

Brailled list of variables, 1 adapted whirly bird set, a braille 30 second clock or braille watch with second hand, brailler with paper, 1 adapted tray, brailled graph, sticky tape about 1/8″ wide.

Adapted Procedure for the Blind Child

The child should record with the brailler all data concerned with time, the number of twists of the rubber band, and the number of turns made by the whirly bird arm.

The blind child should make a recording sheet for each experiment. He can do this by brailling the number of twists of the rubber band, the number of turns the Whirly Bird arm makes per minute, and the number of rivets on each arm. He can also record on the histogram board using the prepared braille number lines. Have him use a different histogram for each experiment. The blind child can also record by using a brailled graph, and by using stickers for dots and narrow sticky tape to join the dots.

An adapted 30 second clock operates by electricity and is activated by pressing a starting knob down. The second hand can be set at zero manually. The clock face is in braille.

Suggested Adaptations for the Deaf Child

Language cards for: Controlling, Variable, Whirly bird, Arm, Base, Rivets, Histogram, Number of turns per minute, Number of twists of rubber band, Number of rivets.

PENDULUMS

MATCH BOX

Suggested Art Match:
A Pendulum House p. 380

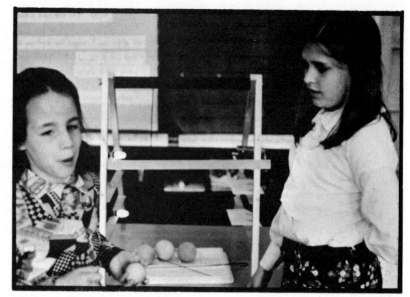

Figure 2.52. Have blind children assist in demonstration (blind child left).

EXPLORATION

To identify the variables that affect the way a pendulum swings: weight of the bob, length of the string, shape of the bob. To explore the different ways to swing a bob other than back and forth.

SCIENCE CONCEPTS

A small massive object suspended at the end of a length of string makes a simple pendulum. Pendulums swing back and forth with such regularity that they are used to control motion of clocks. The time a pendulum takes to swing up and back through small distances does not depend upon its mass nor upon the length of the arc through which it swings. The time of swing depends only upon the length of the pendulum and the acceleration of a freely falling body. Pendulums can be used to measure acceleration due to gravity, which is affected by the densities of underlying formations. A long pendulum swings back and forth more slowly than a short pendulum. The time of one complete up and back swing is called a period.

MATERIALS

These are suggested materials for which substitutes may be used.
For each group of 2

1 pendulum support (could be suspended from ceiling or any school-made support)	7 large steel washers
	1 glass ball, 1″ in diameter
15-yard fishline	9 hooks for wood dowels and wood balls
3 different size wood balls (1″, 2″, and 3″ diameter)	8 eyelets for glass and steel balls
6 different size wood dowels	epoxy glue
	timer (can use the braille timer)

ADVANCE PREPARATION

Set up the pendulum supports at different stations around the room. Assemble and distribute the materials to each station. Set up a demonstration table with the regular and adapted equipment. Put labels on all equipment.

PROCEDURE

Activity 1—Identification of Variables

Give a short demonstration naming and showing how to use the equipment. *Have the blind child demonstrate the adapted equipment while a deaf child works with the regular equipment.* Show the children how to lengthen the string and how to change the bobs.

Invite the children to explore the pendulums. If some children have problems getting started, suggest different bobs, starting the bobs in different ways and in different directions, and shortening or lengthening the length of the line. Give them the challenge of finding out what can be done to a pendulum to change the way it swings. *Make sure that the blind child learns how to use the adapted pendulum support (see Adaptations and Figure 3.6).*

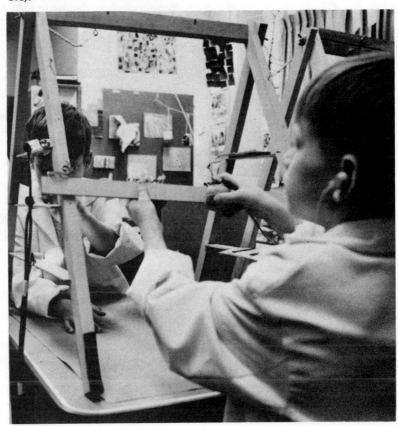

Figure 2.53. Deaf child exploring the adapted pendulum for the blind with the blind child.

Give the children time and freedom to explore on their own. Time the period of exploration according to the interest sustained in the class.

While the children are exploring, interact with individual children at their stations. If they do not suggest, ask whether they can get two pendulums to swing together. If they succeed, sug-

PROCEDURE
Activity 1—Identification of Variables—*continued*

gest that they try to get the two pendulums to swing together for ten swings, then for twenty swings. *See Adapted Procedure for the Blind Child.*

Encourage some children to try to get three pendulums to swing together.

Suggest to other children that they try to shorten the string as the pendulum swings. Let other children shorten the string after the pendulum stops swinging.

Encourage the children to put many bobs on one string to see if weight affects the swing. Suggest to others that they may release the bob so that it travels in directions other than straight back and forth.

Ask some children what happens when they make one string shorter than the other. (The shorter pendulum swings faster than the longer one.)

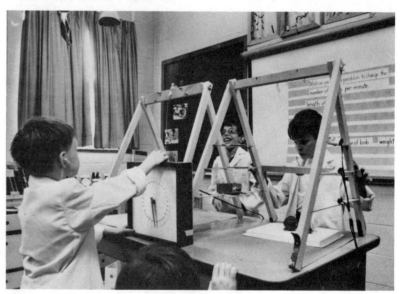

Figure 2.54. Deaf and blind children demonstrating beginning of lesson.

Activity 2—Weight and Shape

Invite the children's ideas on what variables seemed important in their explorations. If no child mentions weight, suggest that they find out how the weight of the bob affects the swing of a pendulum. Ask them to make predictions before doing the experiment. Write the predictions on the board. Discuss their findings. The children should record their findings. *The blind child should record using the brailler.*

Suggest to the children that they try to predict how far the bob will swing to the other side if they pull the bob back and let it go. *Let the blind child let the bob go with one hand and feel where it goes with the other hand.* Let one child on each team hold his hand where the child thinks the bob will reach, *then ask the blind child to pull the bob back and let it go. Have the blind child take turns pulling back and putting his hand where they think the bob will reach.* Suggest that the children try the prediction with different bobs and record their findings. Ask several children to demonstrate their "predictions"

and how successful they were. *Have the deaf child and blind child, with the assistance of a partner, take an active part in demonstrating their discoveries.*

Invite the children to explore whether a heavy bob or a light bob swings out farther.

Suggest they discover whether a heavy bob or a light bob swings for a longer period of time.

Ask them to try to get two bobs of unequal weight to swing together for ten swings. Ask several children to show others what they did to succeed as well as what did not succeed.

Let some children adjust two pendulums of equal weights so that one swings 20 times in the amount of time that the other swings 10 times. Now let them substitute a very heavy bob for one of the bobs and ask them whether the ratio will still be 20 swings for 10.

Invite the children to discuss any of their conclusions about the importance of weight as a factor in affecting the swing of the bob. Try to elicit the statement that the weight of the bob does not affect the time it takes to swing back and forth or the distance it will travel.

Activity 3—Round Trips

Invite the children to explore other ways of swinging a bob besides straight back and forth.

Distribute paper and pencils to each child. *Give the blind child a piece of paper and crayon. Suggest that he press hard to make a raised line.* Suggest that the children place the pencil or crayon close to the bob and follow the bob as it swings, tracing a line on a piece of paper that will show how the bob swung. Suggest that the children try to make the bob go in a circle, in an egg shape, and in a triangle. Ask them to try any other shapes they can think of for the pendulum swing to describe.

Let several children demonstrate unusual shapes.

Ask the children to conduct a race with two pendulums by letting one pendulum swing in a straight line and the other swing in a circle. Ask the children to discover which pendulum returns to the starting point first. Have them time this from the release to return. *Blind child will have the start and return and should time with brailled timer. Help the visually impaired child direct his pendulum.*

Suggest that the children race a pendulum swinging in a straight line with a pendulum swinging in an oval. *Help visually impaired child by directing his hand in a straight line and an oval.* Ask several children which pendulum returns to the starting point first.

Suggest that two children work as a team. Let one child release the bob so that it swings in a big circle. Let the other child time how long it takes to go around by watching the sweep second hand of a clock.

Suggest that the teams compare the times it takes a pendulum to make a circular trip with the time it takes to make a straight back-and-forth trip. Ask several teams to report their results. Write the results on the blackboard. Invite them to dis-

PROCEDURE
Activity 3—Round Trips—
continued

cuss the reasons for the results. Try to elicit the statement that most "round trips" take about the same amount of time as "straight trips."

Suggest to the children that they will play a pendulum bowling game for which they should keep score. *Have the blind child use the brailler.*

The children should set up 10 golf tees in the standard triangular bowling-pin arrangement (four rows of 4, 3, 2, 1, respectively). Suggest that they use a small ball as a bob and try to knock down all the tees in three swings.

Suggest that they "bowl" by using a heavy bob, then a light bob, then a tiny bob, and let them keep score by keeping track of the number of tees knocked down in each three-swing attempt. Tell them to record all their results. If the children are using a pendulum support, the tees can be set up on a desk beneath the support. If they use a ceiling pendulum, they can set the tees on the floor. They can also use a hand-held pendulum and set the tees where convenient. *See Adapted Procedure for the Blind Child.*

ADAPTATIONS

Adapted Materials for the Blind Child

Activity 1

One adapted pendulum support—consists of an ESS pendulum stand with two crossbars between each set of two legs and a starting bar. Cross bars on one side hold the light sensor, cross bars on the other side hold the light source (see Figure 2.55). The adapted pendulum makes use of the light sensor to make it possible for the blind child to see the swings of a pendulum. The sensor gives a steady auditory signal in response to the light of a stationary bulb placed opposite it. When the pendulum swings through, it cuts the light wave, momentarily interrupting the beeping of the sensor and causing a change in the volume and

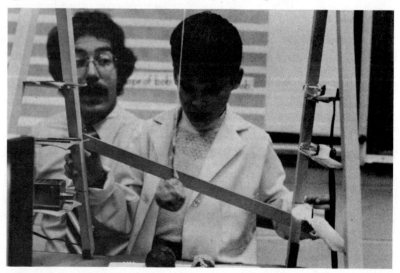

Figure 2.55. Encourage the blind child to explore and become acquainted with materials.

pitch, which is the signal to the blind child. In this manner the blind child can count the swings of the pendulum per unit of time on a brailled timer. Also needed are 1 large tray (15″ × 18″) —cafeteria tray; 1 light sensor; 1 histogram board or 1/2″ raised grid paper for graphing; 1 light source—4 or 7 watt night light with 6 foot electrical cord; 1 braille faced 30 or 60 second timer clock that starts when knob is pressed—stops when knob is released (see Figure 3.5).

Activity 2

Adapted Procedure for the Blind Child

Three tee positioning sheets marked with masking tape.

Encourage the visually impaired child to explore and become acquainted with the materials. Take some time to work directly with the visually impaired child after the period of exploration. Make sure that the child is listening to the sounds of the light sensor and recognizes that the sound is lower each time the pendulum bob passes between the light sensor and the light source. Often the totally blind child has a tendency to count randomly after the bob is released.

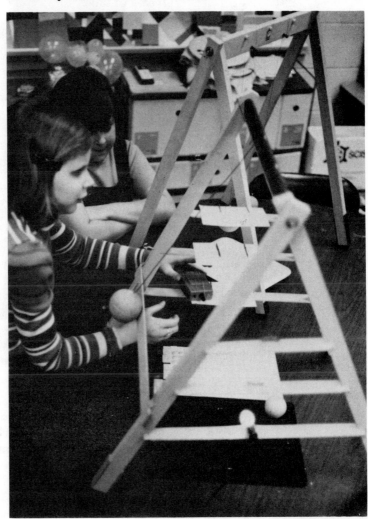

Figure 2.56. Have a sighted partner work with visually impaired child (blind child foreground).

Have a sighted partner work with the visually impaired child. They should both work with the adapted pendulum. Make sure that the sighted child does not take over the control of the equipment, leaving the visually impaired child just counting the number of swings of the pendulum.

When the blind child works with the class in experimenting with more than one string and bob, he must listen very carefully to the sounds of the light sensor. He will know that both pendulums are swinging together when the pitch of the light sensor varies at a periodic rate. If the pitch is erratic, that is a sign that the two pendulums are swinging at different rates.

When the class is working with the golf tees, give the visually impaired child a sheet showing different arrangements for the tees. These are indicated by one inch pieces of masking tape pasted in positions. This way the visually impaired child will be able to locate where he should place the tees. Have the child put one of the sheets on a large tray (15″ × 18″) and set up the tees according to the arrangement on the paper as indicated by the pieces of tape.

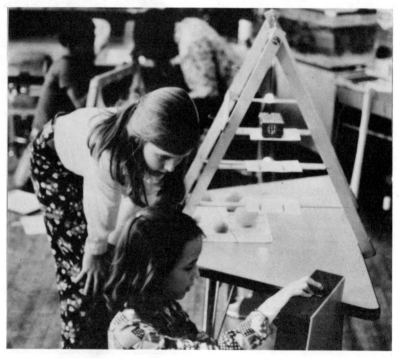

Figure 2.57. Blind child using a brailled timer to time pendulum swings with sighted partner.

The visually impaired child uses a brailled timer when a regular clock is used for timing the pendulum swings. The child should record all data on a histogram board or 1/2″ raised grid paper.

*Additional Material
for the Deaf Child*

Language cards: Short line, Long line, Heavier, Lighter, Pendulum, Bob, Wooden bob, Glass bob, Period, Wood dowel, Slower than, Faster than. Put labels on all parts of the equipment.

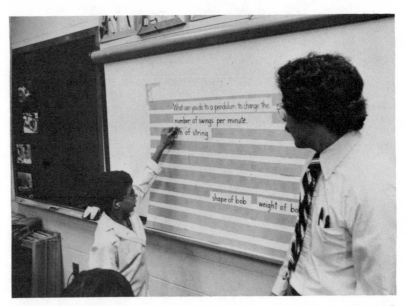

Figure 2.58. Have the deaf child identify activities and concepts with language cards after the exploration and discovery period.

COMMENTS

Intuition will lead the children to expect results that are at variance with what actually occurs. The children may then misread evidence, or seem not to "register" their conclusions, or repeatedly forget or ignore what they see. For example, some children may suppose that a heavy bob will swing much farther out on the other side than a light one will when both are released from the same point. Some children are quite sure that the strings must be of very different lengths if two bobs of different weights are to swing together.

ENERGY

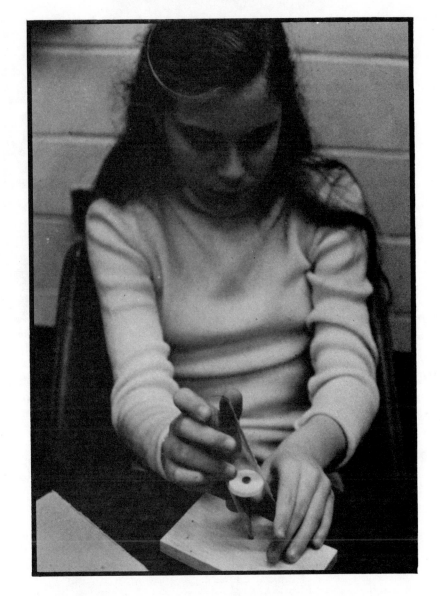

Energy Sources
Energy Receivers
Energy Transfer

EXPLORING ROTOPLANES

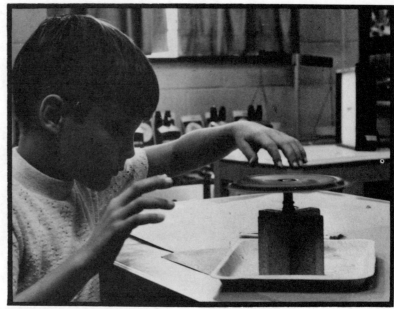

Figure 2.60. Blind child experimenting with rotoplane.

EXPLORATION

To rotate the platform of a rotoplane by transfer of energy from its associated propeller-rubber-band-stick (prs) system. The effect of the number of windings of the rubber band on the prs systems, if other variables are held constant.

SCIENCE CONCEPTS

The process in which an energy source supplies energy to a receiver is called energy transfer.

MATERIALS

For each group of 2

1 rotoplane set, consisting of:
 2 propellers 1 post
 2 sticks 1 colored dot
 2 plastic hooks 1 ramp
 2 rubber bands 1 syringe tube
 1 platform
1 cardboard tray

ADVANCE PREPARATION

Arrange the propellers, rubber bands, sticks, and plastic hooks on a tray for each item. Take the plungers out of the syringes and use only the syringe tubes. Place the platforms, ramps, posts, dots and syringe tubes in a central area where each team can pick them up later. Assemble one rotoplane, without prs systems, as a sample (see Figure 3.12).

Place the ramp section on a table with the wood part flat and the plastic part vertical. Place the syringe tube in the holder of the vertical plastic piece. Insert the post into the hole in the bottom of the platform and attach the combined unit to the

vertical plastic piece by inserting the post into the syringe tube.

Test the platform by spinning it with your hand. Stick a colored dot on the platform to make counting rotations easier. Distribute the prepared trays.

Make language cards, braille labels, and braille number line as indicated in Adaptations. Label all the parts of the rotoplane system for the deaf children in the class. Make braille grid chart as described in Adaptations.

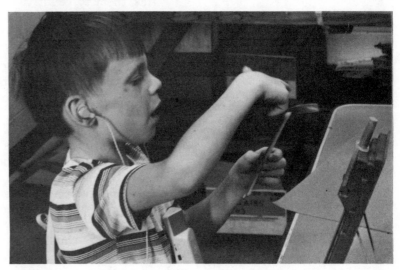

Figure 2.61. *Propeller-rubber-band-stick (prs) system: winding up the propeller.*

PROCEDURE

Activity 1

Visually impaired child should work with sighted child. Have the children assemble the parts on their trays so that the rubber band can spin the propeller after being wound up. Refer to an assembled system as "prs system." Write the words on the blackboard, *have the deaf child place the language card on board*, and point out that it is an abbreviation for "propeller-rubber-band-stick system."

Encourage the children to operate the systems in any way that interests them. (Some will use the system as a fan, others will expect it to fly, others may attach the tray or a piece of paper to serve as "wings.")

Let the children watch one another and discuss their observations informally.

Display the rotoplane you have assembled. *Have the blind child observe it.* Show the children where they can pick up the necessary parts to take to their desks. *Blind child goes with sighted partner if he is not familiar with room.* Invite them to explore and assemble the objects as a rotoplane, together with their prs systems, and then to explore any interesting ways of operating the assembled system. If any team seems to be having difficulty attaching the prs system, show the children how to do so. Do not permit frustration on the part of any child.

Suggest that the children attach a rough colored dot to the platform to use as a reference point for counting rotations. Ask the children to attach one or two prs systems to the platform, wind up the prs systems, release them, and count the number of rotations the platform made after it was released. Lead the children to try different placements for the prs systems, different numbers of prs systems, and different numbers of windings of the systems.

Ask them to count the number of rotations of the platform each time and to record their counts.

Let the children briefly discuss and compare their experiments and observations.

Suggest drawing a histogram. Draw a vertical number line on the blackboard extending from 0 at the bottom to 21 at the top. Tally an X opposite each number for each team reporting that number of rotations. *The blind child should have the braille number line to put on histogram board.* Ask the children to name some of the variables that affect the number of rotations. Write the list on the blackboard. Make language cards and have one of the children put on language board as the variables are suggested. Ask the children to describe the variables in terms of a property and the object to which it refers.

Activity 2

Explain to the children that they will study the effect of changing one variable while keeping all the other variables the same. Lead to the suggestion that they will investigate how winding up the rubber band affects the rotation of the platform. Discuss with the children which variables will remain the same (placement of prs systems, for example).

Ask the children to place their prs systems in parallel slots with the propellers facing in opposite directions. Ask them to count the number of rotations the platform makes when they wind the rubber bands on both systems 40 times, 60 times, 80 times, and 100 times. Have the children record their counts for each experiment.

Suggest that they check their counts at least once for each experiment, then check again if the count differs greatly from the first data.

Ask the children to compute their observations for the four experiments.

Ask several children whether their data were similar when they repeated an experiment without changing any of the variables. Invite the children's ideas on the similarity of such results.

If no child mentions a trend in the data, ask the children why the platform made more rotations in the last experiment than in the earlier ones. Try to elicit the statement that the increased winding of the rubber bands explains the larger number of rotations.

Post a grid chart for the rotoplane data. Label the horizontal axis "Windings of Each Rubber Band" and number the vertical lines from 0–100, letting each vertical line represent ten windings.

Label the vertical axis "Number of Rotoplane Rotations," and number the horizontal lines from 0-15, letting each horizontal line represent one rotation.

Give the blind child the brailled grid chart to mark the data for the four experiments, and have him use the sticky dots to record.

Ask the children to mark their data for the four experiments by marking the number of rotations found in the first experiment along the vertical line for 40 windings, for the second experiment along the vertical line for 60 windings, for the third experiment along the vertical line for 80 windings, and for the last experiment along the vertical line for 100 windings.

When the chart is complete, invite the children to examine it for any trends. Let them discuss the data.

ADAPTATIONS

Adapted Materials for the Blind Child

1 adapted tray; 1 adapted rotoplane set; 1 histogram board; braille labels: Post, Platform, Two-part base, Prs system, Rotoplane system; Number of turns; braille grid with vertical axis—number of rotoplane rotations, and horizontal axis—numbers from 0-15; 1 brailler and paper; braille number line, 1-15 set up horizontally or vertically; sticky dots. (See Equipment Adaptations.)

Adapted Procedure for the Blind Child

Have the prs system already assembled for each visually impaired child. Provide an adapted tray labeled in the following manner: Small Compartment 1—Post, 2-4 (empty); Large Compartment—Two part base. The prs system and platform should be labeled directly and placed in the empty small compartments or large compartment. The adapted rotoplane used consists of the following: 1) a platform with six slots around the edge and a counting ridge, 2) a post with string counting device, and 3) a two-piece interlocking base. Two pieces of the base are interlocked. A post is placed into hole in base. The platform is placed on top of the post. As the platform rotates, the string winds around the post. The children unwind the string and count the number of times the counting ridge hits their fingers (see Figures 2.61 and 3.12).

Whenever a class displays results using a histogram, a braille version of the class histogram (histogram board, see Figure 3.3) should be prepared for each visually impaired child. The visually impaired child should depress the appropriate bubbles opposite the braille number line to correspond with the x's of the class histogram. Have the child record data using brailler.

A *histogram board* is a plastic sheet with raised bumps or bubbles on it. It is used to record data to make histograms. A number line may be placed along the long or the short side of the sheet. A teacher may braille a number line vertically or horizontally. The data are recorded by depressing the bumps next to the appropriate number on the braille number line.

Suggested Adaptations for the Deaf Child

Language cards: Propeller, Sticks, Rubber band, Transfer of energy, Variables, Syringe tube, Rotoplane, Prs system, Data similar, Data different.

TEMPERATURE CHANGE AS EVIDENCE OF ENERGY TRANSFER

+-----------------------------------+
| **MATCH BOX** |
+-----------------------------------+
| Suggested Art Match: |
| Candle Making p. 343 |
+-----------------------------------+

EXPLORATION

To apply the concepts of energy sources, receivers, and transfer to the interaction of systems at different temperatures. To mix warm and cold water. To verify predictions of the temperature of a mixture of equal amounts of cold and warm water from the temperatures of the separate liquids. To compare the amounts of transferred energy as indicated by changes of temperature. To measure temperature in a system using a thermometer.

SCIENCE CONCEPTS

The process in which an energy source supplies energy to a receiver is called energy transfer. Energy is gained by water or other objects when they are heated, and it is given off when they are cooled.

MATERIALS

For each child

2 thermometers (Fahrenheit/Celsius)
4 aluminum cans
1 styrofoam cup
1 cardboard tray

For the class

1 Styrofoam bucket per group of 4
1 bottle food coloring

ADVANCE PREPARATION

Fill necessary number of Styrofoam buckets with water between 120° and 130°, tint the water lightly with food coloring, then keep the lids tightly closed until class. Fill the same number of styrofoam buckets with cold water between 40° and 50°. Place 1 bucket of cold water and one bucket of warm water at each station of four children. Prepare trays for each child and distribute to each station.

PROCEDURE

Activity 1

Tell each child to fill one of the aluminum cans with cold water. Ask the children to measure and record the temperatures of the separate cans of water.

Have the children pour both samples into the styrofoam cups, then record the temperature of the mixture.

Suggest that they represent the experiment and write the second set of data under the first. Ask them to account for any changes between the first and second sets of data in terms of energy transfer.

When all the children have completed their work, prepare a data chart on the blackboard. Write "Cold," "Warm," and "Mixed" as three column headings. *Do the same with language cards for the deaf child. Refer to the brailled chart for the blind child. Blind child uses adapted thermometer (see Figure 3.14).*

Ask the children to report their data. Write the temperature in the proper columns. *Blind child will record data on brailler.* Ask someone to state only the cold and the warm water temperatures. Leave the "Mixed" column blank. Now ask other children what temperature they would predict for that mixture of cold and warm water. Ask any child who makes a prediction to state his reason for the reply. Then invite the reporting children to tell the result, and record it on the board.

Continue recording the data. After every few reports, ask another child to report only the warm and cold temperatures and invite the class to predict the result. Ask the children to explain their reasoning. Then record the actual temperature of the mixture as the children report it.

Ask some children to report the cold and mixed water temperatures only, and let the class infer the warm water temperature. Ask the children to give their reasons for their answers. When all results have been recorded, ask the children to name variables that affect the temperature of the mixture. List the variables on the blackboard or on language board.

Invite the children to describe the energy transfer, identifying energy sources and receivers.

Activity 2

Ask the children to fill the aluminum cans, two cans with hot water and two cans with cold water. Let them measure the temperatures in each of the cans separately and record their findings. Then ask them to pour all four samples into the Styrofoam cup and to record the temperature.

The children may also predict what the temperatures of the mixture will be after they record the temperature of each sample separately. Let them record their predictions, then pour the samples into the cup. Let them measure the temperature of the mixture, write it down, and compare it with their predictions. *Blind child records on brailler.*

Suggest to some children that they may mix various quantities of hot and cold water. Let them use twice as much hot water as cold, measure and record the temperatures separately, predict what the temperature of the mixture will be, then pour the cans together into the Styrofoam cup and measure the temperature of the mixture.

If some children predict that the mixture will be hotter than if equal quantities of water had been used, ask them to give their reasons.

Let the children now use twice as much cold water as hot, and proceed as before. If some children predict that the mixture will be colder than if equal quantities of water had been used, ask them to give their reasons.

Encourage the children to compare their reasoning for using more hot water than cold with using more cold water than hot.

Ask them how they can predict what the temperature of the mixture would be. If any child seems to be suggesting that the temperatures of the three cans of water can be average, help the child to express what he means by inviting the child to make a prediction from another child's recorded data. Let the child compare the prediction with the actual result that the second child had recorded.

ADAPTATIONS

*Adapted Materials
for the Blind Child*

Brailled data chart with headings Cold, Warm, Mixed; 2 adapted syringes; brailler and paper; 1 bimetallic braille thermometer; 1 adapted tray (see Figure 3.14).

*Adapted Procedure
for the Blind Child*

Give each visually impaired child a braille thermometer, two adapted syringes, and a Styrofoam cup. The visually impaired child with his syringe obtains one syringeful each of cold and warm water from the buckets. The child can either read the temperature of the water in the buckets before filling the syringe or a sighted classmate may tell the reading. Both syringes should be filled and emptied twice into the Styrofoam cup. The braille thermometer should be in the cup at all times. Check temperature after each filling. All notes and recording of temperature should be done using the brailler.

The adapted syringe has 10 ridges along the plunger section. The child should fill the syringe by pulling the plunger up slowly. (Caution the children not to pull too hard or the plunger will pop out.) The ridges are now exposed. The child squirts the number of "units" (each ridge one unit) desired by slowly pushing the plunger in and counting the ridges as they disappear. For the children who cannot read the regular thermometer, a special thermometer has been devised. Instead of using the expansion and contraction of a liquid to indicate temperature, the adapted thermometer uses the expansion and contraction of a coil made from a bimetallic strip. The pupil places the coil in the plastic holder into or next to the system whose temperature he wants to measure and waits for the pointer to come to rest. He then holds the pointer in that position, removes the thermometer and reads the dial. Each scale division on the dial represents 10°F.

The pointer moves clockwise as the temperature decreases. The notch represents approximately 70°F. The top section of the thermometer turns so that you can position the thermometer at room temperature before beginning. Either have the children record a change or rise and fall in temperature or, if you prefer, indicate that the notch represents 70°F, and the children can count from there to find other temperatures.

*Suggested Adaptations
for the Deaf Child*

Language cards for: Fahrenheit, Celsius, Energy source, Energy receiver, Energy chain, Ceramic, Cold, Warm, Mixed.

COMMENTS

The procedure of averaging the temperatures is accurate if full cans of water are always used. By using two cans of water at 110°F and one can of water at 50°F, the predicted temperature is 110 plus 110 plus 50 divided by 3, or about 90°F. You can learn a great deal about the children's developing ability to reason abstractly by encouraging discussion of this problem with them.

There is some interesting background information for this experiment. It is discovered in this activity that energy is gained by objects when they are heated, and is given off by objects when they are cooled. This form of energy is called thermal energy. Whenever several systems of differing temperatures interact, they tend to exchange energy until their temperatures are equal or until they are prevented from interacting further. For example, a cold bowl is warmed by hot soup poured into it, and the soup's temperature is lowered by the cold bowl. The system that is initially at the higher temperature always acts as an energy source and gives off heat, while the system initially at the lower temperature always acts as an energy receiver and gains thermal energy. In this experiment, warm water is the energy source. The children, as a result of this activity, apply the concepts of energy sources, receivers, and transfer to the interaction of systems at different temperatures.

MOTION AS EVIDENCE OF ENERGY TRANSFER

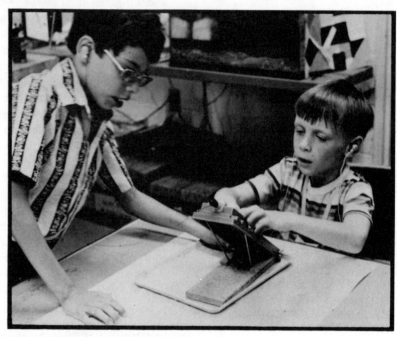

Figure 2.62. Depressing the stopper plunger to release the popper.

EXPLORATION

To experiment with the stopper popper. To identify variables that affect amount of energy transferred to a moving object.

SCIENCE CONCEPTS

Energy that is given off by an energy source is never lost, but is conserved in amount, and always manifests itself in some energy received. Variables that affect the flight distance of a small launched projectile include its speed, the amount of energy transferred to it, the direction in which it is aimed, and the height from which it is launched. The process in which an energy source supplies energy to a receiver is called energy transfer. (See Background Information—Energy.)

MATERIALS

For each group of 2

1 stopper popper set consisting of:
 1 syringe
 1 rubber stopper
 1 ramp

For the class

chart paper

ADVANCE PREPARATION

Choose an area (playground, multipurpose room, cafeteria) where your pupils will be able to work with the stopper poppers on the ground or floor. A space of about 30 feet square without

obstacles is the minimum area. Refer to the area as the "launch area."

Briefly review the use of degrees for describing and comparing angles if your pupils have not measured angles recently. Have all parts of stopper popper labeled for the deaf child. If possible make or have made a poster or overhead transparency showing an example of an energy chain.

PROCEDURE

Blind child and deaf child assist with the demonstration. For this demonstration use the adapted stopper popper with string attached.

Have the children show and name the stopper popper parts one by one. First have them show the ramp, then the syringe, and finally the stopper. Have each part labeled. Snap the syringe tube into place on the ramp, with its open end aiming upward. Have the children set the ramp on a level surface and demonstrate how the angle of the ramp can be adjusted by moving the wire support from one notch to another. Point out that the raised numbers near the notches identify the degrees of angle between the direction of the ramp and the wooden base. Demonstrate how it works.

Pull out the syringe plunger, insert the stopper gently into the tube, aim the stopper popper toward an empty spot in the room, and slowly depress the plunger.

The stopper will pop out and fly in an arc until it hits the floor, then bounce or roll to a stop. Compare results of adapted stopper popper with the regular stopper popper.

Ask the children to estimate the flight distance in feet and in meters. Let the children discuss whether the distance extends from the end of the syringe to a place where the stopper first touched the ground, where it finally came to a stop, or whether it struck an obstacle.

If no child reasons that the place where the stopper first hits the ground is the most valid and reliable end point, because the subsequent bounding and rolling are unpredictable, explain this to the children.

Invite several children to name some of the variables that might affect the flight distance.

Tell the children that they are going to the launch area, but that there are certain safety precautions that everyone must abide by. Warn the children to look carefully before they launch a stopper, never to aim the popper at a person, and to stand behind or far in front of the popper at the moment of launch.

The visually impaired child should work with a sighted partner.

Encourage the children to explore any way to get the stopper to fly that might answer any questions they have.

For any team that finds it difficult to identify the launch distance, suggest dividing the task. Let one partner launch the stopper while the other stands downrange to observe and mark the point of impact with a stone, a stick, or a piece of cloth.

PROCEDURE—*continued*

Call attention to the way the blind child measures the distance with the string on the adapted stopper popper.

After 15-20 minutes, return with the children to the classroom.

Ask several children to describe what procedure they used to get the stopper to fly the longest distance. Let them describe and show their experiments and observations. Invite several children to name the variables that affected the flight distance. Write the variables on the chart paper. *Have blind child record on brailler as you write. Make appropriate language cards for the deaf child.*

When several variables have been recorded, ask various teams to describe their procedures for achieving the longest flight distance in terms of the listed variables. If the children mention additional variables, add these to your list.

Try to elicit some discoveries that will lead to a consensus regarding the variables that affect the flight distance.

Ask the children to consider the variables that affect the amount of energy transferred to the stopper itself.

Underline the variables that the children indicate affect the amount of energy transferred. (Use the chart for the lesson that follows.)

Ask your children to help you describe the launching of the stopper in terms of an energy chain. (One group may believe that the plunger hits the stopper. Another group may believe that the plunger merely compresses the air, which then forces the stopper out of the tube.)

Challenge the class to think of experiments that could enable them to resolve the controversy.

Arrange for a stopper popper contest to see whose stopper can fly the greatest distance. Hold the contest when the class has at least 20 minutes.

Have one measuring tape at the launch area to measure the length of the winning flight.

Require all children to use the same launch point, and give each team two turns.

Appoint two observers to watch each flight and mark the place where the stopper first touches the ground.

Disqualify stoppers that touch an object before they hit the ground.

Visually impaired pupils participating in the contest should use unadapted stoppers. A sighted partner can help them find where the stopper lands and let the visually impaired child measure the distance.

ADAPTATIONS

Adapted Materials for the Blind Child

1 adapted tray, brailler and paper, 1 adapted stopper popper with string attached.

Adapted Procedure for the Blind Child

The adapted stopper popper has a string attached to the stopper. When the stopper is launched, the string can be used by

the child to find where it lands. There is a knot in the string at each one-foot interval, and by counting these knots as he pulls the stopper back in, the child can estimate the distance travelled. The ruler can be used to make more accurate measurements. Stoppers with strings attached will not travel as far as unencumbered stoppers.

The different angles, if possible, should have braille labels taped at each position.

Note: At some settings (almost vertical) a lot more string will go out than the horizontal distance traveled by the stopper. You or a sighted child can discuss this with the visually impaired and help him adjust his measurements. Have the child use the brailler to record observations and answers to any questions.

Suggested Adaptations for the Deaf Child

Language cards: Launch, Stopper popper, Plunger, Flight distance, Energy, Ramp.

COMMENTS

Give your pupils the greatest freedom compatible with safety in the launch area. Some children may believe that flight distance and transferred energy are different terms for the same thing. Others will realize that the flight distance is affected by the launch angle, but that the energy is not.

THE ANGLE OF THE STOPPER POPPER

Figure 2.63. Deaf child tries a new angle.

EXPLORATION

To investigate the effect of an angle at which a projectile is launched on its flight distance. To determine the procedure that results in the longest flight distance of the stopper popper. To review the concept of an energy chain that describes the series of energy transfer during the launching of a stopper.

SCIENCE CONCEPTS

Energy transfer refers to the process in which an energy source supplies energy to a receiver. The angle at which a small projectile is launched influences its flight distance. Energy chain of stopper popper:

$$hand \rightarrow plunger \rightarrow air \rightarrow stopper \rightarrow ground$$

MATERIALS

For each group of 2

1 stopper popper set
1 measuring tape

For the class

chart with list of variables
1 grid chart

ADVANCE PREPARATION

Check the wing nuts on the ramps and tighten them if necessary. Label the grid chart "Stopper Popper." Label the horizontal axis "Ramp Angle in Degrees." Let each vertical line represent 10° but label only 0°, 20°, 40°, 70°, and 90°. Label the vertical axis "Flight Distance in Feet." Let each horizontal line represent 2 feet, but label only 0, 10, 20, 30 and 40 feet. Make a braille graph grid, a braille sheet of G's, and labels as indicated in adapted materials.

PROCEDURE

Briefly review concept of energy chain involved in launching of stopper popper. *Show posters or other visual aids that have raised figures and brailled labels in addition to regular labels (e.g., "Seefee" posters which you can see and feel).*

Lead into the discussion of variables. Show and explain that they will change only that variable while keeping all the other variables the same. Show while explaining that they can find the effect of the angle only if the same amount of energy is transferred to the stopper each time.

Ask a child to explain why all the variables except the angle must remain the same.

Try to elicit the statement that if there were also differences in the amounts of energy transferred, the varying results might arise from that rather than from difference in the angle. Have the child show what he means by doing an experiment where he changes more than one variable.

Ask several children to name the variables that they will keep unchanged.

Tell the children you will want them to record their measurements of flight distance.

Ask them to make two trials for each stopper popper angle of 0°, 20°, 40°, 70°, and 90°.

Tell them to average the data and to enter the average as the record for that angle.

For review, ask one or two children to average some numbers. Be sure that everyone understands how to average. *Have the deaf child show how to average after watching other children do so.*

Ask several children to predict which angle will give the longest flight distance. Write some of the predictions on the blackboard.

Go to the launch site and distribute the equipment there. While the children are taking the measurements, help some children with the measuring tapes if necessary.

Remind those who seem to forget to keep other variables the same while the ramp angle is changed.

When the measurements are complete, return to the classroom.

Break up the class into groups of six for discussion and reporting. Have the children grouped in a circle.

Post the grid chart and ask several children to report which angle gave the longest flight distance.

PROCEDURE—*continued*

Ask the teams in each group to dictate and show on the board their flight distances for all five angles. Mark an "X" for each result on the line referring to that angle. Ask the children at what angles the longest flight distances were found (intermediate angles between 0° and 90°). Ask the children to compare their findings with the predictions they made earlier. Have small groups of six children sitting in a circle discuss their findings.

Suggest a target game to the children. Draw an area on the floor (or place a cardboard box on the floor). The children must hit the target twice in succession from a given spot. Once they succeed, let the children move the target and adjust their stopper poppers to hit the new target position without further trial.

ADAPTATIONS

Adapted Materials for the Blind Child

1 adapted tray; 1 adapted stopper popper with string attached; braille labels for graph—numbers for flight distance in feet and numbers for ramp angle in degrees; 1 adapted tape measure (4 ft) or brailled tape measure (4 ft); braille graph grid—leave inch margin on top, left side, and bottom; braille sheet of G's for plotting on braille graph grid or sticky neoprene rubber patches; brailler and paper.

Adapted Procedure for the Blind Child

The visually impaired child should work with a sighted partner. Ramp angles should be labeled in braille. Visually impaired students who so prefer may use the adapted measuring tape instead of, or in addition to, counting the knots on the stopper string. The visually impaired child may need the help of a sighted partner to straighten out the string before counting the knots. The adapted measuring tape is a regular measuring tape that is stapled in one-inch intervals. The brailled tape measure can be made by taking a regular tape and brailling the numbers using a stylus or brailler. The graphing grid should be set up with an x axis ("Ramp Angle in Degrees") and a y axis ("Flight Distance in Feet") at five-foot intervals. Child should record observations using a brailler.

Suggested Adaptations for the Deaf Child

Language cards for: Angle, Target, Average, Degrees, Measuring tape, Stopper popper, Flight distance.

COMMENTS

You may wish your pupils to practice with the measuring tapes before continuing the stopper popper activities. Suggest that the children measure various room areas, or pieces of furniture. Design some activities to give them practice.

ENERGY TRANSFER FROM SPHERES TO SLIDERS

Figure 2.64. Experimenting with inclined planes: How far will it go this time?

EXPLORATION

To measure and to predict the relative amounts of energy transferred to a sliding object by various arrangements of large and small spheres rolling down an inclined plane.

SCIENCE CONCEPTS

Large spheres rolling down an inclined plane transfer more energy to a sliding object than small spheres do. The acceleration of a body is directly proportional to the net force acting on the body and inversely proportional to the mass of the body.

MATERIALS	For each group of 2	For the class
	1 ramp	chart paper
	1 measuring tape	
	1 slider	
	1 small steel sphere	
	1 large steel sphere	

ADVANCE PREPARATION

Select a smooth-surfaced area large enough to give each team a "slider area" about 2 feet × 6 feet. The areas may be in a large open space, such as a cafeteria, or in the aisles between the children's desks in the classroom. Wood, tile, cement, or blacktop floors are suitable. *Prepare a "slider area" for the blind child as described in Adapted Materials for the Blind Child.*

PROCEDURE

Choose a table or a clearly visible area on the floor for the demonstration. *Use an adapted tape measure or brailled tape measure. Have a blind child show the children how the small steel sphere rolls down the ramp and into the slider, pushing it forward.*

Designate the sphere and the slider as the system for this experiment. *Have the blind child show how to measure the distance the slider moves.* Ask the children to show and describe energy transfer in the system.

Have the children repeat the experiment several times, rolling the sphere at a different speed each time. Ask the children to identify an energy source and an energy receiver in the system *(use language cards).*

Ask the children to construct an energy chain for the interaction of the sphere and the slider. Write their ideas on the blackboard with arrows between the variables that form the chain.

Explain to the children that they will use a ramp to control the direction and speed of the sphere as it rolls, thereby making it easier to hit the slider. Show them that the spheres are to be released from the ramp without being pushed, and that the sliders are to be placed within an inch of the end of the ramp. They may use the large sphere or the small sphere, and they may try various starting positions on the ramp.

Let the children use measuring tapes to measure the distance the slider moved, or let them use markings on the floor (floorboards, tiles). *Use braille tapes for the blind child.*

As the children are working, discuss with them the energy transfer to the slider. Discuss how they can make sure that the same amount of energy could be transferred several times in a row.

Suggest that they find out which variables affect the amount of energy transferred.

If some children want to experiment with angles other than those allowed by the wire support, suggest that they use books to prop up the end of the ramp.

When the children complete their work, invite them to exchange ideas about the energy transfer from sphere to slider.

Ask several children to describe their experiments and observations. *Ask the deaf child to describe his observations by showing what happened as well as telling.*

Ask other children to identify the variables that affect the amount of energy transferred. List these on the blackboard or on chart paper for later reference.

Have the blind child braille the list.

Tell the children that you are going to sketch six different arrangements of the spheres as sources of energy for the sphere slider system, and that you want them to predict which energy source has the greatest amount of energy to transfer and which has the least.

Then sketch the outlines for six ramps, all inclined at the same angle. (A large "V" lying on its side will serve the purpose.) Label the ramps "A" through "F" to designate the six different energy sources, and draw the following arrangements of spheres. *In addition to drawing, set up the arrangements and have a blind child predict from these arrangements by touching each one. If possible, have a sighted partner and a deaf child assist in this activity.*

A. small sphere above large sphere at the top of the ramp
B. large sphere above small sphere at the top of the ramp
C. large sphere alone in the middle of the ramp
D. small sphere alone at the top of the ramp
E. two small spheres at the top of the ramp
F. two large spheres at the bottom of the ramp

Ask the children to predict which energy source will transfer the greatest and which the least amount of energy. *Ask the children to explain their reasons, and to demonstrate on the equipment what they say, thus making it possible for the deaf child to relate to the discussion.*

Ask the children to test each of the energy sources you have sketched and set up. Let them repeat each trial at least once. Ask them to record the sliding distance for each energy source. *Blind child does so on brailler.*

Ask the children to report which energy source transferred the most and which the least amount of energy. Let them speculate about the reasons why some energy sources transfer more energy to the slider than others.

Have the children compare their data. Encourage them to compile the data as histograms to find an average sliding distance from each energy source.

Let the children report the order of energy sources from the greatest to the least amount of energy transferred.

Invite interested children to modify other variables to compensate for the fact that the large sphere will transfer more energy to the slider than the small sphere when both spheres are released from the same ramp position.

Let the children suggest and experiment with these variables: releasing the large sphere from the lower part of the ramp; adjusting the angle of the ramp with books; using the small

sphere repeatedly so that each hit leaves the slider at the position to which it moved previously but realigning the ramp each time so that the next sphere strikes the slider squarely. *Working with a sighted person, the blind child will handle this very well.*

ADAPTATIONS

*Adapted Materials
for the Blind Child*

1 adapted tray; adapted tape measure, or braille tape measure; 1 roll masking tape; 2 meter sticks; braille labels: 20°, 40°, 70°, 90°; brailler and paper; 1 histogram board.

Figure 2.65. Introducing the slider to the blind child.

*Adapted Procedure
for the Blind Child*

When you introduce the slider to the visually impaired child, show him how the bottom of the ramp is placed at one end of the two meter/yard sticks that serve as the track for the sphere and slider to roll through. Tape the two meter/yard sticks to the floor or table horizontally about 4″ apart so that the slider can slide freely between them. A braille or adapted tape measure should be taped or stapled to one of the meter/yard sticks for tracking the distance traveled by the slider during each test. The slider is placed between the two meter sticks against the bottom of the ramp. The child should compute the distance traveled from the bottom of the ramp to the back of the slider. Use a brailler to record observations.

*Suggested Adaptations
for the Deaf Child*

Language cards: Slider, Sphere, Energy transfer, Energy source, Energy receiver. Poster depicting energy chain, energy source, energy receiver.

COMMENTS

The children may separate the variables influencing energy transfer from sphere to slider into these groups: those having to do with energy transfer to the sphere while it rolls down the

ramp, those that relate to the interaction of the sphere with the slider, and those that relate to the interaction of the slider with the floor. After their experiments, the children may agree on which energy sources can transfer the greatest and which the least amount of energy, but they will probably disagree on the intermediate order and on the exact distances the slider moved in each case. The histogram they construct can resolve these disagreements by providing the order of the intermediate cases and also the average sliding distances for intermediate cases.

ENERGY TRANSFER

Figure 2.66. Blind (right) and sighted child explore factors that affect sliding distance of a sliding object.

EXPLORATION

To examine factors that affect sliding distance of a sliding object.

SCIENCE CONCEPTS

If equal amounts of energy are transferred to a sliding object, then the distance the object will slide on a smooth surface depends upon the varying amounts of weight added to the object. The acceleration of a body is directly proportional to the net force acting on the body and inversely proportional to the mass of the body (Newton's Second Law of Motion). Forces other than the applied force may act on an object. Usually these are friction forces that arise from the irregularities in the surface of sliding objects that act as obstructions to motion.

MATERIALS

For each group of 2

1 slider
1 large steel sphere
1 calibrated vial and cap
1 ramp
1 measuring tape (cm)

For each group of 4

1 covered plastic container
sodium thiosulfate crystals

ADVANCE PREPARATION

Fill one plastic container for each team of two with sodium thiosulfate crystals, and cover the containers. Do not let the children taste the crystals, but they may handle the crystals without danger. Snap a capped vial into one slider to make a slider-vial system. Select a second slider. Distribute the other materials to the teams.

PROCEDURE

Show the children the slider and the slider-vial system and ask them to predict the relative sliding distances if equal amounts of energy are transferred to both systems.

Ask the children to explain their predictions. Invite other children to agree or disagree. Leave unresolved questions to be taken up again after the children experiment.

Ask the children to find out whether the weight of the slider affects the distance it slides.

Tell the children to set their ramps at the 20° angle, and to use a large steel sphere on the ramp for an energy source. Remind them to make sure that the sphere transfers about the same amount of energy to the slider in each experiment, and that if they do not control the variables of the energy source carefully, the comparisons they make will not really reflect the effect of the added weight.

Tell the children that the sliding distance should be measured as the distance from the ramp to the rear of the slider, and that it should be measured in centimeters. Have them take two measurements for each weight added and then average the measurements.

Have a deaf child write on the blackboard the following list of weights to be measured: no vial on the slider, empty vial on the slider, vial filled to 10 units, to 20 units, to 30 units, to 40 units, to 50 units. *Have blind child record on brailler.* Let the children proceed independently, but give help if any child requests it.

When the children have completed their experiments, let them graph their data. *Have a deaf child construct a graph on the blackboard. Give the blind child a braille graph.* Call the horizontal axis "Units of Crystals in the Vial," and use each vertical line to represent one of the items on the list of added weights. Call the vertical axis "Average Sliding Distance in Inches," and let each horizontal line represent five inches (from 0–70 inches). Ask one team to read off its data, and mark an X for each reading. Draw a smooth curve to show the trend of the data. *Blind child draws curve with neoprene strips.*

Invite the children to discuss the results of the experiment. Ask several children to explain why the same amount of energy transfer results in shorter and shorter sliding distances when the slider-vial system is made heavier.

Try to elicit ideas about the interaction of the slider with the floor, and about what happens to the energy the slider-vial system receives from the rolling sphere. Some children may question whether the same amount of energy was really transferred to the slider-vial system in all experiments even though they controlled the energy-source variables.

Ask the children how the sphere acquires energy as it rolls down the ramp. Some children will claim that the energy comes from the hand, others that the hand merely lifts and releases the sphere but does not push it, others will refer to the ramp, and occasionally a student may mention that gravity plays a role.

If some children wonder whether the energy transfer to the sliders really changed when the weight of the sliders was in-

PROCEDURE—*continued*

creased, suggest conducting an investigation where they control the energy source but change the surface on which the slider moves.

Invite them to compare a variety of surfaces, always keeping the energy source the same. They might use fabrics such as cotton, rayon, or wool taped to the floor, large sheets of wrapping paper, blotters, freshly waxed tiles, and so on.

Ask several children to describe the results. They will find that the slider moves a shorter distance on a rug than on a smooth floor, and that sand or sawdust on the floor always reduces the sliding distance.

Let the children tabulate their findings and present them to the class.

If a scale or balance is available, suggest that some children may wish to investigate the weight relationships in the experiments. Ask them to investigate whether the ratio of the sphere's weight to the slider's weight influences the distance traveled. (They will find that the lighter sphere will move the lighter slider as far as the heavier sphere moves the correspondingly heavier slider.)

Let the children discover how much the slider, vial, crystals, and spheres weigh. Some child may suggest investigating what effect on the sliding distance is produced by doubling the weight of the slider-vial system, tripling the weight of the sphere, and so on. Let them study any other ratios that catch their interest.

ADAPTATIONS

**Adapted Materials
for the Blind Child**

Sheet of braille G's for plotting on braille graph grid or cut out dots of sticky neoprene; adapted tape measure or brailled tape measure (centimeters); 1 adapted tray; masking tape; braille graphing grid—leave 1 inch margin on top, left side, and bottom; 2 meter/yard sticks; braille labels: Units of crystals in the vial, Average sliding distance in inches, No vial, Empty vial, 10, 20, 30, 40, 50, 20°, 40°, 70°, 90°; braille number line (vertical) top to bottom—45–0 in intervals of 5 (match to graph grid); 1 braille dot strip, made by making K's in a vertical column with a brailler or by cutting out neoprene circles.

**Adapted Procedure
for the Blind Child**

Each visually impaired child should have his own supply of sodium thiosulfate crystals. Place them on an adapted tray and have the child do all measuring and pouring on the tray. The teacher should place the braille degree labels (20°, 40°, 70°, 90°) on the proper angle of the ramp. The teacher should stick a braille dot strip vertically on the outside of a calibrated 14-dram vial. Each dot equals one unit.

The visually impaired child can measure the height of his crystals in the vial by placing the index or middle finger in the vial and the thumb along the dot strip on the outside. Some guidance may be needed.

The brailled or adapted tape measure should be taped or stapled to one of the meter/yard sticks.

Using the graphing grid, the student records with G's or stickers the units of crystals in the vial versus the average sliding distance traveled in centimeters. The x axis is units of crystals in the vial, the y axis is average sliding distance in inches.

Suggested Adaptations for the Deaf Child

Language cards: Slider vial system, Sodium thiosulfate crystals, Slider vial system, Energy was transferred to, Sliding.

DRIVE A NAIL 1

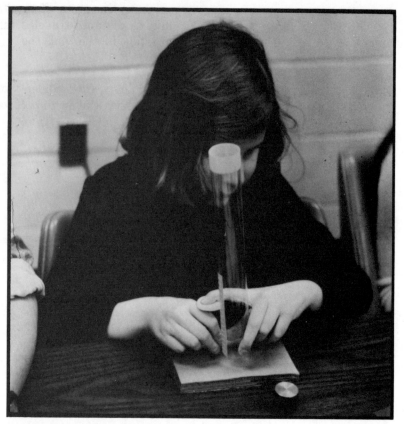

Figure 2.67. Blind child finds out how high the top of the nail is above the block.

EXPLORATION

To find out which of three nails can be driven the furthest into a block.

SCIENCE CONCEPTS

This activity basically deals with the transfer of energy from a falling weight to a nail. The amount of energy transferred is measured by how far the nail is driven into a block of styrofoam. Identifying the variables among various nails, and determining how these variables affect the distance that the nails are driven into a block, are explored.

MATERIALS

16 cm plastic tube, 1 1/2″ diameter
3 nails with plastic tops marked A, B, and C
2 unit weight

Styrofoam block
tray
experiment transcribed in braille

PROCEDURE

Choose a nail and stick it into a block so that it just barely stands up by itself.

Use the measuring scale on the side of the tube to find out how far the top of the nail is above the block. Do this by stand-

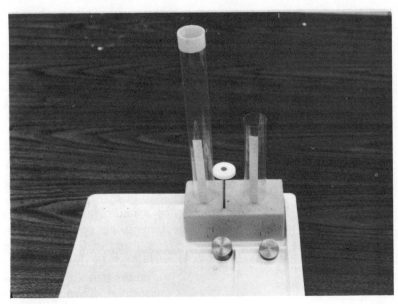

Figure 2.68. Equipment for "Drive a Nail 1."

ing the tube next to the nail and counting the number of raised dots from the bottom of the tube to that point next to the nail's cap.

Record the height of the cap under "Starting Height" on a chart. Be sure to note which nail you are using under "Nail Used."

Place the tube over the nail so that it rests against the block.

Hold the tube in place and drop the weight on the nail from the top of the tube.

Take off the tube, being careful not to disturb the nail, and measure the height of the nail above the block.

Record this under "Ending Height."

Subtract the "Ending Height" from the "Starting Height" to get the distance the nail was driven into the block.

Record this under "Distance Driven into Block."

Before trying the other two nails, examine the nails and list all the differences (the variables) you can find among them.

Which nail do you think will be driven the furthest? Explain why you think this would occur.

Do the procedure outlined for the other two nails. Record your results on the chart. Which nail was driven the deepest?

DIVERGENT ACTIVITIES

Find three ways to increase how far the fattest nail can be driven into the block. You may only strike it once in each experiment.

ADAPTATIONS

Adapted Materials for the Blind Child

16 cm plastic tube with braille measuring scales taped onto the side of the tube; 3 nails with plastic tops marked A, B, and C in braille (see Comments).

Language cards: Nail, Block of styrofoam, Variables, 2 unit weight, Plastic tube, Energy transferred, How is the amount of energy transferred measured? Obtain posters that give visual presentation of variables such as composition of the nail, roughness of the nail, friction between the nail and block material, amount of weight dropped on the nails, height from which the weight is dropped.

COMMENTS

Possible solutions to divergent activities: The student might try any one or a combination of the following: drop a heavier weight on the nail, drop a weight from a greater height, put soap or other substance on the nail, use a hole previously made by a nail. The student may vary any one or more of the above items to get equal distances for the three nails.

A study of the amount of energy transferred occurs in "Drive a Nail 2." In this activity, the student explores with identifying variables (the differences among the nails) and with using the equipment. Throughout the set of activities, the student will find many variables that affect how easily the nails can be driven into a block. These include: composition of the nails, diameter of the nails, roughness of the nails, friction between the nail and the block material, block material, amount of weight dropped on the nail, height from which the weight is dropped. Use histogram board to record data.

Make brailled chart that has columns labeled "Nail Used," "Starting Height," "Ending Height," "Distance Driven Into Block."

Nail used	Starting height	Ending height	Distance driven into block

The lines in this chart are raised. This can be inserted into the brailler.

DRIVE A NAIL 2

```
┌─────────────────────────┐
│      MATCH BOX          │
├─────────────────────────┤
│ Suggested Art Match:    │
│ Metal Into Wood p. 283  │
└─────────────────────────┘
```

EXPLORATION

To find out which helps you the most in driving a nail further: dropping a weight from twice the height, or dropping twice as much weight on the nail.

SCIENCE CONCEPTS

The compensation of two variables in driving a nail, how to increase the transfer of energy in driving a nail, and setting up a controlled experiment are examined.

MATERIALS

1 nail with cap (nail A)
tubes of 8 cm and 16 cm length with brailled measuring scales taped onto the side of tubes
2 weights (a one-unit and two-unit weight)
Styrofoam block

1 nail, 3″
24 cm length tube
three-unit weight
experiment transcribed in braille
recording chart in braille

PROCEDURE

The height from which you drop the weight and the amount of weight you drop are both variables (things you can change). If you want to determine the effect of each variable, you must try to keep everything else the same in your experiment except the variable you are working with.

Using the 8 cm tube, record how far the nail is driven into the block using a one-unit weight (see "Drive a Nail 1" if you do not know how to do this). Record this on a chart.

Repeat the experiment using a two-unit weight, being careful to keep everything else the same. Record your results on a recording chart.

Now repeat the experiment using a one-unit weight, but drop the weight from 16 cm (twice the height). Record your results on recording chart.

Check which helped more in making the nail go farther:

_____Dropping the weight from twice the height
_____Using twice the weight

If you had to drive a nail into a board, which method below would be the best?

_____Having a heavy hammer and using small swings
_____Having a light hammer and using big swings
_____Both are equally good

DIVERGENT ACTIVITIES

Set up an experiment to see how much farther you can drive a nail using three times the weight or dropping the weight from three times the height.

Find the farthest you can drive a 3″ nail by dropping a weight on it only once. You can do anything to your nail driving system, but you can only drop the weight on the nail and only hit the nail once.

Highly recommended: The student finds it interesting to see if it takes more, less, or the same energy to pull the nail out of a block as it took to drive the nail in. This can be accomplished by doing the following:

1. Hook the same amount of weight on the end of the string that was used to drive the nail in (note: a two-unit weight equals 4 ounces)
2. Make the string the same length as the height from which the weight was dropped in driving the nail
3. Use the set-up below to see if the nail can be pulled out with the same force that put it in

Discuss results with class.

Block

table | table

ADAPTATIONS

Adapted Materials for the Deaf Child

Language cards: One-unit weight, Tubes, Weights, Twice as much weight, Twice the height.

COMMENTS

Although the terms "compensation of variables" and "controlled experiments" are never used in the activity, the ideas associated with the terms are implicit in performing the activity. The student finds that 1) increasing the weight dropped on the nail or 2) dropping the weight from a greater height will increase the transfer of energy to the nail. The student will see which of these two is more effective in driving the nail. For the very interested students, have them graph the relationship between increased weight dropped and the distance the nail is driven in. Then have them graph the relationship between the height from which the weight is dropped and the distance the nail is driven in. Ask the student which is more effective in driving the nail: increasing the weight dropped, or the height from which the weight is dropped. (The adapted record boards would be useful for graphing the above relationships.)

ENRICHMENT ACTIVITIES

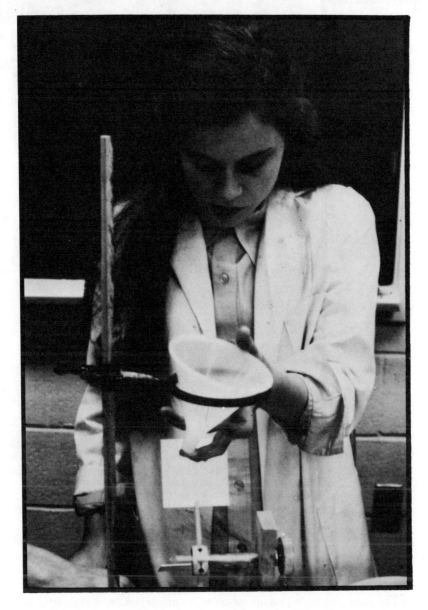

Energy Variables
Science, Sound, and Music
Properties of Light
Independent Activities

ARCHIMEDES' PRINCIPLE

MATCH BOX

Suggested Art Match: Look What Happened to the Paper! p. 287

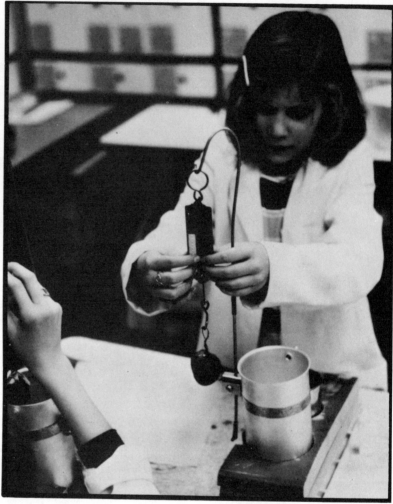

Figure 2.70. Blind child inspecting materials to be used in exploration of Archimedes' Principle.

EXPLORATION

To discover Archimedes' Principle. What keeps a ship afloat? To determine why objects float and/or sink.

Activity 1

What happens to the water level when an object is submerged in a container of water?

SCIENCE CONCEPTS

When an object is immersed in water, the water is displaced. The water level rises.

MATERIALS

container half filled with water
small ball (we used clay), 2″ in diameter, with wire attached
2 balls same size but different weights

large ball, 4″ in diameter, with wire attached
tray
both balls should weigh the same in air

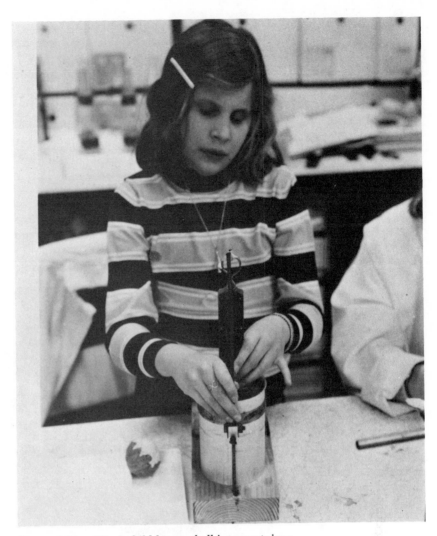

Figure 2.71. Blind child lowers ball into container.

PROCEDURE

Inspect your materials.

Check water level.

Take your small ball and place it slowly into your container half filled with water. Hold onto the wire attached to the ball.

Check water level.

Note any changes in your system.

Remove the small ball. Check water level.

Place the large ball into the container by holding onto the wire. Check water level.

What do you observe? Discuss and record observations.

ADAPTATIONS

Adapted Materials for the Blind Child

Brailler for recording data; 4 furry pipe cleaners; adapted tray. The blind child will check the water levels by feeling the level of the water directly or by putting the pipe cleaner into the water and feeling the height of the water on the pipe cleaner (see Figures 3.7 and 3.10).

Suggested Adaptations for the Deaf Child

Language cards: Float, Sink, Water level, Water displacement.

Science Activities 199

Activity 2

If two objects weigh the same but are different in size (volume), will they displace the same amount of water?

SCIENCE CONCEPTS

Water displaced is determined by the volume of an object, not by its weight.

MATERIALS

Already adapted for blind children.

Archimedes' Principle apparatus

brailled spring scale, 20 g intervals

2 histogram boards (one for small ball and one for large ball)

The balls must weigh the same.

1 clay ball on string, 2″ in diameter

2 clay balls on string, same size

2 clay balls on string, same size, different weights, 1 heavy one and one light one (we stuffed one with aluminum foil)

Figure 2.72. Blind child weighs objects to be lowered into water.

PROCEDURE

Inspect the apparatus.

Your apparatus has an arm that has a spring scale hanging from it. This arm can be moved up and down.

Follow the arm down to the side of the large can. You will find a screw. Loosen the screw with one hand and raise the arm till it stops with your other hand. Tighten the screw.

The arm is in the "up" position.

Now take one hand and gently pull down on the hook on your spring scale.

What happens to the point indicator on the face of the spring scale?

Find the dots on the spring scale face. Each dot is equal to 20 grams.

Use the spring scale.

Weigh small ball and record weight.

Submerge each ball in can filled to the top with water.

What happened to some of the water when you submerged each ball into the large can full of water?

The large can is the over-flow can. We will call the spilled water in the small container displaced water.

How can we find out how much the displaced water weighs? Keep in mind that the small can has weight.

Find out the weight of the water displaced by each ball. (Use pan balance to weigh container plus water and record; pour displaced water back into over-flow can. Weigh the container and record. Subtract weight of container from total weight and record.

Compare with results of other members of the class. Discuss observations.

ADAPTATIONS

Suggested Adaptations for the Deaf Child

Language cards: Water displaced is determined by the volume of an object, not its weight. Volume of an object, Weight of an object.

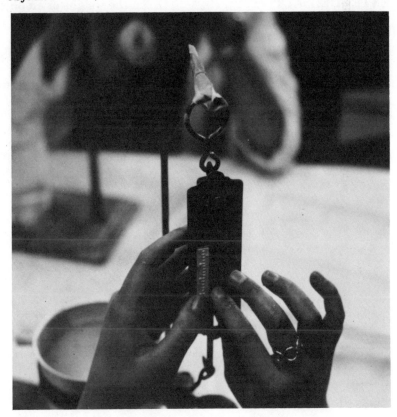

Figure 2.73. Blind child finding the dots on spring scale face.

Activity 3

If you have two objects that are exactly the same size (volume) but one is heavier than the other, what would happen to the water level when each one is submerged separately? What is the amount and weight of water displaced?

SCIENCE CONCEPTS

Objects with the same volumes but different weights displace the same amount of water. The amount of water displaced depends upon the volume of the object.

MATERIALS

Same as Activity 2 except for the balls or objects involved. In this experiment the balls are the same size but of different weights.

PROCEDURE

Same as Activity 2. Discuss and demonstrate class results.

ADAPTATIONS

*Sugested Adaptations
for the Deaf Child*

Language cards: Amount of water displaced, Weight of water displaced, Water level rises, Submerged. Be sure to show the connotations of each language card by using equipment.

Activity 4

Weigh several objects in water. Weigh these same objects in air. Relate the difference between the weight in air and the weight in water of an object to the weight of the water displaced.

EXTENDED ACTIVITY

Given the weight of an object in air, how can we find its weight in water without weighing the object in water?

SCIENCE CONCEPTS

The buoyant force is equal to the weight of the water displaced. The weight of an object in water can be determined by knowing its weight in air and the weight of the volume of water it displaces.

ADAPTATIONS

*Suggested Adaptations
for the Deaf Child*

Language cards: Weight in water, Weight in air.

SOUND TRANSMISSION THROUGH DIFFERENT MEDIA

MATCH BOX
Suggested Art Match: The Sounds and Vibrations of a Branch Harp p. 273

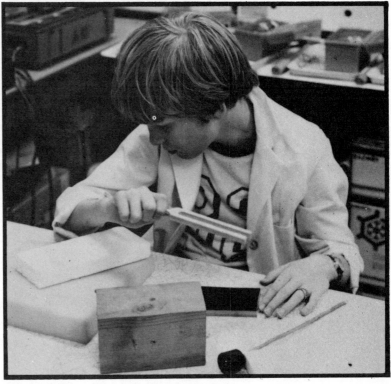

Figure 2.74. *Blind child striking different objects with the tuning fork.*

EXPLORATION

To find out what happens to the sound of a vibrating object when it interacts with different types of media.

SCIENCE CONCEPTS

Sound is physically organized, regular, periodic vibrations of molecules in a medium. The *source* of sound is always some object or system of objects in vibration. In order to vibrate an object must be elastic. A material *medium* is needed for sound to propagate. (See Background Information—Sound and Music.)

MATERIALS

tuning fork
hitting block
different media: plastic block, soft wood, Styrofoam block, clay
 block (1″ × 3″ × 1 1/2″), and a plastic block filled with water

PROCEDURE

Examine your media.
 Take the tuning fork and strike it against the hitting block. Without touching the prongs or dampening the vibration, set the handle-base down on the table. This may be difficult at first so try the procedure a few times.
 What happens to the sound?
 Test different objects around you.

Figure 2.75. Blind child listening to the sound of the tuning fork set handle-base down on block of wood.

EXTENDED ACTIVITY

Find out what the variable factors are that affect the transmission of sound through different media.

PROCEDURE

What are the properties of the different blocks in your media holder?

Test each material to see what happens to the sound when you interact them with the tuning fork.

Arrange the blocks in order of loudness of sound from left (loudest) to right (softest).

ADAPTATIONS

Suggested Adaptations for the Deaf Child

Language cards: Vibrating objects, Different types of media. A tiny watchspring loosely tied to tuning fork shows the different vibrations.

AIR AS A MEDIUM FOR THE PROPAGATION OF SOUND

MATCH BOX

Suggested Art Match:
Vibrating Art Forms p. 375

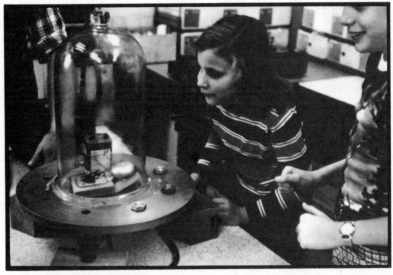

Figure 2.76. *Blind children experiment with sound system inside bell jar to see whether sound propagates through a vacuum.*

EXPLORATION

What will happen to sound when you take air away?

SCIENCE CONCEPTS

A material medium is needed for sound to propagate. The medium may be a solid, liquid, or gas. Sound does not propagate through a vacuum.

MATERIALS

bell jar and plate and hose
stopcock grease
bell and battery system
vacuum pump

PROCEDURE

Explore the science equipment on the table.

Describe the objects.

If possible, identify which objects are the bell jar, vacuum pump, hose, and plate.

On the table now is a bell and battery system. What do we need to do to get the bell to ring?

What evidence of interaction is there to show that the bell and battery are working?

Place the bell and battery (still ringing) on the bell jar plate. Put the greased bell jar over the bell and battery. Keep listening to the ringing bell.

Check to make sure that the rubber hose is connected to the bell jar plate and also to the vacuum pump.

When the vacuum pump is turned on, all of the air is going to be forced out from inside the bell jar. What do you predict will happen?

PROCEDURE—*continued*

What is happening to the sound?

Let air back into the bell jar. What happens?

What did you discover about the relationship between sound and air?

ADAPTATIONS

Suggested Adaptations for the Deaf Child

Language cards: Bell jar, Plate, Hose, Vacuum, Takes air out, Air is a medium for the propagation of sound. The deaf children can feel the vibrations of the bell system. Interacting with the hearing and blind during the exercises provides a valuable learning experience. Not all auditory-impaired children can participate in this activity.

MUSICAL STRINGS

MATCH BOX

Suggested Art Match:
The Sound and Vibrations
of a Branch Harp p. 273

Figure 2.77. Musical Strings: String goes across board over the edge of table where it is attached to weight holder. This blind child is experimenting with three weights attached to weight holder and string.

EXPLORATION

To produce two different tones from the same string when it is plucked.

SCIENCE CONCEPTS

What is the effect of changing the length of a string on the tone produced from a string when it is plucked? The term variable, and how variables should be changed in a controlled experiment, are defined. Other variables that affect the tone produced from a plucked string are identified.

MATERIALS

1 string board
1 string (with looped ends)

1 weight holder
3 weights, 450 g

PROCEDURE

Place the string board (see Figure 2.77) on a table with the long edge in front of you. The rubber pads should be on the table. Take a string and place one of the looped ends around a peg on your string board.

Stretch the string over the board and across the notch on the opposite end of the string board. Move the end of the string board so that the string can hang straight down the edge of the table toward the floor.

Hook the *end* of a weight holder to the free end of the string. Add two weights to the weight holder. Pluck the string with your finger. How can you change the tone of a string?

Now press the string against the string board at a place farther away from the pegged end and pluck the string. Where would you press down on the string to get a higher tone than any other tone you have produced on your string board so far?

What did you change in this experiment?

Something that can be changed is a variable. In an experiment, usually one variable is changed while all other things are kept the same. What was the variable in this experiment?

Name other variables (things) you can change in an experiment that affect the tone produced when a string is plucked.

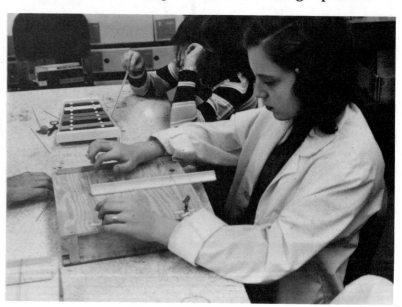

Figure 2.78. Blind child discovers the effect of changing the length of a string on the tone produced from a string when plucked. Other variables that affect the tone produced from a plucked string are identified.

ADAPTATIONS

Suggested Adaptations for the Deaf Child

Language cards: Change length of string, String, Pluck, Vibration, Tone change.

MATERIALS FOR DIVERGENT ACTIVITIES

1 string board
different kinds of string (nylon, wire)
3 weight holders
3 weights, 225 g

12 weights, 450 g
banjo
violin or any other stringed instrument

PROCEDURE

Activity 1

Produce the same tone from two different strings when they are plucked.

Activity 2

Get the same tone from two different strings without pressing the strings against the string board.

Activity 3

Compare your string board to a musical instrument. What do you have to do to this musical instrument to produce different tones?

COMMENTS

The string board has been designed so that it is difficult to flip over. However, unusually rough use of the board could cause it to do this. Be careful that the entire board is always on the table, including the notched end of the board with the rubber padding, and that the student does not pull on the weight holder attachment. Add more weights for greater tension on the string.

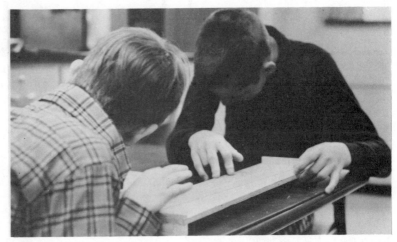

Figure 2.79. Blind children matching the sounds from two plucked strings.

There are several ways to solve Activity 1. One effective way is to set up a second string on the board with an identical number of weights on the end as the first string. Then change the length of one string until it produces the same tone as the second string. If necessary, remind the student of what he learned from the activity (i.e., the shorter the string, the higher the tone produced).

To solve Activity 2, another variable must be found that affects the tone produced from a plucked string. One such variable is the amount of weight placed on the end of the string.

Activity 3 is an open ended activity that has no exact solution. There are many musical instruments that are made of strings. Have the students examine the instruments and produce a sound from them. Have them list what must be done to produce a tone and to change the tone.

INTENSITY OF LIGHT

MATCH BOX
Suggested Art Match: A Building That Never Was p. 260

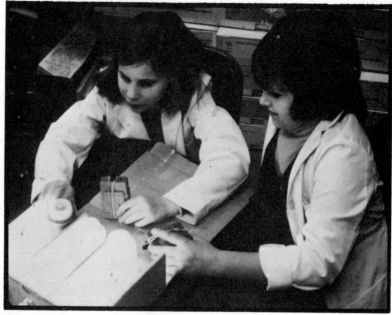

Figure 2.80. Blind child (left) working with a sighted partner to determine the intensity of a light source.

EXPLORATION

To find out which bulb is emitting the most light.

SCIENCE CONCEPTS

A bright light can be distinguished from a dim light by the sounds of the light sensor. The brightest light makes the light sensor produce the highest tone; the dimmer the light, the lower the tone.

MATERIALS

1 light sensor
1 box containing: 3 light bulbs labeled 1, 2, 3 in front of each bulb

stickers labeled in braille 1, 2, 3 (to be used on chart)

PROCEDURE

Put the box containing the three light bulbs flat on the table. Plug in the cord going to the lights in the box.

Turn each light bulb on and make sure that the bulb works. *How can you tell if your light bulb is working? (If the light bulb is warm when you put your hand near the bulb, then it is working.)*

Turn on your light sensor and place it on the line on the bottom of the box leading from one of the light bulbs. It should be against the edge of the wood on the bottom of the box. Be sure that the light sensor is pointing along the line toward the light bulb (see Figure 2.80).

Note the tone given off by the light sensor.

Point the light sensor at the other light bulbs, always being sure to keep the light sensor at the same distance from the light

bulb. You can do this by always having the light sensor against the edge of the wood on the bottom of the box.

COMMENTS

This experiment can be done independently by the blind child or with a seeing partner. The light sensor adds a new dimension to the experience of both the blind and the sighted child. If the light sensor is pointed directly at a light bulb, the tone produced by the sensor depends upon three factors: 1) the distance between the light bulb and the sensor, 2) the amount of light being emitted by the light bulb, and 3) the nature of any material placed in the path between the light bulb and the sensor. It is important to study factors 1 and 2 together, because they can compensate for each other in producing a given tone from the light sensor. An intrinsically bright light far away can produce the same response as an intrinsically dim light close by.

DIVERGENT ACTIVITY

Find out which light bulb emits the least light. Order the bulbs according to how much light they emit and, using the number in front of each bulb, fill out the chart below:

1. _____least light
2. _____
3. _____most light

USING THE LIGHT SENSOR

MATCH BOX
Suggested Art Match: A Building That Never Was p. 260

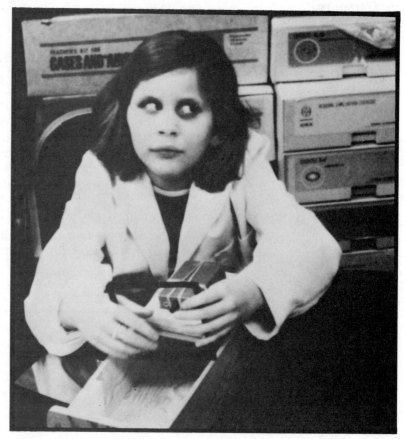

Figure 2.81. Blind child finds ways to make the light sensor give off low tones.

EXPLORATION

To find three ways to make the light sensor give off a lower tone without turning off the lamp or the light sensor.

SCIENCE CONCEPTS

The light sensor is used as a translator of light waves into sound waves. Energy changes from one form to another—light to heat, light to sound.

MATERIALS

1 light sensor
1 light experiment board
1 extension cord (optional)

1 opaque object
transparent materials of varying darkness

PROCEDURE

Plug in the lamp on the experiment board. How can you test to see if the light is on? On the end opposite of the light bulb is the light sensor holder. Be sure that the tube in the sensor is pointing toward the lamp and that the speaker is facing up.

Block the path between the light sensor and the light bulb. An opaque object can be used for complete blocking of the light, or transparent materials of varying darkness can be used for partial blocking.

COMMENTS

This experiment should be done in a darkened room. This lesson is a prerequisite for a series of the nature of light experiments.

BOUNCE THAT LIGHT

MATCH BOX
Suggested Art Match: Aluminum Foil Reliefs p. 379

Figure 2.82. Blind child experimenting with light sensor to find out which card (held in right hand) "bounces" the most light.

EXPLORATION

To find the card surface that reflects (bounces) the most light.

SCIENCE CONCEPTS

Different objects reflect different amounts of light. Using the process of elimination to discover which card reflects the most amount of light.

MATERIALS

4 cards (labeled A, B, C, D; 1 black, 1 white, 2 gray—1 light and 1 dark)
1 experiment board (see Figure 3.9)
1 light sensor
4 small sticker labels (brailled A, B, C, D)

PROCEDURE

Do this experiment in a darkened room.

Turn on the lamp and the light sensor. Aim the light sensor at the light bulb.

Move the wooden dowels as far back from the center of the experiment board as possible so that the light sensor now points down toward the bottom of the board.

Notice the change in the buzz. Is more light or less light picked up by the light sensor?

The light entering the light sensor is not coming directly from the light bulb but is reflected (bounced) off the bottom of the experiment board.

To see how much light is actually coming from the light bulb on your experiment board, turn the lamp off and on, and note how the tone coming from the light sensor changes. Each card reflects a different amount of light. One is black, one is white, and two are gray. Choose one of the four cards. Push it through the slit in the side of the experiment board so it will lie flat on the bottom of the board with the labeled side up. Note the tone coming from the light sensor.

PROCEDURE—*continued*

Place a different card in the bottom of the board and see if your light sensor produces a higher or lower tone than the first card. If it produces a higher tone, then more light is being reflected off the card. If it produces a lower tone, then less light is being reflected. Which card reflected the most light?

Again choose the card that produces the highest tone and compare it to the last card.

The card that gives the highest tone will be the one that reflects more light than any other card. This is the white card.

COMMENTS

The process of elimination used in this activity is an important process in scientific investigation. It gives the student an orderly way to find the card that reflects the most amount of light. The student compares the light reflected by two cards and always eliminates the card that reflects the least amount of light. The piece that the student has at the end of comparing all the cards must be the one that reflects the most amount of light. Many students will try to do this activity by comparing two cards at random. This will allow the students to know which of these two cards reflects the most amount of light, but without an orderly approach the student will have difficulty knowing if he has compared all the cards, and which one reflects the most amount of light.

DIVERGENT ACTIVITY

Find the card surface that reflects the least light. This will be the black card. Order the cards from black to white, and, using the sticky labels, place the letters on the cards, and fill in the blanks below.

1. _____black
2. _____dark gray
3. _____light gray
4. _____white

There are several ways to do this. Since the students have already found the cards to go in blanks one and four on the chart, one possible method is to compare the two remaining cards to see which one reflects more light. The card that reflects the most light is listed in blank 3, and the other in blank 2.

PUMPING PULSE

MATCH BOX

Suggested Art Match:
Lub-A-Dub Paper Chain
Rhythms p. 370

EXPLORATION

To find out if your pulse is faster or slower in different parts of your body.

SCIENCE CONCEPTS

There are several pulse points on your body. Your pulse rate may be the same or different at different points on your body. Are your pulse rate and heartbeat rate the same or different? Does the same relationship occur for other people? The term variable, and how variables are changed in a controlled experiment, are defined. Variables that might make a difference in how fast your pulse beats are identified.

MATERIALS

1 second clock timer, brailled
brailled charts to record data
experiment transcribed in braille

PROCEDURE

Plug the timer into a wall socket. Move the clock hand to zero. Start the clock by pressing the button on top of the clock, and continue to hold it down. The clock will stop when you release the button.

Read the time by feeling where the hand has stopped. Be sure to move the hand back to zero before taking another measurement.

There are several places on your body where you can feel your blood moving. This is your *pulse.* Some common places to find your pulse are: the part of your wrist nearest the palm of your hand, the side of your head between your eyes and ears, just below the ankle bone on the inside of your foot.

Press lightly so you can feel this delicate beating movement. There are other places on your body where you can feel a pulse. Can you find them?

Set the timer at zero. Find your pulse and begin counting as you push in the button. Release the button on the timer when you have counted 20 beats.

Read and record the number of seconds on the timer. Try it again, see if you get about the same time.

Find your pulse at other places on your body. How many seconds does it take for 20 pulse beats? Record your findings under these headings: Place on Your Body, Number of Seconds.

How do these readings compare with your heartbeat? (See "Heartbeat" experiment.)

PROCEDURE—*continued*

Compared to your heart, does your pulse take more time, less time, or the same amount of time for 20 beats? Is this true for everyone? Discuss the results with different members of the class.

What did you find out?

A variable is something that can be changed. In an experiment, you try to change only one variable while all the other things are kept the same. In this experiment, you changed the place on your body where you felt your pulse. The place you felt your pulse was a variable.

Did changing this variable affect how long it took your pulse to beat 20 times?

Another variable that may influence your pulse rate is whether you have been running or sitting. Name some other variables that might affect your pulse rate.

DIVERGENT ACTIVITIES

Activity 1

Find out if your pulse beats faster when you are standing up or sitting down for at least three minutes. Take several measurements.

Activity 2

Find out what happens to your pulse rate after you have been running in place for 20 seconds. Take several measurements. Record pulse rate immediately after running.

Activity 3

Choose another variable and see how it affects your pulse rate.

ADAPTATIONS

Suggested Adaptations for the Deaf Child

Language cards: Pulse, Faster, Slower, Pulse rate, Heartbeat rate, Variables, Controlled experiment, Timer.

COMMENTS

If a student has trouble finding his pulse, suggest that he be sure to use his fingertips only, and that he press lightly. Some students may find it helpful in finding their pulse in their neck to place their hands on each side of their neck so that their hands go almost completely around their neck. If the student only measures his pulse rate once and compares it to a single measurement of his heart rate, he may get different results than if he measures each several times and then compares them. These activities offer a good opportunity to discuss why the measurements of the same phenomenon (heartbeat or pulse) can differ each time. They also provide a good opportunity to emphasize the need to take several measurements and to use an average of the results, or to use that measurement that is between the extremes of your measurements.

HEARTBEAT

MATCH BOX

Suggested Art Match:
Lub-A-Dub Paper Chain
Rhythms p. 370

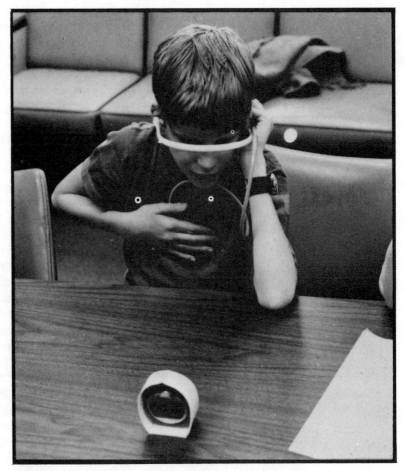

Figure 2.83. "Listening to my heartbeat" (blind child).

EXPLORATION

To find out if the time it takes your heart to beat 15 times is longer or shorter than a person who is taller than you.

SCIENCE CONCEPTS

How many times your heart beats per minute is determined. The term *variable* and how variables are changed in a controlled experiment are defined. Variables that might make a difference in how fast a person's heart beats are identified.

MATERIALS

For each student

1 stethoscope
1 clock timer—braille
alcohol pads (for cleaning
 earplugs)

brailled instruction sheets
brailled charts

PROCEDURE

Practice using the stethoscope. Do not make or let anyone else make a loud noise into your stethoscope. Place the ear plugs into your ears with the stiff U-shaped tube under your chin. The microphone at the end of the flexible tube will pick up sound.

Hold the microphone by the small round disk on the back of the microphone and place the flat surface lightly on the middle of your chest. Put it under heavy clothing or, for best results, directly on your skin.

Listen carefully. Your heart beats softly and makes a "lub-dub" vibration or sound. If you do not hear your heart beating, move the microphone to another place on your chest until you hear it.

Each "lub-dub" is counted as one heartbeat.

Practice using timer. Plug the timer into a wall socket. Move the clock hand to zero.

Start the clock by pressing the button on top of the clock and continue to hold it down. The clock will stop when you release the button. *Read the time by feeling where the hand has stopped.* When the hand goes completely around, 30 seconds have passed.

Be sure to move the hand back to zero before using the timer for another measurement.

To begin the experiment set the timer on zero.

Record the results (data) on chart.

Using the stethoscope, find your heartbeat.

Begin counting as you push in the button on the timer. Release the button when you have counted 20 heartbeats. How many seconds did it take your heart to beat 20 times? Repeat the count two more times. Record your results. How many times per minute does your heart beat?

Sit down quietly and rest for ten seconds. Now count the number of seconds it takes for your heart to beat 20 times. Repeat after resting ten seconds again. Record your results.

Run in place for five seconds. Count the number of seconds it takes your heart to beat 20 times. Try it again. Record your results.

Chart

Number of seconds for 20 heartbeats

	Trial 1	Trial 2	Trial 3
Normal			
After resting 3 minutes			
After running 5 minutes			
What did you find out?			

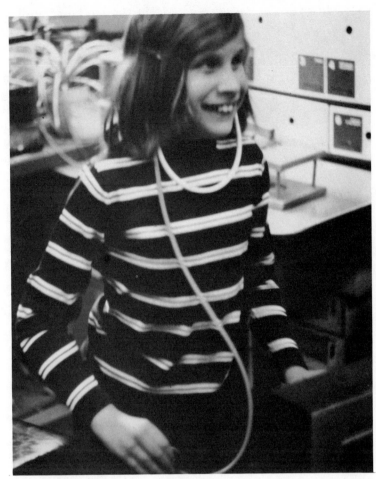

Figure 2.84. Blind child running in place.

A variable is something that can be changed. In an experiment, you try to change only one variable while all other things are kept the same. The variable in this experiment was the amount of exercise.

DIVERGENT ACTIVITIES

Select another variable besides exercise and see if it affects how fast a person's heart beats.

Find out if an animal's heartbeat is faster, slower, or the same as yours. Test more than one animal.

ADAPTATIONS

Suggested Adaptations for the Deaf Child

Language cards: Heartbeat, Variable, Controlled experiment, Heartbeats per minute, Stethoscope. Not all auditory-impaired children can do this experiment. However, those who can will have a profitable learning experience while interacting with the hearing children.

COMMENTS

If the student has trouble hearing his heartbeat, encourage him to concentrate while listening and to place the microphone part

of the stethoscope directly against his skin. The student may count the "lub-dub" of his heartbeat as two separate beats. Be sure that the students are consistent in what they call a heartbeat.

Many students will measure the heart rate of several persons (this should be encouraged), and may find that a taller person's heart does not always beat faster or always beat slower than theirs. This often confuses the student and hinders further investigation. Rather than leave the student in a confused state, have him think about what other variables may affect a person's heartbeat besides a person's height. This confusion should be used to interest the student in doing more experiments (see Divergent Activities).

WATER WHEEL

MATCH BOX

Suggested Art Match:
Cycle-Mill-O-Plane p. 355

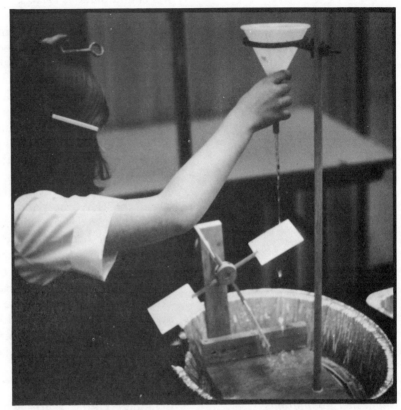

Figure 2.85. Blind child sets up controlled experiment.

EXPLORATION

To find out which will turn your water wheel the greatest amount of times using the same amount of water: a small stream of water or a large stream of water.

SCIENCE CONCEPTS

Effect of different sized streams of water on the number of turns made by a water wheel is examined. Factors that affect energy transfer in a water wheel system are determined. The need for a controlled experiment and experience in setting up a controlled experiment are explored. The slightly different results in repeated trials of an experiment are observed.

MATERIALS

water wheel set up with funnel holder (see Figure 3.8)
2 funnels with different sized openings (adapted)
container for water
large aluminum foil roasting pan
waste bucket and cup for scooping water
rubber tubing and clamp for each funnel
charts to record trial number and number of turns
brailled charts to record results (for blind)
stickers with brailled numbers to record number of turns on
 chart
experiment transcribed in braille

PROCEDURE

In this activity you will pour water into a funnel so that the water coming out the other end will hit the paddles of a water wheel and make it turn.

How to use the water wheel: Place the water wheel set-up inside a sink or large aluminum foil roasting pan and place a funnel into the funnel holder sticking out from the long rod. Be sure that the wheel can turn without the paddles hitting the side of the sink or the bottom of the funnel.

You will find out how many turns the water wheel makes by how many times a string is wound around the water wheel. To get the string in the starting position, find the string attached to the water wheel and pull the string until it is unwound from the water wheel. (Note that one end always stays attached to the water wheel.)

Before pouring water through the funnel, move the paddle wheels so that one paddle is directly under the funnel. Pour the water into the funnel and wait until the splashing stops.

Keep your hand on the wheel with the notch in it (near the end where the string is attached) and count the number of times the wheel turns as you pull on the string.

Now you are ready to start the first experiment.

Increase the height of the funnel one unit at a time (the units are marked on the stick holding the funnel holder), and find out what happens to the number of turns made by the water wheel. Record your results.

ADAPTATIONS

Suggested Adaptations for the Deaf Child

Language cards: Water wheel, Small stream of water, Large stream of water, Number of turns, Funnel, Rubber tubing, Clamp. Determine the effect of changing the size of the stream of water.

COMMENTS

This activity deals with the conversion of potential energy (the water in the funnel) into kinetic energy (the water as it falls, and the turning of the water wheel). The amount of energy transferred is measured by determining how many times the water wheel turns. The student is shown how to perform a controlled experiment while determining the effect of changing the size of the stream of water. The student should set up controlled experiments involving other variables. The variables in this activity can be organized into two categories (this is only a partial list):

Variables associated with the material turning the water wheel	Variables associated with the water wheel
the material poured into the funnel	the number of paddles
the amount of material poured into the funnel	the length of the paddles
the height of the funnel	the area of the paddle's face
the size of the opening in the bottom of the funnel	the weight of the paddles

DIVERGENT ACTIVITIES

Graph the relationship between the height of funnel and number of turns. This can be done by using a graph for the sighted child and a brailled graph with stickers for dots for the visually impaired. Determine the optimum height to place the funnel to get the greatest number of turns. Examine the effect of different length paddles with number of turns made by a water wheel.

Have a contest among all the students in the class to see who can get their water wheel to turn the greatest number of times with a given amount of water.

COILS

MATCH BOX

Suggested Art Match:
Expressing Magnetic Lines
of Force p. 331

Figure 2.86. Blind child (left) explores electromagnetic interactions with sighted partner.

EXPLORATION

To find out which magnet picks up more metal disks: one with 50 coils of wire or one with 25 coils.

SCIENCE CONCEPTS

A moving charge produces a magnetic field. (Current in the coil is accompanied by a strong magnetic field.) Each loop in a coil interacts with the magnetic field produced by other loops in the same coil. A coil with a large number of loops produces a strong magnetic field.

MATERIALS

For each child
2 dry cells, 1 1/2 volt
2 nails, 3 1/2″
 (in a cup)
electrical or adhesive tape
2 pieces of wire 30 cm each

40 paper clips
small metal disks
experiment transcribed in
 braille
adapted tray

ADVANCE PREPARATION

Teacher should scrape off 3/4″ insulation from each end of wire. Prepare adapted tray by putting each object in separate compartments of tray.

PROCEDURE

Wrap 50 coils of wire around one nail and 25 coils around another. For the first part of the experiment, use the battery and the nail wrapped with 25 coils of wire.

Tape one end of the wire to one end of the battery, and the other end of the wire to the other end of the battery. Be sure that the wires are taped in the center of the ends of the battery and that the wires are held tightly in place. You have now made a magnet called an *electromagnet*. See how many of the disks you can pick up at one time with the big end of the nail.

Repeat the experiment using the nail wrapped with 50 coils of wire. Blind child records on histogram.

Which nail picked up more disks?

There is only one thing different between the two parts of this experiment. What is the difference? This is the variable that is changed in this experiment.

If you wanted to pick up more disks than you did before, what do you think you could do to your magnet set-up?

ADAPTATIONS

Suggested Adaptations for the Deaf Child

Language cards: Coils, Magnetic field, Current in the coil, Number of loops, 1 1/2 volt dry cell, 3 1/2 volt dry cells, Small metal disks, Insulation. Which magnet picks up more metal disks?

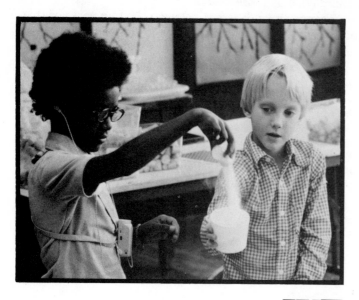

WE
LEARN
TOGETHER

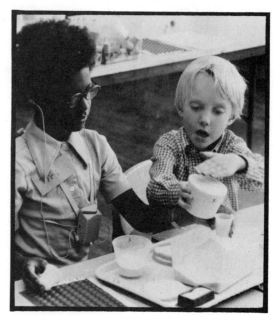

AND
FROM
EACH OTHER

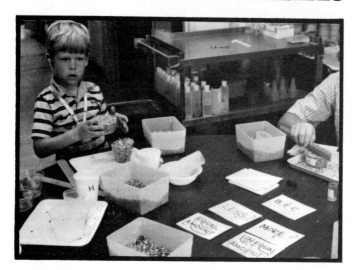

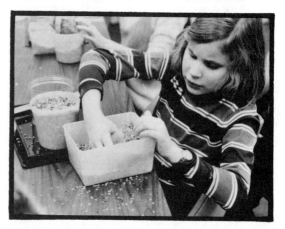

Section III

BACKGROUND INFORMATION

MATTER, MASS, AND WEIGHT

Chemical and Physical Properties of Matter

How can you tell whether the king's crown is real gold? How can you tell if the solution you have has salt in it? Can you take the salt out of your soup and still save the soup? Do you weigh the same on the moon as on earth? Why does Freon boil in a bag in your hand? Can you make water boil by pouring cold water over it in a closed system? The answers to these and an infinite number of more questions can be found in the properties of matter and in the concepts of energy and change. Matter and energy are two of the fundamental concepts of science. What do these terms mean?

Long ago, some unknown cave man made the first accidental discoveries about matter. Perhaps he tried to kick a stone or a piece of wood out of his way. If the object was small and not too heavy, the force of his kick sent it flying. However, an object at rest resists being set into motion. The heavier it is, the more it resists. If the stone was too heavy, the cave man's foot did not move it. Instead, the stone suddenly stopped the foot.

Objects in motion, like the foot, resist being stopped. It took energy to stop the foot—the same energy that would have sent the stone flying had it been light enough. That energy was concentrated at the point where the foot hit the stone.

The result was one unmoved rock, one aching toe—and, maybe, the birth of an idea.

It was Isaac Newton who gave this idea a name: inertia. Newton observed that an object at rest tends to stay at rest, and an object in motion tends to stay in motion, unless they are acted upon by an outside force.

All matter, whether solid, liquid, or gas, possesses inertia. The rock resists being kicked. If

you belly-flop into a pool, you get a painful demonstration of the inertia of water. The inertia of the air that fills a parachute is life-saving: it is what slows the parachute down.

The actual quantity of matter in any body is measured by its mass. It is the mass of a body that is responsible for both its inertia and its weight, and both are proportional to the mass. The masses of bodies can therefore be measured by a comparison of their inertias or of their weights. It is difficult to make a direct comparison of the inertias of bodies. Weights, however, are readily measured.

The weight of a body is a force—the attractive force (gravitation) that the earth exerts on the body. Because it depends upon the distance of the body from the center of the earth, the weight may vary from place to place, whereas the mass of a body is constant. The body of the astronaut in space still has the same amount of stuff in it, but weighs less. As a matter of fact, he is weightless in space. At any given place, however, the weights of equal masses are equal.

One of the properties that is commonly employed to distinguish among various kinds of matter is density, or mass per unit volume. Similarly, many other specific characteristics enable us to recognize and distinguish among substances. A housewife may at times distinguish her starch from powdered sugar by taste. Alcohol usually enables one to recognize it by its odor, and the color of copper is a clue to its identity. Mercury can be recognized by its physical state because, of all metals, it alone is a liquid at room temperature.

Solubility, luster, melting point, crystal structure, boiling point, hardness, elasticity, malleability, ductility, tensile strength, refractivity, conductivity for heat and electricity, and specific heat are other commonly determined properties of matter. These properties are called physical properties, because they can be observed without changing the substance into some new kind of matter by altering the molecular structure.

Those properties that can be observed only when the substance undergoes a change in composition, like molecular structure, are the chemical properties of a substance. A student brings in a rock and with great excitement says he has found gold! The physical properties of pyrite (fool's gold) and real gold are very similar—how can the two be distinguished? They are chemically readily distinguishable; gold will not react

with nitric acid, whereas pyrite reacts with the acid to give a soluble product, ferric nitrate, and a residue of insoluble sulfur. Such properties as the capacity of iron to combine with oxygen to form iron oxide, and of iron oxide to react with coke to produce metallic iron and carbon dioxide, are chemical properties as well.

All the various forms of matter can be divided into three principal kinds of matter: elements, compounds, and mixtures in the category of substances. A substance may be defined as a synonym of matter—anything that occupies space and has mass. Pure substances, such as iron, sulfur, salt, and sugar, are uniform in properties and composition throughout and are therefore said to be homogeneous.

When sugar is dissolved in water, a mixture of substances that is a type of homogeneous matter is produced. This homogeneous mixture of two or more substances is called a solution. A true solution is a uniform, physically stable mixture of the smallest particles—atoms, ions, molecules—from two or more substances. There are several possible kinds of solutions such as gas in liquid (soda water), liquid in a liquid, solid in a liquid, and gas in a gas. Specific properties of a solution such as density, freezing point, boiling point, and refractivity vary with the proportions of the substances making up the solution.

A true solution is a homogeneous mixture. However, there are many mixtures that are heterogeneous. They consist of two or more physically distinct portions that are different in properties and composition, such as sand and salt.

One can easily separate salt from sand in a finely ground mixture of the two by adding water to dissolve the salt and then filtering or decanting the solution from the insoluble sand. The salt solution, even though homogeneous, can be separated into its components by evaporation of the water, leaving the salt crystals as a solid residue. Sugar, in the refining process, is recovered from aqueous solutions by evaporation of the solvent water. Soda water is a solution of carbon dioxide in water. The carbon dioxide separates (escapes) from the solution when the pressure is lowered.

Water and salt are both pure substances; each has a composition that does not change. However, water and salt can be broken down (decomposed) into two simpler substances by electrolysis. If an electric current is passed through water, the amount of water is steadily decreased, and bubbles of gas are liberated at both electrodes. The gas collected at the positive electrode can be proven to be slightly heavier than air; it can be proven that such substances as sulfur and iron burn in it with great brilliance and that it sustains life. This gas is oxygen, the most reactive constituent of the atmosphere.

The gas that can be collected at the negative electrode is much lighter than air. Balloons filled with this gas rise rapidly. The flame of a burning splint thrust into it is immediately extinguished, and the gas itself catches fire. This very light combustible gas is hydrogen. The demise of the Graf Zeppelin (dirigible) was due to this property of hydrogen—it was filled with hydrogen gas that ignited and blew up! By analysis it is known that water (H_2O) always contains 88.81 percent oxygen by weight and 11.19 percent hydrogen.

Many other pure substances can be decomposed by just being heated. An interesting decomposition to observe is when the bright red solid mercuric oxide decomposes to form mercury, a shining liquid, and the gas oxygen. This process of a pure substance breaking down into two or more simpler constituent substances is called decomposition. The reverse of this process, which is called synthesis or combination, is another form of chemical change. When iron and sulfur are heated, the product is iron sulfide; i.e., the iron combines with the oxygen of the air to form the more complex iron oxide. As described above, a pure substance that can be broken down by chemical means into two or more simpler substances is called a compound. Conversely, any pure substance that is the sole product resulting from the chemical combination of two or more other substances is a compound. More than a million different compounds are known. For convenience, compounds are often subdivided into two classes: 1) organic, or carbon- and hydrogen-containing, compounds and 2) inorganic compounds, those that do not contain carbon.

Substances such as chlorine, oxygen, magnesium, hydrogen, iodine, and sodium cannot be broken down into simpler substances, nor can any one of them be formed as the only product of a reaction involving two or more other substances. Simple substances such as these, that are never decomposed in any chemical reaction, are called elements. All of the many forms of

matter are composed of elements; today there are 102 known elements.

Most of these elements have been discovered during the last century and a half. Among the best known are such common metals as iron, aluminum, zinc, lead, copper, tin, and mercury. Familiar nonmetallic elements are solids such as carbon, sulfur, phosphorus, and iodine, as well as such gases as oxygen and nitrogen.

Each element is represented by means of a symbol. Usually the symbol consists of the first letter (capitalized) in the name of the element, or the first letter (capitalized) followed by an appropriate second letter. Thus carbon is represented by C, chlorine by Cl, calcium by Ca, oxygen by O, and hydrogen by H. When this system was first proposed by Berzelius (1779–1848), the Latin names for several metals were used. This can be recognized in such symbols for the early known elements as Fe (from the Latin *ferrum*) for iron, Cu (*cuprum*) for copper, Au (*aurum*) for gold, and Ag (*argentum*) for silver. The symbol W (*wolfram*) for tungsten is derived from the German name.

PHOTOSYNTHESIS

Life and the Electron

Once upon a time, a crackpot inventor took motion pictures of logs burning in a fireplace. The motion picture went on and on—from the time the logs were first set ablaze to the moment when the last flame flickered out over a pile of ashes. Then he ran the film backward, before an audience of distinguished scientists. First there were the ashes. Flames appeared among them and grew brighter. Wood began to build itself up from the ashes. And at the end of a long and monotonous film, the last flames sank into the logs as the last ashes turned back into wood.

"See," said the crackpot to his audience, "I have solved the energy problem. All we have to do is find a way to run a fire backwards!"

"It's been done," said one scientist sourly, "by the trees that made your logs, as well as by other green plants. And it's called photosynthesis."

The story is a fable. But the scientist was right. Let's see why.

Photosynthesis means "putting together with light." That sums up what the process is all about. Put in the form of a simple equation, the overall photosynthetic equation is this:

$$6CO_2 + 6H_2O \xrightarrow[\text{chlorophyll}]{\text{light}} C_6H_{12}O_6 + 6O_2$$

(carbon dioxide+water+energy from sunlight yields oxygen+carbohydrates).

We know today that the above does not describe the actual photosynthetic reaction. Contrary to what the equation suggests, carbohydrates are not formed simply by mixing carbon dioxide and water; the product of such a combination would be only carbonic acid. The above is merely a vague statement of input and output. It indicates what kinds of materials go into photosynthesis and what kinds come out, but it does not, for example, give quantitative information concerning these materials. It does not indicate the amount nor the kind of light required, and it does not specify the requirement of living cells with intact chloroplasts. Most important of all, the statement does not show the many intermediate processes now known to occur between input of carbon dioxide and water, and output of oxygen and carbohydrates.

Carbohydrates are a basic fuel of life. All plants and animals use carbohydrates as a main source of the energy that keeps life going, but only green plants can manufacture carbohydrates.

How is energy obtained from carbohydrates? Both plants and animals combine the carbohydrates with oxygen (oxidation) from the air to get energy (this process is what respiration is all about). Plants use only a small part of the carbohydrates they make as an energy source. The rest is stored in the plant as starches and sugars. "Carbohydrate" is the general chemical name for these substances.

Energy is derived from carbohydrates according to this equation: $C_6H_{12}O_6 + 6O_2 \rightarrow 6CO_2 + 6H_2O$ (carbohydrates+oxygen yields carbon dioxide+water+energy). This equation also does not cover all the intermediate steps in the process. That would be far too complex, and we are not writing a treatise on biochemistry. However, we will later take a somewhat closer look at the process.

You can see that the second equation is the exact reverse of the first. The second equation describes cell respiration. Respiration is a slow, controlled oxidation (burning) that takes place within body cells. The energy released by res-

piration comes from the energy of sunlight "trapped" by green plants.

What does this mean? We've seen that when carbohydrates are oxidized, carbon dioxide and water are formed, as well as energy. Thus, these two substances may be thought of as the "ashes" of respiration—what is left after the carbohydrate is oxidized. By the same token, photosynthesis may be said to "unburn" these substances and turn them back into carbohydrates.

Therefore, the scientist was right. The crackpot's movie was just a stunt, but the ingenious chemistry of nature in the cells of the plant can turn the stunt into reality. The stunt does make a very important point: to reverse an oxidation process (to make it run backwards) you have to put the "flames" (energy) back into the ashes, thus transforming them back into fuel. However, that must happen according to a very strict "rule" of nature—conservation of energy. The plant must use as much energy to synthesize carbohydrates, in photosynthesis, as was released when the carbohydrates were oxidized in cell respiration. The plant gets this energy from sunlight. It converts the energy of sunlight into chemical energy—the energy that bonds the atoms of the carbohydrate molecule together. The energy is stored in the chemical bonds of the carbohydrates.

The synthesis of carbohydrates in photosynthesis takes place in a tiny fraction of a second. Scientists have spent years finding out what goes on inside the plant cells during that time. They still do not have the complete story. They do know that three basic things happen during photosynthesis:

1. Water (H_2O) is split into hydrogen and oxygen (photolysis), and the oxygen escapes into the air
2. Hydrogen molecules (H_2) are moved into contact with carbon dioxide molecules (CO_2)
3. Carbon dioxide and hydrogen are combined to form carbohydrates, e.g., glucose ($C_6H_{12}O_6$)

How does the plant convert light energy into chemical energy? It does so through the action of the chlorophyll found in the leaves of the plant. The chlorophyll acts as a catalyst. It uses the energy of sunlight to make our second equation run backwards. As a catalyst, the chlorophyll itself is not permanently changed in this reaction.

What happens when light of sufficient energy strikes a chlorophyll molecule? The energy of all but the green light waves is absorbed. The result of this absorption of red-orange and blue-violet light is that the chlorophyll molecule becomes excited.

When this happens, the electrons of the atoms that make up the chlorophyll molecule are affected. All atoms normally possess a given number of electrons that orbit around the atomic nucleus at given distances. If such an atom absorbs light of sufficient energy, one of the electrons may be displaced from its normal orbit to a new orbit farther away from the atomic nucleus. This new orbit is of a higher energy level. The atom is then said to be in an "excited," or more energetic, state.

Red light has just sufficient energy to excite chlorophyll. Blue-violet is absorbed, some of the energy excites chlorophyll, and the excess energy of the light dissipates as heat. The chlorophyll atoms trap light energy by becoming excited.

This excited state lasts an incredibly short time—on the order of 10^{-10} sec in the case of chlorophyll. Almost as soon as an electron of an atom moves from its normal orbit to an orbit farther away from the atomic nucleus that is a higher energy level, it jumps back into its normal orbit. The atom may undergo repeated excitation-deexcitation cycles of this kind.

When the electron returns to its normal state, the energy that it had absorbed to begin with is released. In the process of photosynthesis, this stored energy is used to split water into hydrogen and oxygen, and equation two begins running backward.

Upon these chemical events, that depend in large part upon the properties of the electron, all life depends.

ENERGY

Energy is what gets work done. In fact, the term is derived from two Greek words, meaning "in" and "work." We still use the word "erg," from the Greek for "work," to mean a unit of energy or work. Let us consider energy with a little greater involvement (not forgetting that it is the basis of all life) from the physicist's point of view. What does "gets work done" actually imply? One can say that it expresses the idea that energy is the power of a system, such as a car battery, a person, or a steam engine, to bring

about changes in its surroundings or in itself. To be able to effectively utilize energy in our modern technological society involves understanding the kinds and forms of energy, ways in which a system can store energy, how energy can be transferred, the nature of energy sources and energy receivers, and how energy can be transformed from one form to another (see experiments under "Energy Sources").

Energy Sources, Energy Transfer, and Energy Receivers

Winding the propeller of a rotoplane with your hand causes the propeller to move. The energy source is the hand, the energy receiver is the rotoplane. Food is the energy source for growth to the child who is the energy receiver. There are many different kinds of mechanisms whereby energy may be transferred from source to receiver. The food chain is one example, another is a hydroelectric plant run by a waterfall. We see that "work done" engulfs many interesting understandings. What does the scientist consider "work"?

The scientist uses "work" in a special sense. When you pull a wagon, you are exerting the *force* of your muscles to move the wagon through a certain distance. In moving the wagon, work is done by the force exerted by your muscles. Work is measured in units of force and distance. As you see, it designates the energy transfer that is accomplished through a force acting on a body (wagon) that moves or is displaced. Work (W) equals force (F) multiplied by distance (d) moved in the direction of the force: $W = F \times d$.

Power is the rate of doing work. Thus power can be measured in terms of work per unit of time. One horsepower, originally the amount of work done by an average horse in a given time, is measured in joules per second, or watts. One watt of power is expended when one joule of work is done each second. Just as "horsepower" is a concept derived for the muscular strength of the horse, so the ideas of force, work, power, and energy are all derived originally from the sensations of effort that we feel when we do work. Power=Work/Time.

Where do we get the energy to do work? Most of it comes from the sun. It was stored in plants of bygone days through the process of photosynthesis (see Background Information on photosynthesis). Over millenia, the fossil remains of these plants and the animals that ate them were converted into coal, oil, and gas. The coal comes from fossilized plants; the other fossil fuels are in part at least derived from animal remains.

The sun's energy is produced while the sun's store of hydrogen is gradually converted to helium through nuclear fusion. In the process, a small amount of the sun's matter is converted directly into energy.

Energy has many faces. It can be changed readily from one form into another. Let's take a brief look at the different forms.

A moving object, like the wheels of a train, an armature of a generator, or a finger moving a pencil, has *mechanical energy*. A roller coaster at rest on the top of a crest has *potential energy*—energy that was stored in it as it was lifted against gravity. When it starts coasting downhill, that potential energy becomes energy of motion: *kinetic energy*. To stop the roller coaster at the end of its ride, brakes must be used. The brakes stop the roller coaster by slowing down and stopping the wheels. The kinetic energy lost by the train reappears as heat where the brakes rub against the wheels. Heat is another form of energy.

Heat energy, or thermal energy, is really a measure of the average rate of motion of the molecules of a substance. In other words, heat energy is really a form of kinetic energy on a molecular scale. The rapid motion or high kinetic energy of steam does the work in driving a steam engine.

Some chemical reactions release energy, usually in the form of light and heat. This is *chemical energy*. A fire is a series of chemical reactions. You see, you hear, you think, you move—these activities are made possible by a series of chemical reactions that convert the energy stored in the chemical bonds of the molecules of food you eat to other forms of energy. In the reactions, intramolecular bonds (bonds holding the atoms of the molecule together) are broken and new ones are formed. Note that in the process, chemical energy originally in the bonds is transformed into other kinds of energy. Another interesting phenomenon concerning energy is, as we have seen in photosynthesis, a reaction that releases energy can sometimes be run backward by adding energy to the products.

Another form of energy is *electrical energy*. Matter itself is electrical in nature. All atoms contain particles that carry electrical charges. The positively-charged particles—protons—are

in the nucleus of the atom. The negatively-charged particles—electrons—orbit about the nucleus. The negative and positive charges attract each other. Like charges repel.

Some student might question this explanation. Why do protons stay together in the nucleus if like charges repel? This question shows that the student is really thinking. He has put his finger on the source of nuclear ("atomic") power. When we fuse or split the nuclei of atoms, we tap the binding force between the repelling nuclear particles.

When a balloon is rubbed with a wool cloth and brought near a glass rod rubbed with silk, they attract each other. This demonstrates the electrical nature of matter. Normally, atoms contain equal numbers of protons and electrons, and are neutral. When the wool cloth is rubbed against the balloon, electrons are lost from the cloth to the balloon. The balloon gets a negative charge. The glass rod loses electrons to the silk in the same way, and the glass rod gets a positive charge. That is why rod and balloon attract each other.

Usable electric power is in the form of a current of electricity—a flow of electrons through a wire. The flow can be maintained by a battery that converts chemical energy to electrical energy, or it can be maintained by a generator or dynamo that converts mechanical energy to electrical energy.

Radio waves, infrared rays, ultraviolet waves, x-rays, and gamma rays are all forms of *electromagnetic energy*. Only a small portion of these waves are visible to the human eye as light. They all carry energy and travel at the speed of light. They can also be converted into other forms of energy. When light strikes your eyes or a camera film, some of the light energy is changed to chemical energy. In the eye, the process goes still further. Chemical changes in the retina cause a wave of electrochemical change, called a nerve impulse, to flow down the optic nerve to the brain.

SOUND AND MUSIC

One of the simplest musical instruments is the gong: it is a sound source consisting of a metal plate that sounds a musical note when you strike it in the middle. A handy thing to strike it with is a stick padded at one end, called a drumstick (similar in shape to the chicken or turkey

bone called the drumstick). If you don't have that, you can bang it—but not too hard—with your fist.

The metal plate sounds best when it is supported loosely, so that its vibrational motion is not damped out too quickly. It is generally supported by a string, attached to a frame and stand, so that the gong can swing freely.

Now let us consider how the gong works. The metal plate is elastic, and when you strike it, it is set into vibration. These two words, *elastic* and *vibration*, are important in sound or music, so let us make sure we are clear about their meaning.

An elastic object is one that, when deformed and then released, returns to its original shape. For example, if you bend a rubber eraser and let go, it will return to its original shape. The same is true of a rubber band. Another example is a Slinky. Most materials are elastic to some extent, including sheet metal such as that of the gong.

The gong vibrates, that is, it moves to and fro in a repetitive motion that goes on, getting smaller and smaller because of friction, until it dies away and the gong is at rest again. Another example of a vibration is the pendulum of a clock: it also swings to and fro.

Springs, pendulums, and vibrating strings or gongs are all examples of periodic motion—motion that goes to and fro in some regular way.

Centuries ago, a scientist named Hooke saw the similarity between the behavior of springs and pendulums. He was the friend of a great clockmaker, Thomas Tampion, and they often talked about springs and pendulums. Hooke saw the parallel between the motion of a spring and the motion of a pendulum, using the same simple equipment that we can use in the elementary science laboratory today.

It is useful to know the frequency of the vibration, that is, how many swings there are in a second (as measured, for example, on the second hand of a watch).

A pendulum clock might have a frequency of one in each second—or one cycle per second, as we call it. A cycle is a whole vibration: out to one side, over to the other side, then back to the middle. The gong vibrates at a much higher frequency, for example, at 250 cycles per second (fill in the correct number for the gong used, if known). That means the center part of the gong moves forward and back two hundred and fifty

times every second. That is so fast you cannot feel it with your fingers, but your ear can hear it.

The higher the frequency of the gong, the higher the frequency or "pitch" of the note it sounds. The frequency of the gong is determined by its size and the springiness of the metal it is made of. If you change its size and make it bigger, the frequency gets lower.

If you make the gong from a different metal, for instance steel instead of brass, you also change the frequency. Steel is more rigid (less springy) then brass, and will give a higher note than a plate of brass of the same size.

In an orchestra, there are gongs of different sizes so that a range of different notes (that is sounds of different frequency) can be played.

Now we know something about the action of a simple musical instrument, the gong. The action of some other simple percussion instruments, like the tambourine and the xylophone, is quite similar. A "percussion" instrument is one that is struck, like the gong and the drum, as opposed to other instruments that are bowed (the violin), or blown (the trumpet).

Let us now consider how the vibration of the gong is sent out, or radiated, into the air, and then how the ear picks up the sound from the air.

Properties of Air

Sound travels through the air in waves, in something like the same way that surface waves or ripples spread out on the surface of a pool of water when you throw a stone into it.

To explain how the air can transmit sound waves as a vibrating motion, we must review some facts about air and its properties.

Air is a material substance. It consists of material particles—for example, atoms of oxygen and carbon. These atoms are just like the atoms of oxygen and carbon found in solid materials, such as wood, or in liquids, such as water. The difference is that whereas in a solid the atoms are packed tightly together and form a dense structure, in a gas they are flying around, like a swarm of bees, continually colliding with each other and with the boundaries of the container.

Now we want to show that air is elastic, so that when you compress it and then let it go, it will return to its original state and original pressure. For example, blow up a balloon (or a paper bag), then let the air out. By blowing up the balloon you compress the air; when it escapes it returns to its original pressure. The same decompression occurs when you let the air out of the tire of a bike or a car.

Air has weight and elasticity. It is because air has these two properties that sound waves, that is, waves of compression, can travel through it.

Sound Waves in Air

Sound waves are the means by which sound travels from a source, such as the gong, to your ears. Consider a single vibration of the gong: the center part is bent forward, perhaps a length of 1/10″, like the surface of a bubble of bubble gum when you start to blow it out. This pushes the atoms of the air forward, too. That layer of air pushes into the next layer, which passes on the impulse or compression to the next layer, and so on. In air at room temperature, the compression will spread out from the source at a speed of about 700 miles per hour—a little faster than a typical jet airliner like the Boeing 707, which travels at about 600 miles per hour. The gong is vibrating continuously. After a short while, its center part, having reached its farthest forward limit, is pulled back by the elastic forces of the metal plate. Next it bulges backward an equal distance, and then bulges forward again.

The second forward bulge produces a second compression of the air in front of the gong, and this compression follows the first. As the gong continues to vibrate regularly, a regularly spaced series of compressions, or waves, travels out through the air, and continues to travel until the waves are absorbed by friction, or are reflected by some object, like a wall.

Between the compressions, or regions of higher pressure, there are regions of lower pressure. The whole moving system of waves is sometimes called a wave train because it moves along like a train, with the coaches representing the alternate compressions and regions of low pressure.

We can show a model of the waves of sound in air by describing the Slinky toy. It is a coiled spring of metal and is generally used as a child's toy, but it shows compressional waves rather nicely. Stretch it out between your two hands on the table in front of you, with your hands two or three feet apart. Keep your left hand still, and give your right hand a sharp shove to the left, moving it a couple of inches, then stopping it, and moving it back to its original position. You will feel a compressional pulse travel along

the spring from right to left; it will hit your left hand and be reflected back to the right; after one or two reflections it will die away. Repeat this a few times until you understand just what is going on.

The spring obviously has weight and elasticity, and carries the compressional waves from the source (your right hand) until it reaches a reflector (your left hand). Thus, the spring forms a model of the air conducting or transmitting a train of sound waves.

In both cases, the medium is not moved bodily along: it is just the parts that vibrate steadily to and fro. The parts vibrate, and pass on the vibrational motion from one part to the rest.

When you hear a sound, the compressions in the air set your eardrums into motion—they vibrate like little, soft gongs, and pass the motion on into the middle ear inside the skull, as we discuss next.

The Vibrating String

An important group of musical instruments, including the violin, piano, and guitar, have vibrating strings as the origin of musical tone. A sonometer (monochord)—a stock item that can be purchased, e.g., from Cenco—consists of a piano wire stretched over a resonating wooden box, with provision for varying the tension and length of the vibrating section of string. If this is not available, a simpler box and string will do; even a cigar box and rubber band get across the main points.

When we increase the tension, or tautness, of this string, the frequency of the note goes up. This is how we tune a violin or guitar. Any instrument can be tuned to any other instrument by this process.

On a piano, the strings are made of strong steel wire, and may be used at a tension of 150 pounds (equal to that produced if a middle sized adult were to hang on the end of the wire!). In a fiddle or guitar, the strings may be made of nylon (it used to be catgut); these have less tension, about 12 pounds per string.

There are limits to the variation of tension that can be used: if the string is too slack, it loses its musical quality; if it is stretched too tight, it will break.

You probably know how a harp works: it has strings attached to a strong frame, and you pluck the strings with your fingers. The long strings give the low notes, and the shorter strings give the higher notes. The piano works on the same principle.

There is a neat relationship between the length of a vibrating string and its frequency. If you halve the length of the string, you double its frequency. We say that two such notes, one having twice the frequency of the other, are an "octave" apart in frequency, and this frequency interval is the basis of our musical scale. Pythagoras, the ancient Greek sage, of whom you might have heard for his work in geometry, discovered this relationship.

The String Instruments

The vibrating string by itself is no good as a musical instrument, because it radiates so little sound you can barely hear it. An effective musical instrument has to radiate a good volume of sound, so that several people can hear it at the same time.

Because the string is so narrow, it pushes very little air as it vibrates, and sends out only weak sound waves. To use it in a musical instrument we couple the vibrating string to a "sound board," or resonating box, generally of wood, that improves the radiation of sound.

The violin is composed of strings and a wooden box (generally called the body) that has a surface area of about two square feet. This surface is set into vibration by the string, and it vibrates at the same frequency as the string. It pushes a large surface of air, even more than the gong, and thus radiates a good volume of sound; a large hall with 2,000 seated listeners can be entertained by a single violinist.

How does the vibration get from the string to the body of a violin? The two parts are coupled by a thin, springy piece of wood called a "bridge." If the bridge is taken out, the sound radiation from the violin (or sonometer) is greatly reduced. The wooden bridge has to be suitably elastic; if we use an unsuitable material for the bridge (e.g., a rubber eraser, or a solid block of wood), it does not work well.

The resonator, sound board, or body of the violin or guitar must not be touched when you play the instrument. Otherwise, the pressure of your fingers will stop the wood from vibrating and greatly reduce the sound radiation.

The Woodwind Instruments

This group of instruments does not have strings; the origin of their musical tone is a vibrating

column of air. The clarinet, flute, recorder, oboe, and bassoon all belong to this class, as does the pipe organ.

Because air has weight and elasticity, it can easily be set into vibration—as easily as you can set into vibration a Slinky.

The frequency is governed by the length of the vibrating column. As with the string, the shorter the length, the higher the note. The length of the vibrating air column is controlled by finger holes. The vibrating energy radiates out of the first open finger hole, so that the length of the vibrating air column is from the mouth piece to the first open finger hole. If you close all the finger holes, you get the longest length of vibrating air column and the lowest note that the instrument plays.

Percussion Instruments

These include the gong, tambourine, cymbals, triangle, xylophone, and drums. All these instruments are set into vibration by striking them.

The drum is a popular instrument, particularly with boys. There are several different kinds: small ones, about the size of a large birthday cake, that give a higher pitched tone, and large ones the size of a washing machine, about two and one-half feet across, that give low tones.

The sound of a drum is less musical than that of the strings, woodwinds, or brasses, but it is fine for beating time and for special effects. Certainly no orchestra or band is complete without a drum.

The drum is like a circular box, with vibrating surfaces of leather or similar material stretched tightly. It is struck with a drumstick, like a gong.

Summary

If we do not include noise in the definition, sound is (physically): Organized, regular, periodic vibrations of molecules in a medium, propagating energy from place to place. This energy is propagated in the form of sound waves. In discussing sound, we have to consider two principle aspects. One aspect is that the *source* of sound is always some object or system of objects in vibration. In order to vibrate, an object must be elastic. The second aspect is that a material *medium* is needed for sound to propagate. The medium may be a solid, a liquid, or a gas. Sound does not propagate through a vacuum. The medium through which sound propagates must be *elastic.*

The essential aspect of wave propagation is that a "disturbance" (a crest, a trough, a compression, a rarefaction, a displacement, a pressur pulse) is transmitted from point to point through a medium without movement of the medium as a whole in the direction of the waves. Wave motion is flow of *energy*—not of *matter.* The nonmaterial essence of a wave is energy.

In wave motion, the vibrations of the source are transmitted to the medium. Each individual element (particle, molecule, atom) of the medium vibrates in turn as the wave goes by. The frequency of vibration of the source coincides exactly with the frequency of the wave.

Vibration (or oscillation) is defined as back and forth motion of an object along the same path around a central or equilibrium position.

WHERE TO OBTAIN MATERIALS AND EQUIPMENT

The number to the right of the activity lesson indicates where materials can be obtained. See number key below.

Objects in the Classroom (1)
Shapes (3)
Serial Ordering and Comparison of Objects (3)
Rock Candy and Sugar Cubes (1)
Floating and Sinking Objects (2)
Buoyancy of Liquids of Different Densities (2,4)
Using a Balance (2)
What Are the Mystery Powders? (Physical Properties) (2,4)
What Are the Mystery Powders? (Chemical Properties) (2,4)
Balloons and Gases (2)
Evidence of Interaction—Energy Transfer (1)
"Inventing" the Systems Concept (1)
Exploring Pulleys (1,4)
Comparing Pulley Systems (1)
Solutions and Mixtures (1)

"Inventing" Interaction at a Distance (1)
Investigating Magnetic Fields (1)
Electric Circuits (1,5)
Objects That Can Close a Circuit (1)
The Magnetic Field of a Closed Circuit (1)
The Life Cycle of the Frog (1,5)
Separating a Powdered Mixture (1)
"Inventing" the Subsystems Concept (1,4)
Colored Liquids (1,4)
Salt Solution (1,4)
Properties of Freon (1,4)
Converting Liquid Freon to Gas (1)
Whirly Birds (Subsystems and Variables) (1,5,7)
Pendulums (1,5,7)
Exploring Rotoplanes (1)
Temperature Change as Evidence of Energy Transfer (1)

Motion as Evidence of Energy Transfer (1)
The Angle of the Stopper Popper (1)
Energy Transfer from Spheres to Sliders (1)
Energy Transfer (1)
Drive a Nail 1 (5)
Drive a Nail 2 (5)
Archimedes' Principle (7)
Sound Transmission Through Different Media (7)
Air as a Medium for the Propagation of Sound (7)
Musical Strings (5)
Intensity of Light (4,5)
Using the Light Sensor (4,5)
Bounce That Light (4,5)
Pumping Pulse (5)
Heartbeat (5)
Water Wheel (5)
Coils (5)

KEY

1. S.C.I.S.
 Rand McNally & Co., School Order Department
 P.O. Box 7600
 Chicago, Illinois 60680

2. E.S.S.
 Webster/McGraw-Hill
 1221 Avenue of the Americas
 New York, New York 10020

3. S.A.P.A.
 Ginn and Co., A Xerox Education Co.
 191 Spring Street
 Lexington, Massachusetts 02173

4. American Printing House for the Blind
 1839 Frankfurt Ave.
 Louisville, Kentucky 40206

5. Enrichment
 Science Material for the Visually Impaired
 Discovery Corner
 Lawrence Hall of Science
 University of California
 Berkeley, California 94720

6. Perkins School for the Blind
 Watertown, Massachusetts 02172

7. Can be obtained locally by teacher.

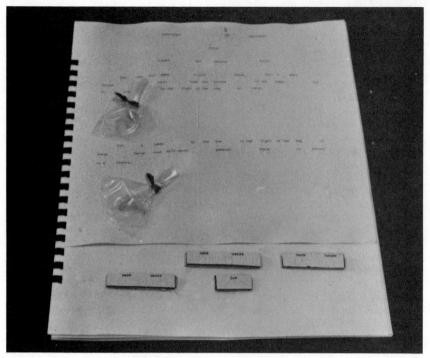

Figure 3.1. Adapted brailled science workbook for the blind. Printed word appears above the brailled word.

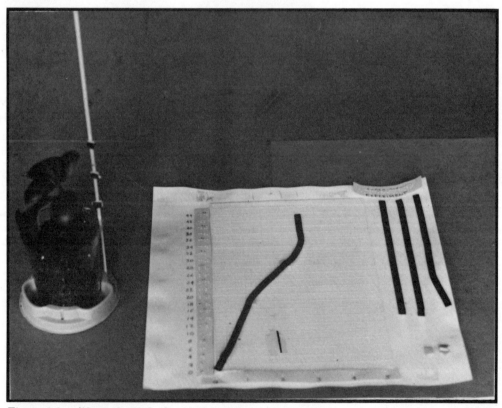

Figure 3.2. Adapted graph. Graph lines are raised. Numbers are brailled. Line is indicated with a raised adhesive line.

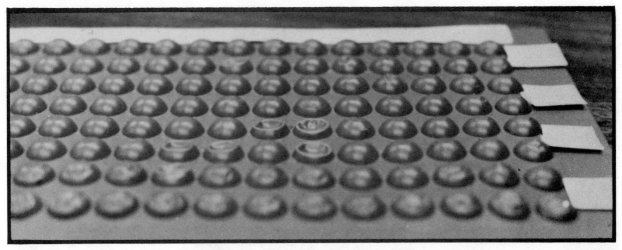

Figure 3.3. Adapted histogram. Brailled numbers along the sides. Raised bubbles are depressed to indicate number. Histograms can be reused by pushing bubbles up from beneath.

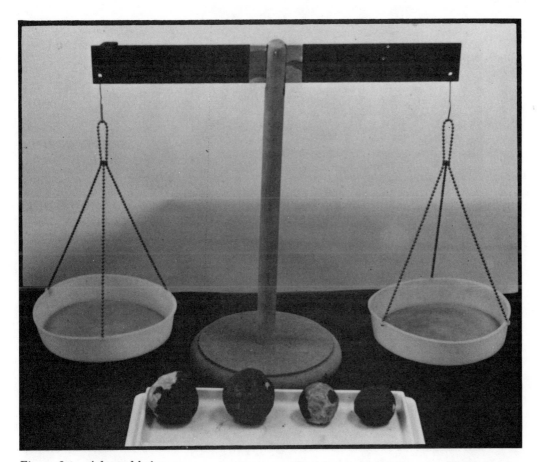

Figure 3.4. Adapted balance.

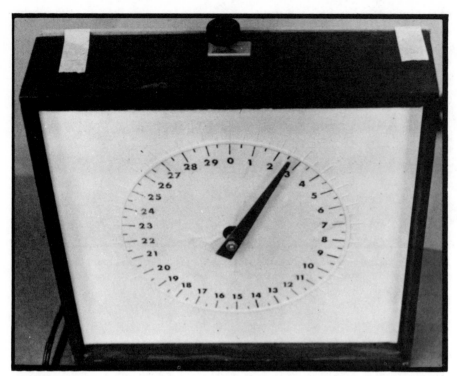

Figure 3.5. Adapted timer.

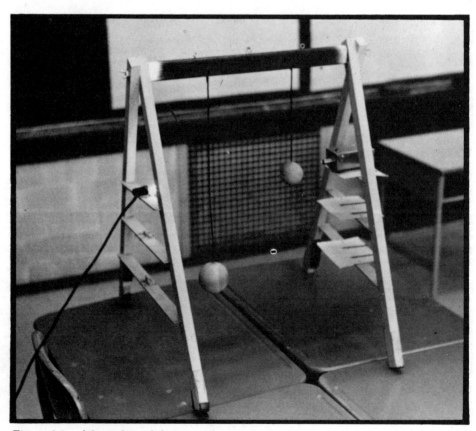

Figure 3.6. Adapted pendulum.

Laboratory Science and Art for Blind, Deaf, and Emotionally Disturbed Children

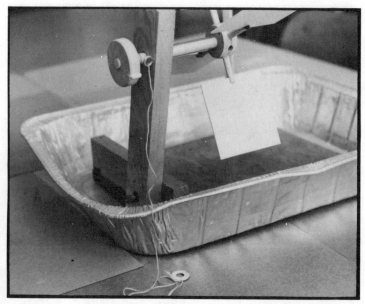

Figure 3.8. Adapted water wheel.

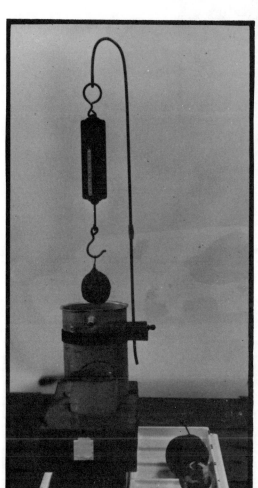

Figure 3.7. Adaptation for Archimedes' Principle activity.

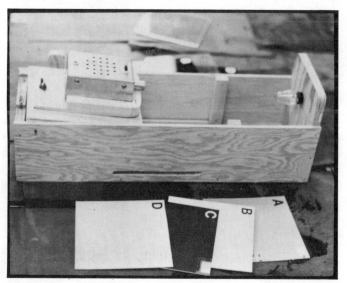

Figure 3.9. Light box.

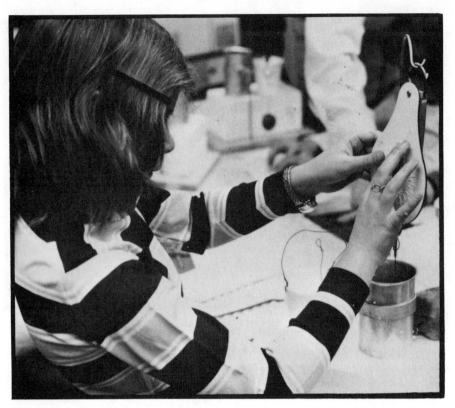

Figure 3.10. Adapted spring balance.

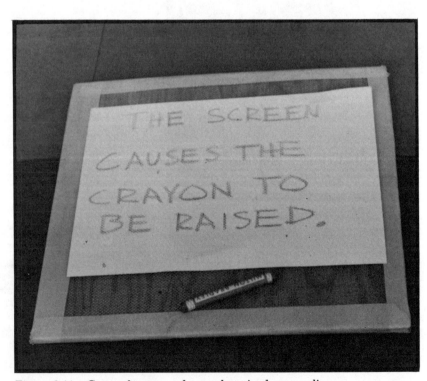

THE SCREEN
CAUSES THE
CRAYON TO
BE RAISED.

Figure 3.11. Screen board used to make raised crayon line.

242 Laboratory Science and Art for Blind, Deaf, and Emotionally Disturbed Children

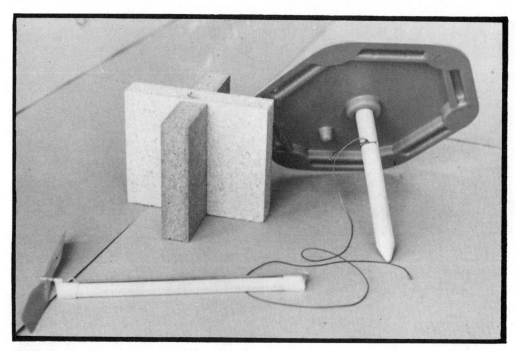

Figure 3.12. Adapted rotoplane.

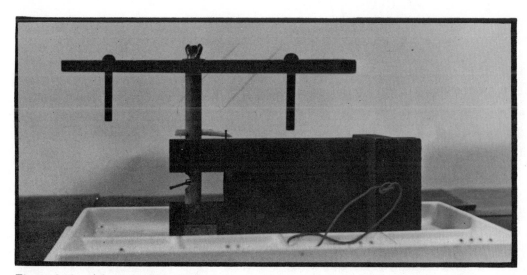

Figure 3.13. Adapted whirly bird.

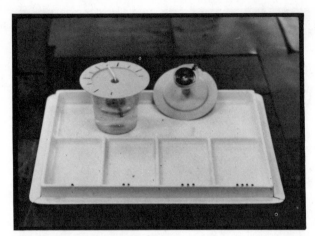

Figure 3.14. Adapted thermometer.

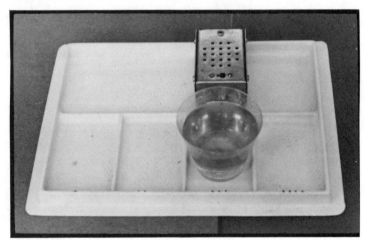

Figure 3.15. Light sensor. Line up light sensor in front of cup to register color change.

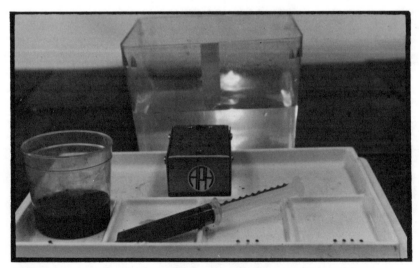

Figure 3.16. Using the light sensor for detection of color change.

Section IV

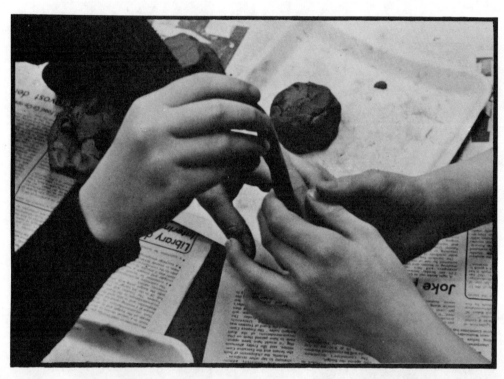

INTRODUCTION
TO
ART
ACTIVITIES

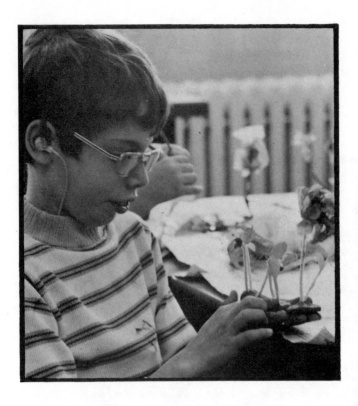

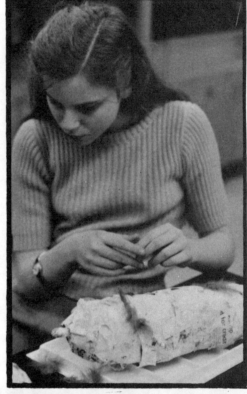

PURPOSE OF ART ACTIVITIES

The art activities collected in this volume have three basic purposes: 1) to allow blind and deaf children to actively participate in art experiences side by side with ordinary children, 2) to provide art activities that enrich and imaginatively express science experiences, and 3) to provide all children with the opportunity to explore a wide variety of art media and techniques, and through them find the opportunity for individual expression.

Elementary school children, day after day, leave the school building clutching crayon drawings—the result of their school time exposure to art. With this most limited conception of art, it is no wonder that skeptics raise their eyebrows when it is suggested that blind children can effectively create art forms. It is time for the world to open its eyes and see the broad horizons of art and the expressive experiences it can provide to all children. No longer should children be confined to crayon drawings of houses and trees. Through the rich experience of science a flower becomes more than a red crayoned circle. The structure of the flower is examined, the discovery expressed perhaps in clay, perhaps in wire sculptures. Magnetic attraction experienced in science stimulates the expression of magnetic lines of force using nails and string. Blind children, deaf children, "emotionally disturbed" children, "ordinary children," your children, and my children deserve the equal opportunity, the dynamic opportunity, of working together in expressing individual responses to a wide variety of experiences with as many art media and techniques as possible.

HOW TO USE THESE ACTIVITIES

The art activities suggested in this section are good starting points from which to develop lessons that take into consideration the needs of the children involved and the materials available. If a decision is made to follow one of the activities, check to make sure that materials are

Figure 4.6. Blind and sighted children working together.

Figure 4.7. Deaf child and hearing child learning together.

available. If not, adapt the activity and substitute available materials.

Remember, while guiding the children through an art activity, that there is no right way in art; there is no defined end product. A clay flower may become a boat. Presenting children with a finished product at the beginning of an activity results in imitative art work. The end product created by the children should not be an attempt to imitate a model produced by the teacher. What is important is that the children are encouraged to explore different media, to experiment with line, shape, textures, and patterns to create an individualized expression. Only when techniques new to the children are being used— such as printing, weaving, or papier maché—are demonstrations needed. Remember to have blind, deaf, and ordinary children assist with the demonstration. Making a chart or listing the steps involved on the blackboard is a helpful reminder for children of reading age. There should be braille instructions for blind children.

Displaying of finished art work is very important. Paintings of "great masters," if heaped in a corner, appear valueless; their potential communication is lost. Keep bulletin boards fresh with new creations. Collages, pictures, and paintings look better if framed with paper, poster paper, or cardboard, or are mounted. Hang mobiles in the classroom and corridors. If display cases are available, use them for sculptures. Use wood blocks to mount sculptures when possible. Involve the children in displaying the art. All children—blind, sighted, deaf, hearing—take great pride in this activity.

Figure 4.8. *Expression should come from within, not from imitation of a teacher's conception (blind child).*

MATCHING SCIENCE AND ART ACTIVITIES

The art activities have been designed so that blind, deaf, and ordinary children may be stimulated by a science experience to explore line, shape, texture, dimension, and pattern. Each science activity has been matched to at least one art activity (see Listing of Science Activities, Listing of Art Activities). The matches are also indicated in a match box at the top of each activity. Select the most appropriate match listed for your purposes, or look through the art activities to make your own matches, or design your own activities relevant to the science concepts.

The scope of activities selected and/or created should cover as wide a variety of media and techniques as possible.

The art activities are designed to foster individual expression while they reinforce the matched science activity. Use the science concepts and words in art. For example, after doing a science lesson on interaction, choose one of the indicated art matched activities. In the art lesson use the word interaction, and encourage children to be aware of the interactions taking place in the art activity. Have models, objects, and equipment used in science on display and readily accessible for children to reexamine. A science activity introducing the term property may be followed by stringing objects, creating property collages, or creating properties in clay.

Figure 4.9. *Stringing objects of different shape, size, and texture properties to form property patterns (blind child).*

Figure 4.10. *Creating texture collages (deaf child).*

Figure 4.11. Creating properties in clay (blind child).

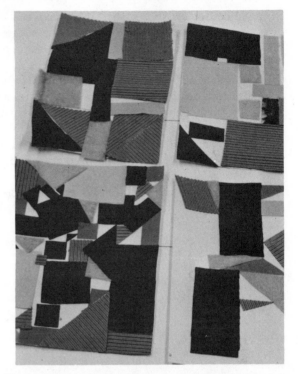

Figure 4.12. Creating property collages emphasizing specific properties: shape, size, and texture.

KNOWING THE CHILD

Working with Blind Children

The art activities included in this collection have been specifically designed to allow maximum participation and expression on the part of blind children. Such activities present new opportunities for sighted and blind children alike. All too frequently young children come to limit their understanding of art to crayon drawings and paintings. Together, the blind and sighted child, through use of the suggested art activities, explore texture, dimension, line, pattern, and shape using a wide variety of materials—clay, textured papers, wire, boxes, hammers, wood and nails, yarns—and a wide variety of techniques including collage, mobile construction, wire sculpture, printing, papier maché, and weaving.

When working with blind children, remember that:

Blind children need to know where their materials are. Prepare a tray or box for each blind child with all the necessary materials before each activity.

A sighted partner is of great assistance to the blind child who may not yet have developed the skills of cutting, knot tying, pasting, or taping. The sighted partner is also essential for providing feedback to the blind child. For example, in the tie dying activity the sighted partner describes the designs made by the dyes.

Blind children may need a little extra time to complete the art activity.

Blind children "see" with their fingers. Provide dampened paper towel for the blind child when an activity involves paste, clay, plaster, or papier maché. Sticky fingers find it hard to manipulate materials.

Blind children must be warned not to touch their brailled watches unless their hands are clean.

Blind children should be involved in all demonstrations.

Brailled instruction sheets should be prepared for blind children listing steps of new techniques such as printing, papier maché, weaving.

Blind children should have access to models and objects used in the science activity during the art session. For example, the blind child needs

Introduction to Art Activities 249

to have contact with a model of the fish while creating a plaster fish, or models of the stages of life cycles when asked to create clay expressions of the life cycle.

A screen board can be used by blind children to create linear designs. The screen board is simply a wooden frame with screening attached tautly and securely over the open area. By placing a piece of paper over the screen and rubbing it with a crayon, a textured crayon design results (see Equipment Adaptations).

The art work produced by blind children reflects their very personal expression of a mental image not influenced by vision or the art work of other children. Encourage this personal expression. It is art in its purest form.

Always provide models and objects used in the science activity for reference during the art session.

Figure 4.13. Blind child examining root structure before creating an expression of roots with wire.

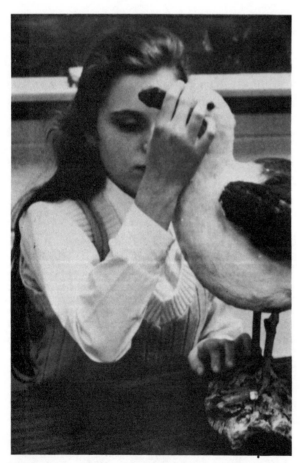

Figure 4.14. Blind child examining the structure of a bird before creating an expression of a bird.

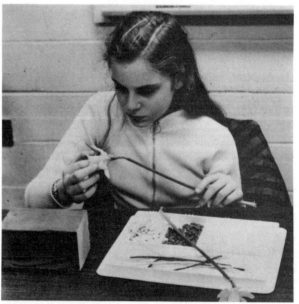

Figure 4.15. Blind child examining the structure of the flower before making a mixed media relief of the flower.

Working with Deaf Children

The following are important to remember when working with deaf children:

Always include the deaf child in demonstrations of new techniques.

Remember that the deaf child needs to see your lips—do not stand in front of a bright light.

Figure 4.16. Remember that the deaf child needs to see your lips.

Figure 4.17. In art there are no handicapped children, only creative children.

If a deaf child does not understand, reword your sentence. Do not shout—this does not help.

Use pantomime.

Always label all materials.

Use vocabulary cards to assist your communications with the deaf child. Suggestions for vocabulary cards are listed with each art activity. Select words and phrases that are appropriate to the reading level of the deaf child. Create your own vocabulary cards to match the activity and use them to introduce it. For deaf children proficient at reading, you should have a vocabulary card for each material and tool used as well as cards outlining the main steps in the technique.

Always have objects and models used in the science activity accessible for deaf children to re-examine. For example: provide a pulley for deaf children who will be creating a stitchery pulley.

In art there are not handicapped children, only creative children.

LISTING OF ART ACTIVITIES AND THEIR SUGGESTED SCIENCE MATCHES

ART ACTIVITIES SUGGESTED SCIENCE MATCH

ART ACTIVITY SUGGESTED SCIENCE MATCH

Mixing Your Own Dies for Tie Dying (p. 345) — Solutions and Mixtures (p. 98)
 Colored Liquids (p. 136)

Straw Structures (p. 348) — Serial Ordering and Comparison of Objects (p. 52)
 Whirly Birds (Subsystems and Variables) (p. 150)
 Controlling Variables (p. 155)

A Cycle-Mill-O-Plane (p. 355) — Exploring Rotoplanes (p. 168)
 Motion as Evidence of Energy Transfer (p. 176)
 Water Wheel (p. 221)

Moving Machines: Energy Transfer (p. 358) — Motion as Evidence of Energy Transfer (p. 176)
 Electric Circuits (p. 107)
 Objects That Can Close a Circuit (p. 111)

Energy Transfer Hangings:
Mobiles That Make Noise (p. 360) — Motion as Evidence of Energy Transfer (p. 176)

Wavy Patterns (p. 363) — Salt Solution (p. 139)

Making Balls Roll: A Sphere Slider
Construction (p. 364) — Energy Transfer from Spheres to Sliders (p. 183)
 Energy Transfer (p. 188)

A Collage of Angles (p. 365) — The Angle of the Stopper Popper (p. 180)

Weaving: Yarns Close Together and
Far Apart (p. 366) — Buoyancy of Liquids of Different Densities (p. 62)

Density Windows (p. 368) — Buoyancy of Liquids of Different Densities (p. 62)

Lub-A-Dub Paper Chain Rhythms (p. 370) — Pumping Pulse (p. 215)
 Heartbeat (p. 217)

Jack-in-the-Box (p. 371) — Energy Transfer (p. 188)

The Sounds and Vibrations of a Branch
Harp (p. 273) — Sound Transmission Through Different Media (p. 203)
 Musical Strings (p. 207)

Vibrating Art Forms (p. 375) — Air as A Medium for the Propagation of Sound (p. 205)

Cork Towers: An Expression of Sound (p. 377) — Serial Ordering and Comparison of Objects (p. 52)

Aluminum Foil Reliefs (p. 379) — Bounce That Light (p. 213)

A Pendulum House (p. 380) — Pendulums (p. 158)

ART
ACTIVITIES

AROUND THE OUTSIDE: Contours

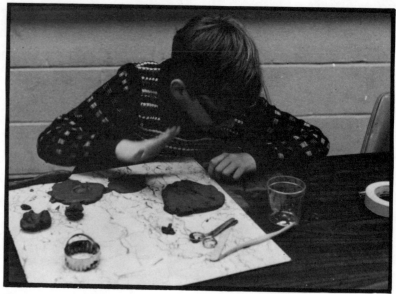

Figure 4.18. *"Flatten it, that's easy, I know how, just pound it real hard and then it gets smooth and flat." Blind child preparing clay to make object contours.*

EXPLORATION

To create an expression of the contours of objects.

ART CONCEPTS

Understanding the meaning of contour. Creating the contours of objects.

MATERIALS

paper
clay
crayons
seeds

leaves
match sticks or dried
 lima beans
scissors

PROCEDURE

Ask the children to put their hand on a piece of paper and draw around the outside with a crayon. This is called contour drawing. Ask the children to fill up the paper with as many hand contours as can fit on the page. What happens when contours overlap?

Contour drawings can be made of many different objects such as scissors, other classroom objects, and leaves.

Large contour drawings of a friend can be made with large sheets of brown wrapping paper and crayons.

Contour drawings can be made in clay, too. First ask the children to flatten clay by pounding it. Once it is flattened, ask the children to put their left hand on the clay. The contour of the hand can be made by putting beans or match sticks around the hand to make a dotted contour, or the contour can simply be expressed by moving a stick, pencil, or crayon around the outside of an object. Clay contours can be made of scissors, shells, leaves, or any other readily available objects.

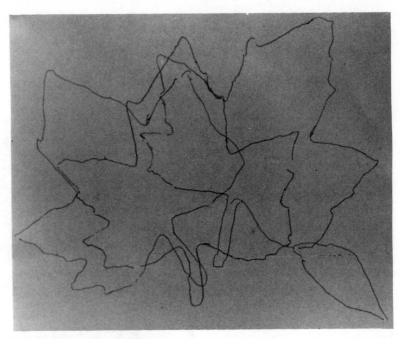

Figure 4.19. Contours

ADAPTATIONS

*Adaptations for
the Blind Child*

Blind children can make contours in clay. First flatten the clay, put object on clay, and then make contours with beans or match sticks.

*Suggested Adaptations
for the Deaf Child*

Language cards: Paper, Crayons, Leaves, Scissors, Hand, Clay, Flatten, Press, Seed, Match stick, Draw, Around, Contour. Draw around the shape of your hand. Make the contour of your hand. Make a contour drawing of your friend. Make a contour drawing on clay. Use match sticks to make a contour in clay.

COMMENTS

Contours made in clay by linear impressions can easily be turned into pendants or wall hangings by pushing out a hole in the clay while still wet. Once the clay is dry it can be painted with tempera and shellacked, or glazed and fired in a kiln.

SNOWFLAKES, STARS, AND FLOWERS:
Recognizing and Creating with Geometric Shapes

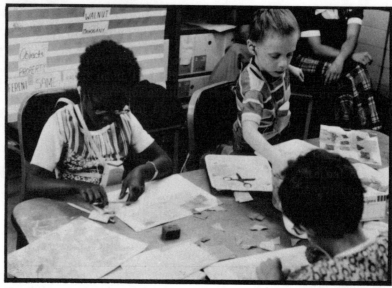

Figure 4.20. Deaf children busy making two-dimensional geometric designs.

EXPLORATION

To make two-dimensional geometric designs.

ART CONCEPTS

Recognizing geometric shapes—squares, rectangles, circles, and triangles. Reducing forms to their geometric components. Using geometric shapes to create abstract and figurative designs.

MATERIALS

construction paper
glue/paste/masking tape
scissors

PROCEDURE

Ask the children to cut a number of squares or rectangles from colored construction paper. Where do the children see rectangles in the classroom? Windows, doors, desk tops, linoleum squares on floor, blackboard, etc. Now have the children arrange the cut rectangles on a large uncut piece of construction paper.

Can they make a checker board? What happens when the rectangles are turned to make diamond shapes?

Ask the children to cut triangles and circles. What can a circle be? The sun, the moon, a wheel, a ball, a head, or a balloon are some of the things the children may suggest.

Now invite the children to arrange and adhere the triangles, circles, and rectangles in a design. Most children will need no prompting for ideas. Some suggestions, if necessary, may be snowflakes, stars, flowers, bicycles, cars, rockets, planets, or buildings.

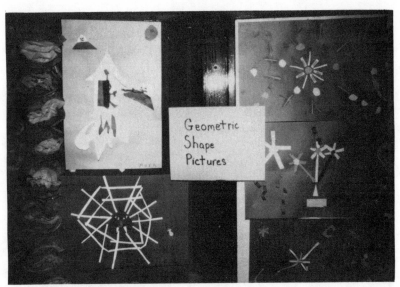

Figure 4.21. Geometric shape designs prepared by blind, deaf, and disturbed children in a mainstream setting.

ADAPTATIONS

Adaptations for the Blind Child

Before the activity, cut out a number of geometric shapes for blind children to use in a two-dimensional geometric design.

Suggested Adaptations for the Deaf Child

Language cards: Paper, Construction paper, Glue/Paste/Masking tape, Scissors, Cut, Arrange, Design, Geometric shape, Square, Rectangle, Circle, Triangle. Cut geometric shapes from construction paper. Arrange the shapes to create a design. Paste the shapes to the paper.

A BUILDING THAT NEVER WAS:
Three-Dimensional Geometric Constructions

MATCH BOX

Suggested Science Match:
Shapes p. 49
Intensity of Light p. 210
Using the Light Sensor
p. 212

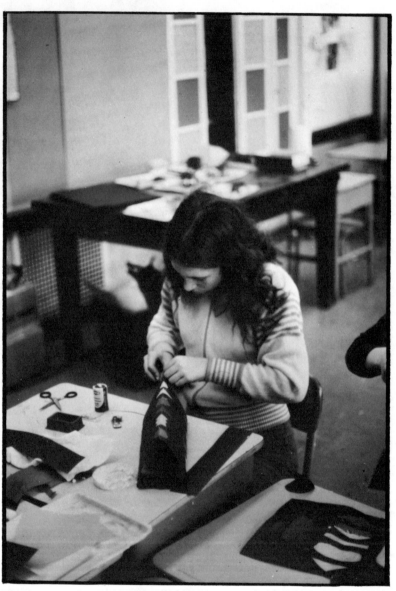

Figure 4.22. Building a three-dimensional geometric structure.

EXPLORATION To make three-dimensional geometric structures.

ART CONCEPTS Recognizing three-dimensional geometric shapes—cubes, rectangle, cones, and cylinders. Using three-dimensional geometric shapes to build structures.

MATERIALS

construction paper	empty food boxes or empty
glue	paper rolls
masking tape	glue
scissors	masking tape

Figure 4.23. A completed three-dimensional geometric construction.

PROCEDURE

Activity 1

Use the geometrical shapes of the empty food cartons to create a fantasy building. Glue cartons together. Hold the cartons in place with tape while the glue is drying. After the glue dries, remove the tape.

Children may want to paint or paper their constructions to further elaborate their imaginative conceptions.

Activity 2

Older children may want to construct their own three-dimensional shapes from construction paper. Cylinders are easy—just roll the paper. Rectangles can be made by folding the paper. Let the children discover how to make these shapes. Once constructed, the shapes should be glued together. Use masking tape to hold the shapes in place while the glue is drying.

Activity 3

The three-dimensional construction can also be made by gluing wooden shapes to a piece of flat wood. Wooden shapes can include lumber yard scraps, spools, door knobs, or packaged wooden shapes available from a craft store.

ADAPTATIONS

Adaptations for the Blind Child

Have blind children use empty food containers and cardboard tubing.

Suggested Adaptations for the Deaf Child

Language cards: Glue, Masking tape, Scissors, Food containers, Boxes, Rectangle, Cylinder, Cube, Build, Construction, Geometric shape, Three-dimensional. Glue the shapes together. Use the tape to hold shapes in place while glue is drying. What

ADAPTATIONS—*continued*

shapes have you used in your geometric construction? Remove the tape when the glue is dry.

EMPHASIS

When matched to the following science lessons the emphasis indicated should be used.

Intensity of Light: Create a geometric construction that represents two light bulbs, one emitting a greater amount of light than the other.

Using the Light Sensor: Make a geometric construction that symbolically represents light being blocked from the light sensor.

SOFT-SMOOTH-BUMPY-ROUGH: A Texture Collage

<table>
<tr><td>

MATCH BOX

Suggested Science Match:
Objects in the Classroom
p. 46

</td><td>

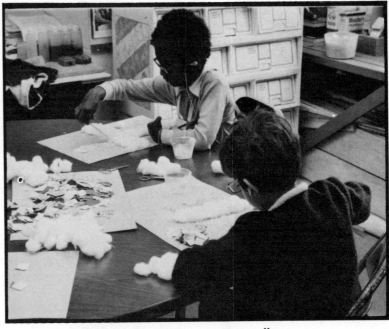

</td></tr>
</table>

Figure 4.24. Deaf children making a texture collage.

EXPLORATION

To create a collage of many textures.

ART CONCEPTS

Recognizing different textures. Using different textures in design.

MATERIALS

poster paper or cardboard for base
fabric scraps: felt, corduroy, burlap, etc.
paper: aluminum foil, tissue paper, etc.
glue
scissors
cotton balls (optional)

PROCEDURE

Ask the children to examine the different textures of the papers and the fabric scraps. Let the children decide which textures they wish to use in their texture collage.

Have the children cut shapes from the fabric and paper and then glue them to the base piece of cardboard.

ADAPTATIONS

*Adaptations for
the Blind Child*

Before the activity cut fabric and paper into geometric shapes for use in the collage.

*Suggested Adaptations
for the Deaf Child*

Language cards: Texture, Rough, Smooth, Soft, Bumpy, Paper, Glue, Collage, Feel, Arrange, Cardboard, Scissors. Feel the dif-

Figure 4.25. A completed texture collage made from different fabrics by blind students in class during class project.

COMMENTS

ferent textures. Cut the fabric into geometric shapes. Cut the paper into geometric shapes. Glue the shapes to the cardboard. Make a collage of many textures. What textures have you used?

For most younger children it is advisable to pre-cut shapes from fabric and textured papers. Younger children enjoy making texture crowns. To make texture crowns, use a base piece of paper that can easily fit around the head of the child. After gluing on the different texture papers and fabrics, staple the crown so that it fits the child's head.

MAKING TEXTURED TOTEM POLES

<table>
<tr><td>MATCH BOX</td></tr>
<tr><td>Suggested Science Match:
Objects in the Classroom
p. 46</td></tr>
</table>

Figure 4.26. "My nose is going to be a triangle—what's your's?"
"Mine is a triangle, too." Blind and sighted children starting to create
textured totem poles.

EXPLORATION

To create an imaginary three-dimensional textured head that will be one section of a totem pole.

ART CONCEPTS

Recognizing and using textures in three-dimensional art. Exploring shapes within shapes—features to head. Developing concepts of scale and position.

MATERIALS

oatmeal boxes
scissors
cotton balls
paint and paint brushes (optional)

glue
yarn
pipe cleaners (optional)
construction paper
tissue paper

PROCEDURE

Discuss the composition of a totem pole. Ask each child to decide on the face of an animal or person to make.

Have the children examine their own faces. What is the relationship of the eyes to the nose and mouth? What is the shape of the eyes, nose, and mouth?

Ask the children to explore the different textures of the materials they will be using.

Have each child construct one segment of the totem pole using as many textures as possible. First glue a piece of construction paper around the cylindrical box. Then glue on features, hair, etc.

Ask several children to glue the different segments of the totem pole together. Each totem pole should consist of no more than eight segments. Prop the totem pole against a wall while it dries.

Art Activities 265

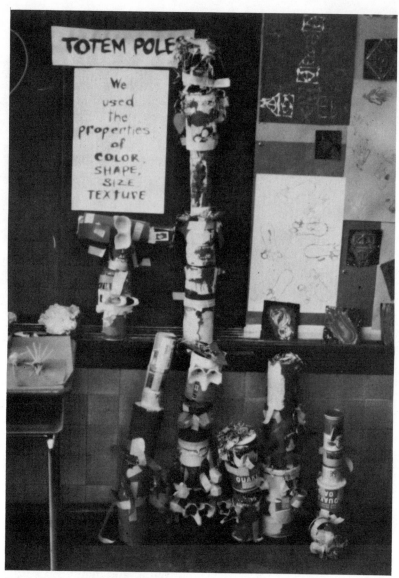

Figure 4.27. Completed textured totem poles created in the main-stream environment by all children.

ADAPTATIONS

Suggested Adaptations for the Deaf Child

Language cards: Cylinder, Box, Rough, Smooth, Face, Texture, Scissors, Glue, Construction paper, Yarn, Tissue paper, Cotton balls, Nose, Beak, Eyes, Mouth, Teeth, Ears, Totem pole. Make a face on the box. Cut mouth, eyes, nose, and ears. Glue features to box. Use different textures for the different features. What can you use to make hair? Put your face on top of someone else's to make a totem pole.

COMMENTS

Older children may each make an entire totem pole. Encourage the use of imagination and extensive use of texture. Broken bits of egg cartons are ideal for use in this activity.

Blind children may find it easier to tear rather than to cut construction paper.

TEXTURED AND SMOOTH CLAY PENDANTS

MATCH BOX

Suggested Science Match: Objects in the Classroom p. 46

Figure 4.28. Blind child texturing a clay pendant.

EXPLORATION

To make textured and smooth clay pendants.

ART CONCEPTS

Creating different texture to develop an awareness of texture range. Discovering ways to texture clay.

MATERIALS

clay
string
scissors
stick or pencil
cookie cutter (optional)

clay tools (optional)
paint and shellac (optional)
glaze and kiln (optional)
paper or board to work on

Figure 4.29. Placing glazed clay pendants in kiln for firing.

PROCEDURE

First make sure that each child's working area is covered with newspaper.

Ask the children to make a ball of clay and then to flatten it by pounding it with their hands.

Have the children cut the flattened clay into the desired shape. Let the children experiment with texturing the clay. What happens when you pound it with your hand? What happens when you poke your finger into the clay? What happens when you roll it with a pencil or stick?

After the pendants have been made, have the children put holes at the top for later stringing. Remember that clay shrinks, so the holes need to be quite large in the wet clay.

After the clay is dry, it may be painted with tempera and shellacked. If a kiln is available, bake the pendants, glaze, and fire them.

String the pendants.

ADAPTATIONS

Suggested Adaptations for the Deaf Child

Language cards: Pendant, String, Clay, Hole, Texture, Smooth, Pound, Hand, Rough, Stick, Glaze, Kiln, Bake, Wear. Pound the clay flat. Cut the clay into a shape. Texture the shape with your stick. How can you texture the clay? Make a hole at the top of the pendant. Let the clay dry. Hang the pendant on a string.

PROPERTY PATTERNS

MATCH BOX

Suggested Science Match:
Objects in the Classroom
p. 46

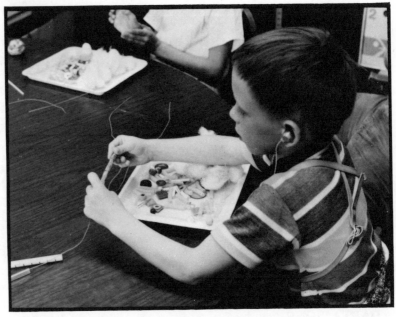

Figure 4.30. Creating property patterns on a piece of wire.

EXPLORATION

To create a composition whose components interact by property pattern.

ART CONCEPTS

Classifying and relating diverse objects by the properties of shape, size, and texture. Understanding the meaning of pattern: repetition and alternation of specified quantities of objects.

MATERIALS

macaroni
beads
scissors
plastic straws cut into 1″
 pieces

any small object that can be
 strung
pipe cleaners, string, or wire

PROCEDURE

Ask the children to arrange the objects in a pattern on their desks. Have the children explain their patterns. Remember that a pattern should repeat: e.g., two shorts, two longs, two shorts, or three smooth objects, one rough, three smooth.

Allow the children to work out different patterns by rearranging the objects.

Have the children string their object property patterns, or put them on a wire or pipe cleaners.

Pipe cleaners can be attached to create three-dimensional shapes.

Patterns on string can be made into necklaces.

Older children may want to make wooden frames on which to string a number of property strings or wires, with each string having a different pattern.

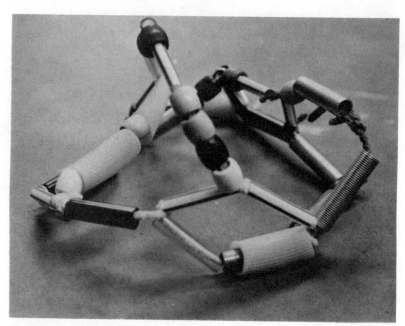

Figure 4.31. A property pattern on pipe cleaners becomes a three-dimentional form (art work created by blind child).

ADAPTATIONS

*Adaptations for
the Blind Child*

Blind children can more successfully manipulate pipe cleaners or wire. If wire is used, tape the ends to prevent eye injury. If pipe cleaners or wire are not available, tape the end of string to create shoe lace effect so that objects can be strung more easily. Cut string into 14″ pieces.

*Suggested Adaptations for
the Deaf Child*

Language cards: String, Macaroni, Straw, Beads, Pattern, Texture, Size, Shape, Quantity, Pattern, Repetition, Alternation. Put the objects on the string. Make a pattern with the objects.

CLAY AS A COPYCAT: Creating Properties with Clay

<table>
<tr><td>

MATCH BOX

General Concepts:
Material objects
Properties of matter
Evidence of interaction

</td><td>

</td></tr>
</table>

Figure 4.32. "Come feel what the shell did to my clay." A blind child discovers the copycat nature of clay.

EXPLORATION

To discover designs and textures that can be made by pushing objects into clay.

ART CONCEPTS

Exploring the properties of clay: malleable, impressionable, and capable of taking form.

MATERIALS

clay
board or other appropriate surface to work on, objects to make impressions in clay: shells, scissors, sticks, buttons, wire screening, etc.

PROCEDURE

Ask the children to make clay balls and then to pound them flat. Let the children experiment by pushing different objects into the clay to make impressions.

Let them discover ways to make the smooth property of the flattened clay into a roughly textured surface.

Ask the children to use the many discovered texturing techniques to create a clay sculpture or relief.

ADAPTATIONS

Suggested Adaptations for the Deaf Child

Language cards: Clay, Impression, Push, Remove, Shell, Scissors, Sticks, Buttons, Wire screening, Texture, Property. Flatten the clay. Push objects into clay to make impressions. Make an arrangement of impressions. How does the texture of the clay change?

Figure 4.33. "My clay person has smooth and bumpy texture and a shell belly" (blind child).

COMMENTS

After the clay has dried, some children may want to paint and shellac their work. If you have a kiln and glazes available, you may want to bake, glaze, and fire the work as another class activity.

Young children enjoy making property beads, texturing each bead in a different design. Beads should be dried on a drinking straw to insure against holes becoming too small for stringing during the drying process.

COILING CLAY POTS

Figure 4.34. "Can I feel your coil? I mean how long is it?" Blind children making coils for coil pots.

EXPLORATION

To create long clay coils to be used in the making of coil pottery.

ART CONCEPTS

Changing the shapeless mass of clay into a coil. Discovering the idea of dimension, inside and out, circularity, and form.

MATERIALS

Wood board or suitable surface on which to work, clay.

PROCEDURE

Ask the children to make long clay coils by rolling the clay with their hands. As the children roll the clay up and back let them discover how the clay coil gets longer and longer. What happens when it gets "too long"?

Let the children experiment and discover ways to make pots with their clay coils.

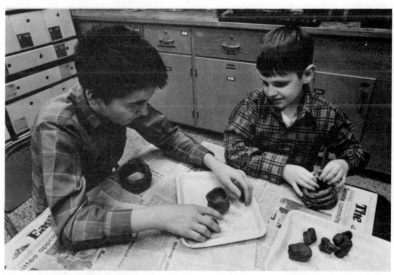

Figure 4.35. Blind children making coil pots.

ADAPTATIONS

**Suggested Adaptations
for the Deaf Child**

Language cards: Clay, Roll, Long, Thin, Coil, Wrap, Circular, Pot, Build. Roll the clay. Make the clay long. Use the long coils to build a pot.

COMMENTS

After the clay has dried it can be painted and shellacked, or baked, glazed, and fired if a kiln is available.

EMPHASIS

When matched to the following science lessons the emphasis indicated should be used.

Controlling Variables: Give each child the same amount of clay. Ask each child to make twenty (optional) coils from the clay, and coil a pot with them. The amount of clay has been controlled, and the number of coils has been controlled. Do the pots look different? Why? What variables have not been controlled?

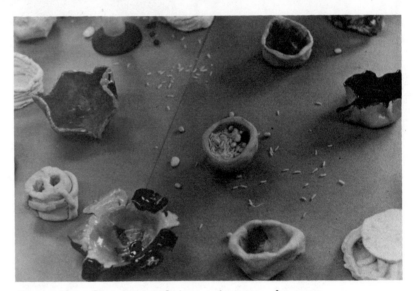

Figure 4.36. Clay pots made in a mainstream classroom.

Figure 4.37. *"Make a LONG coil."*

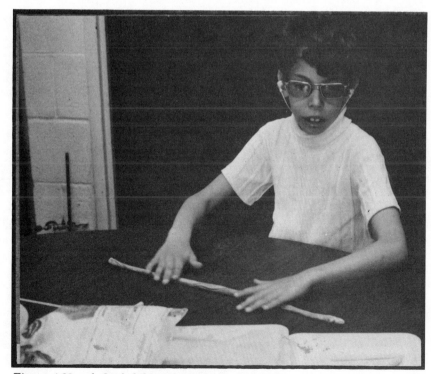

Figure 4.38. *A deaf child making a very long coil.*

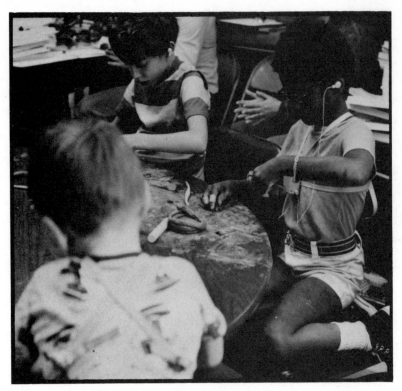

Figure 4.39. Deaf children making coil pots.

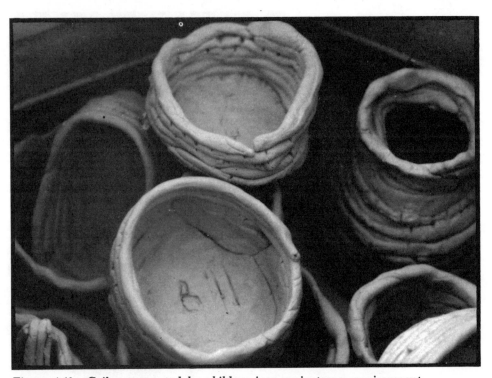

Figure 4.40. Coil pots created by children in a mainstream environment.

EXPRESSIVE CLAY SCULPTURES

MATCH BOX

General Concepts:
Properties of matter
Evidence of interaction
Shapes
Clay sculptures of systems

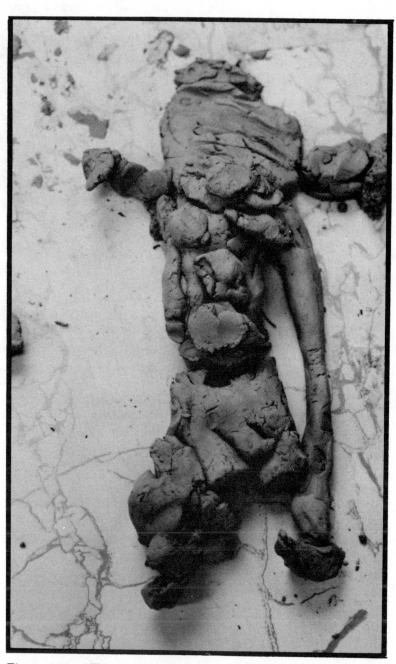

Figure 4.41. *"This girl I made has one coiled leg and one pinch leg."*
Art work produced by blind child.

EXPLORATION

To use different clay techniques to change the form of clay from shapelessness to an expressive sculpture.

ART CONCEPTS

Using pinch, coil, and slab techniques to change the form of clay. Creating the properties of size, shape, and texture.

MATERIALS

clay
wooden board or good surface on which to work
clay tools or sticks (optional)

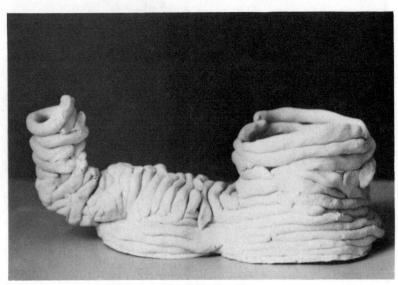

Figure 4.42. An expressive sculpture made by coiling clay.

PROCEDURE

Let the children explore the different ways to manipulate clay. Clay can be pinched, pounded, rolled, coiled, poked, etc.

Ask the children to use one or some of these manipulations to create an expressive clay sculpture.

Encourage the children to note the changes in size, shape, and texture as they work with the clay.

ADAPTATIONS

Suggested Adaptations for the Deaf Child

Language cards: Clay, Fat, Texture, Coil, Sculpture, Wrap, Property, Thin, Size, Pinch, Press, Create, Big, Long, Shape, Slab, Flatten, Smooth, Short, Rough, Roll. Use the clay to create a sculpture. Use many shapes in your sculpture. Use many textures in your sculpture. Try to change the shape of the clay.

MAKING PAPIER MACHE PROPERTY MASKS

MATCH BOX
General Concepts: Properties of matter Evidence of interaction Symmetry in nature

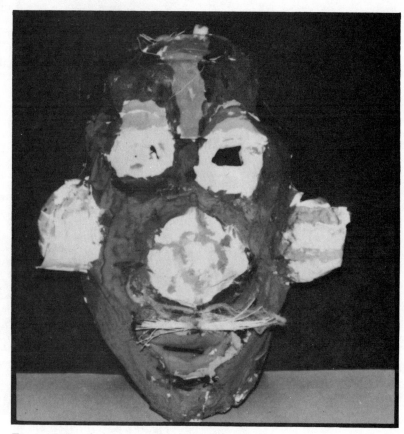

Figure 4.43. A papier maché property mask.

EXPLORATION

To create many-textured papier maché property masks.

ART CONCEPTS

Recognizing and using different textures. Exploring the medium of papier maché. Exploring shapes within shapes—features to head. Developing concepts of scale and position.

MATERIALS

newspaper	yarn
egg cartons	balloons
straw	string
glue	container for mixing
bread knife (used by teacher only)	cotton balls
	masking tape
flour	

PROCEDURE

Ask each child to blow up a balloon. Some children may need assistance tying the balloon.

Have children mix flour and water to the consistency of heavy cream.

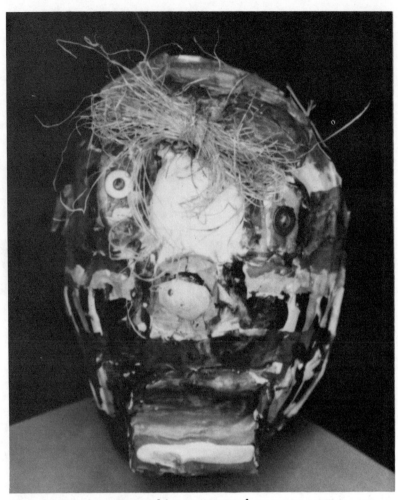

Figure 4.44. A papier maché property mask.

PROCEDURE—*continued*

Now have the children tear strips of newspaper and dip them in the flour and water mixture. Cover the entire balloon with several layers of dipped newspaper strips.

Have children build up areas where the nose, ears, and chin will be. The papier maché can be smoothed or wrinkled with the hand, depending upon desired facial texture.

Allow the masks to dry for several days.

Once dry, cut the back portion of the mask off. Have children develop the textures, dimensions, and features (shapes) with cotton, yarn, straw, egg carton bits, etc. Use paint for more color.

Make two holes behind the ears of the mask and attach string.

ADAPTATIONS

*Suggested Adaptations
for the Deaf Child*

Language cards: Newspaper, Flour, Water, Mix, Creamy consistency, Mouth, Ears, Hair, Papier maché, Container, Egg carton, Smooth, Rough, Soft, Hard, Yarn, Cotton ball, Straw, Balloon, Mask, Eyes, Nose, Texture. Blow up the balloon. Tear strips of newspaper. Dip newspaper strips into flour and water mixture. Wrap newspaper around the balloon. Build up many layers of newspaper. Make the features—eyes, nose, mouth, and ears.

BIG OR LITTLE?
Creating Designs by Sorting and Classifying by Property

MATCH BOX

Suggested Science Match:
Separating a Powdered
Mixture p. 130

Figure 4.45. Examining the size of objects before making a big or little design.

EXPLORATION

To sort objects used in an art design according to their size.

ART CONCEPTS

Discovering the size relationship of objects used in an art design. Relating the part to the whole by an orderly arrangement. Making patterns relating to the size of objects.

MATERIALS

glue, paste, or masking tape
buttons of assorted sizes
shells, seeds, or other small objects
poster paper or lightweight cardboard
small paper plates (optional)
plaster, water, and paint brushes (optional)

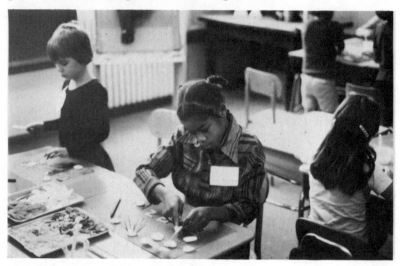

Figure 4.46. Sorting and classifying in design.

PROCEDURE

Ask the children to examine the different objects that you have selected and distributed for use in this activity. Have the children arrange them in different ways on their desks.

Have the children adhere the paper plates to the poster paper with glue. Then ask them to make a design with each paper plate having different sized elements. Encourage the children to create designs that relate to the shape of the objects and the circularity of the paper plates.

Once the desired design/patterns have been established they should be glued to the paper plates.

To emphasize the relationship of size, the properties of texture and color can be eliminated by painting the collage with a thin solution of plaster and water.

ADAPTATIONS

Suggested Adaptations for the Deaf Child

Language cards: Big, Little, Size, Classify, Sort, Glue, Shells or seeds, Poster paper, Plaster, Make, Water, Paint brush, Paint, Design, Pattern, Alternate. Sort the objects according to size. Sort the objects according to texture. Arrange the objects in a design. Can you use a pattern in your design? What is the size relationship of the objects? Paint the objects with the plaster mixture.

EMPHASIS

When matched to the following science lessons the indicated emphasis should be used.

Separating a Powdered Mixture: Using the screens from the science activity have the children separate a powdered mixture. Glue the separate powders to the cardboard in the sequential manner described above.

METAL INTO WOOD: A Bas Relief

MATCH BOX

Suggested Science Match:
Drive a Nail 1 p. 192
Drive a Nail 2 p. 195

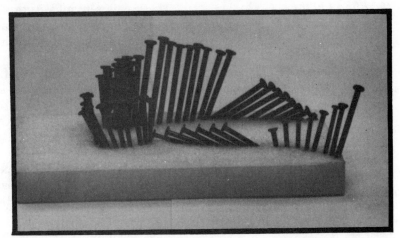

Figure 4.47. *An exciting use of diagonals and angles in a nail bas-relief produced by a blind child.*

EXPLORATION

To distinguish between qualities of metal and wood while creating a bas-relief formed by grouping nails at various levels and angles.

ART CONCEPTS

Exploring and creating dimension. Using diagonals.

MATERIALS

nails (all the same length)
one piece of wood per child
hammers (one for each child)

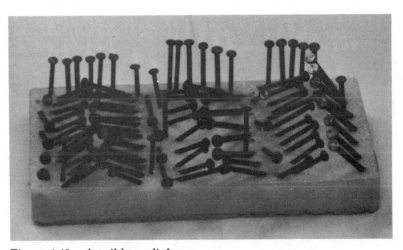

Figure 4.48. *A nail bas-relief.*

PROCEDURE

Ask the children to create a bas-relief using nails, hammers, and wood. What different levels can be created by hammering nails to different depths? How can diagonals/angles be created with the nails? How can the height of the nail be changed? What patterns can be created with nails of different heights?

ADAPTATIONS

Suggested Adaptations for the Blind Child

Some blind children may experience difficulty in nailing. For these children substitute styrofoam or clay for the base of the bas-relief. This will eliminate the need for hammering, and the children will be able to push nails into the base with their fingers.

Adaptations for the Deaf Child

Language cards: Bas-relief, Nails, Hammer, Wood, Properties, Metal, Height, Dimension, Distance, Diagonal angle, Group, Pattern. Hammer the nails into the wood. Make the nails different heights. Make patterns with the nails. Group the nails. Hammer some nails at an angle.

COMMENTS

Younger children may experience difficulty using the hammer well enough to create the bas-relief. Use styrofoam or clay as the base so that the nails can be easily pushed in with fingers.

EMPHASIS

When matched to the following science lessons the indicated emphasis should be used.

Drive a Nail 1 and 2: Encourage children to be aware of the number of times they hit the nails with hammers, how hard they hit the nails, and the effect this has on the amount the nail enters the wood.

ALL FROM A TREE:
Multi-Type Wood Constructions

MATCH BOX
General Concepts: Material objects Physical change Forms of matter

Figure 4.49. Starting out with branches and twigs.

EXPLORATION

To design and build a wood sculpture using many different types of wood.

ART CONCEPTS

Observing and creating texture. Designing three-dimensional structures.

MATERIALS

wood scraps
twigs
dowel
toothpicks
Popsicle sticks
wood shavings

bark
sawdust
sandpaper
glue
masking tape

PROCEDURE

Ask the children to examine the materials for this activity. Can they discover the common denominator? Ask the children if they know how to change the texture of wood. Let the children use sandpaper to change the texture of the wooden scraps and twigs, making them as smooth as possible.

Have the children glue together the wood pieces to create a three-dimensional multi-type wood construction.

PROCEDURE—*continued*

Tape wood together while glue is drying to prevent the construction from falling apart.

Remove the tape the following day. Put finishing touches on construction by sanding rough spots, oiling with linseed oil and a cloth, or by staining or painting.

ADAPTATIONS

Suggested Adaptations for the Deaf Child

Language cards: Wood scrap, Twigs, Dowel, Toothpicks, Popsicle sticks, Wood shavings, Bark, Sawdust, Sculpture, Sandpaper, Texture, Rough, Smooth, Rub, Three-dimensional, Glue, Tape. Make a wood sculpture. Use many forms of wood. Change the texture of the wood with sandpaper. Glue the pieces together. Use tape to hold the pieces while the glue dries.

LOOK WHAT HAPPENED TO THE PAPER!

<table>
<tr><td>

MATCH BOX

Suggested Science Match:
Rock Candy and Sugar
Cubes p. 55
What Are the Mystery
Powders? (Physical Prop-
erties) p. 68
Archimedes' Principle
p. 198

</td></tr>
</table>

Figure 4.50. Changing the shape of paper.

EXPLORATION

To make designs by changing the shape of one piece of paper into many different shapes.

ART CONCEPTS

Creating new shapes. Exploring positive and negative areas.

MATERIALS

construction paper: two pieces for each child, different colors

scissors

paste or glue

PROCEDURE

Ask the children to change the shape of a piece of paper by using scissors. What can happen to the original rectangle?

Have the children arrange the now cut up first paper on a second piece of paper. Encourage the children to explore different arrangements of the shapes.

Once the design has been finalized, paste the shapes in place. These two pieces of paper that started out the same are now different. What are the changes? What new shapes have been formed from the one rectangle? What are the positive areas of the design?

Some children may want to change their paper into very small geometric shapes—in this case they are well on their way to creating a mosaic, an exciting discovery.

ADAPTATIONS

Suggested Adaptations for the Deaf Child

Language cards: Construction paper, Shapes, Scissors, Positive space, Cut, Negative space, Glue/paste. Change the shape of the construction paper. Cut the paper into many smaller shapes. Arrange all the shapes on another piece of paper. Paste the pieces on to the paper. Point to the positive space in your design.

Art Activities 287

Figure 4.51. *"I've changed the shape of my paper—it's moving now."*

EMPHASIS

When matched to the following science lessons the indicated emphasis should be used.

Rock Candy and Sugar Cubes: Encourage the comparison between the science activity and the art activity. What has happened to the paper?

What Are the Mystery Powders? (Physical Properties): Encourage the children to note that while the size and shape of the paper may be changing in this art activity, the molecular structure of the paper is not.

Archimedes' Principle: Use the art activity to show displacement. Have the children create a design using the original paper and the shapes that have been "displaced" from it with the scissors.

LOOK WHAT HAPPENED TO THE CRAYON!

MATCH BOX

Suggested Science Match:
Rock Candy and Sugar
Cubes p. 55
What Are the Mystery
Powders? (Physical Prop-
erties) p. 68

EXPLORATION

To make crayon shavings into color designs using heat.

ART CONCEPTS

Exploring color and color mixing. Creating abstract design. Using heat to change the form of an object.

MATERIALS

wax paper	newspaper
scissors	plastic pencil sharpeners
old, thin crayons	iron (to be used by teacher only)

PROCEDURE

Have the children spread newspaper on their tables. This is essential for this activity.

Ask the children to make piles of crayon shavings by using the pencil sharpener. Each color should be kept separately.

Give each child wax paper and ask them to fold the paper once. The wax paper should then be cut into the desired shape. Between the two pieces of wax paper place pinches of colored wax shavings.

The shavings are now ready to be ironed. This is an adult task. Place the wax paper between two sheets of newspaper and iron with a warm iron. If the paper starts to turn brown, smell slightly, or smoke, your iron is too hot.

Let the children examine the design after it has been ironed. What has happened to the shavings? What has happened to the colors? What new colors have been created?

These wax designs can be used to hang on windows, as the beginnings of place mats, mobiles, card fronts, or tree decorations.

ADAPTATIONS

*Adaptations for
the Blind Child*

This is not a relevant lesson for blind children. Use the activity "Look What Happened to the Paper."

*Suggested Adaptations
for the Deaf Child*

Language cards: Wax paper, Scissors, Cut, Crayons, Pencil sharpener, Crayon shavings, Iron, Hot, Melt, Wax, Color, Red, Blue, Yellow, Green, Purple. Spread newspaper on your table. Make crayon shavings with the pencil sharpener. Keep the dif-

ferent colors separate. Fold the wax paper in half. Cut a shape from the wax paper. Put pinches of crayon shavings between the two sheets of wax paper. Put the wax paper between two sheets of newspaper. Ask your teacher to iron your papers. What happened to the crayon? What new colors do you have?

EMPHASIS

When matched to the following science lessons the indicated emphasis should be used.

What Are the Mystery Powders? (Physical Properties): Encourage the children to note that while the color and space occupied by the crayon are changing in this art activity, the molecular structure of the crayon is not.

BOATS WITH ANCHORS

MATCH BOX

Suggested Science Match:
Floating and Sinking
Objects p. 58

EXPLORATION

To create boats that float from wood and paper.

ART CONCEPTS

Learning to manipulate wood and woodworking tools. Creating a representational form of a boat. Simplifying complex structures into basic shapes.

MATERIALS

wood scraps
sandpaper
scissors
construction paper
dowel cut to 6″ pieces (dowel
 size should correspond to
 drill bits)

drills
nails
hammers
glue

PROCEDURE

Provide each child with a small piece of wood to be the base of the boat. Have each child drill a hole in the wood for the mast. Sand the base of the boat until it is smooth.

Put glue in the bottom of the hole that has been drilled. Insert six-inch dowel piece for mast. If the drilled hole is larger than the width of the dowel, wrap the bottom of the dowel with masking tape so that it fits snugly into the hole.

Have the children make sails by cutting construction paper into triangles. Glue the sails to the masts.

Ask the children to nail one nail into the boat. To this nail have the children tie a piece of string. To the other end of the string the children should tie a nail, which will serve as an anchor. Encourage children to invent their own kind of anchors.

Allow the children to develop this basic boat into a more individual expression.

ADAPTATIONS

*Suggested Adaptations
for the Deaf Child*

Language cards: Wood, Sandpaper, Glue, Drill, Smooth, Anchor, Hole, Mast, Sink, Paper, Sail, Boat, Scissors, String, Float, Cut, Nail. Drill a hole in your boat for the mast. Put glue in the bottom of the hole. Put the mast in. Cut a sail from construction paper. Glue the sail to the mast. Put a nail in your boat. Tie a string to the nail. Put a nail at the other end of the string. This nail is your anchor. What part of your boat sinks? What part of your boat floats?

COMMENTS If you have a large wash tub available or an aquarium not in use, fill it with water. Float the boats and allow the anchors to sink. The wash tub can be turned into a harbor with rafts, docks, sea animals, seaweed, deep sea divers, sunken pirate ships, and treasures.

CAN YOU BALANCE A MOBILE?

```
┌─────────────────────────────┐
│      MATCH BOX              │
├─────────────────────────────┤
│ Suggested Science Match:    │
│ Using a Balance p. 65       │
└─────────────────────────────┘
```

EXPLORATION

To create a balanced mobile.

ART CONCEPTS

Using weight balance in a mobile. Creating "godseyes" with yarn.

MATERIALS

tree branch (approximately 12", one per child)
string
yarn

four Popsicle sticks per child
scissors
fishline (only for older children)

PROCEDURE

Before the activity starts, suspend a string across the classroom slightly above head level of the children, but well within reach of the shortest child. Secure it tightly at both ends so that it will be able to support the children's mobiles as they attempt to balance them. Do not attach this string to lighting fixtures in the classroom.

Distribute two sets of Popsicle sticks (or branches) to each child. Ask the children to use the yarn to tie the sticks into a cross. Each child should make two crosses.

Invite the children to make "godseyes" with the Popsicle sticks and the yarn, which will be hung on a mobile.

To make a "godseye," have the children tie one end of the yarn to the center of the cross. Then take the yarn and wrap it around the closest segment of the cross. Move the yarn around the cross in a circular clockwise manner, always wrapping the yarn around each segment of the cross when passing it. Very soon the children will start to notice the formation of a diamond shape made by the yarn.

After each child has made two "godseyes," have them attach a branch to the string suspended across the classroom.

After the branch is suspended, let the children experiment hanging the godseyes to find positions that will balance the mobile.

ADAPTATIONS

*Adaptations for
the Blind Child*

To facilitate the making of "godseyes" for blind children, secure popsicle sticks in a cross. Do this with masking tape or a staple gun. If staples protrude, cover with masking tape to prevent injury.

Suggested Adaptations for the Deaf Child

Language cards: Branch, Popsicle stick, Cross, Yarn, Mobile, Balance, Weight, Tie, Scissors. Tie the yarn to the center of a Popsicle stick. Cross the Popsicle stick with another one. Weave the yarn over and under the crossed Popsicle stick. Make a "godseye." Hang the "godseye" from the branch. Make another "godseye." Hang it from the branch so that it balances the first one.

COMMENTS

Many different created objects can be substituted for the godseye. For example, the children can just cut out paper shapes to hang from the mobiles. Other suggestions include: painted blown eggs (older children), figures made from wood shavings, toothpicks, and corks. Older children can make complex mobiles with branches hanging from branches, each balanced.

A NATURE COLLAGE

MATCH BOX

Suggested Science Match:
Objects in the Classroom
p. 46

Figure 4.52. "I made a big seed shape with the branches and put seeds inside it."

EXPLORATION To create a collage using seeds and other natural objects.

ART CONCEPTS Finding an aesthetic balance in composition. Working with color, texture, and pattern.

MATERIALS

seeds small bits of branches
dried beans glue
acorns poster paper or cardboard
pine cones

Figure 4.53. Blind children displaying the nature collages they made with bird seed.

PROCEDURE

Invite the children to examine the different seeds and natural objects available for use in the collage. What are the shapes, colors, relative sizes, and textures?

Have the children create an imaginative collage by gluing these objects to a piece of poster paper or cardboard.

ADAPTATIONS

Suggested Adaptations for the Deaf Child

Language cards: Seed, Bean, Acorn, Pine cone, Branch, Glue, collage, Texture, Shape, Color, Pattern, Poster paper. Arrange the objects on the paper. Make a design with the objects. Glue the objects to the paper.

COMMENTS

Before this activity you may want to take the children on a nature walk. Provide each child with a paper bag to collect their own materials for use in the collage.

The fall is an ideal time of year for this because the children can also collect colorful leaves. Leaves collected should be pressed in a book or in a homemade leaf press for at least a week before they are used in a collage.

A good source of seed is wild bird feed available at large supermarkets. If using this kind of seed, provide blind children with aluminum foil containers in which to put their paper so that the small seeds do not "escape" while they are working.

IMAGING WHAT COMES FROM A SEED

MATCH BOX
General Concepts: Plant growth and development

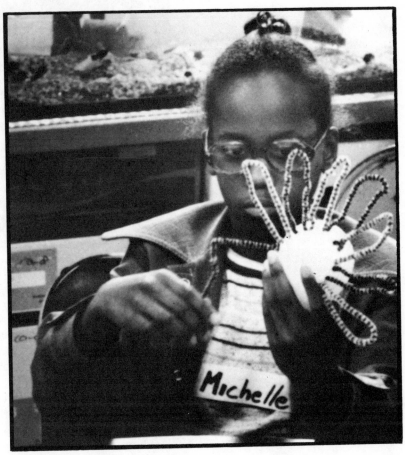

Figure 4.54. *"This is what will come from my seed."*

EXPLORATION
Creating a three-dimensional art form expressing the imagined plant that will grow from a seed.

ART CONCEPTS
Expressing imaginary vision. Using variety of shape, size, color, and texture in a three-dimensional art form.

MATERIALS
clay or Plasticine tissue paper
seeds twigs
pipe cleaners

PROCEDURE
If you plan to use clay in this activity, have the children spread newspaper over their desks.

Challenge the children to use their imagination in deciding what will come from a seed. There is no right or accurate answer. The more imagination, the better.

Encourage the children to use a variety of textures, shapes, and sizes as they work to create their imagined vision of what will come from the seed.

Art Activities 297

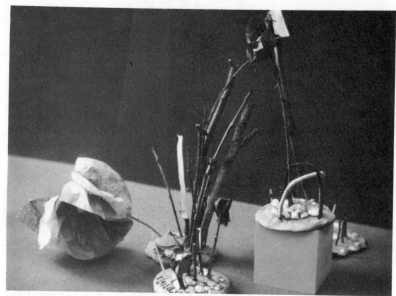

Figure 4.55. A mainstreamed class expresses what came from a seed.

*Suggested Adaptations
for the Deaf Child*

Language cards: Imagine, Create, Twigs, Guess, Clay, Pipe cleaners, Show, Tissue paper, Cut, Design, Seeds, Size, Shape, Texture. What do you think will come out of this seed? Create a plant that you think will grow from the seed.

COMMENTS

You may want to give each child several seeds that can then be incorporated into his art work.

An alternate activity is to tape one seed to the center of the blackboard and place a large question mark next to it. Invite the blind children to the blackboard to feel the seed.

PRINTING SEEDS, LEAVES, OR BRANCHES

Figure 4.56. *Printing seeds.*

EXPLORATION	To print objects from nature such as seeds, leaves, or branches.
ART CONCEPTS	Using printing as a technique to create design and pattern. Using repetition in design.
MATERIALS	seeds or small branches or leaves tempera paint mixed to a creamy consistency small rimmed aluminum foil containers to hold paint paper
PROCEDURE	Invite the children to make nature prints using seeds, branches, and leaves. Ask the children to dip the seeds, branches, or leaves into the heavy mixture of tempera paint. Make just a quick dip—too much paint makes a mess, not a print. Have the children print the objects by pressing them against the paper. Encourage the children to be aware of the color and patterns they are making by printing the objects.
ADAPTATIONS *Adaptations for the Blind Child*	Printing in Plaster: Before class mix plaster and water to a creamy consistency. Pour into a rimmed aluminum foil container

**Adaptations for the
Blind Child**—*continued*

to depth of about one-half inch. Let the plaster start to harden—about 20 minutes, time varies.

Once the plaster starts to harden, invite the blind children to press seeds, sticks, or leaves into the plaster to make prints. Encourage children to use the entire plaster surface. Allow plaster to dry. (Do not pour plaster or plaster particles into sink.)

**Suggested Adaptations
for the Deaf Child**

Language cards: Print, Seed, Branch, Leaf, Press, Design, Color, Pattern, Repeat, Paper, Paint. Dip the wet seed against the paper. Print the seed many different times. Can you make a pattern with the seed? Explain the pattern you have made.

PROGRESSION FOLD-OUTS

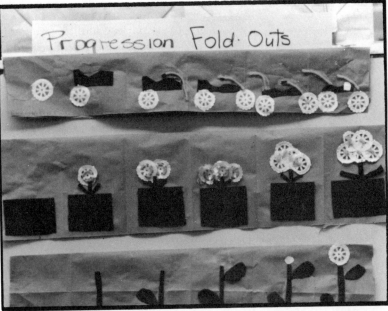

Figure 4.57. Progression fold-outs tell a story, and provide the children the opportunity to explore the concept of progression.

EXPLORATION

To invent and to compile a sequentially progressive system where growth is viewed as a progression of size, shape, texture, and complexity.

ART CONCEPTS

Exploring progression as *cumulative* growth in art and nature. Creating a systematic, readable work of art. Utilizing geometric shapes (circle, rectangle, triangle, and spiral), as well as scale, texture, and complexity to invent a kinesthetic progression.

MATERIALS

24″ × 7″ strip of Kraft paper, accordion-pleated into six spaces of 4″ × 7″ each

1″ triangles of paper
small circles cut from doilies
small lengths of yarn
scissors, glue
2″ × 3 1/2″ rectangles of felt

PROCEDURES

In order to explore progression as cumulative growth, start a game of "I went to Grandma's tea party and we had: milk ... milk and cake ... milk and cake and ice cream ...

Emphasize that nothing is dropped as each new item is added.

Examine plant growth: seed, seed and roots, seed and roots and stem, etc.

Invite the children to create a progression of different abstract shapes and textures. Remind them that whatever goes into the first space must be added to each subsequent space for a cumulative progression: felt rectangle; felt rectangle and paper triangle; etc.

Invent a cumulative progression story from nature, architecture, or daily event.

ADAPTATIONS

*Adaptations for
the Deaf Child*

Omit the game of "I went to Grandma's tea party" and include discussion of plant growth. Language cards: Folded paper, 6 spaces, Progression, Seed, Seed and roots, Seed and roots and stem, Seed and roots and stem and leaf, Seed and roots and stem and leaf and leaf, Seed and roots and stem and leaf and leaf and flower, Felt rectangles, Paper triangles, Doily circles, Yarn lines, Scissors, Glue. Divide the paper into 6 spaces. Create a progression on plant growth. Describe how a seed turns into a flower. Add (name) one part for each space. Keep all the parts from before. Make a shape progression (rectangle, triangle, circle, spiral). Tell a story about your progression.

THE BEAUTY OF SEED GERMINATION

MATCH BOX

Suggested Science Match:
Growing Beans and Peas
p. 120

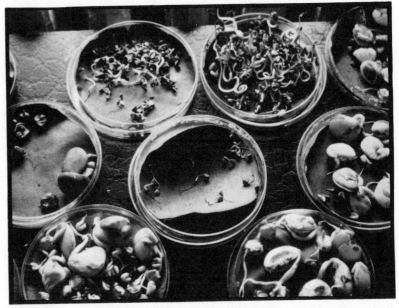

Figure 4.58. Germinating seeds—a source of design inspiration.

EXPLORATION	To observe and to express the beauty of seed germination through shaded, tonal, charcoal drawings.
ART CONCEPTS	Using seed germination as a source of design. Focusing upon the linear quality of stems growing from seeds. Using the potential of the charcoal medium to create dimensional drawings of seed and growth from seed.

MATERIALS

Activity 1

flat dishes with covers—plastic Petri dishes if available scissors	red construction paper lima bean and/or radish seeds water
or	
half egg shells cotton	lima bean and/or radish seeds water

Activity 2 — construction paper — charcoal

PROCEDURE

Activity 1

Have the children cut sheets of red construction paper into circles to fit the inside of petri dishes.

If you are using egg shells, have the children gently put cotton inside the shell.

Moisten the red paper or the cotton.

PROCEDURE

Activity 1—*continued*

Put seeds on moistened surface.

Keep the seeds moistened for several days, observing continuously to note germination.

Activity 2

Ask the children to express the seed germination by using charcoal and paper. Have the children explore the process of shading charcoal. How can the dimension of the seed be recreated using charcoal? How can distance, perspective, and movement be expressed with charcoal? What are the different qualities of line that can be created? How does the amount of pressure on the charcoal influence the quality of line?

ADAPTATIONS

*Adaptations
for the Blind Child*

To express seed germination, the blind child can glue a seed to construction paper, then cut from additional sheet of construction paper the evidence of growth observed. The blind child may also express the growth of the seed by using screen board and crayons.

*Suggested Adaptations
for the Deaf Child*

Language cards: Lima bean seed, Charcoal, Radish seed, Shade, Petri dish, Black, Construction paper, Gray, Scissors, Light Gray, Cut, Dimension, Water, Line, Germination. Observe the growing parts of the seed. Use the charcoal to express seed germination. Make different shades of gray by shading the charcoal with your finger.

TAPING THE LINES OF ROOTS

MATCH BOX
Suggested Science Match: Growing Beans and Peas p. 120

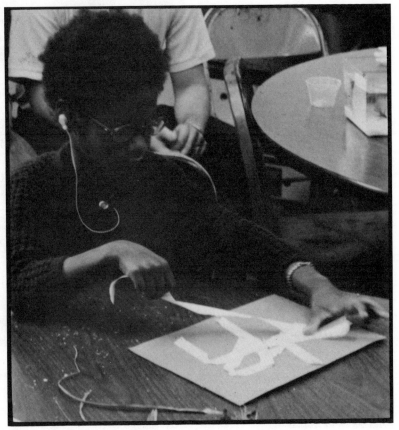

Figure 4.59. *Expressing the root system of a plant with tape.*

EXPLORATION

To interpret a root system in two dimensions using tape and poster paper.

ART CONCEPTS

Expressing the linear and branching qualities of a root system. Expressing linear direction.

MATERIALS

plant scissors
aluminum foil pie pan black poster paper
water masking tape

PROCEDURE

Ask the children to gently remove the plant from the soil. Carefully remove particles of soil. Rinse roots in a pie pan of water. Have the children feel and examine the roots to observe the evident linear qualities. Encourage children to note the branching characteristic of the root system.

Invite the children to express their observations by cutting or tearing pieces of tape and arranging them in an expression of a root system on the poster paper.

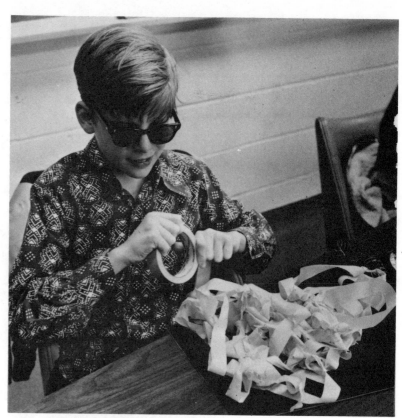

Figure 4.60. *"This root is growing over and under—touching and away." Blind child creating a root system.*

ADAPTATIONS

Suggested Adaptations for the Deaf Child

Language cards: Plant, Line, Roots, Branching, Soil, Tape, Wash, Poster paper. Make a root system using tape. Where do the roots branch? What happens to the roots as they grow? Where is the biggest root?

Figure 4.61. *Completed expression of root system. Artwork produced by blind child.*

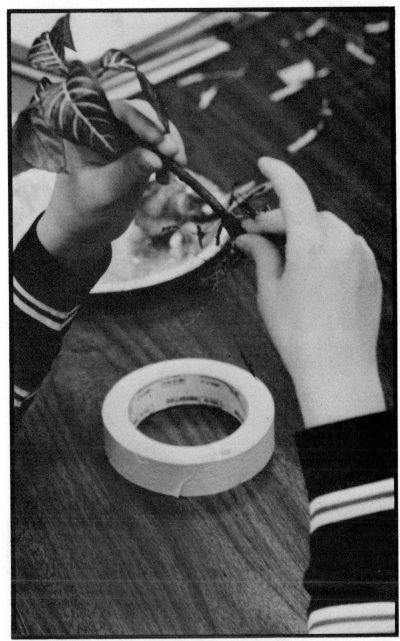

Figure 4.62. "*I have to feel the roots to find out where they are going and where they are coming from.*" *Blind child creating the root system of a plant.*

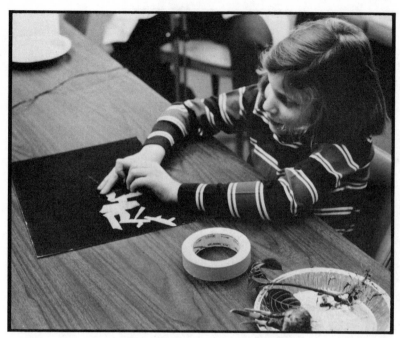

Figure 4.63. "They start big in the center and move outward getting smaller and smaller."

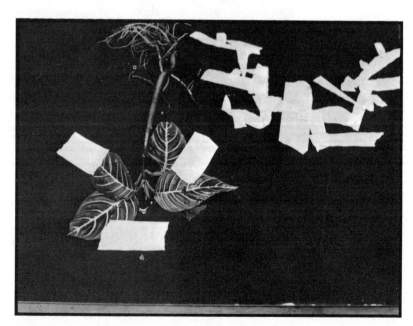

Figure 4.64. Completed expression of root growth, created by blind child.

CREATING ROOTS WITH WIRE

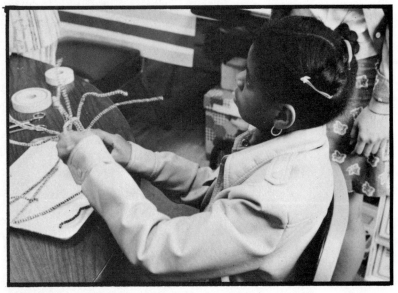

Figure 4.65. Using pipe cleaners to express a root system.

EXPLORATION

To interpret a root system in three-dimensional wire sculpture.

ART CONCEPTS

Expressing the linear qualities of a root system. Expressing linear direction.

MATERIALS

plant
aluminum foil pie pan
water
clay or Styrofoam base

flexible wire and wire cutter for teacher or long pipe cleaners
wooden block for display (optional)

PROCEDURE

Before the lesson, cut twelve-inch lengths of wire if you plan to be using wire.

Have the children remove the plant from the soil. Shake off excess particles of dirt. Wash roots in pie pan filled with water to remove remaining soil.

Ask the children to examine the roots and to note the space occupied by the root system and the linear quality of the roots.

Invite children to express linear quality of roots by manipulating wire or pipe cleaners and inserting ends in clay or Styrofoam base.

Mount completed sculpture on wooden base.

ADAPTATIONS

Adaptations for the Blind Child

To prevent eye injury, all ends of the wire must be taped with masking tape. Do not use wire hangers.

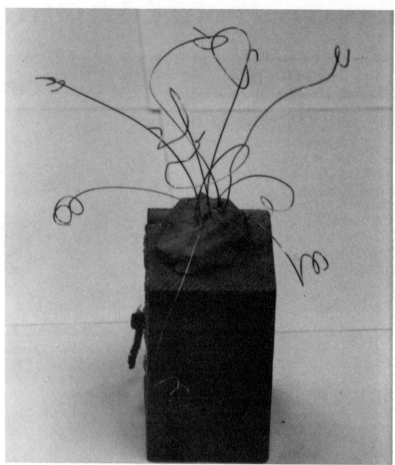

Figure 4.66. A wire sculpture expressing the root system moving through soil. Created by blind child.

Suggested Adaptations for the Deaf Child

Language cards: Wire, Line, Root, Base, Sculpture, Make. Use the wire to make a sculpture of a root system. Show the movement of the roots.

COMMENTS

Do not use hangers for this project. Wire from hangers is not flexible enough to manipulate and may spring back to cause injuries.

CREATING A FLOWER

MATCH BOX

Suggested Science Match:
Growing Beans and Peas
p. 120

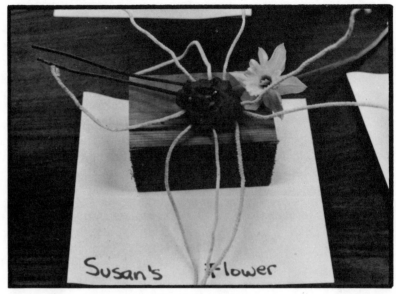

Figure 4.67. Flower created by blind child.

EXPLORATION

To use the structure of the flower as inspiration for a mixed media bas-relief.

ART CONCEPTS

Simulating and interpreting the structure of a flower. Creating a flower that exhibits properties of shape, symmetry, and circularity.

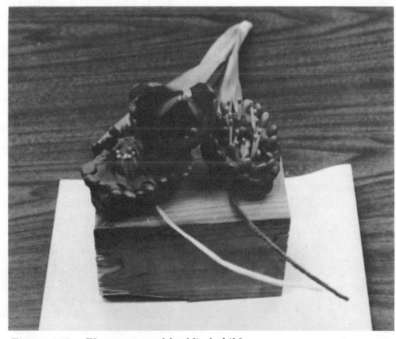

Figure 4.68. Flower created by blind child.

MATERIALS

newspaper or board on which to work
clay
live flowers—tulips are excellent objects to use in mixed bas-relief
kidney beans, pipe cleaners, match sticks

PROCEDURE

Invite the children to carefully examine the structure of the flower. What is the shape of the stigma, the pistil, the petals, the stem? How do these parts relate to each other? What are the textures of these parts?

Ask the children to express their observations, using clay as the base of the flowers. Encourage individuality and creativity in use of the other objects with which you have provided the children for this activity.

ADAPTATIONS

Suggested Adaptations for the Deaf Child

Language cards: Flower, Recreate, Circularity, Pistil, Examine, Shape, Round, Petal, Structure, Symmetry, Stigma, Stem, Match, Bean, Pipe cleaner, Clay. Examine the flower carefully. What shapes do you see? How are the shapes arranged? Recreate your own flower. Use clay, beans, and pipe cleaners.

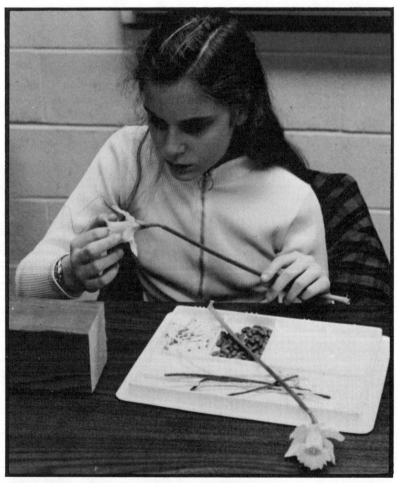

Figure 4.69. "I'm just feeling the inside of the flower to find out what's there."

Figure 4.70. Blind child making flower from clay.

Figure 4.71. Feeling the finished flower (blind child).

BUILDING A GREENHOUSE

MATCH BOX

Suggested Science Match:
Growing Beans and Peas
p. 120

Figure 4.72. Opening the greenhouse for blind children to examine growth.

EXPLORATION

To design and build a greenhouse that houses plants.

ART CONCEPTS

Creating three-dimensional geometric shape. Enclosing objects that in turn enclose others. Creating clay containers—coiling pots.

MATERIALS

building materials for frame such as:

Tinker toys or cardboard box cut down to frame	wood, nails and hammer
twist ties	large plastic bag in which frame can fit
seeds	clay
sponge cut into small rectangles	water
	string

PROCEDURE

If the children will be using cardboard frames, cut out the necessary parts from box before class if the children are unable to do this.

Invite the children to create their own greenhouses. What are the essential ingredients for a greenhouse?

Ask the children to create the geometric framework for the greenhouse (unless this has been done for them already).

Have the children create containers to hold the seeds by coiling pots.

There is no need to let the clay dry, just put a damp sponge inside the pot. Sprinkle seeds on the damp sponge surface and between coils on pot. Now have the children place the geometric frame, the pots, and sponges inside the plastic bag, tying it shut with a twist tie. What is the purpose of the plastic bag?

Figure 4.73. Open greenhouse for blind students.

Why must it be transparent? Hang the greenhouses in front of windows and daily observe the changing art of nature.

ADAPTATIONS

Adaptations for the Blind Child

If possible, use Tinker Toys for blind children to construct geometric frame.

Suggested Adaptations for the Deaf Child

Language cards: Geometric framework, Seed, Tinker Toys, Pot, Plant, Greenhouse, Clay, Sponge, Seeds, Coil, Moisten, Light, Container, Water, Plastic bag, Hold, Twist tie, Enclose. Construct a frame for the greenhouse. Put the frame inside of the plastic bag. Make coil pots to put inside the greenhouse. Put seeds on wet sponge inside of pots.

COMMENTS

Grass seed or bird feed is ideal for this project because it grows quickly. Older children can build more complex wooden structures, taping plastic bags or sheeting to the wood to form the necessary enclosing planes.

MOSIAC LIFE CYCLES

MATCH BOX
Suggested Science Match: The Life Cycle of the Frog p. 124

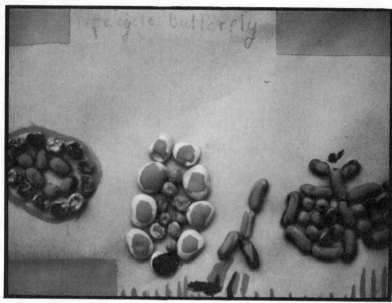

Figure 4.74. A mosaic expressing the life cycle of a butterfly.

EXPLORATION

To create a mosaic representation of animal life cycles.

ART CONCEPTS

Creating a whole by arranging a number of parts.

MATERIALS

beans or small pieces of construction paper to use for mosaic elements
scissors

glue
heavy construction paper or poster paper
paint and paint brushes (optional)

PROCEDURE

Invite the children to create a mosaic expression of the life cycle of an animal (butterfly, frog, etc.). How does the shape of the animal change during the life cycle?

If you are using beans as your mosaic element, have the children glue the beans to the construction paper to create the mosaic life cycle.

If you are using construction paper, have the children cut it into small geometric shapes that will be used to form the mosaic.

ADAPTATIONS

Adaptations for the Blind Child

Be sure to have models of life cycle available for blind children to feel.

Suggested Adaptations for the Deaf Child

Language cards: Beans, Glue, Scissors, Construction paper, Mosaic, Cut, Arrange, Geometric shapes, Life cycle, Poster paper. Cut the construction paper into small geometric shapes. Ar-

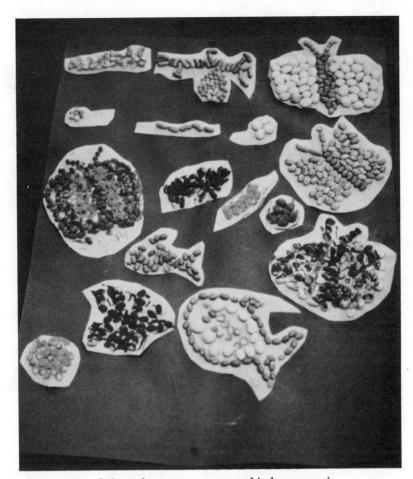

Figure 4.75. Life cycle stages represented in bean mosaic.

range the shapes to make the life cycle of the butterfly. Glue the shapes to the poster paper.

COMMENTS

Colored pictures in magazines, weekend newspaper magazines, etc., can be used by sighted children to cut into geometric shapes. The gloss of these pictures will give the mosaics a quality similar to that of glazed tiles.

CLAY LIFE CYCLES

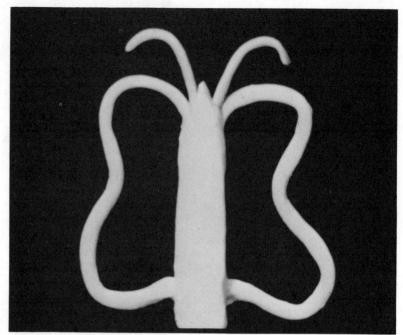

Figure 4.76. A clay butterfly.

EXPLORATION

To create clay representations of animal life cycles.

ART CONCEPTS

Using clay to express form, line, and texture observed in animals during the life cycle process.

MATERIALS

clay
clay tools (optional)
glaze and kiln (optional)

wood board or newspaper to
work on

Figure 4.77. Clay sculpture stimulated by the life cycle of the butterfly.

PROCEDURE

Invite the children to observe and to discuss the stages of the life cycle of the animal selected.

Ask the children to create an imaginative representation of these stages using clay. What shapes will they need to create? What textures and types of line can be made with clay?

How can the different stages of the life cycle, once completed, be assembled to create an interesting sculptural form?

If you have a kiln available, bake, glaze, and fire the clay life cycle sculpture.

ADAPTATIONS

Adaptations for the Blind Child

Be sure to have models available for blind child to feel.

Suggested Adaptations for the Deaf Child

Language cards: Clay, Texture, Create, Shape, Animal, Line, Life cycle. Shape the clay to make the different stages of the life cycle. What are the different stages?

INTERACTION GAMES

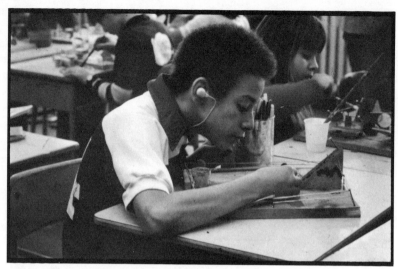

Figure 4.78. Creating an interaction game (deaf child).

EXPLORATION

To construct a game that demonstrates the principle of inter-action and interaction at a distance.

ART CONCEPTS

Using line and shape in a relief. Creating a functional art form.

MATERIALS

9″×12″ (approximate size)
 pine or plywood board
rubber bands
bells (necessary for blind only)
aluminum foil or small
 wooden balls (marble size)

hammer
nails
small scraps of wood
corks (optional)

Figure 4.79. An interaction game.

PROCEDURE

Ask the children to create a board game that demonstrates interaction at a distance.

Have the children hammer nails around the perimeter of the board at widely spaced intervals. Use rubber bands stretched between the nails to enclose the board. If using bells, string the rubber band through the bells before attaching to the nails.

Encourage the children to create individualized games by nailing wood scraps on the board, creating lanes with nails, creating shapes within shapes with nails and rubber bands, tunnels, etc.

If you do not have small wooden balls, have the children make balls from aluminum foil. Move the ball through the game by propelling it with an extended rubber band from the perimeter of the board.

How does the game created demonstrate interaction? Interaction at a distance?

ADAPTATIONS

Suggested Adaptations for the Deaf Child

Language cards: Wooden board, Nails, Bells, Balls, Hammer, Game, Construct, Rubber band, Aluminum foil, Interaction. Construct a game. Hammer the nails into the wood. Stretch rubber bands between nails. Move the ball with the rubber band.

EMPHASIS

When matched to the following science lessons the indicated emphasis should be used.

Motion as Evidence of Energy Transfer: Encourage the children to notice that energy given off by an energy source is never lost, but is conserved in amount, and always manifests itself in some energy received.

Energy Transfer: Encourage children to notice that the acceleration of a body is directly proportional to the net force acting on the body, and inversely proportional to the mass of the body.

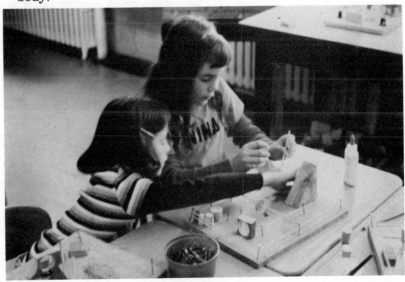

Figure 4.80. Helping in a mainstream classroom.

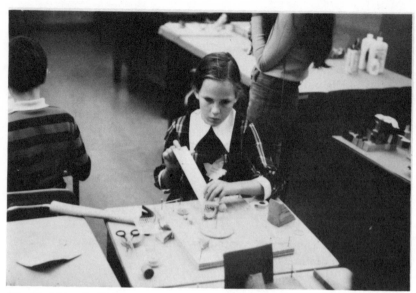

Figure 4.81. Building an interaction game.

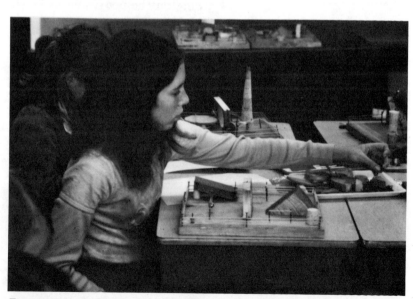

Figure 4.82. Exploring the potential of a completed interaction game by deaf student.

THE PRINTING PROCESS:
Interaction, Systems, Subsystems, and Variables

```
┌─────────────────────────────┐
│         MATCH BOX           │
├─────────────────────────────┤
│ Suggested Science Match:    │
│ "Inventing" the Systems     │
│ Concept p. 91               │
│ "Inventing" the Subsystems  │
│ Concept p. 132              │
│                             │
│                             │
└─────────────────────────────┘
```

EXPLORATION

To examine the process of printing in terms of its scientific components of interactions, systems, subsystems, and variables.

ART CONCEPTS

Learning to use printing as an expressive medium. Understanding the relationship between cutting and amount of color.

MATERIALS

colored printing ink (water soluble)
pieces of linoleum
cookie sheet

cutting tools (Japanese, U and V shape only)
ink rollers
paper

PROCEDURE

Before giving the children cutting tools, have each child demonstrate the proper cutting position. Hand with tool should cut *away* from body and other hand.

Caution: Never put hand holding linoleum in front of hand cutting.

Invite the children to cut a design in the linoleum. Encourage children to make designs that use line as well as cut away areas.

Have the children put a little ink on a cookie sheet and spread it by rolling it with roller. Roll the ink on to the cut linoleum.

Put paper on top of the inked linoleum and press it down. Rub the back of the paper with any flat, blunt object (the side of a pencil will do).

After the children have made a print, discuss the printing process. What was the evidence of interaction observed? the systems? the subsystems and variables?

Evidence of interaction in cut linoleum should be noted by all children. The tool has interacted with the linoleum. Sighted children should observe the interaction of ink with paper. These are a few of the many interactions taking place in the printing process. The "printing" system involves tools, linoleum, ink, roller, paper, and hand. A subsystem could be 1) tools and linoleum, or 2) linoleum, ink and paper.

PROCEDURE—*continued*

There are many variables in printing. Some of them include: the number of cuts made in linoleum, the shape of the tool used to make the cut, the color ink used, the amount of ink used, the type of paper used, the amount of pressure used in printing.

ADAPTATIONS

Adaptations for the Blind Child

Blind children should work with a sighted partner who will describe print, or blind child can compare printed paper with non-printed paper by using the light sensor (dark ink must be used). Other printing possibilities for the blind include printing cut linoleum in clay that has been flattened with a rolling pin. Blind children can also dampen paper by blotting with blotting paper, putting on top of inked linoleum, and rolling firmly for several minutes with rolling pin. Inked areas will become raised—embossed. Let ink dry before feeling.

Suggested Adaptations for the Deaf Child

Language cards: Linoleum, Interaction, Cut, System, Linoleum tool, Subsystem, Ink, Variables, Roller, Cookie sheet. Cut a design in linoleum. Roll ink on the cookie sheet. Roll ink on the linoleum. Cover linoleum completely with ink. Press the paper over inked linoleum. Rub paper.

BUBBLES AND BALLOONS:
Creating a Sculpture of Air

MATCH BOX

Suggested Science Match:
What Are the Mystery
Powders? (Chemical
Properties) p. 73
Balloons and Gases p. 81

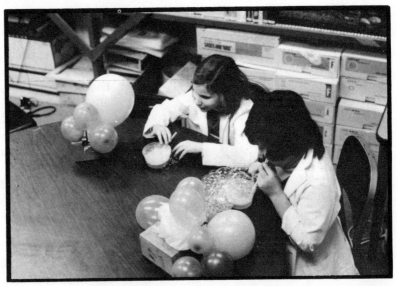

Figure 4.83. Blind (left) and sighted child working to make bubbles and sculptures expressing the qualities of bubbling.

EXPLORATION

To create an expressive sculpture, linguistically based on concepts of "bubbling," "growing," and "flowing over."

ART CONCEPTS

Developing a visual form based on the verbal description of an experience. Making concrete the abstract concepts of "airy," "light," and "floating." Exploring dimension, volume, and expansion. Recognizing the similarity and multiplicity of spherical shapes.

MATERIALS

liquid dishwashing soap
 diluted with water
tape or glue

straws
balloons
wooden base or string to
 suspend sculpture bowl

PROCEDURE

Invite the children to explore the process of bubble making. How can you make bubbles with soap and a straw? Make sure that every child knows to *exhale* through the straw—not *inhale*. *With younger, blind, or deaf children, hold your hand in front of the straws to make sure that they are in fact exhaling before giving them diluted soap mixture.*

Have children make bubbles by blowing gently into the liquid diluted soap mixture. Encourage the children to describe this bubbling process.

Invite the children to create a more lasting expression of bubbling by using balloons. How can you trap the air? How much air can you trap? What happens to the size and shape of the balloon as it traps air?

PROCEDURE—*continued*

Glue balloons together to create an expression of piling, spilling, bursting, growing, feeling light, an airy quality.

Balloon sculptures may be glued to a wooden base, or suspended by string to further enhance the floating expression of bubbling.

ADAPTATIONS

Suggested Adaptations for the Deaf Child

Language cards: Straw, Blow, Exhale, Bubbles, Bubbling, Describe balloons, Blow up, Glue. Let's make bubbles. Blow through the straw into the liquid soap. Describe the bubbles that you have made. Make a sculpture of bubbles with the balloons.

COMMENTS

Younger children and blind children may need assistance with the tying of balloons.

Some other interesting activities related to bubbling include making bubbles with pipe cleaners or wire, or creating collages with smooth textures that duplicate the circularity of the bubble.

Interesting art challenges: Can you make clay bubbles? Clay is a heavy medium—how can the children change it to represent a light, airy bubbling? Can you make cotton ball bubbles? Cotton is light—can it be made to represent the feelings of bubbles? Try wrapping cotton balls in pieces of cellophane. Suspend the cellophane balls in a bubbling fashion from a mobile or from a wire sculpture. Be sure to make lots of bubbles to create the piling effect.

STITCHERY PULLEYS

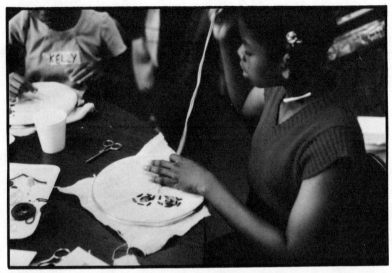

Figure 4.84. Using stitchery to expressively diagram the pulley.

EXPLORATION

To diagram the pulley concept using stitchery.

ART CONCEPTS

Diagramming an observed experience. Exploring a variety of stitches: running stitch, satin stitch, and French knot. Imaginatively elaborating on an observed experience.

MATERIALS

12 ″ burlap squares
worsted yarn cut to
 arm's length
prepared model of stitches
buttons or felt cut into
 different size circles

10″ steel spring hoops
 (blind only)
plastic tapestry needles
 with large holes

PROCEDURE

Ask the children to express the pulley using burlap and yarn.

Invite the children to examine the model of different stitches, and how the stitches can be used in the design.

Supply butttons or felt circles to be used in diagramming the pulley.

Encourage children to utilize the entire burlap square by making large pulleys or a number of small ones. Have children fill in areas with stitching as well as using the yarn as a linear element.

Let the diagram of the pulley be just the starting point of the stitchery project. How can the circular nature of the pulley be emphasized? How can the movement be expressed?

ADAPTATIONS

*Adaptations for
the Blind Child*

Using steel hoops greatly facilitates stitchery for a blind child beginning in this area. Before the activity, mount burlap squares on hoops. Thread needles with yarn.

Art Activities 327

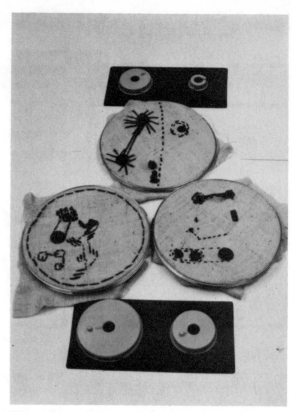

Figure 4.85. Stitchery pulleys.

Language cards: Stitchery, Types of stitches, Button, Burlap, Running stitch, Felt circles, Hoop, Satin stitch, Diagram, Yarn, French knot, Pulley, Needle, Line, Sew, Large circle, Small circle, hole. Diagram the pulleys on the burlap. Use the different stitches to make lines.

COMMENTS

Older children may stitch together burlap squares created by the class to create a stitchery patch work to be hung on the wall.

Some children may want to use their stitchery square as the beginnings for a pillow. Sew backing onto burlap square, stuff with cotton, and then sew closed.

SOLUTION SCULPTURE

MATCH BOX

Suggested Science Match:
Colored Liquids p. 136

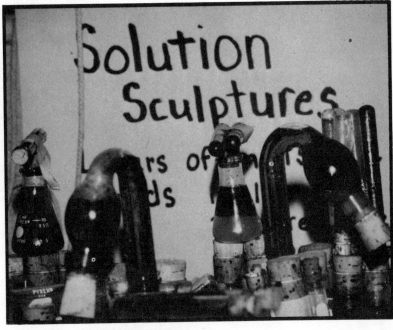

Figure 4.86. Solution sculptures.

EXPLORATION

To create a sculpture of many colored layers of miscible and immiscible solutions.

ART CONCEPTS

Discovering different sources of color. Recognizing primary and secondary color. Mixing secondary colors. Understanding color systems.

MATERIALS

colored crystals (e.g., potassium permanganate)
food coloring or paints
plastic test tubes or other containers
beakers or tumblers for mixing solutions
berries or roots to color solutions
cooking oil
stoppers or corks
stirring rods or sticks
glue
masking tape

PROCEDURE

Have the children experiment with making colored solutions. What can the color sources be?

What happens when you mix colors? What are the primary colors? (Red, blue, and yellow.) What are the secondary colors? (Green, orange, and purple.)

How can you make layers of color? What does miscible mean? What does immiscible mean?

Invite the children to make solution sculptures with different colored layers of solutions. Be sure to tightly cork test tubes or other liquid containers before gluing them together. Create a solution sculpture of many colors. Tape the containers in place while the glue is drying.

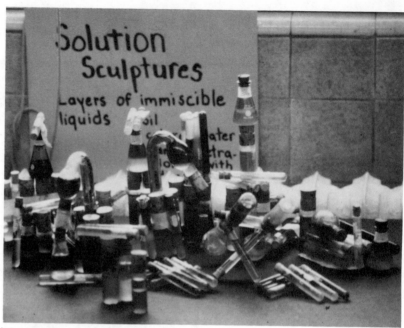

Figure 4.87. Solution sculptures.

COMMENTS

Sighted children may try another activity using colored cellophanes to represent different colored solutions. What happens when yellow and blue cellophanes are overlaid?

An activity involving paint or dye mixing may also be developed from this lesson.

ADAPTATIONS

Adaptations for the Blind Child

Use large containers for blind children to enclose their solutions. Solution colors can be determined by use of light sensor. Have blind children tape small pieces of different textured paper to outside of container to relate light sensor.

Suggested Adaptations for the Deaf Child

Language cards: Test tube, Primary color, Miscible, Cork, Red, Immiscible, Beaker, Blue, Layers, Stirring rod, Yellow, Solutions, Glue, Secondary color, Sculpture, Food coloring, Green, Assemble, Berries, Orange, Crystals, Purple. What different color solutions can you make?

EMPHASIS

When matched to the following science lessons the indicated emphasis should be used.

Colored Liquids: Are the colored liquids created by the children true solutions? How can they find out? They should recall from their science activity that in a solution the solute is mixed thoroughly and evenly throughout the solvent, and that true solutions are transparent, non-filterable, and homogeneous.

EXPRESSING MAGNETIC LINES OF FORCE: A Nail and String Design

EXPLORATION

To express magnetic lines of force with a nail and string relief.

ART CONCEPTS

Using string to represent a line connecting two separate elements. Creating linear design with string. To relate the concepts of pull, force, and attraction.

MATERIALS

pine board (9″ × 12″ approximate size)
scissors

nails with heads
string

PROCEDURE

Discuss magnetic attraction with the children. What words do they use to describe their science experience? Pull? Attraction? Force?

Ask the children to express this observed attraction by creating a nail and string design. Have one nail in the design be designated as the magnet. Hammer this nail into the wood. Hammer in the other nails. These nails represent metal objects attracted to a magnet.

Tie a string to the magnet nail. Attach the other end to a metal object nail. Tie strings to all nails. All strings must have one end tied to the magnet nail. Strings should be tied tightly to express the pull of attraction.

The placement of nails determines the expressive quality of the design. For example, the magnet nail can be placed in the center of the board with others in a circle around it, or the magnet nail can be placed at one side of the board with metal object nails on the other side.

Encourage the children to use as many nails as possible to create interesting linear designs expressing attraction.

ADAPTATIONS

Suggested Adaptations for the Deaf Child

Language cards: Board, Nails, Hammer, String, Scissors, Cut, Tie, Magnet. Hammer the nails into wood. One nail represents the magnet. All other nails represent metal objects. Show magnetic lines of force. Tie the magnet nail to all the other nails.

COMMENTS

Older children may want to use different colored strings or threads creating boards covered with fine colored line.

Nail and string designs can be made three-dimensional by gluing wood block columns of different heights to a piece of board. Nails at the top of the column may represent magnets while nails on the base board represent attracted objects. Using string, yarn, thread, or fishline, attach the magnet nails to the metallic objects.

ARTICULATED PUPPETS

MATCH BOX
Suggested Science Match: "Inventing" Interaction at a Distance p. 100 Motion as Evidence of Energy Transfer p. 176

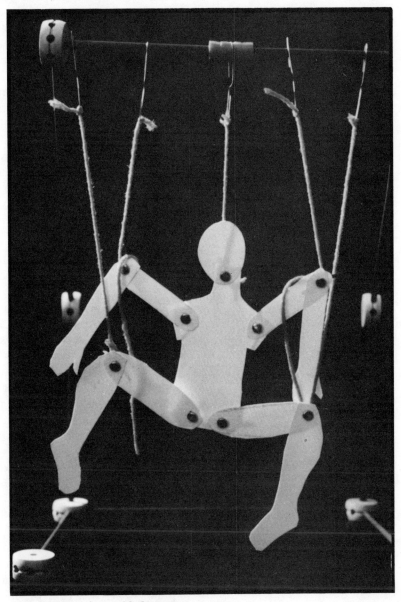

Figure 4.88. Assembled puppet.

EXPLORATION

To create a puppet that can be moved by pulling on yarn attachments.

ART CONCEPTS

Constructing the universal form of man. Recognizing shape relationships and scale. Realizing the relationship of the part to the whole. Verifying the symmetry in the human form.

MATERIALS

frame (large cardboard
 box or Tinker Toys)
hole punch

yarn
heavy construction paper
paper fasteners (8 per child)

PROCEDURE

Invite the children to make puppets that can be manipulated by yarn. The puppets will be in the form of a human body. Ask the children to examine their bodies—what is the relationship of the size of upper arm to lower arm? Upper leg to lower leg? Which is longer—the arm, or the leg? How big is the head in relationship to the torso?

Have the children cut the anatomical parts indicated on the prototype from paper. How can the legs be made symmetrical? (Hint: Cut two pieces of paper at the same time.) What other parts of the body exhibit symmetry?

Ask the children to assemble their puppets by punching holes at indicated places and then fastening appropriate parts with paper fasteners. Once assembled, tie yarn to paper fasteners at knee joints, elbow joints, and head. Attach yarn to Tinker Toy frame or cardboard box frame.

Manipulate the puppets by moving the yarn.

ADAPTATIONS

Adaptations for the Blind Child

Before the activity cut anatomical parts from heavy paper using the prototype provided. Hole punch parts in indicated places.

Suggested Adaptations for the Deaf Child

Language cards: Puppet, Paper, Cut, Arms, Legs, Thighs, Torso, Upper arm, Scissors, Attach, Symmetry, Lower arm, Paper fastener, Yarn. Make the parts of the body—head, torso, legs, thighs, lower arms, and upper arms. The arms are the same. Make them symmetrical by cutting two pieces of paper at the same time. What other parts of the body are symmetrical? Put the puppet together with paper fasteners. Attach the puppet to the frame with the yarn. Make the puppet move.

COMMENTS

It may be necessary to make a large prototype of the anatomical parts on the board or on a piece of paper to display to the children.

Puppets may be decorated before hanging with paint, fabric, felt tip pens, etc.

Younger children may want to make a more simple puppet—e.g., a bird with two wings, or a caterpillar made from styrofoam balls attached with pipe cleaners. Tie ends and middle of caterpillar with yarn to a branch or stick and make the caterpillar move and wiggle.

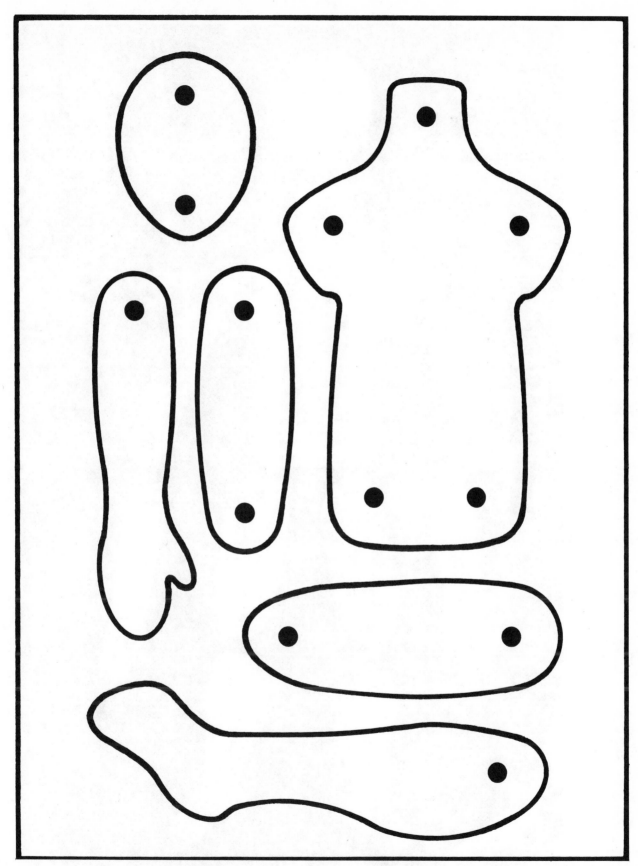

Figure 4.89. Prototype for anatomical parts.

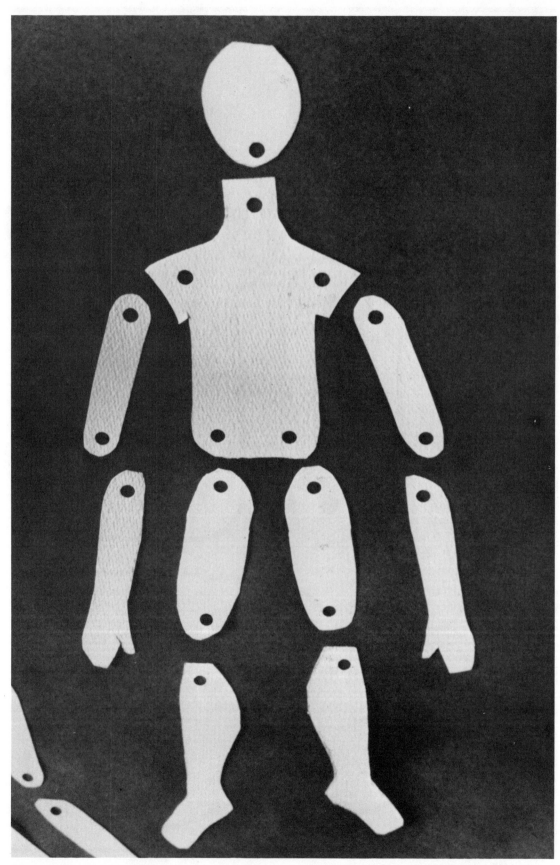

Figure 4.90. Cut-out shapes assembled and ready for stringing—the articulated puppet.

MAKING LANTERNS:
Using Electric Circuits in Art

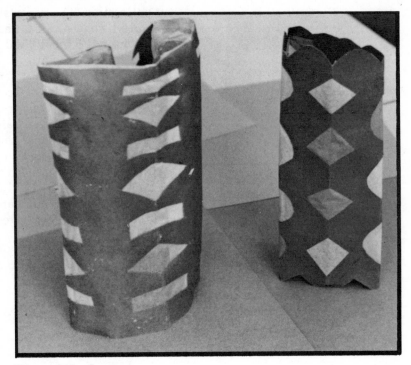

Figure 4.91. Lanterns.

EXPLORATION

To create three-dimensional lanterns.

ART CONCEPTS

Cutting geometrical designs and patterns. Creating an art form using light.

MATERIALS

black construction paper yarn
colored tissue paper tape or paste
 or colored cellophane scissors
batteries, wire, and light bulbs

PROCEDURE

Invite the children to make lanterns that will light up.

Ask the children to cut geometric shapes from the black construction paper. This can easily be done by folding the paper several times and cutting small geometric shapes along the fold. What patterns of shapes can be made?

After the shapes have been cut, ask the children to tape or paste small pieces of different colored tissue or cellophane behind each of the cut out areas.

When the children have finished, ask them to roll the black paper into a cylinder. Holes should be punched at the top of each lantern. Tie strings or yarn through these holes to create a handle for hanging.

Have the children connect batteries to light bulbs and hang lanterns over the light bulbs.

ADAPTATIONS

*Adaptations for
the Blind Child*

Blind children should cut large geometrical shapes from the construction paper. Using tape they should adhere light colored cellophane to the back of the construction paper to cover the cut-out section. The paper should then be rolled into a cylindrical lantern shape, taped, and put over a light bulb. By using a light sensor the blind child should be able to determine when the lantern has been lit.

*Suggested Adaptations
for the Deaf Child*

Language cards: Black paper, Geometric shape, Colored tissue paper, Paste, Cut, Scissors. Cut geometric shapes from the black paper, saving the framework. Paste tissue paper behind the holes. Roll the paper to form a cylinder. Light the lantern using batteries, wire, and a light bulb.

COMMENTS

A large branch supported in a bucket of sand is an ideal base from which to hang mini-lanterns. Wire the branch with bulbs and then attach lanterns over bulbs.

ELECTRIC CIRCUIT DESIGNS

```
+--------------------------------+
|          MATCH BOX             |
+--------------------------------+
| Suggested Science Match:       |
| Electric Circuits p. 107       |
| Objects That Can Close a       |
| Circuit p. 111                 |
+--------------------------------+
```

EXPLORATION

To use electric circuit puzzles as a stimulus for linear art design.

ART CONCEPTS

Making patterns and groupings of similar shapes. Making lines by attaching points.

MATERIALS

red construction paper
blue construction paper
hole punch
colored pens, crayons, or
 chalks

aluminum foil
rulers
tape and yarn

PROCEDURE

Explain to the children that they will be using the electric circuit puzzle as a starting point for an art design.

Have the children punch holes in red sheet of construction paper. Behind some of the holes they should tape aluminum foil.

When the children have finished taping aluminum foil behind circles, have them tape the red sheet of construction paper to the blue sheet. The two sheets should be taped together in such a way that only dots of aluminum foil show.

Ask the children to connect the aluminum foil holes by drawing straight lines with felt tip pen, crayon, or chalk and ruler. The children could also attach foil holes with yarn.

Holes showing blue paper should not be attached by lines.

Blind children should be reminded to attach only holes through which they can feel aluminum foil.

ADAPTATIONS

*Adaptations for
the Blind Child*

Instead of having blind children draw lines, have them indicate lines by using yarn taped into place. Blind children should feel the difference in texture between aluminum foil and construction paper, and should attach only aluminum foil circles.

*Suggested Adaptations
for the Deaf Child*

Language cards: Red paper, Hole punch, Blue paper, Pen, Ruler. Make holes with the hole punch. Tape aluminum foil behind some holes. Attach red paper to blue paper so that tape does not show. Connect aluminum foil circles to show electric circuits.

MAKING PUZZLES

```
┌─────────────────────────────┐
│        MATCH BOX            │
├─────────────────────────────┤
│ Suggested Science Match:    │
│ "Inventing" the Systems     │
│ Concept p. 91               │
└─────────────────────────────┘
```

EXPLORATION To create puzzles from cardboard.

ART CONCEPTS Establishing the relationship between the part and the whole. Designing a puzzle.

MATERIALS

cardboard or poster paper
 (2 pieces per child)
masking tape

paint and paint brushes
scissors

PROCEDURE Invite the children to make their own puzzles.

First have the children make a picture or design on poster paper with paint.

Once the paint is dry, have the children cut the picture into large size puzzle pieces.

Challenge the children to put their puzzles back together.

Pieces can be taped to an uncut piece of poster paper to hold them in place.

ADAPTATIONS

Adaptations for the Blind Child

Cut geometric shapes from fabric—felt, corduroy, and cotton—before the class. Ask the blind children to glue these fabric pieces to a piece of poster paper or cardboard. Assist the blind children to cut their fabric designs into large geometric shapes —the puzzle pieces. Have the children put their puzzle together and tape it to an uncut piece of poster paper.

Sugggested Adaptations for the Deaf Child

Language cards: Paint, Pieces, Poster paper, Picture, System, Cut, Subsystem, Puzzle, Tape. Paint a picture. Cut the picture into puzzle pieces. Put the puzzle back together. Tape the pieces to a piece of poster paper while holding them in place the right way.

A SUBSYSTEM MOBILE

MATCH BOX

Suggested Science Match: "Inventing" the Subsystems Concept p. 132

EXPLORATION

To construct a mobile of several subsystems.

ART CONCEPTS

Understanding the relationship of parts to the whole. Using balance and movement in art.

MATERIALS

several branches or pieces of balsa wood for each child
yarn, string, or fishline
construction paper
scissors

PROCEDURE

Before the activity, suspend a string across the classroom at what is shoulder height for most of the children.

Invite the children to make a mobile of several subsystems. Suggest using different geometric shapes for each subsystem, but encourage children who want to use different symbols.

First, hang the main branch or piece of wood from the string suspended across the classroom. At each end of the branch attach a string. To the other end of the string attach a branch. From the ends of these branches hang groups of cut-out similar shapes. For example, hanging from one end of the branch may be a number of triangles of different sizes. Hanging at the opposite end of the branch may be a number of rectangles of different sizes. Each grouping of geometric shapes used to balance the mobile is a subsystem of the entire mobile system.

Older children may make mobiles of many subsystems. Complex geometric shapes, one- or two-dimensional, can be used. Challenge the children to be as creative as possible in designing the elements to hang from the mobile.

ADAPTATIONS

Suggested Adaptations for the Deaf Child

Language cards: Mobile, Yarn, Construction paper, Branch, Cut, Scissors, Shapes, System, Subsystem. Hang circle shapes from one end of the branch. Hang rectangular shapes from the other end.

FELT PICTURES: Before and After

EXPLORATION

To express change observed in science activity with felt pictures.

ART CONCEPTS

Diagrammatically representing change in an art form. Developing design and pattern with geometric shape.

MATERIALS

construction paper glue or paste
felt scissors

PROCEDURE

Invite the children to create a two-part representation of a mixture, and a mixture that has been separated.

Have the children divide their paper in half. On the first half, paste a variety of geometric shapes in a nonsorted design. On the second half of the paper, sort the shapes and create a design where similar geometric shapes are together.

ADAPTATIONS

Adaptations for the Blind Child

Before the activity, cut a number of triangles, circles, and rectangles from felt for blind children to use in their felt pictures.

Suggested Adaptations for the Deaf Child

Language cards: Felt, Geometric shapes, Square, Rectangle, Triangle, Circle. Cut geometric shapes from the felt. Divide your paper in half. On one half of the paper paste geometric shapes to represent a mixture. On the other half paste geometric shapes to represent a mixture that has been sorted.

EMPHASIS

When matched to the following science lesson the indicated emphasis should be used.

Converting Liquid Freon to Gas: Have the children cut out a number of felt circles the same size. Divide the paper in half. On one half of the paper use the circles to represent liquid Freon. On the other half of the paper use the circles to represent gas Freon. The circles on the liquid Freon side of the paper should be arranged closely together. Circles on the gaseous Freon side of the paper should be far apart, filling up the entire half of the paper.

CANDLE MAKING

MATCH BOX

Suggested Science Match:
Evidence of Interaction—
Energy Transfer p. 90
Properties of Freon p. 142
Temperature Change as
Evidence of Energy
Transfer p. 172

EXPLORATION

To make hand-dipped candles that demonstrate changing states of matter.

ART CONCEPTS

Using a color in candle making. Mixing colors. Creating a wax form.

MATERIALS

wax and wick (obtainable at hobby and craft stores)
empty coffee cans
water
oven mittens

old colored crayons with paper removed
hot plate
scissors
heat resistant trays or wooden board

PROCEDURE

Ask the children to break the white wax into small pieces that will fit into a coffee can.

Have the children place wax in coffee can. Then have the children put crayons (with paper removed) into the coffee can.

Place the coffee cans on the hot plate.

While the wax is melting, have children fill additional coffee cans with cold water. Each child should have his own can of water. Melted wax cans can be shared by three or four children.

After the wax is melted, an adult should remove the can from the hot plate using oven mittens. The can of melted wax should be placed on a heat resistant tray or piece of board between the three children who will be using it.

Ask the children to dip twelve-inch lengths of wick into the hot wax and then into cold water. This process is repeated many times to allow wax to build up on the wick.

Children may wish to exchange places to dip different colors of melted wax on to their candles.

When the wax in the coffee can starts to harden, it should be reheated on the hot plate.

After candles are finished, they should be suspended by the unused portion of wick to harden.

ADAPTATIONS

Adaptations for the Blind Child

It is necessary to exercise extreme caution when blind children are working with the hot wax. A teacher, aide, or older student should work closely with the blind child.

Suggested Adaptations for the Deaf Child

Language cards: Crayon, Color, Wick, Melt, Cool, Hot plate, Scissors, Cut, Solid, Liquid, Change of state. Put wax in a coffee can. Melt the crayons to make colors. Dip the wick into wax. The wax is hot. Dip wick into water.

COMMENTS

Some children may want to make candlestick holders. Take a scrap of wood and hammer a long nail through the wood so that one inch protrudes through the wood. Heat the nail and gently push candle onto the nail.

EMPHASIS

When matched to the following science lesson the indicated emphasis should be used.

Temperature Change As Evidence of Energy Transfer: Encourage the children to recall from their science activity that energy is gained by objects when they are heated and is given off by objects when they are cooled. After making candles, have the children feel the water in which they have been dipping the hot wax candles. Note that this water has now become warm. In the process of making candles, the wax has changed from a solid to a liquid and back to a solid. Solids are changed to liquids by adding energy. Liquids are changed to solids by removing energy.

MIXING YOUR OWN DYES FOR TIE DYING

MATCH BOX

Suggested Science Match:
Solutions and Mixtures
p. 98
Colored Liquids p. 136

EXPLORATION

To dye cloth by tying and dipping into dye.

ART CONCEPTS

Mixing dye colors. Creating patterns and designs on cloth by dying.

MATERIALS

cold water dyes (obtainable at large grocery stores)
sticks to stir dyes
cotton fabric or old T shirts
string
buckets
water and an easily available water source—sink, outdoor faucet, or hose

PROCEDURE

Ask the children to mix dye powder with a little cold water in the bucket. Once all the dye powder has dissolved, add more cold water.

Have the children tie knots in the cloth they will be using. They may also tie the cloth with string.

Have the children put the knotted/tied fabric into the bucket of cold water and dye. They should stir the cloth in the dye using a stick.

Remove the cloth from the dye and wash it vigorously in a running source of water until no more dye washes out.

Ask the children to unknot and untie the cloth and hang it up to dry.

ADAPTATIONS

Adaptations for the Blind Child

For this activity blind children should work with sighted partner. The tie dye product should be described by the sighted partner to the blind child.

Suggested Adaptations for the Deaf Child

Language cards: Dye, Mix, Water, Stir, Stick, Cloth, Tie, Dip, Rinse, Color. Mix the dye in a little bit of cold water. Make sure that all the colored powder has dissolved. Add more cold water. Tie cloth in knots. Tie string tightly around cloth. Dip cloth into dye. Move the cloth around with stick. Remove cloth from the dye. Rinse the cloth in water until no more dye comes off. Untie the knots.

COMMENTS

Children should wear smocks or aprons for this activity. It is inevitable that hands will become slightly colored; this dye will wash off after a day or so. Old pillow cases and torn up old sheets are ideal for dying.

If it is a warm day and an outside water source exists, dye outside, and spills won't matter.

SOLID-LIQUID-GAS BAGS

```
┌─────────────────────────────┐
│      MATCH BOX              │
├─────────────────────────────┤
│ No Suggested Science        │
│ Match.                      │
└─────────────────────────────┘
```

EXPLORATION To use solids, liquids, and gases in creating an art form.

ART CONCEPTS Using the three states of matter in creating art sculptures. Mixing colors.

MATERIALS

transparent plastic bags
 assorted sizes
water
water color paints or
 food coloring
masking tape

marbles, pebbles, shells,
 or sand
paper cups
cooking oil (optional)
twist ties
string

PROCEDURE Challenge the children to make an art form using solids, liquids, and gas.

Have the children mix a variety of colored solutions in paper cups. Pour the colored liquid into the largest plastic bag. What happens when you add oil?

Have the children add solid material—pebbles, shells, sand, sticks, etc.—to the colored liquid.

Here are some suggestions to try. Fill small bags with different colored liquids, tie, and put inside large plastic bag of different colored liquids. Fill the large plastic bag, partially tie in the middle, and then fill the other segment—a "double bubble." Fill a number of large plastic bags using as many alternatives as possible, group together, and tie. Tape to make sure they stay together.

After the solid-liquid-gas bags have been completed, ask the children to identify the solids, liquids, and gas. What colors have been created?

Hang bags in the classroom or from a tree in the school yard.

ADAPTATIONS

Adaptations for the Blind Child Blind children should create their sculpture by making liquid bags, solid bags, and gas bags, each separately.

Suggested Adaptations for the Deaf Child Language cards: Plastic bag, Big, Little, Tie, Water, Liquid, Pebbles, Solid, Air, Gas, Mix, Colors, Oil. Mix colored water. Fill large plastic bag with some colored water. Put solid material into plastic bag. What will the gas be? Tie bag with twist tie.

STRAW STRUCTURES

Figure 4.92. Creating a straw structure.

EXPLORATION

To make straw designs using a controlled number of straws.

ART CONCEPTS

Creating a design using controlled materials. Recognizing and using geometric shape in design. Organizing elements in design.

MATERIALS

paper drinking straws construction paper
paste or glue scissors

PROCEDURE

Invite the children to make geometric designs using straws. All straws must, however, remain the same length.

Have the children paste the straws to the construction paper.

After the children have completed the first design, ask them to create another straw design. This time all the straws must be cut in half. What is the difference? How has changing the length of the straw changed the way in which they work with the straws?

ADAPTATIONS

*Suggested Adaptations
for the Deaf Child*

Language cards: Straw, Paste/glue, Paper, Geometric shape, Triangle, Square, Rectangle, Control, Variable. Create a design using straws the same length. Paste straws to the paper. Cut the straws in half.

EMPHASIS

When matched to the following science lessons the indicated emphasis should be used.

Figure 4.93. Straw structure under construction.

Serial Ordering and Comparison of Objects: Invite the children to make a design with straws, arranging them according to length.

Whirly Birds: Have the children make three straw designs. In design 1, use straws cut to the same length. Now recreate design 1, but this time use straws cut one inch longer. In design 3 use straws cut two inches longer than in design 1. Encourage children to notice the variable length of the straws. What effect does this variable have on the finished design?

GRAPHING:
Bar Graph and Histogram Sculptures, and Woven Graphs

MATCH BOX
General Concepts: Making and using graphs and histograms

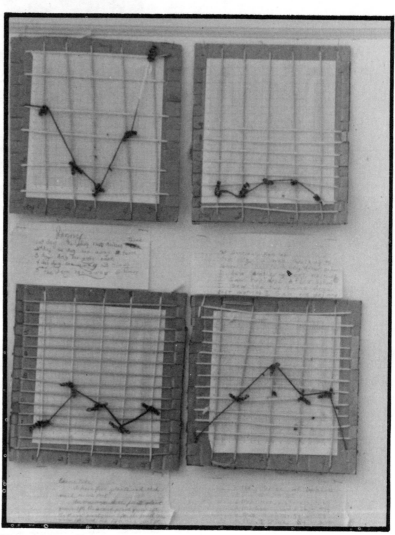

Figure 4.94. Graphs that tell a story.

EXPLORATION

To invent and to visualize a five-day or five-event story through a bar graph sculpture and woven graph.

ART CONCEPTS

Creating a systematic, readable art work. Moving from the verbal to the visual. Utilizing art to diagram experience. Keeping track of a system from story to three-dimensional bar graph to path graph. Exploring measurement, progressive pattern, and concepts of vertical and horizontal.

MATERIALS

paper and pencil
5" × 1" × 1/2" slab of clay
5 pipe cleaners, 6" lengths
plastic straws, 1" lengths

8" × 8" cardboard "looms," notched at 1" intervals along the 4 sides (graph paper glued to top surface)
yarn lengths for warp and weft and path
5 pipe cleaners, 1 1/2" lengths
scissors

PROCEDURE

Ask the children to make up a story. For example: On Monday, I gave my dog one dog biscuit; on Tuesday, he didn't deserve any; on Wednesday, he got two biscuits; and so on, through Friday. They could use a week by week report on plant growth.

While the first child invents a sample story, construct a bar graph sculpture: each event is represented by a pipe cleaner inserted in the clay slab, and the number is represented by the same number of straws slipped over the pipe cleaner.

Hand out the looms and have the children wrap the yarn through the *vertical* notches. Have them weave the yarn over and under *horizontally* through the vertical yarn. Be sure to demonstrate activity and give clear verbal directions ("show and tell"). Explore the concepts of horizontal, vertical, and grid.

Have the children number serially up from the bottom to top rows and from left to right: a gridded graph. (Use prepared braille paper tabs for the blind.)

Invite the children to recreate their story and bar graph in gridded graph form. Wrap a pipe cleaner around the vertical and horizontal yarn at the proper point and twist. Example: the days are at the bottom and number is at the side so that day one—1 biscuit is first vertical row at left, and bottom horizontal row. Have the children continue until five days and five events are mapped. Use a yarn length to move from point to point.

Exchange graphs and have another child "read" your story.

ADAPTATIONS

Adaptations for the Blind Child

Braille gridded graph, braille paper tabs.

Suggested Adaptations for the Deaf Child

Language cards: Five-day story, Paper, Pencil, Bar graph, Clay base, 5 pipe cleaners, Cut straws, Numbers, Amount, Loom, Yarn, Wrap up and down, Weave across, Grid, Write, Pipe cleaner marks, Yarn path, Intersection. Write a five-day story: example—On Monday, I gave my dog...On Tuesday, I gave my dog...On Wednesday, I gave my dog...On Thursday, I gave my dog...On Friday, I gave my dog...Write your own story. Put a pipe cleaner in the clay for each day. Put _____ number of straws over your pipe cleaner for the amount. Do the numbers match your amounts? Weave a grid on your loom. Write your numbers (for days) across the bottom (1,2,3,4,5). Write your amounts on left side bottom to top. Place your pipe cleaners at the intersection of day and amount. Make a yarn path from pipe cleaner mark to the next.

COLLAGE HISTOGRAMS

<table>
<tr><td colspan="2">MATCH BOX</td></tr>
<tr><td>General Concepts:
Making and using graphs
and histograms</td><td>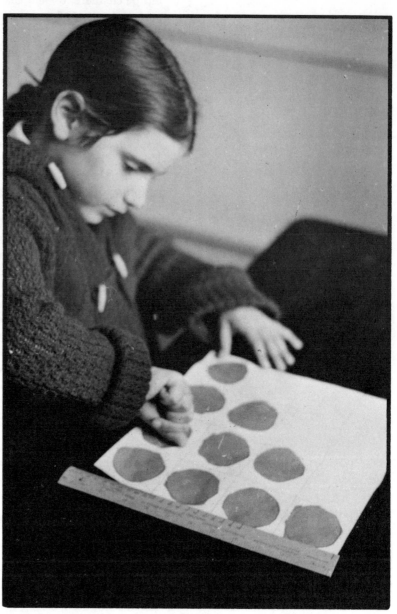</td></tr>
</table>

Figure 4.95. *Making a collage histogram.*

EXPLORATION To design histograms using geometric shape as symbols.

ART CONCEPTS Using measurement in art. Using art to diagram experience. Using geometric shape and pattern.

MATERIALS

poster paper	rulers
masking tape	scissors
construction paper	pencils
tape	paste

PROCEDURE

Ask the children to make up a story. For example: On Monday I ate one peanut, on Tuesday I ate four, on Wednesday I ate six, and on Thursday I ate two.

Explain to the children that they are going to make collage histograms that symbolically relate their stories.

Have the children divide their poster paper into a grid of equal squares. The size and number of squares will depend upon the story their histogram has to tell. Squares may represent one unit, five units, ten units, etc.

Ask the children to tape the lines of their grids.

Now invite the children to create a symbol of geometric shapes to be used in the histogram. Have the children cut these shapes from construction paper.

Use the created symbols to fill in squares to tell the histogram story.

ADAPTATIONS

Suggested Adaptations for the Deaf Child

Language cards: Histogram, Squares, Measure, Poster paper, Tape, Grid, Equal, Construction paper, Cut, Geometric shape, Symbol, Pattern. Divide the poster paper into equal squares. Cut paper into geometric shapes. Create a symbol with the shapes. Repeat the symbol to tell a story. Paste symbols to poster paper.

COMMENTS

Blind children should use brailled rulers. It is essential for the blind children to tape the lines of their grids. Other children may mark off the lines with felt tip pens or crayons.

Sighted children may paint or crayon their symbols rather than use cut-out construction paper shapes.

BUILDING UP HISTOGRAMS

+------------------------------+
| **MATCH BOX** |
+------------------------------+
| General Concepts: |
| Using histograms |
| |
+------------------------------+

EXPLORATION

To build wooden sculptures that tell the histogram story.

ART CONCEPTS

Diagramming a story. Building a three-dimensional structure. Creating size relationships.

MATERIALS

wood scraps from lumber yard or corks

wooden board for base

glue

masking tape

paint and paint brushes (optional)

PROCEDURE

Ask the children to make up a story. For example: The first week my plant grew two inches, the second week my plant grew four inches, the third week my plant grew three inches, the fourth week my plant grew one inch.

Preferably the story should relate to science activities involving histograms.

Explain to the children that they are going to make sculpture histograms that symbolically relate their stories.

Have the children select wooden blocks to use in telling their story. Each block will represent one unit, five units, ten units, etc.

Invite the children to build towers with the wooden blocks to make their sculptural histogram. Glue blocks to the base piece of wood. Block towers should grow according to the story. Each fact should be represented by a tower of corresponding height.

Blocks should be glued together and taped in place while the glue is drying. After the glue has dried, remove the tape.

Some children may want to paint their sculptural histogram.

ADAPTATIONS

Suggested Adaptations for the Deaf Child

Language cards: Wood block, Glue, Wood base, Tape, Histogram, Sculpture, Three-dimensional, Diagram, Size, Height, Relationship, Tall, Short. Build a histogram. Glue wooden blocks. Tell a story. Use each block to represent a unit. Tape blocks until glue dries.

COMMENTS

There are a number of exciting alternative ways to build three-dimensional histograms. Instead of wood blocks, try using corks or frozen orange juice containers. A piece of Styrofoam and nails can also be used to indicate the histogram story.

A CYCLE-MILL-O-PLANE

MATCH BOX

Suggested Science Match:
Exploring Rotoplanes
p. 168
Motion as Evidence of
Energy Transfer p. 176
Water Wheel p. 221

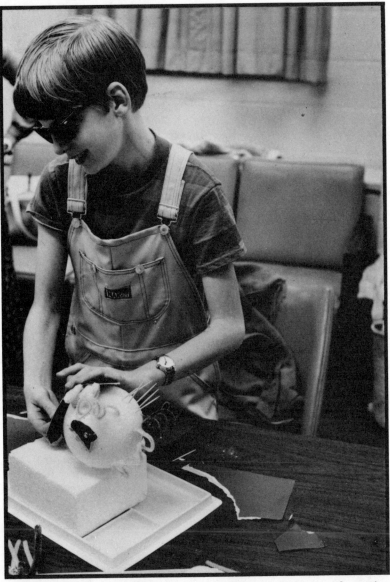

Figure 4.96. *Blind child building an imaginary machine with moving parts.*

EXPLORATION To create a sculpture that has moving parts.

ART CONCEPTS Building a three-dimensional structure. Using movable parts in an art form.

MATERIALS

Styrofoam blocks and balls
pipe cleaners
scissors
paint and paint brushes
 (optional)

toothpicks
heavy construction paper
paper fasteners

Figure 4.97. A cycle-mill-o-plane created by blind child.

PROCEDURE

Invite the children to create an imaginary machine with many moving parts.

Have the children use the Styrofoam balls and blocks as a base. Styrofoam can be attached by using pipe cleaners and toothpicks.

Have the children cut shapes for the imaginary machine from construction paper, joining them with paper fasteners.

Machines may be painted upon completion.

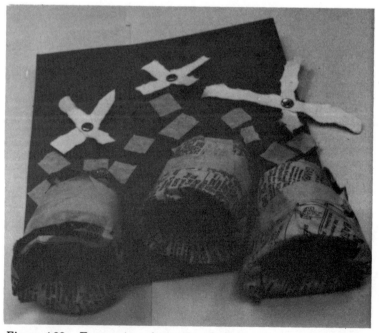

Figure 4.98. Expression of a water wheel.

ADAPTATIONS

Suggested Adaptations for the Deaf Child

Language cards: Styrofoam, Tooth picks, Pipe cleaners, Paper fasteners, Scissors, Shape, Moving parts, Wheels, Propellers, Wind mills, Cutting, Folding, Bending. Make a sculpture with moving parts. Invent your own machine. Attach Styrofoam with toothpicks and pipe cleaners. Cut moving parts from construction paper.

EMPHASIS

When matched to the following science lessons the indicated emphasis should be used.

Exploring Rotoplanes: Invite the children to elaborate on the design of the rotoplane used in the science activity by creating an imaginary machine with moving propellers.

Motion as Evidence of Energy Transfer: After the children have completed their imaginary machine with moving parts, have them identify the variables that affect the amount of energy transferred to the moving part of their machine.

Water Wheel: Invite the children to create an expression of the water wheel used in their science activity.

MOVING MACHINES: Energy Transfer

<table>
<tr><td>

MATCH BOX

Suggested Science Match:
Electric Circuits p. 107
Objects That Can Close A
Circuit p. 111
Motion as Evidence of
Energy Transfer p. 176

</td><td>

Figure 4.99. Making a machine with batteries and motors.

</td></tr>
</table>

EXPLORATION

To create an art form with moving parts powered by battery, demonstrating energy sources, energy transfer, and energy receivers.

ART CONCEPTS

Using movement in art. Designing three-dimensional constructions.

MATERIALS

small boxes—shoe box size or smaller
masking tape
batteries and small motors

lightweight cardboard or poster paper
wire
paint and paint brushes (optional)

PROCEDURE

Ask the children to create an imaginary machine with parts that will move, powered by battery.

Have the children work with a box base and cut shapes from poster paper for the moving parts.

Once the machine has been constructed, attach parts to battery and motor to make the parts move.

Optional: Paint the machine construction.

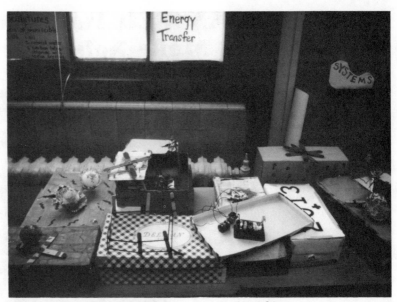

Figure 4.100. Completed battery powered machines.

ADAPTATIONS

*Adaptations for
the Blind Child*

*Suggested Adaptations
for the Deaf Child*

Before the activity cut propeller shapes from poster paper for blind children.

Language cards: Box, Battery, Wire, Poster paper, Scissors, Tape, Paint, Paint brush, Construct, Moving parts, Motor, Energy transfer, Energy source, Energy receiver. Make a machine with moving parts. Use the motor to make the parts move. Cut shapes from poster paper.

ENERGY TRANSFER HANGINGS:
Mobiles That Make Noise

MATCH BOX

Suggested Science Match:
Motion as Evidence of
Energy Transfer p. 176

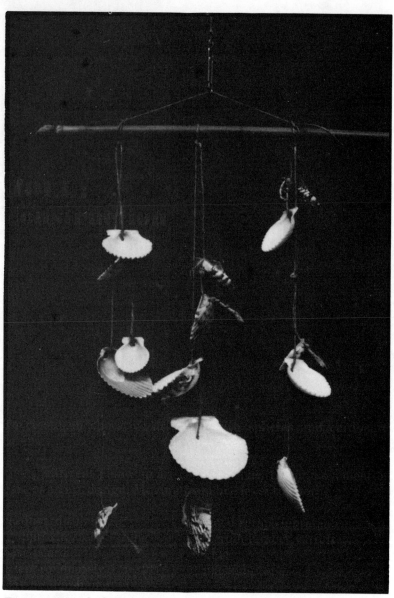

Figure 4.101. A shell mobile.

EXPLORATION

To create a mobile whose moving parts create sound.

ART CONCEPTS

Expressing mobility. Discovering balance and imbalance. Recognizing and using symmetry and asymmetry.

MATERIALS

a base from which to
 hang strings: this can
 be a number of things—a
 bamboo stick, a piece of

string
scissors
objects to hang: there are a
 number of possibilities—

wood with nails protruding to attach string to, the bottom of an egg carton with holes punched to allow string to pass through and be knotted

anything that can be strung and will make noise when moved against another object. Suggestions include: shells, small pieces of bamboo, macaroni, plastic clothes pins, large nails

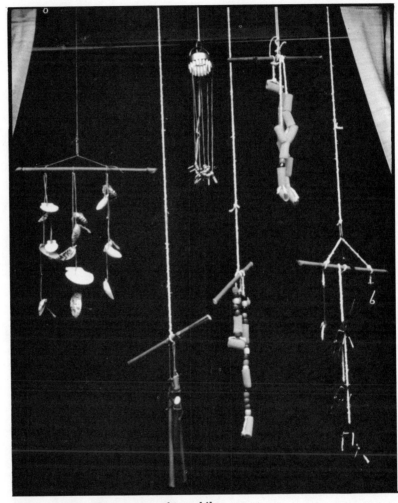

Figure 4.102. Energy transfer mobiles.

PROCEDURE

Ask the children to make a base according to the materials you have selected for them.

Invite the children to string a number of objects and hang them from the base.

Encourage the children to produce a balanced mobile whose strings can move freely back and forth.

ADAPTATIONS

Adaptations for the Blind Child

It is particularly important for the blind children to work with objects that produce a maximum amount of noise when swung together. The egg carton or wood base with nails is the most easily manipulated base for blind children.

Language cards: Energy transfer hanging, Base, Mobile, Energy transfer, String, Suspend, Energy receiver, Objects, Hang, Energy source, Balance, Movement. Attach the objects to the string. Hang the string from the base.

WAVY PATTERNS

```
┌─────────────────────────────┐
│        MATCH BOX            │
├─────────────────────────────┤
│                             │
│  Suggested Science Match:   │
│  Salt Solution p. 139       │
│                             │
└─────────────────────────────┘
```

EXPLORATION

To create a sand painting that expresses the wavy patterns of schlieren.

ART CONCEPTS

Understanding the difference between straight and wavy line. Creating wavy lines.

MATERIALS

heavy weight paper: poster paper or lightweight cardboard

glue
paint brushes
fine sand

PROCEDURE

Have the children recall the wavy lines observed in the Salt Solution science activity. Invite the children to express the wavy lines observed by creating a sand painting.

First paint the poster paper with wavy lines of glue. Sprinkle the entire paper with sand. Shake off the excess sand. Observe the wavy lines of sand left on the paper.

ADAPTATIONS

Suggested Adaptations for the Deaf Child

Language cards: Sand, Glue, Paint brush, Paint, Wavy lines. Paint wavy lines on the poster paper with glue. Sprinkle sand all over the paper. Shake off extra sand. Observe the wavy patterns.

MAKING BALLS ROLL:
A Sphere Slider Construction

```
┌─────────────────────────────┐
│         MATCH BOX           │
├─────────────────────────────┤
│ Suggested Science Match:    │
│ Energy Transfer from        │
│ Spheres to Sliders p. 183   │
│ Energy Transfer p. 188      │
└─────────────────────────────┘
```

EXPLORATION

To create an operative art form with spheres and cardboard tubing.

ART CONCEPTS

Using different planes in art constructions. Using movement as part of an art design. Moving from one level to another.

MATERIALS

cardboard tubing
 approximately 8″ long
base board
 (approximately 9″ × 12″)
clay or aluminum
 foil to make balls

wood scraps (obtainable
 from lumber yard free)
glue
masking tape

PROCEDURE

Ask the children to create a sculpture using the cardboard tubes and wooden board base.

Have the children glue blocks of wood into columns of different height. Tape the glued columns in place while drying.

Attach cardboard tubes at one end to the top of the block column, and at the other end to the base board.

Ask the children to create as many different angles as possible with the different pieces of cardboard tubing.

Make balls from clay or aluminum foil, or use wooden balls or marbles.

Invite the children to explore their sphere slider construction by rolling balls down the different cardboard tubes.

ADAPTATIONS

*Suggested Adaptations
for the Deaf Child*

Language cards: Cardboard tube, Base board, Wood blocks, Glue, Height, Angle, Clay ball, Build. Glue wooden blocks together. Create block buildings of different height. Glue tube to top of the blocks and to the base board. Make a ball from clay. Roll the ball down the cardboard tubes.

A COLLAGE OF ANGLES

```
┌─────────────────────────────────┐
│          MATCH BOX              │
├─────────────────────────────────┤
│                                 │
│  Suggested Science Match:       │
│  The Angle of the Stopper       │
│  Popper p. 180                  │
│                                 │
└─────────────────────────────────┘
```

EXPLORATION

To create a collage of angles and spheres representing the path traveled by the popper.

ART CONCEPTS

Using angles in art. Diagrammatically representing movement.

MATERIALS

construction paper
scissors
glue or paste

PROCEDURE

Invite the children to make a diagrammatic representation of the science stopper popper activity.

Have the children cut several triangles from construction paper, each composed of different angles. Now cut a number of circles from construction paper.

Glue a triangle onto construction paper. Then glue a number of balls starting at the peak of the top angle of the triangle, diagramming the path the ball would take. Fill the paper with angles (triangles) and balls moving through space, marking the pathways originating at the top of triangle.

ADAPTATIONS

*Adaptations for
the Deaf Child*

Language cards: Angle, Triangle, Ball, Cut, Paste. Cut triangles from construction paper. Have each triangle made of different angles. Cut balls from construction paper. Show where the balls would go.

WEAVING:
Yarns Close Together and Far Apart

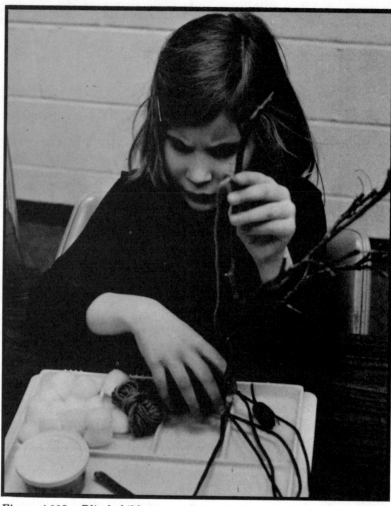

Figure 4.103. Blind child gets ready to start weaving.

EXPLORATION

To weave yarns closely and far apart on a branch.

ART CONCEPTS

Using the dendritic nature of a branch as a grid for weaving. Developing spacial concepts by transforming negative space into positive space. Creating planes.

MATERIALS

a branch with at least
 two parts
scissors
cotton balls (optional)

yarn (assorted colors for
 sighted, assorted thick-
 nesses for blind)
feathers (optional)

PROCEDURE

Ask children to examine the branches. Who can figure out how the branch was growing from the tree? In what direction was it

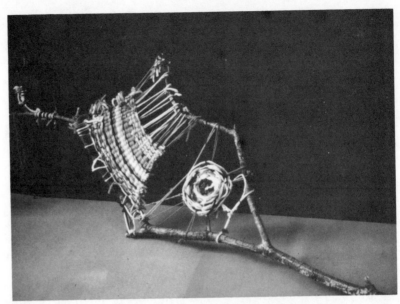

Figure 4.104. A branch weaving of different yarn densities.

growing? Was the narrow end of the branch closer or farther away from the trunk of the tree?

Ask the children to find where the branch parts meet—this is the juncture point.

Discuss with the children the principle of weaving—going over and under with yarns.

Ask the children to tie a number of yarns horizontally between the two parts of the branch.

When they have finished, ask them to weave pieces of yarn under and over the horizontal pieces of yarn. Weave some areas densely to contrast with areas with only a few yarns.

Feathers, small sticks, and bits of cotton can be woven into the design. If the branch has more than two segments, weave these into the design, creating different planes.

ADAPTATIONS

Suggested Adaptations for the Deaf Child

Language cards: Branch, Juncture point, Yarn, Tie, Weave, Horizontal, Vertical, In and out, Plane, Connect. Tie a number of yarns going horizontally between two segments of the branch. Going vertically weave yarn in and out of the horizontal yarns.

COMMENTS

If children are not familiar with the technique of weaving, you might want them to experiment with weaving paper strips before the lesson.

Wrapping branches with yarn is another interesting activity. Children discover the circularity of the branch as they densely wrap yarn to cover the entire form of the branch.

DENSITY WINDOWS

```
┌─────────────────────────────┐
│         MATCH BOX           │
├─────────────────────────────┤
│                             │
│  Suggested Science Match:   │
│  Buoyancy of Liquids of     │
│  Different Densities p. 62  │
│                             │
└─────────────────────────────┘
```

EXPLORATION

To create window designs of varying density by altering the number of segments used in the design.

ART CONCEPTS

Understanding density in art. Creating an art form from a number of small parts. Repeating shape in art.

MATERIALS

black construction paper masking tape
scissors colored tissue paper

PROCEDURE

Discuss the concept of density with the children. Who remembers or knows about particles in liquids? Gases? Solids? In which are the particles closer?

Explain to the children that they are going to create density windows.

Have the children cut out black outlines of circles—circles with the middles cut out. Tape tissue paper over the empty space—this will be the symbol of the particle.

Assign several children to each window in the classroom. *Blind children should have sighted partners.* Ask each group to make as many particles as they can and tape them to their window.

Shortly before time runs out, ask the children to look at the different windows. Which window is most densely packed with particles? Allow blind children to feel the windows.

ADAPTATIONS

Adaptations for the Blind Child

Have sighted partners for blind children. Sighted partners should lead blind children to the window. Blind children can feel the finished product to experience the quality of density.

Suggested Adaptations for the Deaf Child

Language cards: Construction paper, Masking tape, Colored tissue, Scissors, Cut, Circles, Stick, Windows, Dense, Less dense, Most dense. Cut circles from black construction paper. Cut out inside of circle. Tape tissue paper to black circle. Tape "particles" to window.

COMMENTS

If your classroom does not have windows, or if they are too high to reach, each child can make a density paper, or the class can make a density mural, with particles spaced at different distances from each other.

EMPHASIS

When matched to the following science lessons the indicated emphasis should be used.

Buoyancy of Liquids of Different Densities: Recall with the children that the buoyancy of a liquid depends upon its density. Have the children create a weaving where yarns are closely woven together, representing a buoyant liquid of great density.

LUB-A-DUB PAPER CHAIN RHYTHMS

```
┌─────────────────────────────────┐
│          MATCH BOX              │
├─────────────────────────────────┤
│ Suggested Science Match:        │
│ Pumping Pulse p. 215            │
│ Heartbeat p. 217                │
└─────────────────────────────────┘
```

EXPLORATION

To create paper chains that express the rhythmic quality of heartbeats.

ART CONCEPTS

Creating circular form. Making patterns relating to the heartbeat sound.

MATERIALS

construction paper
scissors
tape

PROCEDURE

Ask the children to express the rhythm of their heartbeat by making a paper chain.

First have the children listen to their hearts with a stethoscope. How does the rhythm change when they jump up and down or exercise?

Can you feel your heartbeat, or do you have to listen to it with a stethoscope?

Have the children beat out the rhythm of their heartbeats on the desk.

Ask the children to make a paper chain that relates the rhythm of their heart. For example, lub-a-dub could be big link, little link, very big link, etc., repeating the pattern of the rhythm.

ADAPTATIONS

*Suggested Adaptations
for the Deaf Child*

Language cards: Heartbeat, Rhythm, Short, Long, Stethoscope, Paper chain, Paper, Scissors, Tape. Your friend will listen to your heartbeat. Your friend will pat your hand so that you can feel the rhythm of your heart. Make a paper chain that shows the rhythm of your heart. Cut strips from construction paper. Tape the strips together to make a paper chain that shows the rhythm of your heart.

Ask a child with no auditory problem to listen to the heartbeat of a deaf child with a stethoscope. Have the listening child gently pat the rhythm of the heart on the deaf child's hand.

JACK-IN-THE-BOX

MATCH BOX
Suggested Science Match: Energy Transfer p. 188

Figure 4.105. Jack-in-the-box.

EXPLORATION

To construct a jack-in-the-box where the release of the compressed form produces sound through the oscillation of the coiled wire.

ART CONCEPTS

Design a working model demonstrating and emulating the oscillation of sound waves and/or the transfer of energy. Construct an additive, kinesthetic, kinetic structure of multiple circular shapes: sphere (ball head), spiral (coil), and cylinder (housing).

MATERIALS

cardboard cylinder (with bottom lid) 6″ high (frozen juice container or chips container)
coils (springs, cut Slinky toy, or homemade spring of 0.18 gauge steel wire, 60″ long, wrapped around 3/4″ pipe)
clay at bottom of container to embed coil
Styrofoam ball small enough to fit diameter of can
crepe paper, bits of cloth (body and head)
construction and tissue paper
glue, scissors, tape
small jingle bells, paper clips
small circle for the lid

PROCEDURE

Invite the children to create a jack-in-the-box. Examine coil compression and decompression. Attach a bell to coil. What is needed to produce sound? What is needed to produce movement of the spring? (Compression and decompression produce *vibration-oscillation*.)

Ask the children to embed coil in clay at bottom of cylinder and to attach ball to other end of coil. Make jack by making a head and clown hat and body with materials. Examine struc-

ture for circles. How many can they identify? Discuss spiral, cylinder, sphere, circle.

For sound, attach bells.

Test by compressing and release. What happens? (Movement and sound.) Whose jack moves and sounds the longest?

Decorate the outside with "circular shape" designs and noisy objects. Attach lid to one side of the top.

ADAPTATIONS

Suggested Adaptations for the Blind Child

Explore decoration of the housing with additional sound-makers (clips, bells, etc.) to emphasize compression and decompression of the spring.

Suggested Adaptations for the Deaf Child

Language cards: Coil, Coil=spiral, Transfer of energy, Compress and release the coil (spiral), Vibration, Cylinder box, Box=cylinder, Clay, Attach, Jack's head, Glue, Cut, Geometric shapes, Construction paper, Tissue paper, Lid circle, Tape. Place coil in clay at bottom of cylinder. Jack's head=sphere. Make a face and a hat for the sphere. Find circular shapes. Decorate the outside of Jack's box with circular shapes. Put lid on the cylinder.

THE SOUNDS AND VIBRATIONS OF A BRANCH HARP

MATCH BOX

Suggested Science Match:
Sound Transmission
through Different Media
p. 203
Musical Strings p. 207

Figure 4.106. *A branch harp created by blind child.*

EXPLORATION

To develop a harp using the dendritic branching properties of a branch in combination with a vibrating rubber band.

ART CONCEPTS

Recognizing the dendritic and branching qualities of a branch. Creating planes by adjoining branches. Creating an art form that produces sound and vibration.

MATERIALS

sturdy branch with at least one fork
rubber bands
beads, homemade or purchased (optional)

PROCEDURE

Invite the children to examine their branches. Where is the branch the thinnest? Where is it the thickest?

Ask the children to make a branch harp by stretching rubber bands across the branch.

Let the children explore their harps, once completed. What rubber bands make high sounds and what rubber bands make low sounds? Can the sound of the rubber band be changed by shortening it with your fingers?

Completed branch harps can be decorated with beads.

ADAPTATIONS

*Suggested Adaptations
for the Deaf Child*

Language cards: Branch, Branching quality, Dendritic quality, Plane, Rubber band, Beads, Stretch, Feel, Vibration. Examine the branch. Where is it thinnest? Where is it thickest? Stretch

a rubber band over the branch. Pluck the rubber band. Can you feel the vibration?

Although deaf children will not be able to hear the sound, they will be able to feel the movement of the vibration.

EMPHASIS

When matched to the following science lesson the indicated emphasis should be used.

Sound Transmission through Different Media. While the children construct the branch harp, encourage them to notice that the source of sound is always some object or system of objects in vibration.

VIBRATING ART FORMS

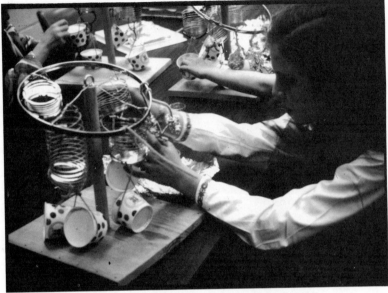

Figure 4.107. Exploring a vibrating creation (blind child).

EXPLORATION

To create an art form that demonstrates the elastic nature of vibrations.

ART CONCEPTS

Using elasticity in art. Using movement in art.

MATERIALS

one branch for each child or a frame from which to hand objects—the frame may be improvised from wood base, dowel, eye hook, wire, and steel hoop, or more simply by cutting away inside portions of large cardboard box, leaving the frame
Slinkies or springs
Dixie cups or paper cups
string
weights: marbles, bells, or dried beans

PROCEDURE

If the children will be using branches, before the class suspend a string, at shoulder height for most children, across the classroom. Tie string securely so that it can support weight and movement.

Invite the children to make vibrating art forms with Slinkies (springs). Ask the children to recall the nature of elastic and vibrating objects from their science activity.

Suspend springs from branch/frame. At the end of the springs attach cups. Inside the cups place different weights, and observe the movement of the springs. What happens once the weights are removed from the cups? (Springs return to original form.)

ADAPTATIONS

*Adaptations for
the Blind Child*

Use bells as weights for blind children so that they may verify the elastic movement of the Slinky.

*Suggested Adaptations
for the Deaf Child*

Deaf child should verify the elastic motion of the Slinky by observation.

Language cards: Slinky/spring, Frame, Weights, Bells, Beans or Marbles, String, Dixie cups, Vibration, Elasticity. Hang a spring from the frame/branch. To the end of the spring attach a Dixie cup/paper cup. Put different weights in the cup. What happens to the spring?

CORK TOWERS:
An Expression of Sound

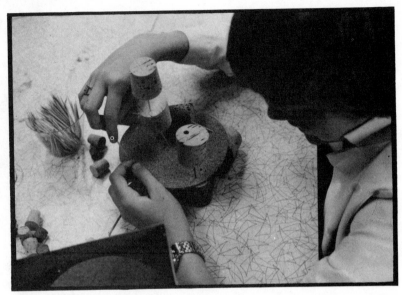

Figure 4.108. *"A low tone, a higher tone, and I'm starting a higher one."*

EXPLORATION

To express the tonal qualities of music with cork towers of differing heights.

ART CONCEPTS

Creating a sculptural art form that is expressive artistically and scientifically. Using vertical line to express the quality of sound.

MATERIALS

corks
toothpicks
Styrofoam or wooden base

glue (needed for wooden base)
musical instruments that can produce low and high tones

PROCEDURE

Ask the children to sing a low tone, a high tone, and an even higher tone.

Invite the children to express the different qualities of tone by making cork towers. Have each tone represented by a tower of different height.

Starting from the base, have the children build towers of different heights using toothpicks to join corks.

Ask the children to sing their cork towers.

ADAPTATIONS

Suggested Adaptations for the Deaf Child

Deaf children can relate this art activity to qualities of touch, size or texture. Some deaf children may be able to relate to vibrations or be able to in fact hear very high or low tones.

Language cards: Cork, Tower, Sculpture, Height, Vertical, Toothpick, Base. Build a cork tower. Use the toothpicks to hold corks together. Make the cork tower grow. Attach the tower to the base.

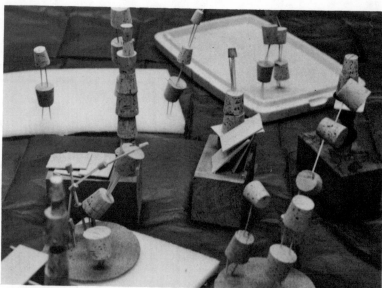

Figure 4.109. Completed cork towers.

COMMENTS

Cork towers can be made using glue instead of toothpicks. Older children may want to compose little songs by using one cork for each musical interval.

EMPHASIS

When matched to the following science lesson the indicated emphasis should be used.

Serial Ordering and Comparison of Objects: Invite the children to arrange the cork towers in order according to height, to establish a comparison of greater and lesser height.

ALUMINUM FOIL RELIEFS

```
┌─────────────────────────────┐
│         MATCH BOX           │
├─────────────────────────────┤
│                             │
│  Suggested Science Match:   │
│  Bounce That Light p. 213   │
│                             │
└─────────────────────────────┘
```

EXPLORATION

To use linear elements in making an aluminum foil relief that will bounce and reflect light.

ART CONCEPTS

Using raised line to delineate shape and pattern. Making linear designs.

MATERIALS

double weight aluminum foil
cardboard
masking tape
ball point pen to make lines

PROCEDURE

Invite the children to make a raised line relief on aluminum foil.
 Put the aluminum foil on a piece of cardboard. Fold foil over edges to prevent from slipping.
 Using a ball point pen, push firmly but gently while drawing on the aluminum foil.
 Try filling in some shapes with little lines, some with dots, some with cross hatching.
 Once the design is complete, turn it over to feel the raised line relief.
 Tape the relief to the cardboard so that the raised line portion is now facing outward.
 Try some experiments with your aluminum foil relief. What will it do to the light? Hold it in front of a light source and use the light sensor to see what happens.

ADAPTATIONS

Suggested Adaptations for the Deaf Child

Language cards: Aluminum foil, Relief, Raised line, Pen, Cardboard. Put the aluminum foil on the cardboard. Use the pen to gently draw lines on the aluminum foil. Make different lines. Fill in some areas with little lines. Turn the paper over to see your raised line drawing. Test your relief with the light sensor.

COMMENTS

In addition to the aluminum foil panel, panels can be made from cellophane, tissue paper, and dark construction paper. For tissue paper and cellophane panels, cut cardboard into a frame and tape cellophane shapes across it. Use collage technique for these additional panels. Once completed, test them all with the light sensor and a light source. What do the different panels do to the light?

A PENDULUM HOUSE

MATCH BOX
Suggested Science Match: Pendulums p. 158

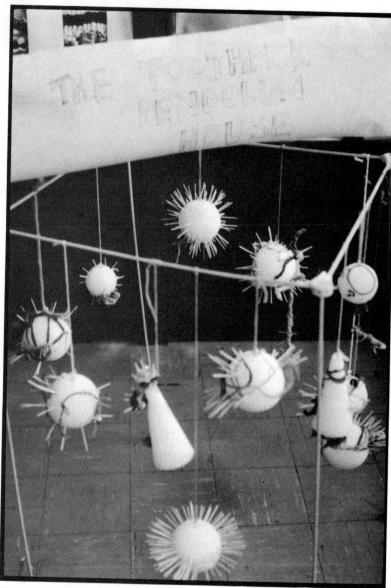

Figure 4.110. A pendulum house built by blind, deaf, and ordinary children in a mainstream setting.

EXPLORATION To design and create elements for a pendulum house.

ART CONCEPTS Using free swinging movement in art. Creating segments of a total group of art expression.

MATERIALS

Styrofoam balls
toothpicks
pipe cleaners
yarn

a frame for every six children created from a large box, or dowel and Tinker toy parts

PROCEDURE

Invite the children to make pendulums.

Have the children make the pendulum from a Styrofoam ball and toothpicks. Encourage the children to use as many toothpicks as possible.

Create a circle with a tail from the pipe cleaner. Push the tail end of the pipe cleaner into the Styrofoam ball.

Attach the yarn to the pipe cleaner and hang the pendulum in the pendulum house.

ADAPTATIONS

*Adaptations for
the Blind Child*

Every blind child should have a sighted partner to assist in hanging the pendulums in the pendulum house.

*Suggested Adaptations
for the Deaf Child*

Language cards: Styrofoam ball, Toothpicks, Pipe cleaner, Yarn, Hang, Pendulum, Swing, Movement. Put as many toothpicks into the styrofoam ball as possible. Use the pipe cleaner to make a circle. Stick the circle into the Styrofoam ball. Hang the pendulum you have made in the pendulum house.

COMMENTS

Pendulums can be made in numerous ways. You may want to have children make pendulums from paper plates. Give each child two paper plates. Invite the children to decorate the plates with paint or paper shapes and glue. After the plates have been decorated, attach them back to back with the yarn in the middle, or punch holes in paper plates and string yarn through the hole. Paper plate pendulums may be suspended from a string that spans the classroom. Do not attach string to lighting fixtures.

REFERENCES

Barraga, N. C. 1976. Visual Handicaps and Learning. Wadsworth Publishing Co., Belmont, California.

Bruner, J. S. 1960. The Process of Education. Harvard University Press, Cambridge, Massachusetts. (See especially Chapter 2, "The Importance of Structure.")

Cutsforth, T. D., 1972. The Blind in School and Society: A Psychological Study. American Foundation for the Blind. New York.

Dale, D. M. C. 1974. Language Development in Deaf and Partially Hearing Children. Charles C. Thomas Publishers, Springfield, Illinois.

Furth, H. G. 1966. Thinking Without Language: Psychological Implications of Deafness. The Free Press, New York.

Furth, H. G. 1973. Deafness and Learning: A Psychological Approach. Wadsworth Publishing Co., Belmont, California.

Hadary, D. E. 1975. Picking up good vibrations from science for the handicapped. Sci. Teach. 42:12–13.

Hadary, D. E. 1976. Interaction and creation through laboratory science and art for special children. Sci. and Child. 13:31–33.

Hadary, D. E., et al. 1976. Breaking sound barriers for the deaf child. Sci. and Child. 14:33.

Hadary, D. E. 1977. Science and art for visually handicapped children. J. Vis. Impair. Blind. 71:15.

Hadary, D. E., and Long, N. J. 1975. Twenty-five field tested science lessons for elementary age pupils with special needs. The American University, Mimeographed. Washington, D.C.

Hadary D. E., Long, N., and Griffin, W. 1975. A research evaluation of a specialized American University science curriculum for emotionally disturbed pupils in elementary schools. The American University, Washington, D.C.

Hunt, J. McV. 1961. Intelligence and Experience. The Ronald Press Co., New York.

Inhelder, B., and Piaget, J. 1958. The Growth of Logical Thinking from Childhood to Adolescence. Basic Books, New York.

Karplus, R. 1964. One physicist looks at science education. In Intellectual Development: Another Look. Association for Supervision and Curriculum Development, Washington, D.C.

Karplus, R. 1969. Introductory Physics: A Model Approach. W. A. Benjamin, Inc., New York and Amsterdam.

Karplus, R., et al. 1977. Science teaching and the development of reasoning. Lawrence Hall of Science, University of California, Berkeley, California. The Regents of the University of California.

Kirk, S. A. 1972. Educating Exceptional Children. Houghton Mifflin Co., Boston.

Linn, M., Hadary, D. E., Rosenberg, R., and Haushalter, R. 1978. Evaluation of ideal mainstream and resource programs to teach science to deaf students Paper presented at AERA Annual Meeting.

Long, N. J., Morse, W. C., and Newman, R. G. 1976. Conflict in the Classroom: The Education of Emotionally Disturbed Children. 3rd edition. Wadsworth Publishing Company, Belmont, California.

Lydon, W. T., and McGraw, M. L. Concept Development for Visually Handicapped Children. Handbook for Teachers of the Visually Handicapped. Instructional Materials Center for Visually Handicapped Children.

Smith, R. M., and Neisworth, J. 1975. A functional approach. Excep. Child.

Struve, N. L., Hadary, D. E., Thier, H. D., and Linn, M. 1975. The effects of an experiential science curriculum for the visually impaired on course objectives and manipulative skills. Educ. Vis. Handicapped 7 (1):9. The official publication of the Association for Education of the Visually Handicapped.

Thier, H. D. and Hadary, D. E. 1973. We can do it, too. Sci. Child. 11:7–9.

Walsh, E. 1977. The handicapped and science: Moving into the mainstream. Science 196.

Weiss, M. E. 1976. Seeing Through the Dark: Blind and Sighted—A Vision Shared. Harcourt Brace Jovanovich, New York.

PROGRAM FILMS

Fulfillment of Human Potential. 16-mm, 18 minutes. Color. The American University, Department of Chemistry, Washington, D.C.

Laboratory Science and Art for the Blind, Part I. 16-mm, 18 minutes. Color. The American University, Department of Chemistry, Washington, D.C.

Laboratory Science and Art for the Blind, Part II. (Advanced and Gifted Handicapped.) 16-mm, 18 minutes. Color. The American University, Department of Chemistry, Washington, D.C.

Mainstreaming. Evidence of Interaction—Handicapped Children Learning Science and Art in a Mainstream Setting. The American University, Department of Chemistry, Washington, D. C.

Touching Science. Blind Children and the Laboratory Approach to Science and Art. The American University, Department of Chemistry, Washington, D.C.

SLIDE PRESENTATIONS

History: Laboratory Science and Art, 1972–Present. The American University, Department of Chemistry, Washington, D.C.

Laboratory Science and Art for the Blind. The American University, Washington, D.C.

Laboratory Science and Art for the Deaf. The American University, Washington, D.C.

Laboratory Science and Art for Special Children. The American University, Washington, D.C.

Laboratory Science, Music and Art for the Blind. The American University, Washington, D.C.

Mainstreaming, How It Works in the Science and Art Room for Deaf, Blind, Emotionally Disturbed and "Normal" Children. The American University, Washington, D.C.

SOURCES OF INFORMATION AND MATERIALS FOR THE BLIND

American Foundation for the Blind
 15 West 16th Street
 New York, N.Y. 10011
 A national private organization that serves as a clearing house for all information about blindness, and that promotes the development of education, rehabilitation, and social welfare services for blind and deaf-blind children and adults. Develops and sells at cost special appliances. Some aids are available without cost.
American Printing House for the Blind, Inc.
 1839 Frankfort Avenue
 Louisville, Kentucky 40206
 Manufactures special educational aids.
Howe Press of Perkins School for the Blind
 175 N. Beacon Street
 Boston, Massachusetts 02172
 Manufactures and distributes appliances such as writing aids, braille paper, and the Perkins Brailler.
Library of Congress
 Division for the Blind
 Washington, D.C. 20540
 Braille reading material lent without charge.

Recordings for the Blind
 215 East 58th Street
 New York, N.Y. 10022
 Recorded books and texts are supplied without charge.

State Agencies (Maryland)

Maryland School for the Blind
 3501 Taylor Avenue
 Baltimore, Maryland 21236
 A private state-aided residential and day school.
State Library for the Physically Handicapped
 1715 North Charles Street
 Baltimore, Maryland 21201
 Loans free braille and recorded materials without charge.

Volunteer Services

The following agencies will prepare materials in braille and/or supply tape recordings free of charge for visually impaired persons:

The American Red Cross
 Baltimore Chapter
 Baltimore, Maryland
Volunteer Services for the Blind, Inc.
 332 S. 13th Street
 Philadelphia, Pennsylvania 17107